D1063428

IMAGES OF SAINTHOOD IN
MEDIEVAL EUROPE

IMAGES OF SAINTHOOD IN MEDIEVAL EUROPE

Edited by

Renate Blumenfeld-Kosinski

and

Timea Szell

Cornell University Press

ITHACA AND LONDON

Copyright © 1991 by Cornell University

All rights reserved. Except for brief quotations in a review, this book,
or parts thereof, must not be reproduced in any form without
permission in writing from the publisher. For information, address
Cornell University Press, 124 Roberts Place, Ithaca, New York 14850.

First published 1991 by Cornell University Press.

International Standard Book Number 0-8014-2507-7 (cloth)
International Standard Book Number 0-8014-9745-0 (paper)
Library of Congress Catalog Card Number 90-55889

Printed in the United States of America

*Librarians: Library of Congress cataloging information
appears on the last page of the book.*

⊗ The paper in this book meets the minimum requirements of the
American National Standard for Information Sciences—Permanence of
Paper for Printed Library Materials, ANSI Z39.48–1984.

Contents

Editors' Note

How was sainthood represented in the Middle Ages? What role did these representations play in medieval culture and politics? How does the issue of gender enter into the creation of images of sainthood? These are the questions addressed by the contributors to this volume. Adopting a wide variety of critical approaches, the essays range from detailed analyses of religious discourse to theoretical inquiries into the forces that shaped ideas of sanctity. They offer an equally wide range of conclusions, in particular with respect to the complex and multiple functions of sainthood in medieval culture. Taken together, they point to new ways of imagining and "imaging" the medieval saint.

The book had its origins in the Barnard Medieval and Renaissance Conference in 1987. The editors thank Barnard College for material assistance in preparing the manuscript for publication.

RENATE BLUMENFELD-KOSINSKI *and* TIMEA SZELL

New York City

IMAGES OF SAINTHOOD IN MEDIEVAL EUROPE

BRIGITTE CAZELLES

Introduction

Since sainthood designates a state of perfection fully known only by those who experience it, any attempt to define and describe this experience is of necessity indirect. Indeed, hagiology is first and foremost a mediative enterprise undertaken by external observers as they reflect on the conditions leading to Christian perfection. The resulting discourse provides its public with a gallery of portraits, each emblematic of a particular virtue and each endowed with a specific exemplary value. A typical hagiologic document thus comprises two distinct and complementary types of mediation: the aim is, first, to evoke, at the biographical level, the facts and events accounting for the sanctification of an individual; and, second, to inspire the believer to respond actively to such exemplary stories. It is this twofold process of mediation that the present volume considers, through a cross-disciplinary perspective whose goal is to reproduce in its very diversity the medieval representation of holiness.

If hagiography has been, throughout its history, a fundamentally didactic enterprise, the lessons conveyed by the verbal and visual documents commemorating the saints nevertheless vary, reflecting the political, spiritual, and social realities that gave rise to them. While always retaining their power to edify, these documents reached different audiences and exalted different modes of sanctity in accordance with their date and place of composition, as well as with their medium of expression. It is clear for instance that the martyrs of early Christianity—the first saintly heroes venerated in Western Europe—played different roles in third-, eighth-, and thirteenth-century hagiography; similarly a Pas-

sion composed in Latin had a different effect from one in the vernacular. Even though martyrdom remained the most popular type of saintly achievement throughout the Middle Ages, this particular expression of Christian faith was, for the medieval worshiper, also the most remote. That the early martyrs continued to fascinate the Christian community some ten centuries after their death underscores one important aspect of medieval hagiology, namely, that the saints thus portrayed were not so much models to be imitated as they were exceptions to be admired. For not only martyrs, but in effect all the major types of saints—hermits, confessors, ascetics—commemorated in medieval hagiography were generally viewed as superlative figures distinguished by extraordinary spiritual accomplishments. Heroic death in the case of the martyrs and, in the case of their holy successors, lifelong devotion to the service of God were achievements that the average Christian could not hope to emulate.

Distance is thus, on the one hand, an integral component of the medieval portrayal of sainthood: closeness to God is here the result of a merit attained only by a select few. On the other hand, the saints' exceptional contact with the Deity is also what places them in a privileged position to act as intercessors.

Focusing on the saints' power as advocates, as well as on the hagiographers' ability to translate and transcribe the language of the sacred into ordinary speech, medieval hagiology is on two counts a discourse on mediation. Language therefore plays a prominent role in the medieval representation of holiness, because language is the instrument that brings human beings closer to God, either because a person knows how to speak to God, as the saint does, or because, like the hagiographer, he or she knows how to interpret the sacred. In contrast with the average believer's relative lack of verbal or exegetical sophistication, perfection and literacy empower both the saint and his or her spokesperson to channel the communication between heaven and earth. As testified throughout the various images of sainthood examined in this volume, medieval hagiology is indeed an authoritative discourse in that it orchestrates the communication between God and the ordinary Christian. In this typically medieval articulation of order, access to God is proportional to one's position in the hierarchy of the Christian community. As a consequence, the hagiologic discourse elaborated during the Middle Ages tends to posit a synonymy between spiritual merit and social distinction. It comes as no surprise to see that until the late twelfth century the attribute of sainthood was almost

exclusively reserved to personages of episcopal or aristocratic status. Distant, noble, heroic, admirable, inimitable: such were the images of sainthood proffered by the Latin and vernacular lives of the saints. Medieval hagiologic mediation thus consists in exalting, first, the exceptional nature of the Christian hero, and second, his or her exceptional intercessive value. At the descriptive level, the saint's spiritual perfection is depicted in terms of distance, in consonance with the idea that the prerequisite for sainthood is remoteness from the world, either because the world in which the saint evolved no longer exists, as is the case of the martyrs of early Christianity, or, in the case of nonmartyr saints, such as monks, hermits, and ascetics, because of the heroes' desire to escape from society. But at the functional level, the hagiologic discourse on the contrary celebrates the active participation of the saint in temporal affairs: now dead and in heaven, the heroes commemorated in these documents intervene both to assist those who honor them and to punish those who threaten the Christian order. In time, however, the concept of holiness was to lose some of its exclusive dimension as ecclesiastical authorities adopted a new attitude toward certain strata and orders of society, thus laying open, from the twelfth century on, the path to sainthood for common lay men and women.

Yet such an inclusion of new models of sanctity did not radically affect the traditional understanding of sainthood as an exceptional achievement. A noble birth and a monastic or clerical affiliation continued throughout the Middle Ages to be almost sine qua non biographical requirements. The ability to perform miracles, which is to this day a prerequisite for canonization, remained an indispensable part of the process that led to the public recognition of the holiness of an individual. While the official cult of the saints as orchestrated by the church glorified them as exemplary embodiments of the humanity of Christ, a parallel and more popular form of devotion persisted until the Reformation, giving priority to their divine dimension. Popular devotion was not itself uniform but differed according to geographical location, sanctifying—particularly in the southern part of western Europe—certain exceptional urban lay people, and in northern areas, the more traditional heroic models.

All these aspects attest to the complexity of the medieval representation of holiness as it evolved throughout the Middle Ages. There is no question, therefore, of a linear process leading to a definition of sainthood as a selfless and altruistic behavior, as the term is now commonly understood. What characterizes the medieval cult of the saints

is, rather, the persistence of a plurality of responses to manifestations of Christian faith. Predictably, medieval hagiography is highly diversified, and the resulting discourse constitutes a privileged medium of access to the mental attitudes and aptitudes that pertain to the period under consideration. The essays gathered in this volume, which convincingly demonstrate the documentary value of the hagiologic discourse, render manifest the omnipresence of the saints in the life of both the medieval elite and the common Christian. Three main areas of interest emerge with particular insistence from an examination of medieval hagiologic mediation: first, the social and political realities against which hagiography flourished; second, the various translative modes involved in the articulation of holiness; and third, the treatment of female spirituality by Latin and vernacular hagiographers.

Part I. Hagiography and History

The four articles grouped in the first section focus on the twelfth and thirteenth centuries as a time of transition during which common people and laymen came to play a more important role in the life of the church. André Vauchez sets the spiritual and political background for this transition by tracing the changing relations between clerics and lay people from the tenth to the fourteenth century. Magdalena Carrasco, Lester K. Little, and Klaus P. Jankofsky explore the manifestations of this transition in hagiographic texts.

In the early Middle Ages, according to Vauchez's "Lay People's Sanctity in Western Europe: Evolution of a Pattern (Twelfth and Thirteenth Centuries)," the church manifested a positive appreciation of conjugal life. The Gregorian reforms of the late eleventh century proved an obstacle to this mentality by insisting on a new, more spiritual monasticism, which in turn led to disparagement of the lay state. This attitude was to change again by the end of the twelfth century, when commoners began to be recognized as saints. These fluctuations in the church's attitude toward the laity reflected its own struggles to recover its freedom and property from monarchical and feudal interests. In periods of conflict, such as the late eleventh century, there was a tendency to disparage the lay state, while in relatively calmer times, in the tenth and early eleventh centuries, the role of lay Christians was recognized as a necessary complement to the contemplative life lived within the institutional church. The Latin vitae attributed noble birth to their

subjects almost as a matter of course, and the connection between sanctity and nobility was to remain as long as the feudal mentality persisted. It is significant in this connection, as Vauchez observes, that the practice of venerating people who were commoners appeared and developed at a time, and precisely in those regions, where imperial rule and feudalism were losing their sway, that is, mainly in the urbanized areas of northern and central Italy and Belgium. Elsewhere, the feudal mentality assured the persistence of saintliness in its more traditional forms. By the thirteenth century the active life was rehabilitated and monastic life was no longer a requirement for sainthood. These changing attitudes were reflected in hagiography, as demonstrated by a comparison of the lives of Saint Margaret of Scotland (d. 1093) and of Saint Elisabeth of Hungary (d. 1231). Saint Margaret was praised by her hagiographers for the good advice she gave to her royal husband, the excellent education she provided her children, and her support of the church. Almost two centuries later, Saint Elisabeth was praised for her rejection of life at court and for founding a hospital in which she herself cared for the sick. By the mid-thirteenth century, carrying out the responsibilities of one's position and exemplifying the highest moral values were no longer sufficient qualifications for sainthood; one had to imitate the meekness and poverty of Christ, as well as his humility and suffering.

Against these changing definitions of sainthood, Carrasco, in "Sanctity and Experience in Pictorial Hagiography: Two Illustrated Lives of Saints from Romanesque France," examines pictorial hagiography and finds that here, too, the conceptions of sanctity change according to social, religious, and political developments. Carrasco draws a parallel between the tendency of hagiographers to "rewrite" the original text by supplementing it with posthumous miracles and the process of revision practiced by the illustrators of hagiographic texts, who both added new images and reworked older formulas in order to associate their subject with older, illustrious models. Citing the representations of Saint Albinus in an eleventh-century illustrated manuscript, she points to local popular devotion and the orchestrations of ecclesiastical authority as factors shaping this pictorial image of sanctity. The illustrations commemorated not only the saint himself, but also his miracle-working tomb. Thus, while the saints were portrayed as transcending historical time through the use of a Christological typology, "each act of transcendence remains rooted in earthly reality."

In "Spiritual Sanctions in Wales," Little studies the twelfth-century

Welsh *Book of Llandaff*, a collection of saints' lives and other texts prepared to advance the temporal claims of a bishop of Llandaff. The twenty-four examples of spiritual sanctions are useful in formulating a definition of sainthood in twelfth-century Wales. The saints represented here were no longer distant exemplars of the holy life but active participants in the affairs of the see. Not only were saints called upon to punish malefactors such as thieves, murderers, and political enemies, but the saints themselves were subject to sanction and humiliation if they failed to protect the interests of their church. The *Book of Llandaff* also makes effective use of a fictitious sixth-century privilege allegedly granted to a local saint.

Jankofsky shows how Latin hagiographic sources were adapted to a thirteenth-century English audience in his chapter, "National Characteristics in the Portrayal of English Saints in the *South English Legendary*." Two categories of saints are included: traditional "Latin" saints and martyrs, whose lives receive narrative treatment, and local—English and Irish—saints, whose lives are replete with historical and factual information, such as place names, topographical details, and names of their family members. The lives of local saints were thus anchored in a historical reality that was reflected in the references to Christianity before the arrival of Saint Augustine at Canterbury, to the English-Danish conflicts, and in the occasional anti-Norman sentiment. While giving voice to the ideals of Franciscan saintliness and to the religious fervor of the age, these lives provided for their audiences models of Christian virtue that could be related to everyday reality. Humankind was depicted by these texts in the categories of hero, sinner, and saint, suggesting certain similarities with Middle English romances and chronicles.

Part II. The Language of Religious Discourse

Certainly the hearing or reading of hagiographic texts in vernacular languages served in itself to mitigate the remoteness of the early Christian saints. A medieval audience that heard a saint speaking in its native tongue would have little difficulty conceiving of that saint as capable of participating in its daily life as well. But the use of the vernacular also affected both the content and form of the hagiographic discourse, as illustrated in the essays by Evelyn Birge Vitz, who examines the use

of oral and written tradition in saints' lives; Kevin Brownlee, who explores the use of hagiographic material as a vehicle for affirming the writer's authority; and Gail Berkeley Sherman, who studies Chaucer's use of hagiographic material to question social and literary conventions. The new images of sainthood that appeared in hagiographic texts reflected new modes of thought that found expression in both literary and nonliterary form. Cynthia Hahn deals with the problem of depicting language in art, and David Damrosch studies the feminization of religious language in the sermons of Bernard of Clairvaux.

In "From the Oral to the Written in Medieval and Renaissance Saints' Lives," Vitz argues that hagiography has been historically a fusion of oral and written traditions. Its oral features are to be found in its rhetorical character, its use of anecdotal material, and its emphasis on prayer, while its written features are represented by its claim to historicity, its relation to liturgy, and its function as sacred book. At various times one or the other of these traditions predominated. In vernacular French hagiography, Vitz finds an emphasis on the oral tradition manifested through what she calls the "reoralization" of the Latin texts. Primarily performed rather than read in private, these texts used the Latin book as an actual or remembered model but attempted to engage their nonliterate, lay audiences by the use of dialogue, drama, first- and second-person pronouns, and present and perfect tenses in place of past tenses. Between the Middle Ages and the Renaissance the emphasis shifted toward the written tradition. *The Golden Legend* of Jacobus de Voragine, written in Latin about 1260, is cited here as a transitional work between periods of oral and written dominance. While it attained a high level of popularity after its appearance, that popularity was short lived, and by the sixteenth century, when the oral tradition was at its end and a new literary standard called for the production of "definitive" editions of ancient texts modeled on Plutarch and Livy, *The Golden Legend* came under attack by Protestant and Catholic humanists alike, who found it unworthy of its subject matter as well as stylistically deficient compared with classical models.

Brownlee, in "Martyrdom and the Female Voice: Saint Christine in the *Cité des dames*," focuses on part 3 of the *Cité des dames* as the culmination of the book's basic rhetorical strategy—to defend women against the misogynistic tradition by citing examples of superlative achievement in politics, law, war, arts, sciences (book 1), in moral virtue (book 2), and in the spiritual realm (book 3). Among the group of female saints and holy women enumerated in book 3, the central

figure, both rhetorically and structurally is Saint Christine, who not only exemplifies spiritual virtue, but also authorizes the voice of Christine de Pizan as writer. This authorization is arrived at in three steps: first, Christ bestows his *name* on the saint—and, implicitly, on the writer—thus creating a genealogic link between himself and each of them; second, the power of the saint's—and, implicitly, the writer's—voice is manifested through words that function as deeds; third, the saint's spiritual voice—and, implicitly, the writer's auctorial voice—is miraculously confirmed. By the end of the *Cité des dames* Christine de Pizan assumes for herself the authority both of the hagiographer and of the saintly martyr, thus doubly guaranteeing her voice as author.

The function of hagiographic discourse in Chaucer is the focus of Sherman's chapter, "Saints, Nuns, and Speech in the *Canterbury Tales.*" Noting that hagiographic speech in the *Canterbury Tales* is restricted to two female religious pilgrims, the Second Nun, who recounts a miracle of Saint Cecilia, and the Prioress, who recounts a miracle of the Virgin Mary, Sherman draws on both the psychological theory of Julia Kristeva, which understands "the feminine" as the construct of unified preverbal knowledge that "authorizes" verbal speech, and her own detailed textual analysis to challenge the logical assumption that the ecclesiastically authorized language of hagiography attributed to the female narrators simply reproduces authority in their speech. The invocation to Mary that precedes both tales invites a resemblance between the speakers and Mary. In her essay "Stabat Mater," Kristeva argues that the Virgin Mother who brings forth the Word evokes the notion of a unity of knowledge before the expression of the Word. Thus for Sherman the female speakers implicitly represent an extralinguistic element in the tales. In going beyond the literal, the feminine here signifies the obstacle posed by language itself. Chaucer creates a "fiction of the feminine," which is necessary for his poetics, but that necessity is figuratively veiled, as when both the Virgin Mary and the Second Nun are "masculinized." Sherman concludes that Chaucer uses the speech of these two female religious pilgrims as a vehicle to question the "doctrines of the unity of thought and language, the hierarchies of male and female, 'auctoritee' and experience, speech and writing, salvific word and redemptive act, on which it apparently rests."

Hahn, in her chapter, "Speaking without Tongues: The Martyr Romanus and Augustine's Theory of Language in Illustrations of Bern Burgerbibliothek Codex 264," shows how a ninth-century artist depicted Christian rhetoric in pictures. The subject, Romanus of Antioch,

was a typologically complex figure, being both martyr and rhetor. The dilemma of the artist was to represent in pictorial form both the narrative of Romanus's martyrdom and the abstract discourse of Romanus as rhetor. This the artist accomplished by encompassing the types of both martyr and rhetor in the concept of *witness*. The narrative aspects of Romanus's life are shown in fairly conventional images: Romanus and his pagan persecutor Asclepiades confronting each other in the act of debate, with clear indication that Romanus holds the upper hand. Using the text of the tenth poem of Prudentius's *Peristephanon* as his point of departure, the artist represents the problems of Christian discourse raised by Prudentius—the relation of speech to the church, the authority to preach, and the possibility of pure and holy speech. Romanus's authority to preach and his relation to the church are established in the very first miniature of the codex, where Romanus is shown in clerical robes standing in the attitude of guard in the doorway of a church. Drawing both on Prudentius and on Saint Augustine's *De doctrina Christiana,* the artist attempts to show the gradual ascent of Romanus's speech through various levels until it reached the status of divine truth, which has the power to convert. In the final scenes of the story of Romanus, his miraculous and purified speech is shown as converting both the actual witnesses of his martyrdom and, by implication, the contemporary witnesses who heard, or saw, the story of his martyrdom. Thus both the content and structure of the illustrations reflect the successful metamorphosis of the Word into pictorial image.

Damrosch focuses on the function of feminine imagery in Bernard's sermons on the Song of Songs in "*Non Alia Sed Aliter:* The Hermeneutics of Gender in Bernard of Clairvaux." Building on the tradition of Origen's commentary on the Song of Songs in which the "heroine" is the soul as bride of Christ, Bernard developed a comprehensive image of the feminine and applied it to the process of interpreting, preaching, and meditating on Scripture. What is remarkable about Bernard's use of feminine imagery here is that he was creating a hermeneutic for the monks of his Cistercian community. Bernard viewed womanhood as a condition of limitation and exclusion, corresponding to the mortal condition of humanity. Thus the woman's role in society was parallel to the relation of the soul of God—both were a mediated experience—and Bernard himself assumed the role of mediator for the souls in his congregation. To achieve this he likened himself to a mother feeding his congregation the sacred text of the Gospels, and his work to women's work in a culture of poverty. Bernard balanced his portrayal of

women as an excluded group by presenting them as images of partic-
ipation, albeit without plenitude, in connection with questions of inter-
pretation of Scripture. Women were depicted as occupying the middle
ground between the overly literal interpretation favored by Jews and
the overly "private" reading of Scripture practiced by heretics. In this
way, the hermeneutics of exile was transformed into the hermeneutics
of participation, and Bernard proposed a way of reading Scripture that
linked personal piety and communal authority.

Part III. Saintliness and Gender

The vernacular lives of the saints often reflected the spiritual concerns
of their time, which in turn reflected political and social attitudes and
concerns. The lives of women saints, for example, provided medieval
hagiographers an opportunity to explore the differences between male
and female spirituality. These differences were marked, as the third
group of essays in this volume demonstrates: women's attitudes about
giving reflected political and social factors; women's spiritual experience
was characterized by mystical, paramystical, and charismatic gifts sel-
dom connected with men; the extraordinary power of women saints
reflected in the hagiographic texts was legitimized by their assimilation
to the bride of Christ figure; a woman's redemption was achieved not
by her transcendence of earthly desire but through her transference of
physical desire to Christ.

Jo Ann McNamara, in "The Need to Give: Suffering and Female
Sanctity in the Middle Ages," focuses on three phases of women's
attitudes toward giving at different times during the Middle Ages and
finds in each case that these attitudes were affected by the laws of
inheritance as well as by the church's tolerance of economic power
wielded by laywomen. In the early Middle Ages aristocratic women
utilized the personal wealth they were able to accumulate through
inheritance and marriage to found monasteries. As patrons of monastic
houses they supported both poor women within the monastery and
the needy who came to the monastery to seek assistance. This wide-
spread system of monastic charity was successful because it achieved a
delicate balance in providing benefits for all concerned: the patrons
themselves, the needy, the church, and secular authorities. In the High
Middle Ages the extension of feudalism and the trend toward more
restrictive inheritance customs increasingly deprived women of the

ability to accumulate, and consequently to dispose of, personal wealth. Their ability to subsidize large-scale charitable systems through monastic institutions was curtailed, signaling the growing powerlessness of women in the twelfth and thirteenth centuries. The life of Saint Elisabeth of Hungary serves as a paradigm for the evolution from the old to the new style of giving: practiced, voluntary poverty. At the same time, while secular forces continued to reduce women to the level of involuntary poverty, forces within the church, notably the popes from Gregory IX to Boniface VIII—as part of an effort to disentangle the church from the power of lay patrons—blocked women from embracing voluntary poverty: religious women were no longer to be dispensers of charity but cloistered, silent, and themselves dependent on the charity of others. These restrictions, according to McNamara, gave rise to experimentation with spiritual almsgiving, in the form of prayers to assist the dead in purgatory, or physical suffering such as fasting, vigils, and flagellation, as a replacement for material almsgiving.

In "Friars as Confidants of Holy Women in Medieval Dominican Hagiography," John Coakley notes the large number of vitae of holy women written by Dominicans between 1240 and 1506 and studies the significance of these women for the writers. From the thirteenth century on, Dominicans had an extensive role in ministering to religious and semireligious women. This role provided the writers firsthand knowledge of the religious experience of holy women and at the same time raised troubling questions about male religious experience. The common denominator in the seven lives studied by Coakley is men's sense of deprivation of the felt presence of the divine. If mystical and charismatic gifts are more connected with women than men, then a problem arises in defining the mediative role of women vis à vis the mediative, priestly authority of men. Recognition of this problem evolved slowly, until it was given voice in the sixteenth century. In the earlier lives, the writers portrayed themselves as spiritual partners of the holy women who were their subjects: Siger of Lille emphasized his own role in the holiness of Margaret of Ypres (d. 1237); Peter of Dacia wove an elaborate metaphor of himself and Christine of Stommeln (d. 1312) as sisters in Christ; and Raymond of Capua, writing to promote the canonization of Catherine of Siena (d. 1380), included himself in the events of her life. By recounting his vision of God's face in hers, Raymond implicitly raised the question of the need for sacerdotal mediation but retained the idea of a partnership between himself and Catherine. By the early sixteenth century, the idea of part-

nership had disappeared and the lives of Columba of Rieti (d. 1501) and Osanna of Mantua (d. 1505) were less personalized accounts than the earlier Dominican lives of holy women.

The reasons behind the extraordinary importance accorded to women in vernacular hagiography are the subject of the chapter "Women Saints, the Vernacular, and History in Early Medieval France," by Karl D. Uitti. This importance was manifested in numerous ways. Women saints were invariably represented as brides of Christ. As such, they formed part of a "sacred couple" and acquired rights and privileges deriving from their status as faithful betrothed or spouse of Christ. Uitti finds the basis of this special coupling of God and woman in the role attributed by Scripture to women in the two fundamental mysteries of Christian faith—the Incarnation and the Resurrection. Mary is spouse and mother of God, as well as his handmaiden and daughter; and the good news of Christ's resurrection is revealed first to the women at the tomb. The erotic nature of the vocabulary used to describe this sacred coupling in the vernacular texts also reflected the language of the marriage symbolism in the Song of Songs. The life of Saint Fides provides support for Uitti's contention that woman, empowered and rendered extraordinarily eloquent by her status as sacred spouse, not only "keeps alive the fundamentally revolutionary character of Christianity," but functions as an instrument of Christianization—in the case of Fides, the Christianization of the Roman Empire. The importance of women in vernacular hagiography is linked by Uitti to the emergence in the early twelfth century of woman as "doctor of love" and to the idea of woman as disruptor and restorer of history.

The thirteenth-century Middle English *Life of Saint Margaret* is found by Elizabeth Robertson, in "The Corporeality of Female Sanctity in 'The Life of Saint Margaret,'" to incorporate the contemporary view that a woman's relation with God could be realized only through the body. Physical suffering identified the female saint with Christ's suffering and gained salvation for her soul. The author of this English text departed from his Latin model by expanding and emphasizing those passages dealing with the physical suffering of the saint. Robertson traces the idea of the essential corporeality of female nature to Aristotle, who defined women through their bodies alone as beings lacking in reason. Saint Augustine tried to reconcile Plato's gender-neutral view of the soul with Aristotle's and concluded that while men's and women's souls were equal, their bodies were not, and thus women had a conflict of body and soul that men did not. Saint Jerome was one

of the many proponents of the view that women could transcend their female nature only by denying it, that is, by preserving their virginity. Robertson finds that in most English male saints' lives sexual temptation was one among many temptations and was usually subordinated to pride, while in the lives of female saints it was the only or the central temptation. The encounter of Saint Margaret with the devil is cited as a case in point. According to Robertson, the desire of the female saint for her heavenly spouse reflected both the Aristotelian view that female nature is conditioned by its desire for a male mate and the medieval view of woman as a being fundamentally dependent on others. The *Life of Saint Margaret* ends with the saint's prayers for women in childbirth, thus underlining the significance of physical suffering as the central theme of this text.

Richard Kieckhefer argues, in "Holiness and the Culture of Devotion: Remarks on Some Late Medieval Male Saints," on the basis of a fifteenth-century devotional document that in the late Middle Ages it became increasingly difficult to distinguish between saintly laymen and their sainted contemporaries. The same did not hold true for women, however. Drawing on the work of Caroline Walker Bynum, Kieckhefer explores the different representations of men's and women's spirituality in fourteenth- and fifteenth-century vitae. While the men's lives were written from an external and objective point of view, the accounts of women probed the subjective element in religious life. Kieckhefer suggest three possible causes for this phenomenon: male saints were more reticent than female saints, there was less of an audience for the inner life of the male soul, and men were too preoccupied with life outside the cloister to cultivate such experiences. Kieckhefer also finds differences in male and female piety, citing the relation to the Eucharist, the activity of reading, and the use of devotional art as representative examples. In connection with the Eucharist, the female experience emphasized tasting and eating, while the male experience emphasized seeing as part of a broader liturgical piety. While women saints had visions related to communion, men's visions were more frequently related to the consecration. The activity of reading was mentioned more often in women's than in men's lives. Here Kieckhefer cautiously suggests that the act of reading "was in closer accord with the central themes of women's piety than with those of men's." The vitae show both men and women using religious art, but men use it more frequently and its function is different. Men seemed more inclined to an objective relationship with the crucifix, statue, or picture before

them; women sought full empathetic identification with Christ or the Virgin through the religious art object. Kieckhefer concludes, first, that men's piety was more diffuse than women's; second, that the piety in men's lives was essentially traditional and was distinguished from "ordinary" lay piety by use of traditional hagiographic conventions; and third, that men's piety tended to be more public than women's and more often served as a form of pedagogy. Finally, he notes that the importance of gender cannot be understood except within "its natural context . . . of roles and meanings within society as a whole."

As witness the diversity of approaches and perspectives offered in this volume, devotion to the saints was a widespread phenomenon during the Middle Ages and inspired a variety of responses. If saints were uniformly portrayed as entertaining a special relationship with God, the significance and effects of this relationship fluctuated vastly according to the cultural and social standpoint of believers. In translating the merits of holiness into words, the hagiologic discourse elaborated different and at times contradictory images of the saint's mediative function. Not surprisingly, the ability to meditate on the spiritual value of sanctity, to venerate the Christ-like virtues of the saints, or to ground on them the authority of certain ecclesiastical institutions is to be found in the hands of the upper strata of the Christian society. In this particular approach to the phenomenon of sanctity, both the embodiment and the commemoration of religious perfection manifest a form of mental power reserved to an elite. A second type of devotional expression pertained to the oral and textual transcription of the sacred. Given that sainthood was an essentially theological concept, works composed for lay and mostly unsophisticated audiences were in effect confronting the issues of authority and literacy. Vernacular adaptations of Latin hagiography at times used their source as a means to validate the veracity of the whole hagiologic discourse, while at other times the goal was, rather, to question the authority of tradition and to initiate new models of writing. A third hagiologic manifestation focused on the interaction between holiness and ordinary human experience. The emphasis this time is put, not so much on the saint's internal excellence, as on the tangible effects such interaction has upon the believer: instrumental to the triumph of Christianity over paganism, to the economic welfare of the community, and to the resolution of such social concerns as that of poverty and illness, religious perfection becomes part of a discourse stressing the temporal

benefits obtained through saintly intercession. Hagiologic materials therefore shed light on the mental and political realities of the time, in their regional specificity, and are also of high documentary value, since they testify to the emergence of new linguistic and literary modes of expression regarding the role and status of the individual in society.

Indeed, vernacular hagiography is, like profane literature, interested in the concept of greatness. Along with epic and courtly heroes, saints are engaged in a quest for perfection that launches them on a demanding and often dangerous journey. It is to the extent that these heroes triumph over adversity that they occupy center stage. Sanctity evokes, however, a form of excellence quite different from that embodied by secular greatness. For, if all heroes are by definition exceptional, only in the case of the saints can exception be said to coincide with, and to result from, a denial of the self: rather than a personal penchant toward self-discipline, it is a spiritual calling that motivates these individuals' singular desire to forsake the temporal world. This insistence on abnegation and anonymity does situate the phenomenon of sainthood as an original adventure in the history of individualism, but it also raises many issues regarding its function. Given the medieval tendency to define the self in relation to society, and the corresponding fear of estrangement and alienation, the distance—in terms of time, space, or mental aptitudes—that sets saints apart is indeed ambivalent. Why does the saint evolve in a sphere different from the one that delineates the activities of ordinary humanity? Why is the intercessive value of these holy heroes always presented as a posthumous process, and always the outcome of their self-sacrifice? And why this need to sacralize certain elements of society?

These questions in fact suggest the presence of an implicit synonymy between sanctification and sacralization, pointing to the sacrificial significance of the medieval hagiologic discourse. Because saints, like martyrs, endure heroic deaths, or because, like hermits and ascetics, they suffer lives of hardships, they are granted, mostly post mortem, intercessive power. Suffering is thus part of a dual exchange: on the one hand, saints give themselves to God and are rewarded with the eternal bliss of paradise; now dead and in heaven, they are also the mediums ensuring or facilitating the communication between God and the ordinary believer. At the didactic level, the first type of reciprocity gives their ordeal a just compensation; in the second, however, this compensation is noticeably absent, since the believer has in effect nothing to offer the saint in exchange for his protection. The believer's admis-

sion of his or her own spiritual and verbal shortcoming does necessitate the intervention of a third party—and such is the role of the saint—to establish, albeit indirectly, a channel of communication from earth to heaven. Yet since ordinary Christians turn to saints precisely because of an acknowledged lack of mental and religious competence, commemorating these holy heroes entails above all invoking their names in time of distress, rather than imitating, or meditating on, their virtues. The saints portrayed in medieval hagiology thus serve as safeguards against all evil, be it the troubles of this world or the threat of hell. Venerating the saints implies first and foremost a desire to guarantee one's welfare and salvation by calling upon their power of advocacy. To a certain degree, the saints are not so much mediators as they are shields protecting the believer from too close a contact with the sacred. That the cult of the saints addresses essentially the tangible benefits obtained through these holy protectors is evinced by yet another hagiologic activity, that inspired by the saints' relics. The widespread devotion to these holy objects confirms the hypothesis, suggested above, that medieval hagiology has a fundamentally sacrificial significance. It is because they are dead that the saints are powerful agents in temporal affairs; it is thanks to their self-sacrifice that their bodies can become the source of cures and salvation. If there is no exchange between the saints and the believers, the saints' function as substitutes explains it: for them the ordeal and reward of sanctity; but for the believers, the tangible benefits channeled through the saints' bodies.

It is therefore not surprising that many of the essays gathered in this volume give particular attention to such topics as sacrifice and suffering. Most noteworthy is the often mentioned relation between physical suffering and female sanctity. Indeed, if the history of sainthood originated with that of the martyrs of early Christianity, it seems that martyrdom was gradually to become a predominant if not the sole mode of female valorization. The fact that women—martyrs and non-martyrs alike—tended to be portrayed in a sacrificial context and were sanctified to the extent that they castigated their bodies is certainly a remarkable element in the discourse proffered by medieval hagiographers.

Their distinguishing the circumstances conducive to male and female greatness and identifying female virtue in strictly passive and corporeal terms can in effect be viewed as an effort to restrict woman's active participation in the intellectual, institutional, or moral welfare of the Christian society. What was first, on the part of the martyrs of the

great persecutions, a demonstration of personal spiritual commitment eventually was transformed into a manipulative definition of the place and role of women in Western culture. For the women saints portrayed in medieval hagiology, it seems therefore more accurate to speak of forced sacrifice rather than of "self"-sacrifice, and of marginalization rather than of voluntary distancing from the world. In the midst of a discourse insisting on the virtue of self-effacement and secundarity, holy heroines and ordinary female believers were simultaneously excluded from the circle of male power. Images of female holiness thus lay bare the sacrificial dimensions of sainthood, when heroism is the result of a process of victimization in the course of which one individual must die for the others to survive.

PART I

HAGIOGRAPHY AND HISTORY

Lay People's Sanctity in Western Europe: Evolution of a Pattern (Twelfth and Thirteenth Centuries)

Many recent works have drawn attention to the fluctuating importance of the phenomenon of lay sanctity during the Middle Ages. At certain times, lay people's sanctity gained in importance, while at other periods the holy bishops or monks seem to have completely eclipsed the ordinary faithful.[1] These intermittent cycles should, of course, be seen in the context of the fluctuating relations between clerics and laymen within the church between the ninth and fourteenth centuries. Depending on the particular period, the irreplaceable and important role played by Christians in the lay world or the difficulty they may have posed for the church was emphasized. Ecclesiastical figures such as Pope Boniface VIII argued that lay people, with their constant hostility toward the clergy, with their materialism and tendency to mock and criticize, were obstacles to the propagation of the faith.[2] This essay will illustrate the repercussions of these changing attitudes in the field of hagiography, stressing in particular the period of transformation of lay sanctity in the twelfth and thirteenth centuries.

The problem of lay sanctity originates in the tenth and eleventh centuries, during which we find a situation quite favorable to the

1. See especially Joseph Claude Poulain, *L'idéal de sainteté dans l'Aquitaine carolingienne d'après les sources hagiographiques (750–950)* (Quebec, 1975); Michael Goodich, *Vita Perfecta: The Ideal of Sainthood in the Thirteenth Century* (Stuttgart, 1982); André Vauchez, *La sainteté en Occident aux derniers siècles du moyen âge, d'après les procès de canonisation et les documents hagiographiques* (Rome, 1981), and *Les laïcs au moyen âge: Pratiques et expériences religieuses* (Paris, 1987).

2. Boniface VIII, "Clericis laicos," in *Registres de Boniface VIII*, ed. Georges Digard and Antoine Thomas (Paris, 1884), cols. 584–85.

layman. In line with Jonas of Orleans and his treatise *De institutione laicali,* many clerics of the Carolingian and Ottonian periods strove to enhance the station of lay men and women and tried to offer them more concrete models than those they could find in the different *specula* composed for them at that time.

Works like, for example, the *Life of Saint Gérard of Aurillac,* written about 930 by Odo of Cluny, or the lives of Saint Mathilda (d. 968), the mother of the Germanic emperor Otto I, written in Saxony between 970 and 1003, are best understood in this positive perspective.[3]

If the biography of the count of Aurillac appears rather timid in its representation of the count as a monk "manqué," who remained in the outside world, rather than as a layman reaching holiness within his station in the world, the last *Life of Saint Mathilda,* as Patrick Corbet has shown, is a remarkably well balanced text that defines norms of behavior consistent with the Saxon upper classes of the year 1000. It is characterized by great moderation where miracles are concerned and by restraint in the practice of pious acts, consistent with the restrictions on the social life of an aristocratic lady. Furthermore, the writer prizes the conjugal and family life of Mathilda, extolling her qualities as a wife, mother, and widow above all else—a valuation that subsequently becomes rare.

The same can be said, *mutatis mutandis,* of the *Life of Saint Margaret,* Queen of Scotland (d. 1093), written by Turgot, the prior of Durham, at the request of his daughter Mathilda, wife of Henry I Beauclerc, king of England.[4] On the whole, the hagiography of this period has produced coherent, ambitious models of lay Christian life, even if these models had to do only with a narrow aristocratic elite.

The Gregorian reform, however, and the development of a new monasticism, much more spiritual than that of the previous period, impeded the development and prevented the spread of hagiography that dealt kindly with life in this world. From the second half of the eleventh century, a tendency to disparage the lay state became perceptible within the church, increasing proportionately with the church's

3. On the *Life of Saint Gérard,* see Poulain, *L'idéal,* pp. 88–144, and Vito Fumagalli, "Note sulla Vita Geraldi di Oddone di Cluny," *Bullettino dell'Istituto Italiano per il Medio Evo* 76 (1964): 217–40; on the lives of Saint Mathilda, see Patrick Corbet, *Les saints ottoniens: Sainteté dynastique, sainteté royale, et sainteté féminine autour de l'an mil* (Sigmaringen, 1986).

4. On this saint see David McRoberts, *Saint Margaret, Queen of Scotland* (Glasgow, 1960), and Derek Baker, "A Nursery of Saints: Saint Margaret Reconsidered," in *Medieval Women* (Oxford, 1976), pp. 119–41.

violently escalating conflict with monarchical and feudal forces to recover its freedom and its property. So the texts produced by the circles of the reformers, from Humbert of Moyenmoutier to Gregory VII, represent the laity as oppressors of the church or "plundering wolves." Furthermore, these ecclesiastical authors emphasize that lay people should be submissive to the clergy, for the "clergymen are the kings," and they alone can claim authority within the church.[5] The most extreme monastic advocates of this position, from Abbo of Fleury to Henry of Albano, underscored a sharp distinction between the two "orders" that made up the church: on the one hand, sensual creatures living—sinfully, in general—within the bonds of marriage, engrossed in temporal matters and incapable of rising above their instinctive desires; on the other hand, spiritual beings who had chosen celibacy, devoting themselves to contemplation and the service of God.

Some authors go so far as to associate the laity solely with the flesh and clerics with the spirit, consequently arguing that clerics should control laymen. The church is sometimes compared to a pyramid, the base of which is made up of the faithful married couples, engulfed in temporal matters, and the tip of which, already in contact with heaven, is composed of the clergy. Moreover, a whimsical piece of etymology—supported by Plato and Origen—declares that the word "hagios" (meaning "saint") was derived from "a-gios," that is, external to the earth and consequently to worldly concerns.[6] Against such a background, the saint can properly be identified with the model of the monk only, who, by his asceticism and his celibacy, is most detached from worldly things and sensuality.

It would be reductive to exaggerate this characteristic, as even during the Gregorian reform some clerics were willing to acknowledge the virtues of certain worthy laymen, especially of those living as hermits. It is, however, essential to differentiate between the possibility of eternal salvation, attainable by pious laymen who observed the laws of the church and were generous toward religious orders and the poor, and Christian perfection, which was identified more and more closely with

5. Humbert de Moyenmoutier, *Adversus simoniacos* (1057), *Monumenta Germaniae historica: Libelli de lite*, section 9, vol. 1 (Hannover, 1891), pp. 208 and 235; Abbon de Fleury, *Apologeticum ad Hugonem et Rodbertum reges francorum* (999), *Patrologia Latina*, vol. 139, col. 463.

6. Text cited by Yves Congar, *Laïcat*, in *Dictionnaire de spiritualité*, vol. 9 (Paris, 1976), cols. 79–93. The image of the pyramid is used by Gilbert of Limerick, *De statu ecclesiae*, in *Patrologia Latina*, vol. 159, col. 997a.

isolation from and contempt of the world. The ordinary faithful layman could scarcely avoid the triple blemish implied, as far as the clerics were concerned, by participation in war, which led inexorably to the spilling of blood; by sexual relations even within the framework of legitimate marriage; and by the immoderate use of money. Although not excluded a priori from the sphere of holiness, laymen could accede to it only in exceptional cases. Moreover, themselves convinced of their sinfulness, laymen strove to mitigate this handicap, inherent in their station in life, by joining a religious order as a last resort and wearing its habit on their death bed, or by placing themselves in the service of the monks as servants or lay brothers in order to benefit from their prayers in the next world.[7] Finally, it should be remembered that the twelfth century was marked by a resurgence of culture and learning and that the monasteries, and later the cathedral schools, became active centers of literary production. This clerical culture, inspired by the Bible, the church fathers, and some classical and early Christian authors, was based on a knowledge of Latin and was expressed in that language. Those ignorant of Latin—that is, almost all laymen—were, by this very fact, excluded from the world of learning and knowledge.

This cultural inferiority widened still further the gap separating laymen from the clergy and contributed to the discrediting of their station, synonymous with ignorance, the mother of foolishness and error. Another piece of etymological whimsy, well documented in the thirteenth century but certainly predating it, proclaimed that the word *laicus* was derived from the Latin *lapis*—meaning "stone"—because the layman is hard and unacquainted with literature.[8]

This general atmosphere, unfavorable as it was to the laity, was bound to be reflected in the hagiographic texts whose authors were, of course, clerics. Significantly, throughout most of Christendom in the twelfth and thirteenth centuries, practically the only lay people, outside the Mediterranean regions, whose lives were written about—among recent saints, of course—were kings and queens. Since the eleventh century, in fact, the clergy had been trying to establish for monarchs the model of the *rex justus:* the pious monarch, generous to the poor

7. André Vauchez, *La spiritualité du moyen âge occidental* (Paris, 1974), pp. 105–25.

8. The comparison of the layman to a stone can be found, among others, in Johannes Balbus's *Catholicon*, ca. 1285 (Farnborough, 1971 [unpaginated facsimile of the 1460 Mainz edition]). Cf. Yves Congar, "Clercs et laïcs au point de vue de la culture du moyen âge," in *Studia Medievalia et Mariologica. Mélanges C. Balic* (Rome, 1971), pp. 309–22.

and governing his subjects in conformity with the precepts of the church. This point is well known, especially through the recent work of Robert Folz on the holy kings of the Middle Ages in the West.[9] Furthermore, the case of kingly saintliness is a very particular one: by virtue of his consecration, in fact, the monarch assumed a dignity comparable to that of the bishops by whom he had been anointed. In the eyes of the clergy and the people, the king was an exceptional person, a kind of mediator between the spheres of the profane and the holy.[10] Thus the historian is entitled to set apart those who exercised kingly power, since the holy kings of the eleventh and twelfth centuries are not typical representatives of the laity.

On the other hand, one might expect to see at this time edifying biographies of laymen who had participated in the crusades. It seems as if the popes, beginning with Urban II, and, in particular, Saint Bernard in his *De laude novae militiae* should have opened the way for the sanctification of knights willing to put their weapons to the service of the church fighting the infidels in Spain or in the Holy Land to deliver and preserve for Christians the tomb of Christ. With the crusades and the creation of the military orders, the church offered the lay aristocracy a new ideal capable of transcending its sinful condition, especially its love of war.

Yet the repercussions of this evolution remained limited in terms of hagiographical output. While some lives of holy knights were indeed produced during the twelfth and thirteenth centuries in northern France, they dealt only with individuals who, after their conversion in adulthood, had renounced military life to become hermits or monks. Examples of such cases were Thibaud of Provins (d. 1066), Simon of Valois (d. 1080 or 1082), and John of Montmirail (d. 1217), who, after fighting gloriously at the battle of Gisors, lived the last year of his life among the Cistercians at Longpont.[11]

As Etienne Delaruelle has clearly shown, works on the lives of saintly soldiers did appear at this time in southern France and northern Spain.[12] But the lives of the holy martyrs Vidian, Gaudens, Aventin,

9. Robert Folz, *Les saints rois au moyen âge* (Brussells, 1984).

10. G. Klaniczay, "From Sacral Kingship to Self-Representation: Hungarian and European Royal Saints in the 11th–13th Centuries," in *Continuity and Change: A Symposium,* ed. E. Vestergaard (Odense, 1986), pp. 61–86.

11. Cf. Michel Parisse, "La conscience chrétienne des nobles," in *La cristianitá dei secoli XI e XII: Coscienza e strutture di una societá* (Milan, 1983), pp. 259–80.

12. Etienne Delaruelle, "Les saints militaires de la région de Toulouse," in *Paix*

and Cizi, whose veneration was encouraged in the Pyrenean regions by the canons of Saint-Sernin of Toulouse, are concerned with individuals from the distant past in which all invaders, from the Visigoths to the Saracens, are more or less mixed together and referred to in general terms as "pagans" or "barbarians."

Even more revealing is the case of the Franco-Spanish saints, who were born in France but lived in Spain and whose veneration is tied up with the Reconquest. Saint Raymond of Barbastro (d. 1126), a bishop from Toulouse, fought at the side of the king of Aragon against Islam, while Saint Raymond of Fitero (d. 1163), a Cistercian monk, distinguished himself by his courageous defense of Calatrava during a Moslem offensive. He subsequently founded a military order, the Order of Calatrava, which fought against the infidels. In these cases, we encounter clerics deeply impressed not by laymen but by the ideal of the holy war. If, then, the twelfth-century church brought respectability to the military profession, the exemplary figures who incarnated the new model of the *miles Christi* (soldier of Christ) were nevertheless either churchmen or knights who had given up their lay state to enter a religious order, or saints from the remote past like Saint George, Saint Theodore, or Saint Maurice, frequently represented on the portals of Gothic cathedrals. Indeed, it is in the epic and popular religion— not hagiography—that contemporary texts begin to appear celebrating the exploits and the heroic death of "Saint Roland" or of "Saint William of Orange," personalities whose literary importance is well established, but whose veneration was tolerated rather than approved by the church.[13]

Another obstacle that reduced the hagiographic impact of contemporary holy laymen, or at least holy laymen, from recent history, was the "telescoping" between sanctity and noble birth that had taken place during the late Middle Ages. While by no means all noblemen were considered saints by the church, it had become almost impossible for someone not of noble stock to acquire a certain repute in this domain, so firmly entrenched became the conviction that moral and spiritual perfection could flourish only in one of noble birth and illustrious descent. In the eleventh and twelfth centuries, holiness was still considered

de Dieu et Guerre Sainte en Languedoc, Cahiers de Fanjeaux, 4 (Toulouse, 1969), pp. 174–83.

13. Rita Lejeune, "L'esprit de croisade dans l'épopée occitane," in *Paix de Dieu et Guerre Sainte en Languedoc*, pp. 143–73; and Rita Lejeune and Jacques Stiennon, *La légende de Roland dans l'art du moyen âge*, 2 vols. (Brussels, 1967).

as grace transmitted rather than acquired. When the hagiographer knew nothing precise about saints from the remote past, he always accorded them aristocratic origins, often with no hesitation making the saints children of kings of distant countries.[14]

This privilege accorded to the nobility persisted north of the Alps, at least as far as official church practice and hagiography were concerned, until the thirteenth century and, in certain places, until much later. Consequently the majority of Christian society and thus most laymen were excluded from the sphere of saintliness.

In the Mediterranean regions during the twelfth century, there appeared and developed the practice of venerating commoners, especially members of the middle class and craftsmen.[15] A whole hagiography, which up to now has remained little known and has received little attention, developed in these countries devoted to figures like Saint Dominic de la Calzada (d. 1120), a pious Spanish layman who attracted the attention of his contemporaries by repairing with his own hands the road to Santiago de Compostella, and Saint Benezet (d. 1184), who began building the Bridge of Avignon and after his death became the object of an ardent local cult.

This phenomenon became relatively widespread, particularly in the most urbanized regions of northern and central Italy, where the communes were in the process of freeing themselves from imperial or feudal rule. Most of these Italian saints were townspeople, businessmen or craftsmen, belonging to the middle class, or the *popolo,* which was sensitive to the new economic and social realities. Some representative figures worthy of mention whose lives were written between the middle of the twelfth and the first decades of the thirteenth centuries include Teobaldo of Alba (d. 1150) in western Lombardy, who was a cobbler and later a street porter; Ramieri of Pisa (d. 1160), son of a rich ship owner of the same town, who, after his conversion, set off for the Holy Land and lived there as a hermit for several years, finally returning to his own country to preach the gospel until his death and accomplishing countless miracles; Raymond Palmerio (d. 1200), a simple journeyman shoemaker, who also went on pilgrimages to Jerusalem and to other places, before devoting himself to the service of the poor

14. Vauchez, *La sainteté,* pp. 204–15.

15. On the importance of this phenomenon, see André Vauchez, "Une nouveauté du XIIe siècle: Les saints laïcs de l'Italie communale," in *L'Europa dei secoli XI e XII fra novitá e tradizione: Sviluppi di una cultura,* Atti della Xa Settimana di studi medievali della Mendola (Milan, 1989), pp. 57–80.

and of all the outcasts in his native town, where he founded a hospital for the sick; and finally, Homobonus of Cremona (d. 1197), a cloth merchant who devoted his money to combating misery and who defended the church against the heretics of the city. He was the only one of all these holy men to acquire a certain repute through his canonization in 1199 by Pope Innocent III, and he was the first holy layman who was not a member of the nobility to receive this supreme consecration.[16]

As the lives dedicated to them reveal, these eminent people shared certain characteristics. All had been either pilgrims or ascetics. Most important, they had devoted themselves to the service of their neighbors, whether by building bridges, roads, and hospices to facilitate the journeys of travelers and pilgrims, or by attacking the problems caused by the chaotic development of towns and helping the misfits and victims of the economic boom that was widening even further the gap between the social classes. As their enthusiastic practice of charitable works showed, behind all these initiatives lay the conviction that the poor were images of Christ and a privileged means of access to God.

These laymen and those who, like Facio of Cremona (d. 1272), kept up this practice in the thirteenth century are also important insofar as they became holy men while practicing a profession, often a modest one, or even one considered suspect by the church, such as that of merchant, and in some cases while they were married.[17] Clearly, in the eyes of their biographers, neither work nor conjugal or family life aided progress to Christian perfection; on the contrary, the wives are presented as obstacles to their husbands' spiritual growth. Nevertheless, significantly, in their attempt to imitate the life of Christ, these *laici religiosi* de-emphasized the earlier insistence on virginity or chastity as essential qualities of the saint and accorded a new respect to the active life, traditionally considered inferior to the life of contemplation. Finally, all these Italian lay saints belonged to the male sex: even in these very advanced regions it was not easy for a woman in the twelfth century to achieve recognition for her holiness, especially if she lived in the lay world. The only place where she could surmount the handicaps of her sex and of her physical and moral weakness was the convent.

The thirteenth century was a time of rapid spiritual and intellectual

16. Vauchez, *La sainteté*, pp. 234–40.
17. André Vauchez, "Sainteté laïque au XIIIe siècle: La vie du Bienheureux Facio de Cremone (1196–1272)," in Vauchez, *Religion et société dans l'Occident médiéval* (Turin, 1981), pp. 171–211.

development. A detailed analysis of its causes is not possible here. In any case, it would be wrong to give all the credit for this development to Saint Francis of Assisi and the mendicant orders. One should, however, emphasize the important repercussions the changes had for lay sanctity. In what was undoubtedly the most striking phenomenon after 1200, women now came to prominence and achieved a remarkable advance in the domain from which, except for some empresses and queens, they had been excluded for a long time. In this context, the fundamental importance of the Beguine movement, which developed in Belgium in the 1170s, should be emphasized.[18] This was a movement of young women or widows who chose to lead an intense religious life while remaining part of the world. Some came together in communities; others preferred to live alone at home in a kind of voluntary isolation.

From the hagiographical point of view, the best illustration of this spiritual phenomenon is provided in the *Life of Marie d'Oignies* (d. 1213), written in 1215 by the future bishop and cardinal Jacques de Vitry. This key text shows an academic cleric fascinated by an ordinary laywoman who, through her charitable works and ascetic exercises, was able to elevate herself to the heights of contemplation and the love of God. But although this biography enhanced the respect for women in general by showing that they could equal and even surpass men in the spiritual realm, it should not be regarded as a feminist manifesto. In his prologue, Jacques de Vitry firmly underlines the fact that the *mulieres sanctae* of the diocese of Liège, of whom Marie was the most remarkable example, were humble and obedient, submissive to the church and particularly attached to the veneration of the Eucharist. As is shown by the dedication of the text to Bishop Foulque of Toulouse, at whose request it had been written, Jacques de Vitry felt, above all, that he should offer a model of Catholic saintliness to women who were tempted at that time by the Cathar heresy.[19]

Inclined to the mystical and concerned with women from the working and middle classes, this hagiography, however, enjoyed only limited

18. See Ernest W. McDonnell, *The Beguines and Beghards in Medieval Culture, with Special Emphasis on the Belgian Scene* (New Brunswick, N.J., 1954), and Simone Roisin, *L'hagiographie cistercienne dans le diocèse de Liège au XIIIe siècle* (Louvain, 1947).

19. On this work and its importance see Vauchez, "Prosélytisme et action antihérétique en milieu féminin au XIIIe siècle: La vie de Marie d'Oignies (+ 1213) par Jacques de Vitry," in *Propagande et contre-propagande religieuses,* Actes du colloque de l'Institut d'études des religions de l'Université libre de Bruxelles (Brussels, 1987), pp. 95–110.

success. Most of the lives of the saintly Beguines appear in only a very small number of manuscripts and the famous *Life of Marie d'Oignies* by Jacques de Vitry does not seem to have been translated into the vernacular before the fifteenth century. Outside the area in which these texts were written—that is, what would approximately be modern Belgium—the literature had little impact. Elsewhere, it did not appeal to the sensibilities of those who remained convinced that saintliness could flourish only among those of aristocratic descent.[20] Thus the great holy lay personalities of the thirteenth century remain princesses and kings, like Saint Elisabeth of Hungary (d. 1231); Saint Hedwige, duchess of Silesia (d. 1243); and Saint Louis (d. 1270), all three of whom were canonized by the pope.

If, however, we scrutinize the situation with greater care, we notice that the very qualities of this saintliness have developed considerably: these three personalities were all married and had large families. Moreover, to some degree, they were all influenced by the new spirituality, based on humility, active charity toward the outcasts of fortune, and the spirit of poverty. A comparison between a saintly woman of the eleventh century, Saint Margaret of Scotland (d. 1093) and, on the other hand, Saint Elisabeth of Hungary, the wife of Count Louis IV of Thuringia, reveals the fullness of the change that took place in perceptions of lay holiness.

In his *Life of Saint Margaret,* composed about 1105, Turgot of Durham tries to demonstrate that the queen of Scotland had earned the right to be venerated because of her exemplary behavior as wife, mother, and sovereign.[21] Thus he praises her for the good advice that she constantly gave her husband, for the excellent education she provided for her children, and for the support she lent to the church to bring about the conversion of the country to Christianity, particularly by having Dunfermline Abbey built. The *Life* thus amounts to a justification of Christian action in the world, intended for those in power. Nothing similar can be found regarding Saint Elisabeth, who founded neither church nor abbey, but a hospital at Marburg, in Thuringia,

20. On the link between nobility and saintliness, see, for the High Middle Ages, Martin Heinzelmann, "Sanctitas und Tugendadel. Zu Konzeptionen von 'Heiligkeit' im 5. und 10. Jahrhundert," *Francia* 5 (1977): 741–52. On the situation during the last centuries of the Middle Ages, see André Vauchez, "*Beata stirps:* Sainteté et lignage en Occident aux XIIIe et XIVe siècles," in *Famille et parenté dans l'Occident médiéval,* ed. G. Duby and J. Le Goff (Rome, 1977), pp. 397–406.

21. *Vita auctore Turgoto* (= *Biblioteca Hagiographica Latina* 5325), in *Acta sanctorum, June* (Antwerp, 1698), 2: 324–31.

where she cared for the poor and the sick with her own hands. Even before she became a widow, she had only appeared to be living like a sovereign.[22] Although she was present at court banquets she did not eat, and she gathered up the leftover food to distribute it herself to the beggars. Much to the embarrassment of those around her, she refused to touch food from those estates of her husband where manorial power was exercised unjustly.[23] Finally, after her husband's death, she gave up the family castle and even abandoned her own children to live like the poor. Indeed, she would have been happy to beg, had she not been forbidden to do so by her spiritual director, the dreadful Conrad of Marburg. Worn out by hardships and deprivation, she died at the age of twenty-four and was soon famous and venerated throughout Christendom.[24]

This example clearly illustrates the new conception of holiness: in order to reach perfection, it was no longer enough to carry out the full responsibilities of one's position and to exemplify the highest moral virtues. In addition, the potential saint had to imitate the meekness and poverty of Christ, even his humility and suffering, performing unhesitatingly acts considered "insane" by society—even by medieval society that considered itself Christian. Saint Louis's departure on the crusades for the second time, during which he met his death, exemplified such an act.

Thus the thirteenth century, with different results in each country, witnessed the rehabilitation of the active life and of activity in the world, which encouraged the rise of saintliness among the laity. It was no longer necessary for a man to become a monk or for a woman to become a nun in order to attain Christian perfection. Not even virginity was any longer demanded of God's servants and, if neither work nor family life were, in themselves, considered positive values, at least they did not constitute insurmountable obstacles. Outside the heavily ur- banized areas like northern and central Italy or Belgium, however, with their powerful middle classes, these new ideas were to come into conflict with the established traditions of hagiography and with feudal men-

22. On the hagiographic texts concerning Saint Elisabeth, see Ortrud Reber, *Die Gestaltung des Kultes weiblicher Heiliger im Spätmittelalter* (Hersbruck, 1963), esp. pp. 27–46.

23. See André Vauchez, "Charité et pauvreté chez sainte Elisabeth de Thuringe d'après les actes du procès de canonisation," in *Religion et société*, pp. 27–38.

24. On the rise of the cult of Saint Elisabeth, see Reber, *Die Gestaltung*, pp. 68–109.

tality. Consequently, new lay saints throughout most of the Western world continued to be "recruited," almost exclusively, from male and female representatives of the highest ranks of the aristocracy, a situation that was to endure until the end of the Middle Ages.

Sanctity and Experience in Pictorial Hagiography: Two Illustrated Lives of Saints from Romanesque France

Medieval hagiographers were well aware of the important role played by convention and stereotype in their writings. For example, Gregory of Tours pauses to ask "whether we should say the 'life' of the saints or the 'lives' of the saints." He answers, "It is clear that it is better to talk about the 'life' of the Fathers than the 'lives', because, though there may be some differences in their merits and virtues, yet the life of one body nourished them all in the world."[1] Gregory's text, and others like it, have been cited by a number of scholars seeking to apply the concept of biblical figural representation, as it has been elaborated by Erich Auerbach, to the saints and their hagiographers. In Auerbach's words:

> "the individual earthly event is not regarded as a self-sufficient reality ... but [is] viewed primarily in immediate vertical connection with a divine order which encompasses it, which on some future day will itself be concrete reality.... But this [divine] reality is not only future: it is

This paper served as the basis for two longer articles: "Spirituality and Historicity in Pictorial Hagiography: Two Miracles by Saint Albinus of Angers," *Art History* 12 (1989): 1–20; and "Spiritually in Context: The Romanesque Illustrated Life of St. Radegund of Poitiers (Poitiers, Bibl. Mun., MS 250), *Art Bulletin* 72 (1990): 414–35. My thinking on pictorial hagiography has benefited from the comments and the example set by three colleagues in this field, Barbara Abou-El-Haj, Cynthia Hahn, and Rosemary Argent Svoboda, to whom I am very much indebted.

1. Gregory of Tours, preface to the *Liber vitae patrum,* quoted in Charles W. Jones, *Saints' Lives and Chronicles in Early England* (Ithaca, N.Y., 1947), p. 62. For this text see also Edward James, trans., *Gregory of Tours: Life of the Fathers* (Liverpool, 1985).

always present in the eye of God . . . in transcendence the revealed and true reality is present at all times, or timelessly."[2]

Thus the consistent repetition of conventional motifs minimizes the unique spatiotemporal details of historical experience, stressing instead the collective identity of all the saints in fulfilling a divinely ordained pattern originally established by Christ. But it is also important that we not lose sight of the earthly existence of the saints. As Auerbach himself emphasized, "the historical reality is not annulled, but confirmed and fulfilled by the deeper meaning."[3] This is particularly true of the saints, who demonstrate to the faithful the continuity and actuality of God's activity in the world. They offer an experience of Christ that is potentially more tangible, accessible, and intimately personal than that afforded by biblical and apostolic models. It is worth our while to explore just those "differences in merits and virtues" mentioned by Gregory of Tours, to examine how the Christian ideals of the holy were actualized by individual men and women at a specific historical moment.[4]

Romanesque art of the eleventh and twelfth centuries provides an especially useful setting in which to examine the interplay of historicity and spirituality in pictorial hagiography, for it is in the Romanesque that one finds, increasingly, a close interdependence of worldly and sacred concerns.[5] A significant number of narrative hagiographic cycles survive from these centuries, executed in a variety of media, including

2. Erich Auerbach, "Figura," *Scenes from the Drama of European Literature* (New York, 1959), p. 72. Auerbach's paper, originally published in 1944, has been cited by students of literature, for example, Raymon S. Farrar, "Structure and Function in Representative Old English Saints' Lives," *Neophilologus* 57 (1973): 88–89, and James W. Earl, "Typology and Iconographic Style in Early Medieval Hagiography," *Studies in the Literary Imagination* 8 (1975): 15–46.

3. Auerbach, "Figura," p. 73 (with reference to Dante).

4. Peter Brown used the term "repraesentatio Christi" to describe the process of "making Christ present by one's own life in one's own age and region"; see "The Saint as Exemplar in Late Antiquity," *Representations* 1 (1983): 1–25, esp. p. 8, and the essay of the same title in *Persons in Groups: Social Behavior as Identity Formation in Medieval and Renaissance Europe,* ed. Richard C. Trexler (Binghamton, N.Y., 1985), pp. 183–94, esp. p. 186. Marc van Uytfanghe has noted the importance of local and historical components of hagiographic typology in "Modèles bibliques dans l'hagiographie," in *Le moyen âge et la Bible,* ed. Pierre Riché and Guy Lobrichon (Paris, 1984), pp. 449–87.

5. This is a constant theme in the work of Meyer Schapiro, *Selected Papers: Romanesque Art* (New York, 1977), reiterated by Linda Seidel, *Songs of Glory: The Romanesque Facades of Aquitaine* (Chicago, 1981), pp. 8, 10, 35–37, 57.

ivory, metalwork, wall painting, and manuscript illumination.[6] These cycles were first studied as a group by Francis Wormald, who introduced the term *libellus* in connection with manuscripts entirely dedicated to a saint and often containing, in addition to the life, miracles, and translations, liturgical pieces and monastic records. Wormald considered the *libelli* to be characteristic products of monastic culture, "part and parcel of the equipment of a great abbey which could boast a special cult to a saint."[7] Although recent research suggests that these works may not be exclusively monastic in orientation, it is clear in a number of cases that institutional perspective significantly affected the presentation of the saint's spiritual personality.[8]

A particularly ambitious *libellus* was devoted to Saint Albinus, who died in the year 550 after a long and distinguished career as a monk, an abbot, and finally as bishop of the city of Angers.[9] Produced at the end of the eleventh century at the Abbey of Saint-Aubin in Angers, which housed the saint's shrine and formed the center of his cult, this manuscript has suffered considerably since its creation; the work survives today as a fragment, consisting of seven folios covered on each side with a full-page miniature. By analogy with other *libelli*, the manuscript is likely to have contained a full set of texts associated with Albinus, including the *Vita sancti Albini*, a biography by his close contemporary, Venantius Fortunatus, and a series of posthumous miracles, the *Miracula*, recorded at Saint-Aubin during the eleventh century; comparison between the surviving folios and their textual sources

6. A recent catalogue of these cycles is Rosemary Argent Svoboda, "The Illustrations of the Life of Saint Omer: Saint-Omer, Bibliothèque Municipale, MS 698" (Ph.D. diss., University of Minnesota, 1983), pp. 320–50.

7. "Some Illustrated Manuscripts of the Lives of the Saints," *Bulletin of the John Rylands Library* 35 (1952): 248–66, esp. p. 262.

8. Institutional perspective is emphasized in the work of Barbara Abou-El-Haj, for example, "Consecration and Investiture in the Life of Saint Amand, Valenciennes, Bibl. Mun. MS 502," *Art Bulletin* 61 (1979): 342–58, and "Bury Saint Edmunds Abbey between 1070 and 1124: A History of Property, Privilege, and Monastic Art Production," *Art History* 6 (1983): 1–29. Svoboda used historical, textual, and iconographic evidence to link the Saint Omer *libellus* with the canons of the church Saint-Omer, which housed the saint's tomb, rather than the monastery of Saint-Bertin, as suggested by Wormald ("The Illustrations of the Life of Saint Omer," pp. 234–65). On this issue see also below, n. 46.

9. Paris, Bibliothèque Nationale, MS nouv. acq. lat. 1390; see Jean Porcher, "L'enluminure angevine," in *Anjou roman*, 2d ed. (La-Pierre-qui-Vire, 1987), pp. 245–55, 289–91, and Magdalena Carrasco, "Notes on the Iconography of the Romanesque Illustrated Manuscript of the Life of Saint Albinus of Angers," *Zeitschrift für Kunstgeschichte* 47 (1984): 333–48.

suggests there originally existed at least forty full-page narrative images.[10] Clearly, some aspects of Albinus's original career and personality exerted considerable appeal, for his *libellus* is the only surviving example of large-scale narrative imagery from Angers during this period. But the illustrations are not simply literal transcriptions of the texts; rather, they themselves constitute an interpretation of Albinus's hagiographic personality appropriate to the needs of a specific historical moment. This interpretation is conditioned by the institutional perspective of the monastic patrons but also by a changing temporal perspective: both the eleventh-century miracle texts and the visual images from the end of the century serve to reinvigorate, and to modernize, the cult of a saint over five centuries old.

It is important to recognize that the bond of faith between the saint and his community, both lay and religious, was not simply the spontaneous product of popular devotion. Domitian, Albinus's successor as bishop of Angers, commissioned Fortunatus to write his predecessor's biography, and he also orchestrated the first *translatio,* or relocation, of Albinus's remains.[11] This *translatio* occurred shortly after his burial and is recorded in the original *Vita,* where it is accompanied by a number of miraculous cures (*Vita* 3.17–18). Renewed interest in the cult of Saint Albinus dates to the first part of the eleventh century; his cult parallels the growth of the monastery itself and is part of a larger movement to revive devotion to local saints.[12] The first significant product of the monastic scriptorium at Saint-Aubin is a collection of the lives of the bishops of Angers, a manuscript decorated with a full-page miniature depicting two miraculous cures by Albinus.[13] A number of miracles occurred at Albinus's shrine during the eleventh century,

10. For the construction of the manuscript, see Porcher, "L'enluminure," pp. 249, 290 n. 14. For the basic texts concerning Albinus, see *Acta sanctorum,* Mar. (Paris, 1865), 1:54–63; passages from the *Vita* and the *Miracula* are cited in parentheses according to this edition. See also the edition of the *Vita* by Bruno Krusch, *Monumenta Germaniae Historica: Auctores antiquissimi,* 4.2 (Berlin, 1885), pp. xii–xv, 27–33, and additional texts in Joseph van der Straeten, *Les manuscrits hagiographiques d'Orléans, Tours et Angers* (Brussels, 1982), pp. 276–83.

11. Richard Collins, "Observations on the Form, Language, and Public of the Prose Biographies of Venantius Fortunatus in the Hagiography of Merovingian Gaul," in *Columbanus and Merovingian Monasticism,* ed. H. B. Clarke and M. Brennan (Oxford, 1981), pp. 107–9.

12. Jean-Marc Bienvenu, "La sainteté en Anjou aux onzième et douzième siècles," in *Histoire et sainteté: Rencontre d'histoire religieuse. Angers et Fontevraud 1981* (Angers, 1982), pp. 23–36.

13. Rome, Biblioteca Vaticana, MS Reg. lat. 465, fol. 74v; see Jean Vezin, *Les scriptoria d'Angers au onzième siècle* (Paris, 1974), pp. 239–41.

and these were recorded by the monks of Saint-Aubin.[14] Translations are recorded for the years 1070 and 1128, and in 1151 the saint's head was placed in a gold-and-silver vessel; the monastic complex housing the saint's tomb was rebuilt following a fire in 1032, and a more extensive and elaborate rebuilding took place in the twelfth century.[15] Thus the miniatures in our manuscript were created at a crucial juncture in the history of the cult of Albinus and his monastery: they are both a reflection of his increased popularity and part of a successful and carefully coordinated program of monastic self-promotion.

Examination of a few specific images from the *Vita sancti Albini* will demonstrate pictorially both the constant elements of Albinus's spiritual personality and the ways in which that personality could be made to accord with contemporary issues. Among the most conventional and explicitly Christological aspects of Albinus's life are exorcisms and miraculous cures. In one such miniature, the saint heals a woman possessed by a demon lodged in a tumor on her eye by commanding the demon to depart and making the sign of the cross (*Vita* 3.15) (Figure 2.1). In a second, the saint heals the blind monk Gennomerus, again by making the sign of the cross (*Vita* 3.13) (Figure 2.2). These miracles appear tediously repetitious to the modern viewer. But repetition is a significant and self-conscious stylistic device: it minimizes the variations among the individual miracles and emphasizes their conformity to a single, transcendent truth.[16] Repetition is reinforced by parallelism with miracles from the life of Christ and with miracles performed by earlier saints, for example, Martin of Tours, the archetypal monk-bishop of Merovingian hagiography (Figure 2.3).[17] In each

14. *Acta sanctorum,* 60–63 (see above, n. 10); also van der Straeten, *Les manuscrits hagiographiques,* pp. 280–83.

15. Jacques Mallet, *L'art roman de l'ancien Anjou* (Paris, 1984), pp. 38–41, 138–53.

16. The relevance to medieval art and literature of Mircea Eliade's work on ritual and repetition (*The Myth of the Eternal Return: Cosmos and History,* trans. Willard R. Trask [Princeton, 1954]) has been recognized by a number of scholars, for example, Robert E. Bjork, *The Old English Verse Saints' Lives: A Study in Direct Discourse and the Iconography of Style* (Toronto, 1985), pp. 114, 123, and Seidel, *Songs of Glory,* pp. 35–48, who note the relation of the stylistic device of repetition to typology, allegory, and Christian liturgy. For pictorial hagiography, see the fundamental observations of Cynthia Hahn, *Passio Kiliani . . . Passio Margaretae: Faksimile-Ausgabe des Codex MS. I 189 aus dem Besitz der Niedersächsischen Landesbibliothek Hannover: Kommentarband,* Codices Selecti, 83 (Graz, 1988), esp. pp. 13, 147–55, particularly the concept of pictorial *topoi.*

17. On miracles from the life of Christ, see Albert Boeckler, "Ikonographische Studien zu den Wunderszenen in der ottonischen Malerei der Reichenau," *Bayerische Akademie der Wissenschaften,* Abhandlungen, n.s. 52 (1961): 1–40; Gertrud Schiller, *Iconography of Christian Art,* 2 vols., trans. Janet Seligman (Greenwich, Conn., 1971–72), 1:162–

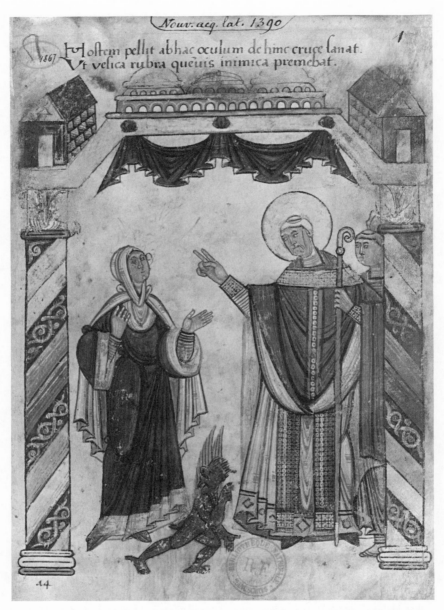

Figure 2.1. Saint Albinus exorcises a woman. Paris, Bibliothèque Nationale, MS n.a.l. 1390, fol. 1r (Photo, Bibliothèque Nationale, Paris).

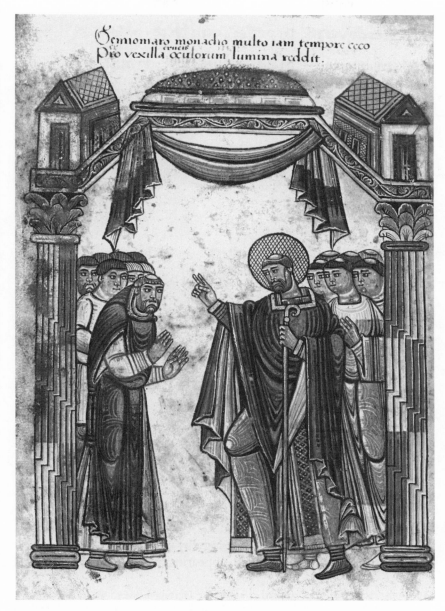

Figure 2.2. Saint Albinus cures Gennomerus. Paris, Bibliothèque Nationale, MS n.a.l. 1390, fol. 4v (Photo, Bibliothèque Nationale, Paris).

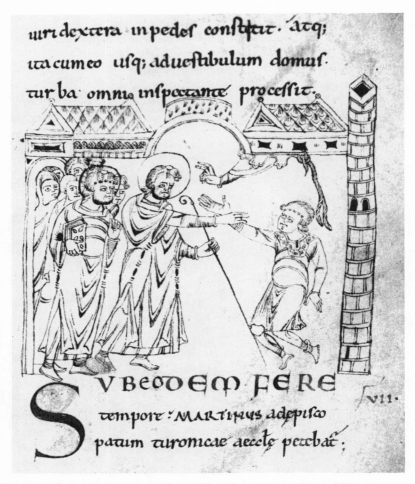

Figure 2.3. Saint Martin revives a slave. Life of Saint Martin. Tours, Bibliothèque Municipale, MS 1018, fol. 18r (Photo, Bibliothèque Nationale, Paris).

case the artist creates a visual typology by employing a familiar compositional formula: the holy man, appearing at the head of a crowd of

86. On miracles performed by earlier saints, see Herbert Kessler, "Pictorial Narrative and Church Mission in Sixth-Century Gaul," in *Pictorial Narrative in Antiquity and the Middle Ages,* ed. Herbert Kessler and Marianna Shreve Simpson, Studies in the History of Art, 16 (Washington, D.C., 1985), pp. 75–91, esp. pp. 87–88. On hagiographic types in the early Middle Ages, see Frantisek Graus, *Volk, Herrscher, und Heiliger im Reich der Merowinger: Studien zur Hagiographie der Merowingerzeit* (Prague, 1965), pp. 62–120.

witnesses, stretches forth his arm in a gesture that conveys relief from suffering. The repeated use of nearly identical pictorial schemata is not the result of a lack of imagination on the part of the artist but represents a conscious attempt to associate the local hero with illustrious models. Albinus's miracles combine two perspectives: they are discrete acts performed by a time-bound historical figure, but they also allow the saint, and his followers, to transcend historical time by becoming one with Christ. These miracles can be perceived on two levels: as actual cures of specific physical ailments, and as ritual acts of purification prefiguring spiritual salvation.[18]

Albinus's ability to transcend time for the benefit of his followers is rendered permanent by his shrine, which continues to work miracles after his death (*Miracula* 1.3, 2) (Figures 2.4, 2.5). In these illustrations the familiar schema is repeated, with the shrine substituting for the living presence of the saint. Here too the individual details of each cure are minimized to conform with a standard formula. If one considers the miracle scenes as a group, the juxtaposition of closely similar images, resulting in a sequence of slightly varied reformulations of a constant theme, can be compared with the paratactic structural pattern of contemporary epic literature. The direction of the narrative is not chronological development over time but a reaffirmation of a timeless, living truth, a constant present.[19] Intimate emotional ties bind the saint with his flock, creating a sense of community that continues and even strengthens as it is ritually reaffirmed with each posthumous miracle. The intensity of the eleventh-century pilgrims to Albinus's shrine echoes the grief exhibited at his sixth-century deathbed, a scene not described by Fortunatus and forming a significant pictorial elaboration of the original text (Figure 2.6). Taken as a whole, these miniatures are a collective assertion of a sense of community, what one might call a spiritual extended family that reaches both through and beyond time.

18. On the social and spiritual significance of healing by saints, see Barbara Abou-El-Haj, "The First Illustrated Life of Saint Amand: Valenciennes, Bibliothèque Municipale MS 502" (Ph.D. diss., University of California at Los Angeles, 1975), pp. 151–52; Peter Brown, *The Cult of the Saints: Its Rise and Function in Latin Christianity* (Chicago, 1981), pp. 106–20; Kessler, "Pictorial Narrative," pp. 81–84; Raymond Van Dam, *Leadership and Community in Late Antique Gaul* (Berkeley and Los Angeles, 1985), pp. 256–76.

19. Gabrielle Spiegel, "Social Change and Literary Language: The Textualization of the Past in Thirteenth-Century Old French Historiography," *Journal of Medieval and Renaissance Studies* 17 (1987): 140; Erich Auerbach, *Mimesis: The Representation of Reality in Western Literature,* trans. Willard R. Trask (Princeton, 1953), pp. 96–122.

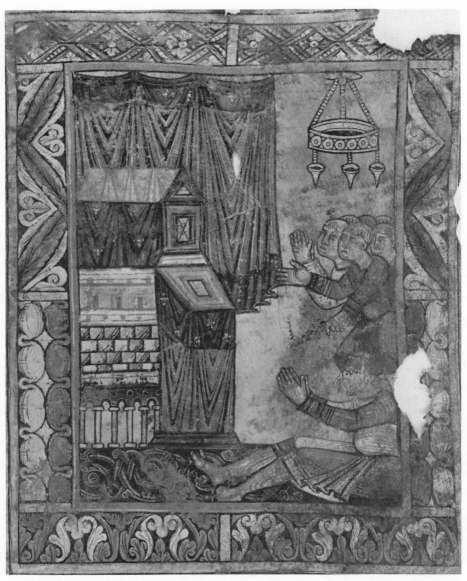

Figure 2.4. Cure of Berfridus at the tomb of Saint Albinus. Paris, Bibliothèque Nationale, MS n.a.l. 1390, fol. 6r (Photo, Bibliothèque Nationale, Paris).

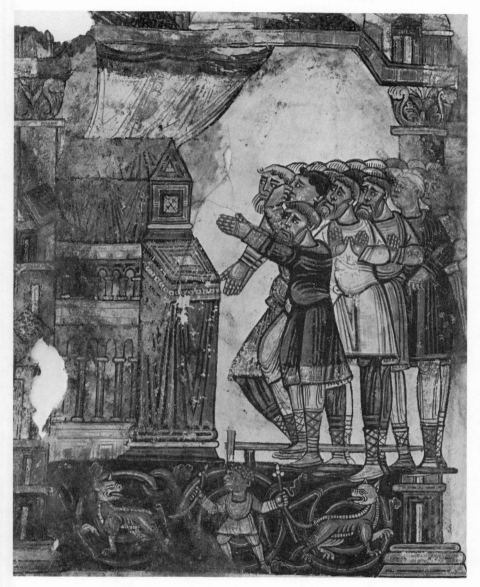

Figure 2.5. Cure of Girmundus at the tomb of Saint Albinus. Paris, Bibliothèque Nationale, MS n.a.l. 1390, fol. 6v (Photo, Bibliothèque Nationale, Paris).

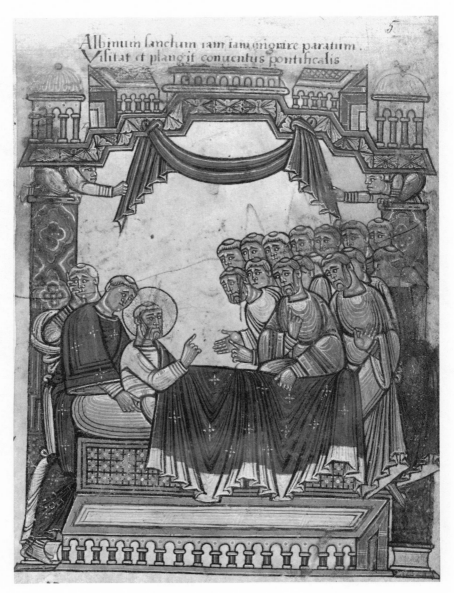

Figure 2.6. Deathbed of Saint Albinus. Paris, Bibliothèque Nationale, MS n.a.l. 1390, fol. 5r (Photo, Bibliothèque Nationale, Paris).

Transcendence is further expressed through the rituals of liturgy, which provide the setting for the commemorative celebration of Albinus's intercessory power: miracles occur during mass or when crowds are gathered at the shrine on the saint's feast day, and the miracle texts are recorded in manuscripts designed for liturgical use.[20]

Much of what has been said thus far might apply with equal validity to many other depictions of miracle scenes. But it is also possible to suggest how the images in the Albinus *libellus* might have been adapted to, and received by, their audience, both lay and monastic. The eleventh and early twelfth centuries marked a period of exceptional religious fervor in western France.[21] Of the various manifestations associated with the Gregorian Reform movement, perhaps the most striking were the calls for a return to the poverty, asceticism, and spiritual purity of the early years of the church, and the rise of hermits and itinerant preachers, who developed a large popular following. Viewed in this context, the typological parallels linking Albinus with Christ and the saints of the early church are more than a hagiographic convention. In advancing the cult of their illustrious patron, the monks of Saint-Aubin appropriated the power and spiritual idealism of the contemporary evangelical reawakening. But Albinus's model of spirituality combines ascetic purity and social activism with a more traditional sense of institutional hierarchy and identity, conveyed by his episcopal

20. The miniatures, and the miracles they record, can be understood in terms of the "rituals of commemoration" discussed by Spiegel, "Social Change and Literary Language," pp. 137–40. Gregory of Tours, *De gloria confessorum,* 94, describes the cure of a paralytic at Albinus's tomb as the bell tolled for mass on the saint's feast day: see *Patrologia Latina,* vol. 71, cols. 899–900, and the recent translation by Raymond Van Dam, *Gregory of Tours: Glory of the Confessors* (Liverpool, 1988), pp. 98–99. The cure of Girmundus also took place on the saint's feast day (*Miracula* 2.8–9). On the miracle texts, see Angers, Bibliothèque Municipale, MS 123 (van der Straeten, *Les manuscrits hagiographiques,* pp. 190–91, 218–24, 228).

21. L. Raison and R. Niderst, "Le mouvement érémitique dans l'ouest de la France à la fin du onzième et au début du douzième siècle," *Annales de Bretagne* 55 (1948): 1–46; Jean Becquet, "L'érémitisme clérical et laïc dans l'ouest de la France," in *L'eremitismo in occidente nei secoli XI e XII,* Miscellanea del Centro di studi medioevali, 4 (Milan, 1965), pp. 182–204; Jean-Marc Bienvenu, "Pauvreté, misères et charité en Anjou aux onzième et douzième siècles," *Le Moyen Age* 72 (1966): 389–424, and 73 (1967): 5–34, 189–216. See also, in general, Giles Constable, "Renewal and Reform in Religious Life: Concepts and Realities," in Robert L. Benson and Giles Constable, eds., *Renaissance and Renewal in the Twelfth Century* (Cambridge, Mass., 1982), pp. 37–67, and John Van Engen, "The 'Crisis of Cenobitism' Reconsidered: Benedictine Monasticism in the Years 1050–1150," *Speculum* 61 (1986): 269–304. For the political history of the region, see Louis Halphen, *Le comté d'Anjou au onzième siècle* (Paris, 1906), and Olivier Guillot, *Le comte d'Anjou et son entourage au onzième siècle* (Paris, 1972).

costume, by his enlarged size in relation to the other figures, and by
the rich architectural framework. In fact the distinctive, peculiarly in-
sistent visual language of these miniatures suggests they carry an overtly
ideological import. The strong colors, dark contours, and emphatic,
silhouetted gestures, reinforced by repetition and typological parallels,
may represent the equivalent, in visual terms, of the powerful religious
language of the itinerant preachers. But the message conveyed by that
language has been reinterpreted from the point of view of a venerable
religious institution.

There is considerable literary evidence attesting to the sensitivity of
established religious authorities to the challenges posed by the itinerant
preachers. Several aspects of the Albinus miniatures can be correlated
with issues raised in the debate between bishops and abbots, like Mar-
bod of Rennes and Ivo of Chartres, and itinerant preachers such as
Robert of Arbrissel and Bernard of Tiron.[22] The most obvious of these
concerns the holy man's appearance, an issue addressed in a letter from
Marbod of Rennes to Robert of Arbrissel.[23] According to Marbod,
Robert took as his model Saint John the Baptist. He is described by
Marbod as going barefoot, wearing a hairshirt and a dirty, tattered
cloak, with long, unkempt hair and beard, and partially bare legs. And
like Saint Anthony and Saint Paul, Robert carried a stick to support
a body weakened by extreme asceticism. In Marbod's opinion, such
behavior is eccentric, inappropriate, and undignified. Marbod appeals
to reason and common sense, as well as to the force of authority and
custom in determining the behavior and dress appropriate to a man
of God. Extreme humility is a sign of pride, rather than piety, according
to Marbod; Robert creates a distracting public spectacle comparable
to that provoked by a fool or a madman. One could hardly imagine a
greater contrast than the robust and dignified image of Saint Albinus,
with his crozier and elaborate robes. Framed by architecture evocative
of his institutional identity and accompanied by a subordinated, densely

22. J. de Petigny, "Robert d'Arbrissel et Geoffroi de Vendôme," *Bibliothèque de
l'École des Chartes,* 3d ser., 5 (1854): 1–30; G. Morin, "Renaud l'ermite et Ives de
Chartres: Une épisode de la crise du cénobitisme au onzième-douzième siècle," *Revue
Bénédictine* 40 (1928): 99–115; Guy Devailly, "Un évêque et un prédicateur errant au
douzième siècle: Marbode de Rennes et Robert d'Arbrissel," *Mémoires de la Société
d'Histoire et Archéologie de Bretagne* 57 (1980): 163–70.

23. The text of Marbod's letter is published in Johannes von Walter, *Die ersten
Wanderprediger Frankreichs* (Leipzig, 1903–1906; repr., Aalen, 1972), pp. 181–89,
esp. pp. 185–86. For what follows see Becquet, "L'érémitisme," p. 191; Raison and
Niderst, "Le mouvement érémitique," p. 18; Devailly, "Un évêque," p. 168.

packed group of monks and lay witnesses, Albinus embodies the sense of hierarchy and authority valued by established Benedictine monasticism. In a similar vein, Marbod emphasizes the responsibility of pastors for their flocks, as well as the importance of the stable, continuous guidance provided by institutions and their representatives.[24]

In many miniatures, pictorial commentary is achieved by elaborating on the given text. Venantius Fortunatus, Albinus's Merovingian hagiographer, tells us that the saint excommunicated a couple guilty of contracting an incestuous marriage and that Albinus resisted the pressure of a church council to retract his decision (*Vita* 3.16) (Figures 2.7, 2.8). Albinus's model, according to Fortunatus, was John the Baptist, who attained martyrdom by condemning an incestuous marriage. The artist reinforces this association by illustrating the text with a banquet scene, not mentioned by Fortunatus but a characteristic element of illustrations of the life of John the Baptist, who was especially popular as a model at this time.[25] One is also reminded here of a contemporary political issue, the incestuous marriage of King Philip I and Bertrade of Montfort, wife of the count of Anjou, a marriage condemned by the monks of Saint-Aubin.[26] The council scene is comparable to contemporary images of theological disputation.[27] The emphasis on dialogue evokes the fascination with new modes of reasoning and debate in France at the end of the eleventh century, and a contemporary viewer would likely have associated this image with the controversy surrounding the heretical doctrines of Berengar of Tours.[28] The miniature depicting Albinus as a fully armed military hero, who returns to protect his followers from a raid by the Norsemen,

24. Devailly, "Un évêque," pp. 169–70; von Walter, *Wanderprediger,* p. 187.

25. On the banquet scene see Carrasco, "Notes," pp. 341–45; and Beat Brenk, "Le texte et l'image dans la 'vie des saints' au moyen âge; rôle du concepteur et rôle du peintre," in *Texte et image: Actes du Colloque international de Chantilly, 13–15 octobre 1982* (Paris, 1984), pp. 36–38.

26. See ibid.; for the opinion of the monks of Saint-Aubin, see Louis Halphen, *Recueil d'annales angevines et vendômoises* (Paris, 1903), p. 42.

27. J. J. G. Alexander, *Norman Illumination at Mont Saint-Michel, 966–1100* (Oxford, 1970), plates 22 and 24a (Saint Augustine disputing with Felicianus and Faustinus, respectively). For this type of imagery, see also Meyer Schapiro, *The Parma Ildefonsus: A Romanesque Illuminated Manuscript from Cluny and Related Works* (New York, 1964), pp. 9, 71.

28. Brian Stock, *The Implications of Literacy* (Princeton, 1983), pp. 272–325; Charles M. Radding, *A World Made by Men: Cognition and Society, 400–1200* (Chapel Hill, N.C., 1985), pp. 156–72. On Berengar, see Alexander, *Norman Illumination,* pp. 100–102; also Carrasco, "Notes," pp. 337–41.

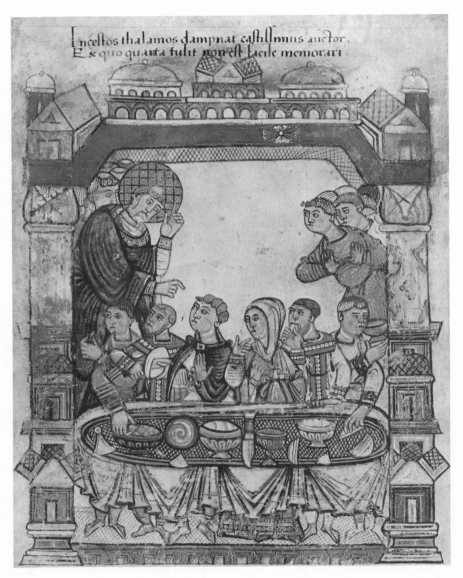

Figure 2.7. Saint Albinus condemns the incestuous couple. Paris, Bibliothèque Nationale, MS n.a.l. 1390, fol. IV (Photo, Bibliothèque Nationale, Paris).

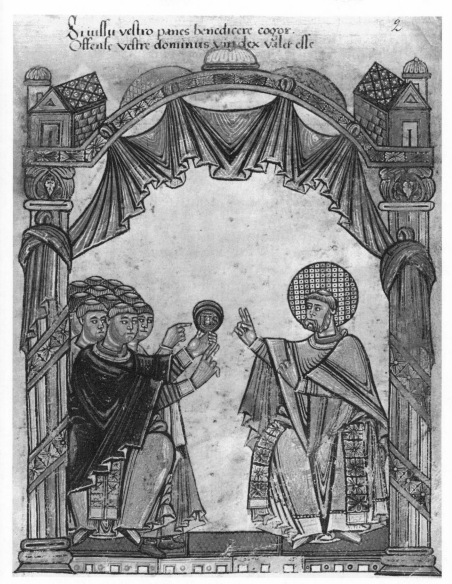

Figure 2.8. Saint Albinus and the church council. Paris, Bibliothèque Nationale, MS n.a.l. 1390, fol. 2r (Photo, Bibliothèque Nationale, Paris).

illustrates one of the posthumous miracles recorded in the eleventh century by the monks at Saint-Aubin (*Miracula* 3.12–14) (Figure 2.9). Here the venerable Merovingian bishop has been reshaped in the image of a military saint, a type newly appropriate to the period of the Crusades.[29] Taken as a group, these images demonstrate how the artist manipulated pictorial conventions to create a visual typology, a typology with immediate relevance to contemporary religious and political life.

A considerably different perspective on the spiritual revival in western France is provided by the second manuscript that I would like to examine, a work dedicated to the Merovingian queen and nun, Radegund of Poitiers.[30] This manuscript, which unfortunately also survives only as a fragment, includes portraits of Radegund's two Merovingian biographers, Fortunatus of Poitiers, and Baudonivia, a nun in Radegund's convent of Holy Cross.[31] A series of narrative miniatures accompanies the text by Fortunatus; although there is good evidence that Baudonivia's text formed part of the manuscript and was also illustrated, these folios do not survive. This manuscript was clearly produced in Poitiers, probably in the final quarter of the eleventh century, but it is not known for certain whether the manuscript should be associated with Radegund's convent of Holy Cross, or the nearby church of Sainte-Radegonde, which housed her tomb. I hope to demonstrate that the miniatures themselves provide some of the best evidence on this point. As with the Albinus *libellus,* the artist employs a visual language based on repetition and typological analogy, mediated in this instance by spiritual ideals particularly congenial to convent life. In addition, the miniatures commemorate specific sites and objects that were associated with Radegund during her lifetime and formed the basis of her cult at Holy Cross.

Radegund's sanctity is intimately linked with her life of prayer, as-

29. Carrasco, "Notes," pp. 345–48.

30. Poitiers, Bibliothèque Municipale, MS 250; see Emile Ginot, "Le manuscrit de sainte Radegonde de Poitiers et ses peintures du onzième siècle," *Bulletin de la Société Française de Reproductions de Manuscrits à Peintures* 4 (1914–20): 9–80. Recent discussions of the style and date of the manuscript are Larry M. Ayres, "The Role of an Angevin Style in English Romanesque Painting," *Zeitschrift für Kunstgeschichte* 27 (1974): 193–98; Janine Wettstein, *La fresque romane: La route de Saint-Jacques, de Tours à León* (Paris, 1978), pp. 27–31; François Avril, *Le monde roman, 1060–1220: Les royaumes d'occident* (Paris, 1983), pp. 164–81.

31. For these texts see the edition by Bruno Krusch, *Monumenta Germaniae Historica: Scriptores rerum Merovingicarum,* vol. 2 (Hanover, 1888), pp. 358–95; hereafter they will be cited as *Vita* 1 (by Fortunatus) and *Vita* 2 (by Baudonivia).

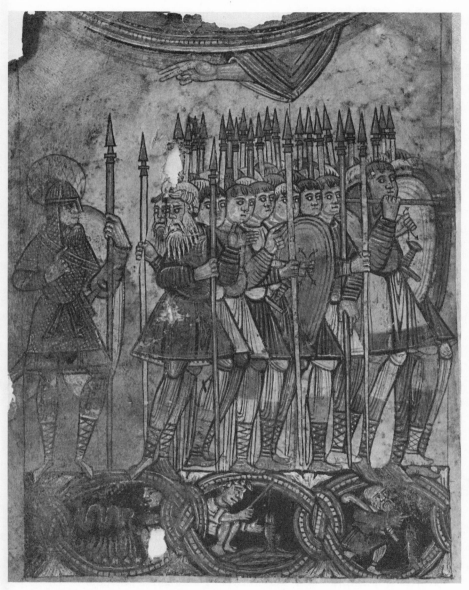

Figure 2.9. Saint Albinus as a military saint. Paris, Bibliothèque Nationale, MS n.a.l. 1390, fol. 7v (Photo, Bibliothèque Nationale, Paris).

ceticism, and confinement. The most striking feature of the miniatures is the repeated association of the saint with her private cell and oratory in her convent of Holy Cross. A full-page miniature depicts Radegund entering her cell, to the acclaim of her nuns as well as the general populace (*Vita* 1.21) (Figure 2.10). In the bottom portion of the folio, Radegund appears inside her cell, holding a book, and we are shown the oratory, with its altar, adjacent to the cell. This miniature is followed in the manuscript by a densely illustrated sequence of folios depicting a series of miracles, many of which are worked by Radegund from within her cell (Figure 2.11). The artist exploits the opportunity for repeating the image of Radegund's enclosure, an image that provides a key to understanding her spirituality.

When the persecution of the church ended and the ascetic replaced the martyr as the ideal Christian hero, the image of the prison was transferred to monastic life.[32] The association between cell and prison is a commonplace in the lives of hermits and monks. The austerity and isolation of the monk or the recluse were a matter of conscious choice, a voluntary self-incarceration enforced not by chains but by the love of God. By enclosing herself in her cell and devoting herself to prayer and harsh asceticism, Radegund imitates both the physical suffering and the incarceration of the early martyrs. Yet the restriction of the body is contrasted with the liberation of the spirit. Radegund's claustration and self-imposed suffering are a source of power, and it is this power that is emphasized in the paintings; the only visual reference to Radegund's physical suffering is the set of iron chains worn around her chest.[33] Paradoxically, practices designed to humiliate, even annihilate individual will and identity become a source of strength as the saint is identified with and absorbs the power of Christ. Visually, the result is a somewhat awkward but significant variation on the conventional Christological formula for miraculous cures, as Radegund reaches out from the window of her cell to work the miracle. Whereas Albinus's power is associated with his ecclesiastical office, Radegund's sanctity derives from her ascetic mode of life within her convent.

The devices of repetition and typological analogy allow the artist to convey Radegund's constant spiritual personality. Fortunatus tells us that she was captured as a young princess during the fall of her home-

32. Paul Meyvaert, "The Medieval Monastic Claustrum," *Gesta* 12 (1973): 57.
33. *Vita* 1.25. These three chains, whose number clearly suggests a spiritual significance, are most easily seen in the color plate published in Yvonne Labande-Mailfert, *Histoire de l'abbaye Sainte-Croix de Poitiers* (Poitiers, 1986), pl. 4, opp. p. 97.

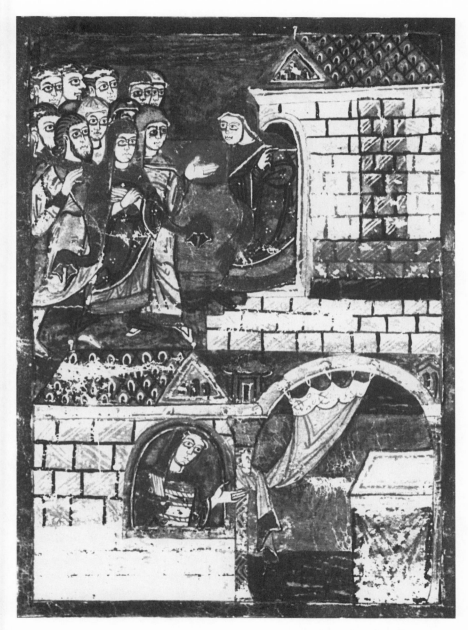

Figure 2.10. Saint Radegund enters monastic life; the saint in her cell. Poitiers, Bibliothèque Municipale, MS 250, fol. 31v (Photo, Bibliothèque Nationale, Paris).

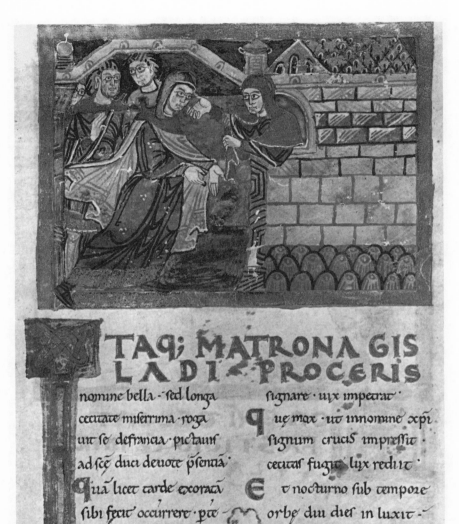

ITAQ; MATRONA GIS LADI PROCERIS

nomine bella · sed longa
cecitate miserrima · roga
uit se defrancia · pictauis
ad sce̅ duci deuote p̅sentia̅ ·

Qua̅ licet tarde exoraca
sibi fecit occurrere · p̅te
tq̅ noctis silentia ·
Prostrata cui adgenua
ut dignaretur oculos e̅

signare · uix impetrat ·

Que max · ut innomine xp̅i
signum crucis impressit ·
cecitas fugit · lux rediit ·

Et nocturno sub tempore
orbe̅ diu dies in luxit ·
ita ut tracta cum uenisset ·
nullo ducente recederet ·

Figure 2.11. Saint Radegund cures Bella. Poitiers, Bibliothèque Municipale, MS 250, fol. 34r (Photo, Bibliothèque Nationale, Paris).

land, Thuringia, to the Franks, and that she formed part of the booty apportioned to Chlothar, who forced her into marriage (*Vita* 1.2). Fortunatus also makes it clear that Radegund's true devotion was not to her earthly husband, but to Christ (*Vita* 1.3), a conflict conveyed pictorially by the successive juxtaposition of scenes of Radegund at prayer, in anticipation of her future life at the convent, and images of Radegund confronted by her husband's demands that she fulfill her obligations to him. Radegund's desire to emulate the martyrs, a point mentioned by Fortunatus (*Vita* 1.2), is suggested visually by the use of a pictorial formula adapted from the traditional imagery of the martyrs of the early church, in which the saint is arrested, interrogated, and returned to prison.[34] Radegund was compelled to appear at court banquets, but Fortunatus tells us that she abstained from food and retreated to her oratory as soon as she could (*Vita* 1.4) (Figure 2.12). As a final contrast, we see Chlothar alone in bed while his wife is again at prayer (*Vita* 1.5). This sequence of opposed images unites the themes of feasting, prayer, and sexual abstinence. In Romanesque art, lavish banquets are conventionally associated with sin and seduction, as in scenes of the dance of Salome and the parable of Dives and Lazarus.[35] The contrast between earthly food, sacrificed in fasting, and the spiritual nourishment derived from prayer is a frequent theme in hagiographic writing, particularly in the lives of female saints.[36]

The scene of Radegund bathing and feeding the poor provides a particularly interesting example of the application of Christological typology to a female saint (Figure 2.13). Fortunatus calls Radegund a "new Martha," and her passion for charitable works among the poor complements the miracles she achieves through prayer and asceticism, reconciling the traditional opposition between the active and contemplative life.[37] Through a process of inversion the earlier scene of feast-

34. Compare the cycle of Saints Savinus and Cyprianus in the crypt at Saint-Savin, in Otto Demus, *Romanesque Mural Painting* (New York, 1970), fig. 141; this juxtaposition is made by Ayres, "The Role of an Angevin Style," figs. 1, 2. For the iconography of the virgin martyr, see Hahn, *Passio Kiliani*, pp. 99–132. These images of arrest and interrogation parallel the extensive verbal exchanges between martyrs and the authorities, a theme discussed by Alison Goddard Elliott, *Roads to Paradise: Reading the Lives of the Early Saints* (Hanover, N.H., 1987), pp. 23–41.

35. Carrasco, "Notes," pp. 341–43; Linda Seidel, "Salome and the Canons," *Women's Studies* 11 (1984): 40–41.

36. On the general subject of food and female spirituality, see Caroline Walker Bynum, *Holy Feast and Holy Fast: The Religious Significance of Food to Medieval Women* (Berkeley and Los Angeles, 1987).

37. On Radegund as a "new Martha," see Claudio Leonardi, "Fortunato e Baudoni-

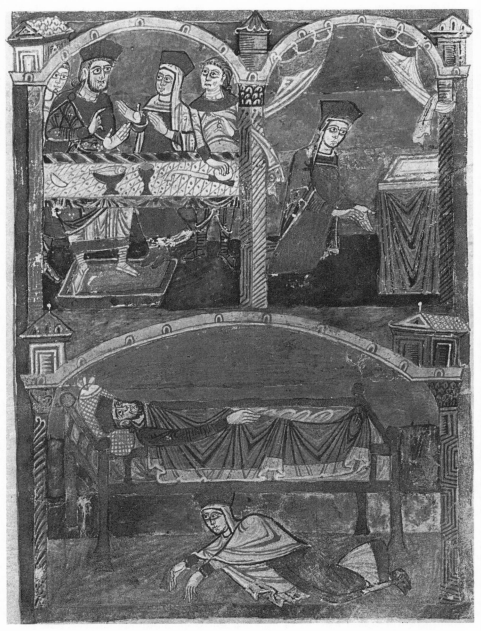

Figure 2.12. Saint Radegund and Chlothar. Poitiers, Bibliothèque Municipale, MS 250, fol. 24r (Photo, Bibliothèque Nationale, Paris).

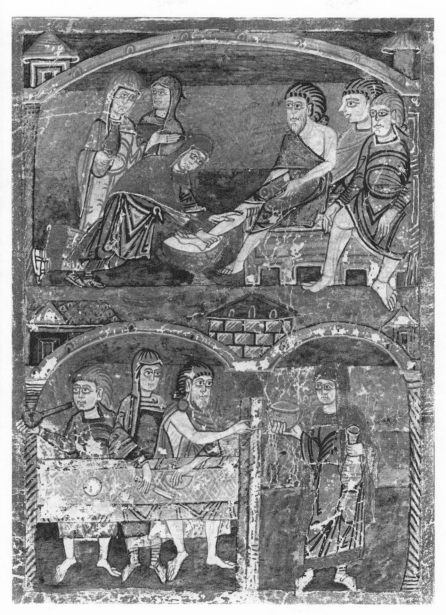

Figure 2.13. Saint Radegund washes the feet of the poor; she serves them at table. Poitiers, Bibliothèque Municipale, MS 250, fol. 29v (Photo, Bibliothèque Nationale, Paris).

ing, a public obligation with overtones of sin and lust, becomes instead an image of sacrifice, charity, and humility. One might expect to find the pictorial sources for this image in scenes of Christ in the house of Mary and Martha, or in scenes of Mary Magdalene washing the feet of Christ.[38] But in fact the artist has based the figure of Radegund on a masculine, Christological model, the scene of Christ washing the feet of the apostles.[39] The priestly and liturgical associations of this image are often reinforced by its juxtaposition with the Last Supper, and Radegund's feeding of the poor also has liturgical implications: here the closest pictorial models are images of the divine service, images that emphasize the elevation and display of the chalice and paten.[40] By performing acts of charity toward the poor, Radegund both serves Christ and imitates his actions.

The image of prison, already alluded to in the context of martyrdom, is developed into a recurrent and unifying visual theme in the Radegund *libellus*. Radegund's first miracle is the freeing of prisoners, whose cries were overheard by the queen as she walked in the royal garden at Péronne; the prisoners are shown below, thanking the queen for their freedom while she is at prayer (*Vita* 1.11) (Figure 2.14). This theme is repeated, illustrated by a similar composition, at the end of the text. Fortunatus does not provide a detailed account of Radegund's death and burial. Instead, he describes how, at the end of her life, Radegund appeared in a dream to an official named Domolenus. She cured him of a throat ailment, but only on condition that he build a church dedicated to Saint Martin and that he release a group of prisoners under his control (*Vita* 1.38). The artist combined the scene of Domolenus in his sickbed with the image of the prisoners enclosed in their cell (fol. 42r).[41] The juxtaposition of these themes—death, healing,

via," in *Aus Reich und Kirche: Festschrift Friedrich Kempf,* ed. H. Mordek (Sigmaringen, 1983), pp. 23–32.

38. Schiller, *Iconography,* 1:157–59, 2:16–18.

39. Ernst H. Kantorowicz, "The Baptism of the Apostles," *Dumbarton Oaks Papers* 9/10 (1956): 203–51; Hildegard Giess, *Die Darstellung der Fusswaschung Christi in den Kunstwerken des 4.–12. Jahrhunderts* (Rome, 1962).

40. Compare the images in Roger E. Reynolds, "Image and Text: The Liturgy of Clerical Ordination in Early Medieval Art," *Gesta* 22 (1983): 27–38, and Victor H. Elbern, "Über die Illustration des Messkanons im frühen Mittelalter," in *Miscellanea pro Arte: Festschrift Hermann Schnitzler,* ed. Peter Bloch (Dusseldorf, 1965), pp. 60–67.

41. On the theme of the release of prisoners in Merovingian hagiography, see Frantisek Graus, "Die Gewalt bei den Anfängen des Feudalismus und die 'Gefangenenbefreiungen' der Merowingischen Hagiographie," *Jahrbuch für Wirtschaftsgeschichte* 1

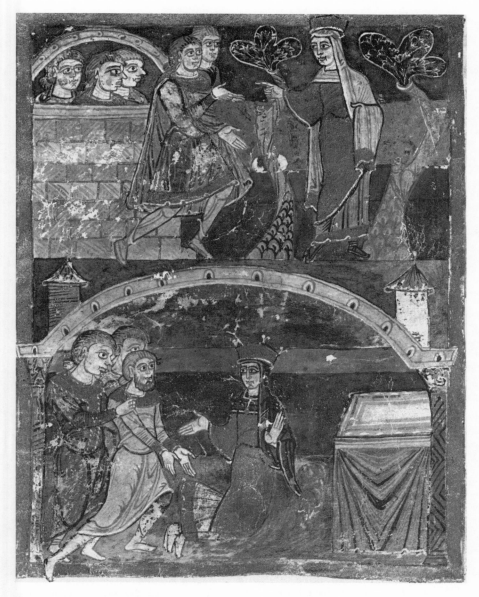

Figure 2.14. Saint Radegund and the prisoners at Péronne. Poitiers, Bibliothèque Municipale, MS 250, fol. 25v (Photo, Bibliothèque Nationale, Paris).

and release from prison—recalls the traditional Christian notion of death as deliverance from the prison of the body. Not surprisingly, scenes of the liberation of Saint Peter from prison, an event cited in the mass for the dead as a symbol of mankind's ultimate salvation, offer visual parallels with the image of Radegund's enclosure.[42]

But the relevance of this imagery to Radegund's own experience, and to the life of her convent, is far more specific. Radegund herself had been a victim of war, and so for her the theme of prison functions on a literal as well as a metaphorical level. For the saintly bishops of the Merovingian church, like Albinus, the freeing and ransoming of prisoners testifies to the social responsibility of the church as a public institution; in Radegund's life, this hagiographic stereotype is grounded in painful personal experience. Captured as a young girl and forced into exile, she expressed those bitter memories in her autobiographical poems. Grieving for her brother, slain by her husband, Chlothar, Radegund declares, "I, who left my homeland once, have twice been captured: when my brother lay felled, I suffered the enemy again." In a second letter, Radegund describes herself as "a wretched woman driven by war's unlucky strife . . . a captive woman."[43] In addition, the image of the enclosed female was particularly congenial to the spiritual mentality of the late eleventh century. The research of Jean Verdon and Mary Skinner has documented a resurgence of monastic life for women.[44] Increasing emphasis was placed on strict claustration for women, and statistical evidence appears to suggest that women selected the life of a recluse more often than did men.[45]

(1961): 61–156; also see William Klingshirn, "Charity and Power: Caesarius of Arles and the Ransoming of Captives in Sub-Roman Gaul," *Journal of Roman Studies* 75 (1985): 183–203.

42. Carolyn Kinder Carr, "Aspects of the Iconography of Saint Peter in Medieval Art of Western Europe to the Thirteenth Century" (Ph.D. diss., Case Western Reserve University, 1978), p. 138.

43. Marcelle Thiebaux, *The Writings of Medieval Women* (New York, 1987), p. 34. For the Latin see Friedrich Leo, *Monumenta Germaniae Historica: Auctores antiquissimi* 4.1 (Berlin, 1881), pp. 274, 278.

44. Jean Verdon, "Les moniales dans la France de l'Ouest au onzième et douzième siècles: Étude d'histoire sociale," *Cahiers de civilisation médiévale* 19 (1976): 247–64; Mary Skinner, "Benedictine Life for Women in Central France, 850–1100: A Feminist Revival," in *Distant Echoes: Medieval Religious Women*, ed. John A. Nichols and Lillian Thomas Shank (Kalamazoo, Mich., 1984), pp. 87–113.

45. Jane Tibbetts Schulenburg, "Strict Active Enclosure and Its Effects on the Female Monastic Experience," in *Distant Echoes,* pp. 51–86. That more women than men selected the reclusive life in England has been demonstrated by Ann K. Warren, *Anchorites and Their Patrons in Medieval England* (Berkeley and Los Angeles, 1985),

It is customary to assume that manuscripts of the lives of the saints from the Romanesque period are essentially shrine books; that is, they were produced by, or at least for, the church that housed the saint's tomb and therefore, presumably, formed the center of his or her cult.[46] This pattern is confirmed by the Albinus *libellus,* where the spiritual power of the living saint continues in force centuries later at his shrine. But in the case of Radegund, the cult celebrations in Poitiers were by no means limited to the funerary church that bears her name. There is considerable evidence that the convent of Holy Cross was itself an important cult center, based on its intimate associations with the saint during her lifetime. At least in the early Middle Ages, Radegund's reputation for sanctity, and the cult associated with her, may be less dependent on the miracle-working tomb than on a series of objects and sites associated with her life at the convent, many of which are commemorated in this manuscript. At once intimate objects of personal use and vehicles of divine power, these items are equally evocative of Radegund's historical existence and her spiritual force. Several of these objects are listed in the relic inventories of the convent.[47] Incorporating such specific, local references transforms relatively conventional pictorial formulas into images whose individuality and immediacy demonstrate how mundane objects and physical sites can bridge the gulf between earthly and spiritual reality.

Foremost among these local references is the saint's cell and oratory (Figures 2.10, 2.11).[48] Baudonivia describes how Christ appeared to Radegund in a vision the year before her death (*Vita* 2.20), and popular

pp. 19–22. The situation on the Continent needs more study; see the review of Warren's book by Penelope D. Johnson, *Speculum* 62 (1987): 749. Schulenburg, "Strict Active Enclosure," pp. 77–79, concludes that strict enclosure in monastic life was a "sex-specific" policy, particularly in the period of the Gregorian Reform.

46. Wormald, "Some Illustrated Manuscripts," pp. 261–62. Hahn has argued, however, that the Hanover manuscript of Saints Kilian and Margaret was created for private reading, rather than the liturgical celebration of a relic shrine (*Passio Kiliani,* pp. 4–5, 133–42, esp. p. 141).

47. Published by Xavier Barbier de Montault, *Le trésor de l'abbaye de Sainte-Croix de Poitiers* (Poitiers, 1882), pp. 8–108; excerpts are also available in Em. Briand, *Histoire de sainte Radegonde, reine de France, et des sanctuaires et pèlerinages en son honneur* (Paris, 1898), pp. 385–405.

48. On Radegund's cell see Gregory of Tours, *De gloria Confessorum* 104, *Patrologia Latina,* vol. 71, cols. 905–7, in Van Dam, *Gregory of Tours,* pp. 105–08; A. Rhein, "Cella de sainte Radegonde," *Congrès Archéologique de France* 79, no. 1 (1912): 269–70; May Vieillard-Troiekouroff, *Les monuments religieux de la Gaule d'après les oeuvres de Grégoire de Tours* (Paris, 1976), pp. 228–29; Labande-Mailfert, *Histoire de Sainte-Croix,* pp. 35, 45–46, 69, 473–74, esp. the ground plan on p. 34.

tradition later held that Christ had left his footprints at the site. Radegund's cell was subsequently enlarged to form a more elaborate sanctuary, called the "Pas de Dieu." This cell was itself the object of veneration by pilgrims. The first devotional visit was made by Gregory of Tours, following Radegund's funeral. Gregory describes how the abbess Agnes, accompanied by her nuns, showed him Radegund's cell and pointed out the place where she had knelt in prayer, as well as her book; overcome with emotion, Gregory wept along with the nuns. Archaeological investigations at the convent confirm the arrangement of two small connecting rooms found in our miniatures. This similarity between the images and the actual site suggests that the scenes of Radegund's cell and oratory may have functioned much like the *loca sancta* images of the early church, created to commemorate holy sites from the life of Christ.[49] William Loerke has recently stressed that the primary function of the *loca sancta* images, with their emphasis on depicting specific topographical detail and spontaneous, interrupted gestures, was to help the viewer enter into the immediate historical experience of the biblical event.[50] Such images have the peculiar power to make the past eternally present. In Loerke's words, the viewer of the work of art, often a pilgrim at the holy site commemorated in the work itself, becomes a witness of the biblical event; similarly, the images in the Radegund *libellus* facilitate the reenactment of Gregory of Tours's experience by later generations of nuns and pilgrims at Holy Cross.

Other miniatures confirm the role played by visual images in the commemoration of places, objects, and events intimately connected with Radegund during her life at the convent. For example, one miniature illustrates the miraculous revival of a dying laurel tree (fol. 37v). In his publication of 1914–20, Emile Ginot described how popular tradition venerated a tree located near the site of Radegund's cell, believed to be the very tree described by Fortunatus.[51] The saint's

49. Kurt Weitzmann, "'Loca Sancta' and the Representational Arts of Palestine," *Dumbarton Oaks Papers* 28 (1974): 31–55; Margaret Frazer, "Holy Sites Representations," in *Age of Spirituality: Late Antique and Early Christian Art, Third to Seventh Century*, ed. Kurt Weitzmann (New York, 1979), pp. 564–91, includes material on saints. The "locus sanctus" idea is invoked in Kessler's work on Saint Martin ("Pictorial Narrative," p. 84).

50. William Loerke, "'Real Presence' in Early Christian Art," *Monasticism and the Arts*, ed. Timothy Verdon (Syracuse, N.Y., 1984), pp. 29–51.

51. Ginot, "Le manuscrit," p. 52; there is a photograph of this tree in Briand, *Histoire de sainte Radegonde*, p. 206.

hairshirt, which miraculously brought an infant back to life (fol. 38v), is listed in a sixteenth-century inventory as one of the relics belonging to the convent.[52] The cure of a woman with hydropsy (fol. 39r), a scene whose clear liturgical overtones are suggested by visual analogy with scenes of baptism, may also refer to the bathing facilities at Holy Cross described by Gregory of Tours.[53] A seventeenth-century biography of Radegund reports that visitors to her convent were shown the stone seats used by the poor whose feet were washed by the saint (Figure 2.13).[54] Radegund's spindle (*fusus*), seen by Gregory of Tours, was depicted in a miniature, now lost, known through an eighteenth-century copy.[55] The book Radegund holds while in her cell is, like the spindle, an object of personal use that evokes her presence, just as it did for Gregory of Tours; the book is also suggestive of the rich devotional and intellectual traditions at Holy Cross.[56]

At least in the early Middle Ages, the initiative in promoting Radegund's cult seems to have been taken by the abbesses of her convent, not by the custodians of her tomb at the nearby church of Sainte-Radegonde.[57] The revival of Radegund's cult following the period of the invasions can be traced to the convent of Holy Cross: an inscription dating to the year 1012 from the church of Sainte-Radegonde states that at that time no one knew the location of the saint's tomb, and that the abbess of Holy Cross, Beliardis, rediscovered the tomb and

52. Barbier de Montault, *Le trésor,* pp. 81, 201; Ginot, "Le manuscrit," p. 53.

53. Gregory of Tours, *Historia Francorum,* 10.16; Vieillard-Troiekouroff, *Les monuments,* p. 227. Compare the baptismal scenes in William M. Hinkle, *The Portal of the Saints of Reims Cathedral* (New York, 1965), figs. 29, 31, 35, 52–54.

54. Cited by Ginot, "Le manuscrit," p. 44.

55. *Vita* 1.30. The copy is partially reproduced in Ginot, "Le manuscrit," p. 50.

56 In the Radegund *libellus,* compare the miracles on fols. 34v and 37r, and the portrait of Baudonivia, who holds a book (fol. 43v); see also *Vita* 1.2 and *Vita* 2.9. For intellectual life at Holy Cross, see Labande-Mailfert, *Histoire de Sainte-Croix,* pp. 48–50; for the Frankish situation in general, see Suzanne Fonay Wemple, *Women in Frankish Society: Marriage and the Cloister, 500 to 900* (Philadelphia, 1980), pp. 175–88.

57. Brian Brennan has recently suggested that Baudonivia's *Vita Radegundis,* written shortly after 600 at the request of the abbess Deidimia, represents a conscious attempt to rehabilitate the monastic enterprise and the reputation of its foundress in the wake of the scandal associated with the revolt of a group of nuns at the convent of Holy Cross: "Saint Radegund and the Early Development of Her Cult at Poitiers," *Journal of Religious History* 13 (1985): 348–49. Unfortunately, we are much less well informed about the history of both Radegund's convent and her church for the period between the seventh and the thirteenth centuries; see Labande-Mailfert, *Histoire de Sainte-Croix,* pp. 77–116.

renovated the crypt.[58] Extensive evidence of an active cult celebrating this tomb dates only to the middle of the thirteenth century, when a series of over a dozen miracles occurred.[59] But liturgical evidence suggests that the convent of Holy Cross had developed its own cult based on the events of the life of its foundress. The special feast days at the convent included the day of Radegund's death (August 13), as well as the day of the rediscovery of her tomb by the abbess Beliardis; in addition, two special feast days are associated with Radegund's cell: the day of the appearance by Christ to Radegund in her cell; and the day that Radegund entered monastic life in Poitiers, an event commemorated in the *libellus* with the image of Radegund striding into her cell (Figure 2.10).[60]

We also have evidence of the relationship between the convent and the chapter of Sainte-Radegonde.[61] In 1072, Pope Alexander II confirmed the reform of the chapter along the lines established by the royal foundress. The canons were obligated to celebrate services at the convent, and the jurisdictional rights of the abbess over the chapter canons were reaffirmed. Continuing disputes between the convent and the chapter resulted in a series of papal judgments in favor of the nuns. The canons were eventually successful in asserting their independence, but the process took many years, and it appears that for the eleventh century, at least, the nuns were able to assert their rights and obtain papal support for their efforts. The illustrated *libellus* of Saint Radegund was thus created at a crucial moment in the history of her convent of Holy Cross; the manuscript's paintings might be viewed as the pictorial equivalent of the legal claims to institutional identity found in the documentary sources.

But these miniatures are also, as has been suggested, a visual expression of the convent's spiritual identity. A number of scholars have suggested that the texts of Fortunatus and Baudonivia exemplify differing models of sanctity, conditioned by the point of view of the author: one masculine, the other feminine; one the external perspective

58 Robert Favreau and Jean Michaud, *Corpus des inscriptions de la France médiévale, I.1: Poitou—Charentes, Ville de Poitiers* (Paris, 1974), pp. 95–96, pl. 35.

59. H. Bodenstaff and A. Largeault, "Miracles de sainte Radegonde: Treizième et quatorzième siècle," *Analecta Bollandiana* 23 (1904): 433–47.

60. Louise Coudanne, "Regards sur la vie liturgique à Sainte-Croix de Poitiers," *Bulletin de la Société des Antiquaires de l'Ouest* 4, no. 14 (1978): 364–65.

61. P. de Monsabert, "Documents inédits pour servir à l'histoire de l'abbaye de Sainte-Croix de Poitiers," *Revue Mabillon* 9 (1913/1914): 52–53; Labande-Mailfert, *Histoire de Sainte-Croix*, pp. 94–99.

of the beneficiary of Radegund's patronage; the other the internal perspective of a member of Radegund's convent.[62] Fortunatus emphasizes Radegund's humility and asceticism; Baudonivia emphasizes her royal status, her political activity, and her maternal, quasi-clerical role in guiding her convent. The miniatures offer an interpretation of Radegund's personality that essentially fuses these two perspectives into a single image, at once priestly, maternal, and ascetic. The use of purple and gold, unusual in eleventh-century French manuscripts, functions on several levels: it effectively conveys Radegund's royal status, her place in the celestial hierarchy, and the generally aristocratic background of nuns at convents such as Holy Cross.[63]

Both Albinus and Radegund are much more than fondly remembered figures from the distant past: they are living presences whose divine authority is consciously invoked by the works of art we have been examining. Both manuscripts commemorate not simply individuals, but also places: the miracle-working shrine of Albinus and Radegund's cell and oratory. In so doing, the images bring the faithful into the immediate, intimate presence of the saint. For if the saints transcend historical time by becoming one with Christ, each act of transcendence remains rooted in earthly reality. Contact with the saints is achieved by means of the physical—the body of Albinus in its shrine, the sites and objects touched by Radegund during her lifetime. The repeated visual commemoration of these relics transforms the illuminated *libellus* itself into a type of relic, in the sense that the manuscript, a concrete physical object, serves as an intermediary between the dual earthly and sacred realities of the saint's existence.[64] This equivalence is likely to have been especially meaningful for the nuns of Holy Cross, who lacked

62. Etienne Delaruelle, "Sainte Radegonde de Poitiers, son type de sainteté et la chrétienté de son temps," in *Etudes mérovingiennes: Actes des Journées de Poitiers, 1er–3 mai 1952* (Paris, 1953), pp. 64–74; Graus, *Volk, Herrscher, und Heiliger,* pp. 407–11; Jacques Fontaine, "Hagiographie et politique, de Sulpice Sévère à Venance Fortunat," *Revue d'Histoire de l'Église de France* 62 (1976): 113–40; Leonardi, "Fortunato e Baudonivia;" Wemple, *Women in Frankish Society,* pp. 181–85; Thomas Head, "Gender and the Construction of Female Sanctity" (Paper presented at the Ninth Annual Barnard Medieval and Renaissance Conference, New York, November 14, 1987). I am grateful to Professor Head for allowing me to read an earlier version of this paper.

63. On eleventh-century manuscripts in France, see Carl Nordenfalk, "Miniature ottonienne et ateliers capétiens," *Art de France* 4 (1964): 48–49, 54–55; on the social status of nuns, see Verdon, "Les moniales," pp. 249–51.

64. A comparison between the *libellus* and the saint's shrine is made by Wormald, "Some Illustrated Manuscripts," p. 262, and in "The Monastic Library," in *Gatherings in Honor of Dorothy Miner,* ed. Ursula E. McCracken (Baltimore, 1974), pp. 94–95.

the body of their foundress. Although it remains true that hagiographic stereotypes gain much of their effectiveness by their very convention- ality, a full understanding of the distinctive power and function of pictorial hagiography emerges only when the imagery is read in terms of the very physical and historical reality that the saints served to transcend.

Spiritual Sanctions in Wales

The bishops of Llandaff in southeastern Wales wielded terrifying—and because of that efficacious—spiritual sanctions against powerful, lay troublemakers. To be sure, the sanction clauses of the Llandaff charters warned potential malefactors, as did charters throughout Europe, that they and theirs would suffer appalling afflictions, including perpetual anathema, if they indeed caused trouble. But whereas it is difficult to find out in most cases whether such warnings had any bite to them, at Llandaff the bishops were apparently able to keep the promise of the sanction clauses. In the middle of the tenth century, for example, King Nowy violated the sanctuary of the three guardian saints of Llandaff (Dyfrig, Teilo, and Euddogwy), whereupon Bishop Pater had only to convoke a synod and the king came forward to ask forgiveness, lying flat on the ground and weeping.¹ A century later, when the kinsmen of King Cadwgon killed a relative of Bishop Here-

I have been greatly assisted in the preparation of this work by Jacqueline M. Cossentino, a history honors student at Smith College in 1985–86; Dr. Lisa Bitel, of the Programs in Women's Studies and Western Civilization at the University of Kansas; and Professor Craig R. Davis of the Department of English at Smith College.

1. The standard edition of the *Liber Landavensis* is that of John G. Evans and John Rhys, eds., *The Text of the Book of Llan Dav* (Oxford, 1893; repr., Aberystwyth, 1979). The standard study of the charters it contains is Wendy Davies, *The Llandaff Charters* (Aberystwyth, 1979). Davies has assigned consecutive numbers to all the charters in the *Liber Landavensis;* in citing these charters I will follow her practice of first giving the page number in the Evans and Rhys edition (occasionally followed by a small letter if more than one charter begins on that page), followed by the number she assigned in parentheses or brackets. Thus the reference to the dispute between King Nowy and Bishop Pater is p. 217 (109).

wald, the latter summoned a synod and there anathematized the king and his family. The king was soon anxious both for himself to be at peace with his pastor and for his family to rejoin the company of Christians (p. 267 [154]).

No fewer than twenty-four such cases appear in the *Book of Llandaff,* a twelfth-century collection of charters, saints' lives, papal privileges, council records, and episcopal correspondence. As the documents range over the period from the sixth century to the twelfth, this collection clearly constitutes one of the treasures of early Welsh history, yet such importance has not prevented its being the subject of extended debate by historians. Discussion has arisen because, to cite only the more egregious problems, just one of the 158 charters it contains bears a date, the lives of the patron saints it contains find only the sketchiest corroboration in other sources, and there seems not even to have been a diocese of Llandaff for most of the period supposedly covered by the book. Some have referred to it, and a few have dismissed it, as a forgery.[2]

The *Book of Llandaff* is a twelfth-century creation, prepared to advance the claims put forth by Bishop Urban, formerly a priest at Worcester, who held the see of Llandaff in Glamorgan from 1107 to 1134. Archbishop Anselm consecrated him at Canterbury and extracted from him a profession of canonical obedience and subjection to the church of Canterbury, the first such profession by a bishop in Wales.[3]

The tasks confronting postconquest bishops were extremely complex. The first of these appointees, a Breton named Hervé who became bishop of Bangor in 1093, was forcibly thrown out of his diocese. The matter went far beyond a struggle between natives and foreigners. Such bishops had to construct territorial dioceses on the Roman model, where these did not previously exist. This need drew them into conflict with one another and with the land-hungry Anglo-Norman aristocracy. In seeking independence for their dioceses, they fell into conflict with Canterbury. They quarreled with nearly everyone except the pope, and

2. Evan D. Jones, "The Book of Llandaff," *National Library of Wales Journal* 4 (1945–46): 3–53; Christopher N. L. Brooke, "The Archbishops of St David's, Llandaff, and Caerleon-on-Usk," in *Studies in the Early British Church,* ed. Nora K. Chadwick, Kathleen Hughes, Christopher N. L. Brooke, and Kenneth Jackson (Cambridge, 1958), pp. 201–42; and Wendy Davies, "*Liber Landavensis:* Its Construction and Credibility," *English Historical Review* 88 (1973): 335–51.

3. Glanmor Williams, *The Welsh Church from Conquest to Reformation* (Cardiff, 1962), p. 2. On Urban, see Wendy Davies, "Saint Mary's Worcester and the *Liber Landavensis,*" *Journal of the Society of Archivists* 4 (1972): 478–83.

the reason they did not quarrel with him is that they took their quarrels to his court; they thus quite readily thrust the Welsh church, which previously had had little to do with Rome, directly into the hands of the papacy.[4]

In his first round with the papacy, Urban had to travel only from Normandy to Champagne. Along with Bernard, the first Norman bishop of the neighboring Welsh diocese of Saint David's, Urban was present at the court of Henry I in Normandy in 1119, and the king sent both of them, along with some other clerics, to a council at Reims called by Pope Calixtus II. Urban went prepared with his formidable list of claims, and he introduced the church of Llandaff to the pope as having been founded in honor of the Apostle Peter. Indeed the new cathedral church on which construction began in 1120 was dedicated to Saint Peter as well as to Saints Dyfrig (whose relics Urban had transferred from Bardsey to Llandaff that same year), Teilo, and Euddogwy. Notwithstanding confirmation by Calixtus of all his claims, Urban's conflicts carried on over the next decade and a half, especially those with the bishops of Saint David's and of Hereford. His journeys to Rome yielded two other papal confirmations, both from Honorius II, in April 1128 and April 1129.[5]

But Bernard of Saint David's also had access to Rome and the papacy, and he managed to have the disputed matters reopened in 1130. The new pope, Innocent II, gave temporary assurances to Urban, but eventually placed the entire matter before a commission made up of the archbishops of Canterbury, York, and Rouen. At their meetings at London and Winchester in 1132, the commissioners found mostly in favor of Saint David's and against Llandaff. This should perhaps not surprise us, for while Bernard was frequently in attendance at the royal court, Urban had (or took) many fewer opportunities to cultivate the powerful in those circles. It is a poignant comment on Urban's career that we last hear of him on yet another trip to Rome, where he died in 1134.[6]

4. Lynn Nelson, *The Normans in South Wales, 1070–1171* (Austin, Tex., 1966), pp. 160–65; David Walker, *The Norman Conquerors* (Swansea, 1977), pp. 82–95.

5. Wendy Davies, *An Early Welsh Microcosm: Studies in the Llandaff Charters,* Royal Historical Society Studies in History, 9 (London, 1978), p. 5. Evans and Rhys, *The Text,* pp. 30–48, 84–96.

6. Evans and Rhys, *The Text,* pp. 54–67; Davies, *"Liber Landavensis,"* pp. 337–38. For a full review of the troubled reign of Bishop Urban, see *Episcopal Acts and Cognate Documents Relating to Welsh Dioceses, 1066–1272,* ed. James C. Davies, 2 vols. (Cardiff, 1946), 1:147–90. I am grateful to C. Warren Hollister of the University of California,

The *Book of Llandaff* was, for Bishop Urban, a combined archive, treasury, and arsenal, accumulated through at least a decade and a half of tense competition on several different fronts; without it he was powerless. The original manuscript survives, and its essential contents—that is, all the charters and the saints' lives—were executed by one hand only, in the second quarter of the twelfth century.[7] We should now review the twenty-four cases found by Urban and his advisers where spiritual sanctions were employed against laymen.

One plunderer, Rhiwallon ap Tudfwlch, was punished by an offended saint without any ecclesiastical intervention, for his booty included the relics of Saint Maughan (whose church he had raided); as he rode off with the booty, his horse stumbled and, as befits a fighter swollen with pride, he was thrown from the horse and badly hurt.[8] He retained enough strength to be penitent and to restore the goods he had stolen (p. 264b [153]).

In three cases, which included the first one cited at the start of this essay, the calling of a synod sufficed to bring a powerful lay lord, who had apparently misbehaved, to a contrite frame of mind. In the seventh century King Morgan violated a vow sworn on holy relics when, at the instigation of the "evil one," he treacherously killed his uncle. He came willingly to a synod to receive judgment for his crime and to render satisfaction (p. 152 [30]). Early in the tenth century, Brochfael ap Meurig gave land to the church for the support of his daughter in the religious life while she lived, and then after she died he tried to claim it as his own again. But at the synod called by Bishop Cyfeilliog, Brochfael confirmed his donation on oath (p. 231 [124]).

More persuasion was called for in eleven cases in which the bishop unsheathed the sword of excommunication. One involves Brochfael ap Meurig, whom we have just seen in a relatively docile mood. But in another dispute, Brochfael went so far as to insult the bishop, and the bishop thereupon wished to excommunicate Brochfael and his entire family before all the people in a full synod. Again Brochfael repented and so the sword, though raised, did not strike (p. 233 [127]).

Santa Barbara, for pointing out that Bernard witnessed many more documents at the royal court than did Urban. For an argument that Urban was Welsh and more of an outsider at court than most of his peers, see Denis L. Bethell, "English Black Monks and Episcopal Elections in the 1120s," *English Historical Review* 84 (1969): 673–98.

7. Evans and Rhys, *The Text,* pp. vii–xxx; Davies, *Llandaff Charters,* pp. 1–2.

8. On falling riders, see Lester K. Little, "Pride Goes before Avarice: Social Change and the Vices in Latin Christendom," *American Historical Review* 76 (1971): 31–37.

In about 925 King Tewdwr ap Elisedd rudely expelled Bishop Libiau from a monastery, whereupon, the *Book* tells us, the offended prelate placed the king and his family under a curse and perpetual anathema (*sub maledictione et perpetuo anathemate*). Then he gathered all the clerics of the diocese in a synod at Llandaff to renew the anathema against the king. After some time (*post intervallum temporis*), the bishop of Saint David's intervened to mediate a settlement (p. 237b [133]). Later in the tenth century King Arthfael of Gwent, having killed his brother, called down on himself both anathema and separation from the whole community of Christians at a synod called by Bishop Gwgon. A tearful reconciliation ensued (p. 244 [137]). In the case of a furious and bloody feud between King Edwin of Gwent and Bishop Bleddri in the second decade of the eleventh century, the bishop intervened to try to make peace but was attacked and wounded by one of Edwin's kinsmen. The wounded prelate retaliated by summoning a synod to anathematize the king and his family and to place the county of Gwent under a curse and leave it without baptism (*sub maledictione et sine baptismo*). King Edwin delivered the offenders for judgment and submitted himself to penance (p. 249b [141]).

In about 1040, King Meurig of Morgannwg, who was engaged in a dispute with a subject named Seisyll, took away Seisyll's wife by force from the church at Llandaff, where she had sought sanctuary. The king also wounded a member of Bishop Joseph's household who was trying to protect the woman. The bishop retaliated successfully by anathematizing the king (p. 259 [147]).

A certain Aguod ap Iouaf had a dispute with Bishop Cerennyr in about 870; he hurled stones against the church and then fled as anathemas were hurled at him (p. 216b [108]). In a similar dispute between Rhiwallon ap Rhun and Bishop Joseph in about 1033, the bishop excommunicated his opponent (p. 257 [145]). When a gang rape took place in a churchyard in about 1091, Bishop Herewald cursed and excommunicated the offenders (p. 271 [156]). There are three other cases in which the bishop first called a synod and then cursed and excommunicated the malefactors (pp. 218 [110], 255 [144], 261 [149]).

The nine remaining cases stand out because they contain a notable escalation of the spiritual means employed to stimulate contrition in the guilty. Bishop Berthwyn called a synod in about 700 to excommunicate King Clodri for killing King Idwallon, the two having previously pledged friendship over sacred relics. The case by now looks

familiar, except that when the excommunication was pronounced, the altar was completely cleared off and the crosses placed on the floor (*denudando altaria dei et deponendo cruces ad terram*) (176b [59]). A very similar case involving a vow to keep the peace followed by a killing led Bishop Euddogwy in about 665 to place the crosses on the floor, but then he cursed the king saying: "May his days be few and may his sons be orphans and his wife a widow" (*et inclinando cruces ad terram ... maledixit regem cum progenie confirmante sinodo et dicente: "Fiant dies eius pauci et fiant filii eius orphani et uxor eius vidua"* [Ps. 108:9]). In a subsequent sentence about the duration of the punishment, the subject was said to have remained for more than two years "under that excommunication" (p. 147 [23]). Along with the crosses, sacred relics were also put on the floor (*denudando altaria dei et prosternando cruces ad terram simul et reliquias sanctorum*); and a further variant involved silencing the bells by turning them over (*depositis crucis ad terram simul et cimbalis versis*) (pp. 167 [47]; 180b [65]). Four cases employ the combination of deposed crosses and relics and overturned bells, three of them in conjunction with an excommunication (pp. 189 [75], 212 [105], 214 [106], 222 [112]).

Finally, there was one case in which still more elaborate means were employed. The circumstances were also a bit out of the ordinary. On Christmas Day of about the year 1070, King Cadwgon of Morgannwg visited Llandaff to participate in the holiday festivities. These got dangerously out of hand and led to the death of a nephew of Bishop Herewald. The bishop convened a full synod; he had the crosses and relics placed on the floor and the bells turned over; moreover, he had the doors of the church closed and barricaded with thorn bushes. "And so the people remained," continues the account, "without service or pastor, for days and nights, while the anathema and separation from the faith rested on the king's family" (p. 267 [154]). This was the second of the cases mentioned near the beginning of this essay, where we saw that the king soon became deeply troubled and came forth to beg forgiveness.

From an episcopal perspective, these were all successful cases; such results seem a reasonable outcome for an episcopal book. But while half the sanctions took effect immediately, the others required more time: some until the condemned was not able to bear it any longer (but no time period is specified), a few until the passage of what can be summarized only as a short while, one we have just seen that continued for days and nights, one that lasted over two years, and still

another that went on for three years. As the source of authority exerted by these bishops lay in their saints, we have before us the image of a sanctity that not only taught the good way by example, as all saints do, but one that could punish severely those who failed to heed the lesson.

The question remains whether such dramatic scenes with their ultimately triumphal endings ever actually took place. The charters and lives have been subjected to painstaking analysis in an attempt to determine what parts of them are historically valid in order to rescue them from the charge of being twelfth-century fabrications. Scholars have found that they contain many archaic terms and names, thus indicating probable derivation from earlier sources; also there are odd omissions and other slips that seem best explained as copyists' errors. An exhaustive study of the charters by Wendy Davies concentrates on the witness lists and the diplomatic formulas. Its main result is a complete inventory of the charters, with approximate dates and with clear demarcations between the probable original material and the later accretions. Moreover, her reconstruction does not suppose the gathering of over 150 separate documents by a twelfth-century compiler, but rather such a compiler's gathering together of three earlier compilations, based ultimately on a total of nine separate compilations. Previous stages in the amalgamation process took place in the ninth, tenth, and eleventh centuries. This work of reconstruction does indeed rescue the collection from uselessness, placing several hundred names of persons and places within a coherent and internally consistent chronological framework.[9]

Among the accretions of the final century before the book was gathered are all of what Davies calls "narratives." These are the discursive accounts of events leading up to the particular donations that the charters serve to record. A given charter may indeed tell of an actual transfer of property that took place at some time in the past, even the very remote past. But a charter may also contain a narrative account of a dispute along with the terms by which that dispute was settled. It is then among such terms that one finds reference to the transfer of property that is the raison d'être of the charter in the first place. And so, to restate Davies' argument, even if the record of an actual transaction has filtered through various compilations from a much earlier document, the tales of disputes and of how they were resolved all lack

9. Davies, *Llandaff Charters*, pp. 92–129.

archaic elements and thus appear to be recent compositions.[10] All twenty-four cases are extracted from such narratives, and thus of all the material in this vast collection, precisely that which is of most interest here is the part that is most suspect.

As it happens, even if there are no sources to corroborate the employment of such sanctions or the playing out of such dramatic scenes, these scenes were certainly not the whimsical mental wanderings of a lone, hyperimaginative scribe. Whether they actually happened, or whether a twelfth-century compiler merely wanted us to think that they did, they correspond to a set of practices then widespread on the Continent.

The word "clamor" does not occur in any of the twenty-four cases narrated, and yet each of the latter nine examined involves, in fact, a clamor. The clamor, sometimes also called *maledictio,* is a special liturgy for use in times of difficulty. There are clamors that consist only of prayers against a malefactor, while more complicated ones pile on staggering quantities of terrible curses.[11] A further variant involves the humiliation of relics, wherein the relics are removed from the altar and placed on the floor of the church.[12] Humiliation can cut two ways. The malefactor should be made aware that his behavior is causing the saint's suffering and humiliation and that only his sincere reform will permit the saint's return to the place of honor. But the saint is also made aware that his behavior, usually, as it happens, his failure to do something, to be vigilant in protecting the interests of his church, has brought about his own humiliation, and that he is going to stay right there on the floor until he wakes up and gets back on the job.[13] This

10. Ibid., pp. 21–23. Davies' detailed analysis confirms the judgment of John G. Evans (Evans and Rhys, *The Text,* p. xxiv): "The charters pure and simple are, on the face of them, genuine; while the Synodal accounts, though based on facts, are clothed in the words of the compiler, and decorated by certain touches calculated to impress rebellious subjects with a salutary fear of church discipline. Hence the interpolated passages about bells being inverted, about relics and crosses being removed from the altar and placed on the ground, at a time earlier by several centuries, than the commencement of such methods for enforcing obedience to the ecclesiastical power." Evans's accompanying note deals only with the use of interdict, citing the case that is mentioned at the end of the first paragraph of this essay.

11. Lester K. Little, "La morphologie des malédictions monastiques," *Annales: Economies, Sociétés, Civilisations* 34 (1979): 53–57.

12. Patrick Geary, "Humiliation of Saints," in *Saints and Their Cults: Studies in Religious Sociology, Folklore, and History,* ed. Stephen Wilson (Cambridge, 1983), pp. 123–40.

13. See, for example, the case of St. Bavon of Ghent in Maurice Coens, "Translations et miracles de saint Bavon au XIe siècle," *Analecta Bollandiana* 86 (1968): 63–64.

latter sense of humiliation applies in the case of King Hywel, who broke an oath sworn on the altar of the saints of Llandaff, whereupon Bishop Cerennyr convened a full diocesan synod and had the crosses laid on the floor, the bells turned over, and "the relics of the saints taken from the altar and thrown to the ground [*reliquiis sanctorum ablatis altari et proiectis in terram*]" (p. 212 [105]).

Formulas for the clamor remain extant from churches throughout the territory corresponding to the northwestern and north-central parts of the Carolingian Empire. To specify only some Norman examples, there is one such formula from the Abbey of Saint-Etienne at Caen, just as there was from the church at Sainte-Barbe-en-Auge (where it was called *missa contra raptores*).[14] Coutances Cathedral and the Abbey of Saint-Wandrille at Fontenelle each had a malediction formula, and whereas at Mont-Saint-Michel no liturgical formula for the clamor is extant, we have dramatic evidence for the use of the clamor there. From Jumièges, we have both formula and evidence of use.[15]

The account by Ordericus Vitalis of a rebellion in the county of Maine against Norman authority in 1090 provides a fine example of the clamor in action. The local temporal notables organized this rebellion, secure in their control of the city of Le Mans and surrounding strongholds. The venerable bishop, however, Hoel by name, held his see by King William's gift. He had always been loyal to the king and his sons; indeed he had tried to dissuade these rebels of 1090. Having failed to block them that way, he excommunicated the whole lot of them. Accordingly, they reacted with fury, which turned to threats, which turned to violence. Once, as the bishop rode about his diocese exercising his episcopal duties, one of the leading rebels captured him and put him in prison, with the idea that he should remain there until a descendant of a former count of Maine arrived in Le Mans to take up the office and title of count, in defiance of the Normans. "Meanwhile," says Ordericus: "the church of God shared in the affliction of its bishop. The holy images of the Lord on the crucifixes and shrines

14. For Caen, see Montpellier, Bibliothèque de la Faculté de Médecine, MS 314, fols. 93–94v. For Sainte-Barbe, see Paris, Bibliothèque Sainte Geneviève, MS 96, fols. 220–221v.

15. For Coutances, see *Gallia Christiana*, 11:223–24. For Fontenelle, see Lester K. Little, "Formules monastiques de malédiction aux IXe et Xe siècles," *Revue Mabillon* 58 (1975): 390–99. For Mont Saint-Michel, see Jean Jacques Desroches, *Histoire du Mont Saint-Michel et de l'ancien diocèse d'Avranches,* 2 vols. (Caen, 1838), 1:277. For Jumièges, see Rouen, Bibliothèque Municipale, MS A 293, fols. 148v–51r, and Jules Joseph Vernier, ed., *Chartes de l'abbaye de Jumièges,* 2 vols. (Rouen, 1916), 1:140–43.

containing the relics of saints were taken down and the doors of the churches blocked up with thorns; the ringing of bells, the chanting of offices, and all the accustomed rites ceased, as the widowed church mourned and gave itself up to weeping."[16] The bishop was soon released.

While a clamor and an excommunication are two different matters, as we saw at Le Mans, they are often inextricably combined, as they appear to be at Llandaff. Many noted formulas for excommunication contain extravagant litanies of cursing. We can cite examples from the Abbey of Saint Germans in Cornwall and from Rochester Cathedral, both of them probably Norman imports.[17] The latter was rendered famous by Laurence Sterne in *Tristram Shandy,* where the full text is read by Dr. Slop, with Uncle Toby whistling "Lillabullero" in the background.[18]

None of the spiritual sanctions deployed in the *Book of Llandaff* has a specific precedent in Wales, while none differs significantly from numerous Continental precedents. At the very least it would appear that the compiler(s) of the book knew the standard usage of Normandy. If the scenes described did not take place, the compiler in telling them showed the way he wanted people to think of how the bishops of Llandaff had handled troublemakers in the past and thus how they could expect the current one to do henceforth. If the purpose was to issue a warning, he surely would not have made up something so fanciful as to be beyond belief.[19]

It may be that this kind of formal, liturgical sanction had its indirect

16. Odericus Vitalis, *Historica ecclesiastica,* 8.11, ed. Marjorie Chibnall (Oxford, 1973), 4:194–95 (punctuation altered).

17. For Saint Germans, see Gilbert H. Doble, ed., *Pontificale Lanaletense: A Pontifical Formerly in Use at St. Germans, Cornwall,* Henry Bradshaw Society, 74 (London, 1937), pp. 130–31. For Rochester, see Felix Liebermann, ed., *Die Gesetze der Angelsachsen,* 3 vols. (Halle, 1903–16), 1:439–40.

18. *The Florida Edition of the Works of Laurence Sterne,* 3 vols., ed. Melvyn New and Joan New (Gainesville, Fla., 1978–84), 1:197–216, 2:952–57, 3:216–27.

19. The same reasoning is used by John W. James in "The Excommunications in the *Book of Llan Dâv,*" *Journal of the Historical Society of the Church in Wales* 8 (1958):5–14. James was troubled by the anachronistic use of interdiction, which led him to question the historical accuracy of such details as the stripping of the altar and the deposition of the crosses and relics. He did not know where to seek precedents for such practices, but the cursing he confidently traced to the druids. Without the benefits of Wendy Davies' researches, he concluded that the bare outlines of information in the charters were genuine but that the twelfth-century editor wrote them up in the terminology of his day.

but ultimate origins in Celtic lands, for two rather tenuous precedents, one from Brittany and one from Ireland, can be cited. In about 550 an assembly of clerics and lay people gathered at Le Mené-Bré in northern Brittany to condemn a murderous usurper and tyrant named Conomor. Among the prelates in the assembly were Saint Hervé and perhaps also Saints Samson, Gildas, and Teilo. Against Conomor the entire assembly launched an excommunication; the format used was probably like that of the ancient poets, who would assemble at the top of a hill, stand back-to-back looking out in all directions, and utter a curse that was supposed to destroy the recipient.[20] The Irish case centers upon Saint Ruadan's cursing of King Diarmait at Tara. The king was holding captive a kinsman of Ruadan, and so the saint gathered his monks and went to Tara to demand the kinsman's release. Upon hearing the king's refusal, Ruadan and his companions proceeded to ring their bells against Diarmait, and "they also sang psalms of malediction and vengeance against him."[21]

Except for these few instances of carefully orchestrated curses, it was spontaneous religious cursing that, especially in Celtic lands, was deeply ingrained and highly regarded. The Welsh saints, like their Irish counterparts, were skillful practitioners of the art of cursing, and in both countries they appear to have inherited this art from the druids.[22] When, for example, King Caradoc beheaded a girl who had resisted his advances, Saint Beino cursed him, and in that hour the king melted into a pool.[23] Saint Cadoc had such powers already as a boy and still after his death. When sent as a boy to get a flame from a servant working at a threshing floor and the servant refused, Cadoc cursed him to die

20. Ibid., pp. 11–12. The scene at Le Mené-Bré is described in the *Vita s. Hervei*, 27, ed. Arthur de la Borderie: "Saint Hervé, texte latin de la vie la plus ancienne de ce saint, publié avec notes et commentaire historique," *Mémoires de la Société d'émulation des Côtes-du-Nord* 29 (1892): 269, whereas, for the ancient ceremony, see Whitley Stokes, "The Second Battle of Moytura," *Revue Celtique* 12 (1891): 90–93, 119–21.

21. Charles Plummer, ed., *Lives of Irish Saints*, 2 vols. (Oxford, 1922), 2:276–78.

22. Charles Plummer, ed., *Vitae sanctorum Hiberniae*, 2 vols. (Oxford, 1910), 1:xciii, cxxix–clxxxviii, especially clix and clxv; Wendy Davies, *Wales in the Early Middle Ages* (Leicester, 1982), pp. 177–78; Wendy Davies, "Property Rights and Property Claims in Welsh *Vitae* of the Eleventh Century," in *Hagiographie, Cultures, et Sociétés, IVe–XIIe siècles* (Paris, 1981), pp. 515–33. Note the presence of druids in the dramatic scene at the approach of the Roman army to Anglesey reported by Tacitus, *Annals*, 14:30.

23. William J. Rees, ed., *Lives of the Cambro-British Saints* (London, 1853), pp. 16–17, 303–4.

in a fire, threshing floor and all, and that is precisely what then hap-
pened.[24] As for what he could do after death, when a foolish rustic
knowingly broke a rule by peeking with one eye into a tomb of a
disciple of the saint, the eye cracked and hung down his face by the
optic nerve.[25] Other saintly curses in Wales led to such interesting
results as a king falling from his horse, and two groups of malefactors
being swallowed up by the earth, exactly as Moses arranged for Dathan,
Abiram, and their followers.[26] And yet for all the stories of punitive
curses in Welsh saints' lives, none of these is a precise source for the
formal, liturgical maledictions we have been examining.

We should inquire in parallel fashion about lay violence, whether it
was indigenous or imported. To be sure, there was violent conflict in
pre-Norman days. A leading Welsh historian, Robert R. Davies, has
recently written in regard to the preconquest period of "the natural
fissiparousness of Welsh 'political' life—if such a genteel term [as 'po-
litical'] may be used for the litany of family and inter-dynastic conflicts,
raids, kidnappings, and murders."[27] But there were new types of conflict
in the early twelfth century, conflict specific to the coming of the Nor-
mans. And it is not enough to say that the conquerors were greedy,
for these same Norman lords were known for generous stewardship
toward churches in their home territories. Davies, in the work just
cited, focuses attention on precisely this point, writing of the "massive
transfer" of land from Welsh churches to the Norman lords' own
religious foundations in Normandy or in England. Tewksbury, for
example, grew rich on lands located in Glamorgan. The Normans
showed a great distaste for the Welsh church; they preferred to transfer
wealth from it to churches that, in their estimation, really mattered.[28]

To be sure, the Normans did establish and sponsor monastic com-
munities in Wales; indeed they introduced there the current liturgical
spirituality of black monasticism, including that of Cluny (whose cus-
toms included a chapter entitled *Quomodo fiat clamor pro tribulatione*
[How to make a clamor, in case of trouble]).[29] Yet they founded no

24. Arthur W. Wade-Evans, ed., *Vitae sanctorum Britanniae et genealogiae* (Cardiff,
1944), pp. 36–39.
25. Ibid., pp. 100–101.
26. Num. 16:1–35.
27. Robert R. Davies, *Conquest, Coexistence, and Change: Wales, 1063–1415* (Oxford,
1987), p. 24.
28. Ibid., pp. 180–81.
29. Marquard Herrgott, ed., *Vetus disciplina monastica* (Paris, 1726), pp. 230–32;

abbey; they founded nineteen priories in South Wales, of which eighteen were dependent upon mother houses in England, Normandy, or other French principalities.[30] Second-class churches for a second-rate place: Wales and the Welsh existed to gratify Norman exploitation. Such was the view of the conquerors, and in it, by the way, we can see the origins of a durable ethnic stereotype.

Urban did score one major political triumph in his career, and that was a compromise settlement reached with the lord of Glamorgan in 1126; this was Earl Robert of Gloucester, one of the natural sons of Henry I. The settlement dealt with the material claims of the church and also procedures for handling rival claims to jurisdiction between the earl and the bishop. The document was signed in the king's presence.[31] What we lack is information about how Urban, or anyone else, was able to bring the earl to a compromising frame of mind.

But lest we start to imagine spiritual sanctions, let us return to the spiritual sanctions imagined by Urban. We are left with the conclusion that these narratives of theatrical scoldings of powerful, lay wrongdoers at Llandaff came not from any indigenous practice, at least not directly, but rather from Normandy or Norman England; they represented one more aspect of Normanization, along with the territorial diocese, the Benedictine monastery, the church dedication to Saint Peter, the synod, subjection to the church of Canterbury, and appeals to the court of Rome.

There is a postscript in the *Book of Llandaff* that can serve the same function in this essay. In a blank space at the bottom of a page part way through the book, a fifteenth-century scribe reported the following: "Be it known that the great sentence of excommunication of Saint Teilo, which he obtained at the Roman Court against any who infringe the liberties or privileges of the cathedral church of Llandaff, was read and promulgated in the usual way on the saint's day in 1410, and that within a few days seven persons who had thus transgressed went wildly insane, and remained that way for the rest of their lives."[32] No bishop, at that date, had to ask for papal permission to perform an excom-

and Peter Dinter, ed., *Liber tramitis aevi Odilonis abbatis,* Corpus Consuetudinum Monasticarum, 10 (Siegburg, 1980), pp. 244–48.

30. F. G. Cowley, *The Monastic Order in South Wales, 1066–1349* (Cardiff, 1977), pp. 9–17, 270.

31. *Glamorgan County History,* vol. 3, "The Middle Ages," ed. T. B. Hugh (Cardiff, 1971), pp. 27–33.

32. Evans and Rhys, *The Text,* pp. 118–21, 350. Cf. Walter de Gray Birch, *Memorials of the See and Cathedral of Llandaff* (Neath, 1912), p. 75.

munication, and no wrongdoers would likely have reacted so strongly had a prelate merely announced that he intended to excommunicate persons who infringed the rights of the church of Llandaff. The text of this excommunication was most likely the sort of formula that was laced with dreadful curses, and the dramatic recital of these curses was surely what so upset the unhappy Llandaff seven. We are reminded of the clamor composed by the monks of Saint-Wandrille in Normandy in the tenth century, a text still breathtaking for both its meanness and completeness; the monks went to great lengths to deny that they had made it up and to show instead that the pope had entrusted this old Roman curse to their founder, Saint Wandrille, on a trip to Rome back in the seventh century.[33]

If there is any truth to this report about the seven malefactors struck by madness in 1410, we can feel sure that the bishop of Llandaff possessed a formula for excommunication filled with terrifying curses. Though we lack this formula, we note how the scribe inserted his report on the very page containing an all-encompassing privilege of Saint Teilo, which purports to have been granted directly to the saint, with apostolic authority, in the sixth century. It provides that those who violate the terms of the privilege be cursed and excommunicated. The main body of this privilege, it so happens, was lifted directly from Calixtus II's bull of 1119, and the remaining elements can also be assigned to the second and third decades of the twelfth century.[34] Thus the formula used in 1410 did not date from the time of Saint Teilo, but rather, like all the rest of Llandaff's maledictory sanctions, from the reign of Bishop Urban. That was a time when the Norman aristocracy, which lived under relatively tight control in Normandy and England, had virtually the free run of Wales.

33. Little, "Formules monastiques de malédiction," pp. 378–81.
34. Davies, *Llandaff Charters*, pp. 18–19.

National Characteristics in the Portrayal
of English Saints in the
South English Legendary

Not unlike William Caxton, who alluded in the preface of his *Eneydos* (1490) to the English national character's being influenced by the phases of the moon, Carl Horstmann expressed certain misgivings about how the English of his day might receive the publication of *The Early South-English Legendary*. When he chose sixty-four items from Bodleian Library MS Laud 108 and edited these saints' lives in 1887 he wrote:

> I know most Englishmen consider it not worth while to print all these Legends; I know they regard them as worthless stuff without any merit, because they are wholly absorbed in questions of the day, of politics and no end, in the fade poetry of poets laureate and lady authors, which to an intellect of the middle ages would have appeared infinitely more insipid (as turning on momentary interests, and the "self" and its lust) than these Legends may appear to the present generation. The English mind is always running into extremes with full steam, with brutal energy, from "Popery" to "no Popery," now into the grossest superstition, and

This is a shortened version of a paper presented at the Ninth Annual Barnard Medieval and Renaissance Conference in 1987. I have tried to minimize verbatim overlap with some of my previously published studies of the *South English Legendary,* although it was sometimes unavoidable; they are: *Darstellungen von Tod und Sterben in mittelenglischer Zeit: Untersuchung literarischer Texte und historischer Quellen* (Duluth, Minn., 1970), chap. 2; but especially "Entertainment, Edification, and Popular Education in the *South English Legendary,*" *Journal of Popular Culture* 11, no. 3 (1977): 707–17; "Personalized Didacticism: The Interplay of Narrator and Subject Matter in the *South English Legendary,*" *Texas A & I University Studies* 10: no. 1 (1977): 69–77; and "*Legenda Aurea* Materials in the *South English Legendary*: Translation, Transformation, and Acculturation," in *"Legenda aurea": Sept siècles de diffusion,* ed. Brenda Dunn-Lardeau (Montreal, 1986): 317–29.

again disclaiming and holding in abhorrence what their own fathers revered and held in awe; it only sees its present objects, and is blind to everything which lies behind or around; it wants the *juste milieu,* the repose of the contemplative mind, and forgets that in the eyes of eternity every epoch, every faith, has its *raison d'être,* and every true poetry its beauty. If the present English public cannot see any merit in these Legends, it does not follow that there is no such merit.[1]

He then identifies the merits of the collection: the legends provide models of sanctity and depict virtues for more complete living, even though the moral they represent may not be to the liking of contemporary society. He praises the legends' value from hagiologic, literary and poetic points of view and appeals to the readers' sense of indebtedness to the past.[2]

During the past one hundred years scholars have studied the *South English Legendary (SEL)* primarily from text-critical (manuscripts, sources), linguistic, formal (the tradition of the genre) and content oriented perspectives.[3] These scholars agree that this collection of *sanctorale* (lives of the saints) and *temporale* materials (events of the church year) is basically a work of translation and adaptation. Its major principles of organizing sources have been identified as a simplification of

1. William J. B. Crotch, ed., *The Prologues and Epilogues of William Caxton,* Early English Text Society *(EETS)* o.s. 176 (London, 1928; repr. Millwood, N.Y., 1978), p. 108; Carl Horstmann, ed., *The Early South-English Legendary, EETS* o.s. 87 (London, 1887; repr. Millwood, N.Y., 1975). In the earliest extant form, MS Laud 108 in the Bodleian Library, the legendary consists of sixty-four lives. The edition by Charlotte d'Evelyn and Anna J. Mill, *The South English Legendary,* 3 vols., EETS, 235, 236, 244, (London, 1956–59), based on Cambridge Corpus Christi MS 145 and British Library MS Harley 2277, contains ninety items, of which the following nineteen are English and Irish saints: Wulfstan; Bridget; Oswald Bishop; Chad; Patrick; Edward the Elder; Cuthbert; Alphege; Brendan; Dunstan; Aldhelm; Augustine of Canterbury; Alban; Swithun; Kenelm; Oswald the King; Edmund the Bishop; Edmund the King; Thomas Becket. All quotations are from this edition, with page references preceding line references. For a brief review of relatively recent studies and bibliographical information, see my footnotes in *"Legenda Aurea* Materials."

2. The passage continues: "To be appreciated, they demand an intellect more robust and sane, a heart more wide and enlarged, a mind more truly Christian and less hypocritical than the present generation is able to supply. They present models of sanctity, models of self-abnegation, virginity, meekness and obedience, virtues which are not to the taste of our time. But if the present time does not like this moral, it does not follow that the moral is bad or worse than our own. They present a different kind of humanity: suffering humanity, which is not the province of 'our conquering heroes.' They represent Christian mythology, as it had been formed in the course of centuries.... So the Collection deserves our attention, not only from an hagiologic, but also from a poetic and literary point of view. In publishing it, we only pay a just debt to the past."

3. See Jankofsky, *"Legenda Aurea* Materials," p. 318 and n. 2.

theological-dogmatic and hagiographic problems; an explanatory, in-
terpretive, and didactic expansion of subject matter; a process of con-
cretization through the creation of enlivening dialogues and scenes
where the sources have plain third-person narrative, that is, dramati-
zation; and a process of acculturation, the adaptation of essentially
Latin sources to an English audience, thereby creating a distinctive
flavor and mood, *Englishing*. The collection's purpose was obviously the
instruction of the laity in matters of the faith, mainly through straight-
forward stories that could be understood at first hearing, told in seven-
stress rhyming couplets. Its singularity consists in the new tone and
mood of compassion and warm human empathy for the lives and deaths
of its protagonists and in the pedagogic care and pastoral concern for
its intended original audience, which seems to have consisted at one
time of unlettered listeners, probably women, as internal evidence in
some legends indicates (e.g., "Edmund of Canterbury," 496.100;
"Lucy," 570.133–36; "The 11,000 Virgins," 444.256–58). Manfred
Görlach's inquiry into the textual relationship of the about sixty extant
manuscripts and his extensive notes provide an indispensable foun-
dation for future philological and other research.[4] My own interests
in the past two decades or so have been primarily content oriented,
especially the dialectic relationship of text-narrator-audience in view of
the collection's value as a means of religious instruction. But more
research is needed to elucidate matters of vocabulary, material culture
and custom, and even legal concepts and formulas underlying some of
its narratives. This essay forms part of a larger study to be undertaken,
together with other scholars, as a cooperative effort to arrive at a critical
assessment of the *SEL* as a whole. The following observations point
out some additional characteristics to those already identified that may
be of help in describing the nature and scope of the collection.

The *SEL* abounds in concrete, historical-factual information about
the English and Irish saints in contrast to the narrative treatment ac-
corded to "Latin" (i.e., non-British) saints and martyrs. The latter are
usually depicted in conformity with the hagiographic schemata iden-
tified by Hippolyte Delehaye long ago, namely, hyperbolic accounts
of the feats of the *athletae Dei* and in close conformity with the infor-
mation and patterns given by the *Legenda aurea (LA)*, where the *LA*

4. Manfred Görlach, *The Textual Tradition of the South English Legendary*, Leeds
Texts and Monographs, n.s. 6 (Leeds, 1974); also "The 'Legenda Aurea' and the Early
History of the *South English Legendary*," in Dunn-Lardeau, *Legenda aurea*, pp.
301–13.

is the identifiable source of the *SEL* legends.[5] The proportion of "historical" versus "hagiographical" information is all the more astonishing as the narratives themselves are relatively short, with more than two-thirds of the collection under three hundred lines long and about 88 percent of the narratives capable of oral delivery in much less than half an hour. More so than in the "Latin" lives, the names of father, mother, and siblings of the saints are given. Thus "Kynedride," "Herston," "Robert, Margerie, Alice" are found, rather than the often ingenious etymologies of the names of the saint so characteristic of Jacobus de Voragine (see the *LA's* "Saint George" and "Saint Thomas of Canterbury" for contradistinction). Place names and topographical details are mentioned; inheritance laws, death duties, the situation of the poor, the rights of church versus state with specific instances of conflict, and historical-geographical accounts of old English kingdoms and bishoprics are given, and even weather conditions are described when appropriate, such as the detailed account of a storm that flooded the south side of High Street in Oxford but not the northern part where Saint Edmund of Abingdon was preaching in the churchyard of All Saints'. All this anchors the narratives in reality and lends them, to a certain degree, the character of historical narrative, if not historical documentation.[6] For author and audience, the description of the geo-political division of the old English kingdoms and bishoprics may have been just as important as the location of Saint Patrick's purgatory.[7] The legends of Saints Thomas Becket and Edmund Rich of Abingdon, archbishops of Canterbury, provide the most obvious illustrations of this historicity; in other legends, such information permits the identification of literary-historical sources.[8]

5. Hippolyte Delehaye, *The Legends of the Saints,* trans. Victoria M. Crawford (London, 1907; repr., Notre Dame, Ill., 1961).

6. See, for example, "Dunstan," "Edmund of Canterbury," "Kenelm," "Edward the Elder." In the latter legend we read, for example, "As seint Edward wende anhonteþ a gret wille him com to / Forto iseo is ȝonge broþer for anon he Poȝte it do / For he was a lite biside as is stepmoder was / In a toun þat me clupede Corf þat bote þreo mile nas / A strong castel þer is nou ac þo nas þar non þere" (lines 45–49). For the usefulness of such hagiographical information to the historian, see D. W. Rollason, "The Cults of Murdered Royal Saints in Anglo-Saxon England," *Anglo-Saxon England* 11 (1983): 1–22, and "Relic Cults as an Instrument of Royal Policy, c. 900–1050," *Anglo-Saxon England* 15 (1986):91–103.

7. "Kenelm," 280.10–74; "Patrick," 87.45–70, etc. In "Thomas Becket," the "A" redactor provided some new passages containing historical and geographical information, as Görlach points out (*Textual Tradition,* p. 214 and notes).

8. The three longest items in the d'Evelyn-Mill edition are "Becket" (2,444 lines

The "national characteristics" of the *SEL* (i.e., the embedding of information indicative of the English people and their culture at a given time, rather than national character traits) can be conveniently, though not exhaustively, listed as the following: references to the existence of Christianity before the arrival of Saint Augustine of Canterbury; references to the English-Danish conflicts; anti-Norman sentiments discernible in some legends (e.g., "Wulfstan"); references to national and local customs; anecdotes that permit glimpses into contemporary life; direct references to the use of *English* as a language (see, for example, "Dunstan," 210.174–84; "Kenelm," 285.183–85; "Edmund of Canterbury," 510–11.574–75), and proverbs. Even though the lives of Saint Augustine of Canterbury and Pope Gregory are among the shortest of the collection, with 100 and 98 lines, respectively, their importance cannot be overlooked, because the *SEL* stresses again and again their role in bringing Christianity to England. It is true, other legends explicitly indicate the existence of monastic houses, such as Glastonbury, and the establishment of Christianity even before the arrival of Saint Patrick in the fifth century and Saint Augustine at the end of the sixth (see "Dunstan," 206.47–54), but the *SEL* narratives clearly emphasize the momentousness of this mission for England and all English Christians. In the "Saint Gregory" legend this is achieved through the repeated use of the term "the apostle of England" applied to him; in "Saint Augustine," implicitly through the careful selection of significant elements from the most likely source, Bede's *Ecclesiastical History of the English People.*[9] Independent of the question of what the ultimate source is for this *SEL* legend, the intentions of the original author of the collection can be deduced from his judicious emphasis on the encounter of Saint Augustine with King Ethelbert: The king, twice characterized by his pose of thoughtful silence, speaks the words that have justly been memorialized even in textbooks on the history of the English language: "Faeger word þis

plus 74 of "Translatio"), "Edmund of Canterbury" (602) and "Michael" (796). The relative length of "Saint Michael" may be due to the inclusion of scientific subject matter—appropriately so, as Gregory M. Sadlek argues in "The Archangel and the Cosmos: The Inner Logic of the *South English Legendary*'s 'St. Michael,' *Studies in Philology* 85 (Spring 1988): 177–91.

9. As I indicated in "*Legenda Aurea* Materials," p. 321 n. 5, the *SEL* text shows striking similarities to the Old English translation of his history (Thomas Miller, ed., *The Old English Version of Bede's Ecclesiastical History of the English People*, EETS, o.s. 95 [London, 1959]), a copy of which, incidentally, was at Worcester, thought by many scholars to be the original home of the *SEL*.

sindon and gehat þe ge brohton and us secgað. Ac forðon hie niwe sindon and uncuðe, ne magon we nu gen þæt þafian þæt we forlæten þa wisan þe we langre tide mid ealle Angelþeode heoldon."[10] The *SEL* renders this thus:

> þe king stod þo he hurde þis as þei he were in þoȝte
> Swuþe fair þing it is he sede þat ȝe bihoteþ me
> Were ich siker þat it were soþ do ich wolde after ȝe
> Ac i ne consenti noȝt þerto for it is ȝute niwe
> Ar ich habbe more underȝite weþer þis message beo triwe. (216.56–60)

The *SEL* account does not give a single line of direct speech to Saint Augustine, thus highlighting the conflict potential and inner dynamics of this encounter. But in the evocation of the procession, complete with the singing of a litany and the solemn display of the crucifix, the narrator can draw on the experience of his listeners in imagining the singularity of the event. (Intriguing inferences to the "Banna sanctorum" prologue of the *SEL* can be drawn as well on the basis of this account.) Furthermore, numerous references to local churches, chapels, shrines, relics, and wells, to institutions, customs, and events, with appropriate explanations if the author-narrator deems them necessary, characterize the legends, particularly those of English saints.[11] In "Edmund of Canterbury," for instance, the audience learns that the saint's mother, Mabille, is buried at Saint Nicholas Church in Abingdon, on the south side, and that her tombstone inscription reads, "her lyþ on þe ston/Mabille flour of widuen" (497.138–42). Adverbial phrases such as "still" or "yet" indicate the continuity of tradition and often the effectiveness of a saint's healing and intercessory powers. In "Edmund the King" the listeners learn that the miraculously preserved body of the saintly king, "al hol and sound," is now nobly enshrined "as riȝt was to do" in the town that is now called "saint Edmundesbury" and that

> Wele whiche fair pelrynage is þider forto fare
> To honury þat holy bodi þat haþ ibeo þer so ȝare. (515.99–100)

The account that the severed head of the martyr, cast into a thicket of brambles and thorns by the Danish, had alerted the English searching

10. Albert C. Baugh and Thomas Cable, *A History of the English Language*, 3d ed. (Englewood Cliffs, N.J., 1978), p. 63.

11. See, for example, "Kenelm" for information on wells, on the precise verses in the psalm (Ps. 108 [109]) Quendride is reading, or for the use of historical information taken from William of Malmesbury in lines 10–74.

for it with the *English* words "her-her-her" highlights the strange and marvelous circumstances of his death and the recovery of his body. It may also provide an insight into underlying legal custom: those walking through the woods had to make their presence known by calling out if they did not wish to be considered outlaws and thus incur the danger of being slain.[12]

A similar function of tying the narratives into contemporary reality and expectations is served by references to physical objects related to the saints. Thus the narrator tells us that the psalter that Saint Kenelm's wicked sister Quendride was reading when suddenly her eyes burst out in just punishment for her brother's murder can still be seen at Winch-combe.[13] In the same legend the audience learns that in Rome is still kept that cryptic message in *English* to the pope, "In Clent Coubach kenelm kinges bern / liþ vnder a þorn heued bireued" (288.267–68); a dove had deposited it on an altar in Saint Peter's at Rome where the pope was reading mass.[14] In fact, the narrator expresses his own amaze-

12. Latin and French accounts by Matthew Paris and Langtoft, for example, also emphasize the *English* words: "Caput martyris eadem lingua respondens dixit: 'Her, her, her,' quod Latine dixitur, 'Hic, hic, hic.' " And, "Après le cors trouvé 'here, here, here' parlait." In the Old English Aelfric's *Lives of Saints,* 2 vols., ed. Walter W. Skeat, EETS, o.s. 76, 82, 94, 114 (London, 1881, 1885, 1890, 1900; repr. 1966), the corresponding passage reads: "Hi eodon þa secende ealle endemes to þam wuda / secende gehwaer geond þyfelas and bremelas / gif hi a-hwaer mihton gemeton þaet heafod / . . . Hi eodon þa secende and symle clypigende / swa swa hit gewunelic is þamðe on wuda gað oft / Hwaer eart þu nu gefera? and him andwyrde þaet heafod / Her her her and swa gelome clypode / andswarigende him eallum swa oft swa heora aenig clypode / oþþaet hi ealle becomen þurh clypunga him to" (2:324, ll. 142–53). I owe the suggestion of a possible connection to the concept of outlawry to Thomas Finkenstaedt. See also Frederick Pollock and Frederick W. Maitland, *The History of English Law before the Time of Edward I,* 2d ed., 2 vols. (Washington, D.C., 1959), esp. 2:578–81. I wonder if there might not even be a common connection to the Anglo-Norman "haro." In any case, the *SEL* version is not as explicit as Aelfric's in describing the actual search.

13. "Kenelm," 285.181–83, 291.351–60; "Aldhelm," 213.79–82. In "Saint Edward the Elder," the knife with which the saint was slain can still be seen in the church at Caversham, reports the narrator (112.78–80). Details like this seem to be the work of the "A" redactor of the collection.

14. "þe writ was iwrite pur Engliss as me radde it þere / And to telle it *wiþoute rime* [my emphasis] þis wordes riȝt it were / In Clent Coubach Kenelm kinges bern / Liþ under a þorn heued bireued" (288.265–68). A marginal note in the manuscript gives the Latin text: "In clento ualle uacce. 'Kenelmus regis natus.' iacet sub spina capite truncatus" (p. 288). This may be the same Latin couplet referred to by the author of the *passio* of Saint Kenelm (Bodl. Lib. Douce 368, fols. 80–83), according to Rollason, "Cults," p. 10 n. 51. Roger of Wendover, *Flowers of History,* 2 vols., trans. John A. Giles (London, 1849), 1:174, quotes the English words "In Clento cou bathe Kenelm kynebearn lith under thorne haevedes bereaved," thus possibly indicating the existence of a vernacular tradition, according to Rollason.

ment at the nature of this missive, the noblest relic of all in Rome for
the reason that it came straight from heaven and from our Lord's hand:

> þis writ was wel nobliche iwest and up ido
> And iholde for grete relike & ȝute it is also
> þe nobloste relike it is on þerof of all Rome
> As it aȝte wel wo so understode riȝt well wanne it come
> For wanne it out of heuene com & of oure Lourdes honde
> Wat noblore relike miȝte beo i necan noȝt understonde. (288.269–74)

We may take his wonderment just as seriously as the urbane reflections
of Friedrich Sieburg, the highly esteemed journalist-historian-writer,
on the theme "Dieu, est-il français?" (Is God a Frenchman?) in his
book on France and its history and the tribe of the Swabians in the
Federal Republic of Germany who speak of their country ("Ländle")
affectionately as being God's special creation of a miniature model of
the earth. Obviously, God finds many ways to show his concern for
and interest in those who serve him. And when the *SEL* narrator tells
his audience that in Canterbury Cathedral pilgrims can look at the tip
of the sword stuck in the pavement in that violent stroke that cut off
Saint Thomas Becket's crown, the bond between the inner truth of
the story and the outward truth of historical reality is established and
reinforced in a manner such as to render it verifiable by all. As a result,
what may be unfamiliar is brought closer to understanding. This con-
nection of the spiritual to the tangible permeated all levels of society.
As the history of English art in the thirteenth century shows, during
the period immediately preceding the composition of the *SEL,* the
ideals of Franciscan saintliness, the religious fervor of the age, and
appeals to popular piety were expressed in many forms: in new archi-
tectural and sculptural programs—for example, in episcopal and royal
tombs (King John's at Worcester) that resemble the shrines of saints,
in the cult of both new and not officially canonized local saints, and
in the translation of Old English saints to more splendid resting places.
King Henry III's own religious zeal and enthusiasm manifested them-
selves in the architectural rebuilding of Westminster Abbey, in the
acquisition of a precious relic—a portion of the Lord's blood—and in
magnificent religious ceremony. The king himself was an excellent
example of the religious fervor of the age: not content to hear three
masses daily, he would try to attend more and would fervently kiss the
hands of the priest elevating the Host.[15] A complementary aspect of

15. Peter Brieger, *English Art, 1216–1307* (Oxford, 1957), esp. pp. 6–7, 96–105.

the temper of the times and the modes of perception of reality manifested itself in violent actions of political protest which took the form of "popular canonizations."[16] But there are inner, thematic links in the *SEL* narratives as well: Before he dies peacefully (in 1240) at Soisy near Pontigny after having left England in the wake of renewed struggles with King Henry III, Edmund Rich, archbishop of Canterbury, has a vision in which Saint Thomas Becket, himself a victim in the struggles of church and state with King Henry II in the preceding century, appears to him. In the *South English Legendary,* the accounts of the deaths of the English saints usually depart from the hagiographic schema of multiple tortures typical of the "Latin" martyrs, with perhaps Saints Alban (ca. 287? venerated as the first martyr in the island of Britain) and Edmund the King (841–69) the exception; the deaths of the English saints are put into a more concrete, historical framework, often with reference to political struggles in which the saints took part or to social injustices and ills that they tried to redress. King Edmund's Sebastian-like death ("the arrows stick in him so thick he looks like a hedgehog," the narrator comments) is clearly depicted as both an "imitatio" type of martyrdom and as a part of the armed conflict of the English with the Danish invaders. And in his dying, Edmund Rich, archbishop of Canterbury, shows the admirable qualities of a "happy death" despite the sufferings of his illness; humor and "merriness" and Christian confidence characterize his last moments, just as fine theological sensitivity as a scholar and social awareness as an administrator had marked his working life. When a distressed widow had come to plead with him, he had commented in Latin to his clerics that he thought it an unjust law that commands that a poor woman who has just lost her husband in death must also give up her best animal as a death duty to her feudal overlord, in this case the archbishop himself. He obeyed the letter of the law but then promptly made an "indefinite loan" of the beast to her (507.465–86).

16. Jean J. Jusserand reports in his *Wayfaring Life in England in the Middle Ages,* trans. Lucy T. Smith (London, 1888), pp. 342–43, that during the reign of Edward II, "Henry de Montfort and Henry de Wylynton, enemies of the king and rebels, on the advice of the royal court, were drawn and hanged at Bristol, and it had been decided that their bodies should remain attached to the gibbet, so that others might abstain from similar misdeeds and crimes against the king." However, "the people made relics of these bloody and mutilated remains, and surrounded them with respect, in violent protest." Even false miracles were organized at the place of execution to stir up hatred against the king. See also John W. McKenna, "Popular Canonization as Political Propaganda: The Cult of Archbishop Scrope," *Speculum* 45 (1970): 608–23.

It is a characteristic of the entire *SEL* that it attempts to provide didactic instruction that is both profitable *and* pleasant and that this endeavor shows signs of the same "delightful Englishness" that scholars appreciate in Chaucer. Thus we find colloquial and proverbial expressions and down-to-earth phrases as "not worth a bean," "not worth a straw," and familiar similes, as well as ironical, clever remarks and instances of grim humor, reminiscent of the Middle English romances, to which the *SEL* explicitly refers in its "Banna sanctorum" prologue.[17] Humorous relief is built into the legends in terms of anecdotes: In "Saint Swithin" we hear of a farm woman come to market to Winchester to sell her eggs; she had been roughly frolicked with against her will by one of the masons working on a bridge repair project (for which the saint as the local episcopal authority was responsible) with the result that all the eggs were broken; the saint blesses them and restores them to their original state. This miracle is then finely balanced by the narrator's comment, "I wish all egg-mongers would fare so now, so they could more boldly hop over ditches and wrestle and tussle." In the legend of "Saint Dunstan" the devil who had tried to tempt the saint in the form of a woman has his nose painfully pinched with tongs in the smithy where Dunstan relaxes from his intellectual and spiritual pursuits with manual labor; the devil—surely an underdevil type reminiscent of medieval comedy rather than the Prince of Darkness—runs off shouting, "Oh, oh, oh, what has this bald-pate done to me!" which prompts the narrator to comment, "he never felt inclined to come thither again to get treatment for his headcold."[18] But to balance things out, the narrator also criticizes his audience for lax religious and social practices, admonishes or castigates his listeners and appeals to their sense of values and aspirations. In the didactically important "All Souls," for example, which contains numerous exempla, tales, and "cases" to illustrate its points, the narrator concretizes his remark that

17. The narrator contrasts his *true* stories with those *false* stories (*lesynge*) that people like to listen to in the secular entertainment literature of the day: "Men wilneþ muche to hure telle of bataille of kynge / And of kniʒtes þat hardy were þat muchedel is lesynge / Wo so wilneþ muche to hure tales of such þinge / Hardi batailles he may hure here þat nis no lesinge / Of apostles & martirs þat hardy kniʒtes were / þat studeuast were in bataille & ne fleide noʒt for fere / þat soffrede þat luþer men al quik hare lymes totere / Telle ichelle bi reuwe of ham as hare dai valþ in þe ʒere" (3.59–66).

18. "Miʒte eirmangars fare nou so þe baldeloker he miʒte / Huppe ouer diches ware hi wolde & boþe wraxli & fiʒte" (276.69–70). "Out wat haþ þis calwe ido wat haþ þis calwe ido / In þe contreie me hurde wide hou þe ssrewe gradde so / As god þe ssrewe hadde ibeo habbe ysnut atom is nose / He ne hiʒede namore þuderward to tilie him of þe pose" (207.89–92).

everyone will find the purgatory corresponding to his or her sins with reference to figures as Dame Aldeth and her treasure chest—dame Aldeþe þat naþ non oþer blis / Bote atome in hire alclyne þer al hire moker is (467.123–24)—and Sir Gilbert, the all-too-lenient priest who gives easy shrift and penance, who spends his days at the tavern and his nights with his concubine, and who will surely go to hell, his jokes notwithstanding (475.343–49):

> For sire Gilbert whan he haþ ymassed his lyf he wole so diʒte
> Atte tauerne he is aday & bi his quene bi nyʒte
> He saiþ whan me clipeþ him preost site stille gode fere
> þe preost hongeþ at churche & ich am nouþe here
> His cope oþer his surpliʒ þe preost he saiþ þat is
> Ac his cope schal bileue atom whan he schal to helle iwis

This popular, vigorous tone links the *SEL* to other writings in Middle English that integrate the realities of everyday life and rely on the listeners' and readers' familiarity with their own culture.

In his voluminous study of English saints' legends in the Middle Ages, Theodor Wolpers has made the historical-comparative assessment that the *SEL* manifests an effort toward edification that concentrates on the *amabile* and *mirabile* in the saints; he identifies the vicarious empathetic experience of an essential feeling of miraculous protectedness, of patience in suffering, and of piety as the central concern in the representation of the saints' lives; and he says that the intent of these stories is to induce in their audience pious emotion.[19] It is also true, however, especially in the English lives, that the audience is given models of Christian virtue and behavior that can be clearly and unambiguously related to everyday reality. The references to historical personages, to local and national custom, to the singing of litanies and liturgical practices, to processions and pilgrimages, to history and events, and the witty asides spicing the narratives, besides the commonly shared tenets of Christian belief, all contribute to create on the audience's part an awareness of the continuum of this world and the next.

To what extent there may be a continuity of the intellectual, spiritual, and emotional aspects of the national life from the Middle Ages through

19. Theodor Wolpers, *Die englische Heiligenlegende des Mittelalters* (Tübingen, 1964). Wolpers examines five legends of the *SEL* in detail. The above is a loose paraphrase of statements on pp. 246 and 250.

the Reformation is difficult to assess but worth pondering.[20] Most historians see the reign of King Henry VII and the establishment of the Tudor dynasty—the sixteenth-century English historians' creation of the Tudor myth with Henry as God's providential instrument notwithstanding—as the beginning of a new age, with 1485 as a convenient historical landmark and cut-off date. To me, it somehow seems significant, too, that Caxton's two great printing endeavors also signal an end to the Middle Ages with a last gathering up of two major medieval narrative traditions: Jacobus de Voragine's *Golden Legend* in 1483 and Malory's *Morte Darthur* in 1485. Poets and preachers have this at least in common: they sometimes voice the unconscious longings and actions of the people whose "uncreated conscience"—to use James Joyce's words—makes holy places in the land we inhabit by assigning mythic and sacred qualities to caves and wells, hills and landscapes, and by associating healing, restorative, and redeeming powers with individuals, be they kings or saints. Yet, even momentous changes in the political, social, and religious structure of England in Tudor times did not in essence change such a basic outlook. The lessons to be derived from the stories of the saints, the demonstration *ad oculos* of certain Christian virtues and ultimate trust in God's saving grace seem to have been enacted in particularly remarkable behavior during the political and religious persecutions of the sixteenth and seventeenth centuries when thousands of men and women died in ways reminiscent of the earlier Christian saints and martyrs. John Foxe's *Actes and Monuments,* also known as the *Book of Martyrs,* is the most outstanding witness to that, as well as to how an earlier hagiographic, if not historiographic, tradition is put to effective use in the service of religio-political convictions. Even a cursory comparison of the *SEL*'s "Banna sanctorum" prologue with Foxe's prefatory materials entitled "The Utility of the Story" makes this abundantly clear.[21]

The narratives of the *SEL* depict basic human endeavors and experiences in coming to grips with the physical and spiritual aspects of life; they appeal to the imagination, both popular and learned, to

20. For suggestions on the topic of continuity, see my "Entertainment"; "Public Executions in England in the Late Middle Ages," *Omega: Journal of Death and Dying* 10, no. 1 (1979): 43–57; and "From Lion to Lamb: Exemplary Deaths in Chronicles of the Middle English Period," *Omega* 13, no. 3 (1981–82): 209–26.

21. The fourth edition of this work (London, 1583) is a huge volume of over 1,800 printed folio pages. For more information on this question, see my "Entertainment," pp. 710 and 716.

envisage what the Christian is called upon to do in the here and now. In so doing, the *SEL* can take its place as a quasi-historical document beside the Middle English romances, medieval drama, and Latin and vernacular chronicles of the thirteenth to the fifteenth century, because it views, as they do, humankind in the categories of hero, sinner, and saint. It is perhaps this that Horstmann sensed when he acknowledged an indebtedness to the past in the legendary. Similarly, the modern reader may also sense the inexhaustibility of the past and its value for our understanding when studying these legends.

THE LANGUAGE OF

RELIGIOUS DISCOURSE

From the Oral to the Written in Medieval and Renaissance Saints' Lives

Hagiography is a fusion of oral and written traditions, oral and written mentalities.[1] Hagiography is oral in three senses. First, in its deeply rhetorical, or oratorical, character; it is invariably a discourse of praise and persuasion and often one of proof. Second, it is oral in its narrative reliance on anecdotal material; its patterns of amplification and transmission are commonly almost identical to those of the folktale. And, third, it is oral—or, if you will, profoundly vocal and personal— in its emphasis on prayer; it is often set in a context of communal prayer. Hagiography is also strongly rooted in the written: in its claim to historical status; in its relation to the liturgy, which is written, and as such, authoritative[2] and in its function as sacred book, with icon status. Hagiography has, then, a tradition that is, to borrow Marshall McLuhan's terms, fundamentally both "warm" and "cool": it is warm in that it is personal and immediate; cool in that it is anchored in a permanent, and impersonal, written text.

Hagiographical works vary considerably, however, in the degree and in the nature of their adherence to oral and written traditions. With

I thank several friends and colleagues for their valuable reactions to earlier drafts of this essay: Renate Blumenfeld-Kosinski, André Vauchez, Nancy Regalado, Laurie Postlewate, and Michel Beaujour; I also thank the Cornell University Press readers, who made useful recommendations. This research was supported bt the NEH.

1. For a fuller elaboration of this basic thesis, see Evelyn Birge Vitz, "Vie, légende, littérature: Traditions orales et écrites dans les histoires des saints," *Poétique* 72 (1987): 387–402.

2. I am speaking here of Western tradition; the situation in Eastern Orthodoxy was more complicated, as the liturgy was not reliably a written text.

respect to its mode of reception, both Latin and vernacular hagiography moved markedly, over the course of the later medieval period, from a heavily *oral/aural* mode to a predominantly *written* one.[3] This shift culminated in "humanist" or "scientific" hagiography. Launched in the Renaissance, this sort of hagiography is still in many respects the dominant one today. The shift is from works composed to be read aloud or otherwise performed, to works that are read or consulted privately—and, increasingly, silently.[4] Thus, for example, hagiography moves from a liturgical framework, in which the rhetoric of personal appeal is strong, to the compilation of saints' lives intended for private perusal and consultation, from which such an appeal is largely absent.

Hagiography also moves from a storytelling mode, in which entertainment and charm and the ability to appeal to the emotions rank high, to a historiographic model, where historical accuracy outweighs other considerations. There is indeed a shift from hagio*graphy* (works about the saints) to hagio*logy* (works about works about the saints, i.e., the editing and evaluating of lives of the saints).[5] While this great and complex shift has involved many generally appreciated gains, it entailed some rather underrecognized losses as well, in view of the basic nature and functions of hagiography.

My central focus here will be on the *Legenda aurea,* or *Golden Legend,* of Jacobus de Voragine, not merely because of its immense success and influence, but also because it is, in many respects, a watershed: a major work of transition between oral and written dominance. But *The Golden Legend* can also serve to illuminate large questions of oral and written tradition in a general medieval and Renaissance context.

With respect to oral and written issues, there are many obvious differences between medieval hagiography composed in Latin and that composed in the vernacular. The differences between French vernacular literature, which emerged in the eleventh and twelfth centuries, and the Latin hagiography can be taken as paradigmatic. Latin works were commonly written by religious or clerics primarily for purposes of inspiration. Such works were generally performed—read aloud from

3. My essential focus here is not on the mode of composition or of transmission but on the way in which works are received, perceived, by the public.

4. See Paul Saenger, "Silent Reading: Its Impact on Late Medieval Script and Society," *Viator* 13 (1982): 367–414.

5. Though even in the term "hagiography" there is a bias toward the written: "-graphy."

a lectionary, occasionally sung—in a sedate fashion in a liturgical or semiliturgical setting: in the Mass itself; more commonly, in the Liturgy of the Hours (matins especially); or in the refectory or chapter. By contrast, vernacular works were generally composed for nonreligious, nonliterates, and commonly performed by jongleurs. The requirement that a story about a saint be entertaining—that it be a "good story"— is markedly greater for vernacular works than for those in Latin, though in fact many Latin works are quite entertaining and were surely intended at least in part as an innocent, interesting, and pleasurable way to fill leisure time. (The very fact that this was largely refectory reading rather suggests this.)[6] But laymen are not a captive audience like monks and nuns, and if they do not appreciate the way a story is told, or what is told, they may well just walk away, or fail to pay the performer. Thus, while Latin sources are sometimes a bit dry or undramatic, vernacular compositions reliably liven up the story: they give the characters names, provide dramatic details and vivid dialogue, and so on.[7]

Formally and stylistically speaking, there are differences as well. Whereas the Latin works are generally set in cool past tenses, the vernacular compositions are recounted largely in the present: listeners are made to feel that they are *there,* and that the saint is—still—*present.* While Latin works are composed either in prose or in verse, no early saint's life is done in prose. All are set in verse forms of one kind or another, indicating clearly the connection between such works and older oral/voiced traditions (including that of hymn singing).[8]

The character of the inspiration intended is generally rather different: while both Latin and vernacular works are clearly meant to move the listener, the former can rely on the fact that the religious to whom they are addressed have already devoted their lives to God and need only be reminded of their calling; the tone of the Latin hagiographical work is rarely impassioned—though it *is* set in a broader liturgical or semiliturgical context of prayer and supplication. By contrast, vernacular compositions, which cannot rely on any such religious motivation,

6. The ninth-century Latin *Life of Brendan* is an obvious example; it has been translated in *The Age of Bede* (Harmondsworth).

7. They also add motifs that have been successful in other stories—whether any written ("historical") sources contain these bits of information or not. But one finds this in Latin works as well—which merely shows that the desire to entertain is not reliably absent from monastic works.

8. On oral and written traditions in early French literature, see Evelyn Birge Vitz, "Rethinking Old French Literature: Orality, Literacy, and the Octosyllabic Rhymed Couplet," *Romanic Review* 77 (1986): 307–21.

must—and do—deploy a very different sort of rhetoric in their attempt to stimulate and encourage worldly listeners to turn to God.

Many a vernacular saint's life is said to be a "translation from the Latin." But in some cases it would be more accurate to speak of such works as "re-oralizations" than as "translations" of the Latin. Thus, the Latin prose has invariably been turned into rhyme, the past tenses are generally recast into the present, unnamed characters have been named, emphases have been shifted, and so on. And the audience is now generally addressed, personally, as "you"—and an "I" speaks.[9]

Some early vernacular works were certainly composed by a clerical narrator working from a Latin text. But we have, in my view, been far too credulous, far too ready to believe that medieval narrators all actually read the Latin text on which they said they based their work. The fact that someone had "a Latin source" does not mean that he himself could read (Latin in particular). It may very well be that he had the story read to him, or just that he heard it read, in church perhaps; or again, perhaps someone told him the story. This hypothesis of the illiterate narrator may account for the extreme looseness that we sometimes find in so-called "translations" of saints' lives composed by nonclerical jongleurs like Rutebeuf. (By "looseness" I mean the lack of faithfulness to or close reliance on the alleged Latin source.)

The relation between Latin and vernacular hagiography is indeed one of "translation"—but in the medieval as much as in the modern sense of this word. Just as the bodies of saints were "translated," transferred, from one place to another, making the healing power of the saint available to a new audience, so were the lives of the saints "translated," carried by narrators to a new tongue, a new audience, with a new set of needs and expectations. But the translator of the life and miracles of the saints, like the translator of the relics, need not have been "literate"; nor did he have to be a clerk. The "oraliser" of the

9. Such shifts can be found, to varying degrees and in varying fashions, in almost all the early French lives, such as *La vie de Saint Alexis, La vie de Saint Brendan* (by Benedeit), *La vie de Sainte Marguerite* (by Wace)—and are still to be found, as we will see, in the lives done by Nicholas Bozon early in the fourteenth century. For example, a ninth-century Latin text of the Brendan story, intended for a monkish audience, was redone early in the twelfth century for an Anglo-Norman court public. The story was changed in a good many ways, so that it could speak to this new audience. Issues of purely monastic interest were eliminated, the relevance of Brendan to a general Christian public was brought out, and so on. The narrator—"Benedeit," apparently a papal legate—is rather reserved about using the first- and second-person pronouns: he does little overt preaching, preferring (it would appear) to allow Brendan to speak—and preach and teach—himself.

Latin written material could have been a nonliterate, such as a jongleur, or some other sort of nonliterate, nonclerical poet-performer, working essentially within oral tradition but wishing to associate himself with the prestige of the written by referring to his Latin source. Or it could have been a literate figure (such as a cleric or monk, or a nun) grafting himself or herself, as it were, onto vernacular oral traditions because of the power of the latter to move and inspire.

There are, then, a good many (and hardly surprising) differences between the two traditions, not the least of which, from our point of view, is the fact that the Latin tradition of performance is strongly anchored to a written text, whereas the vernacular is not: Latin works were intended to be read aloud, while vernacular compositions were often performed from memory. If the former are text-fixed, the latter are text-free, or text-liberated.[10]

But whatever the differences between them, the two traditions (the Latin and the vernacular) do have one absolutely fundamental feature in common: both were designed to be voiced by some sort of "performer"; to be performed aloud, perceived—received—aurally. Both are set in contexts—whether the liturgy or a jongleur's song in the town square—in which the listener is spoken to directly and vividly. Whatever the differences in their relation to "oral tradition," whatever their relation to writing, they share a common "aurality" in that they are *heard*.

The Golden Legend, composed about 1260, provides in many respects of course a continuation of older Latin traditions.[11] Written in Latin

10. Even if read privately, they were not read silently but were voiced. See Saenger, "Silent Reading."

11. It may be useful to point out here, as I begin my discussion of *The Golden Legend,* both the differences and the points of agreement between my approach and that of Alain Boureau in his valuable *La légende dorée: Le système narratif de Jacques de Voragine (+ 1298)* (Paris, 1984). Boureau argues that Jacobus intended his *Golden Legend* to serve as a preaching manual, and that in it dogmatic and ideological concerns triumphed over storytelling. I too believe that Jacobus largely abandoned the art of storytelling, and I agree that his stories are heavily freighted with ideological and dogmatic concerns. But whereas Boureau emphasizes Jacobus's (apparent) *intention*—that his work should serve as a reference manual for Dominicans and others to use in their preaching—what interests me is the work as it *stands,* and as it *functioned*: it is a chilly, dry work (Boureau refers to it by this latter term repeatedly: e.g., "la plume sèche de notre auteur," p. 28); and it was used—as Boureau himself points out on pp. 24–25—largely for private reading. Boureau's emphasis is, then, on what Jacobus intended; mine, on what Jacobus did in fact write and on how it was in fact used.

Some differences in emphasis result from the fact that Boureau systematically avoids

prose by a religious (a Dominican, later to become a bishop) it is, like the lectionary used in the Mass and the Hours, a compilation of saints' lives. Jacobus de Voragine's *Golden Legend,* however, is not a *lectionary* but, rather, what is called a *legendary*—and the difference between the two is worth elaboration.[12] A lectionary is a codex with a liturgical function: it is a book of official readings intended to be read aloud. By contrast, a legendary is a book of saints' lives (and only saints' lives), having *no* liturgical purpose: it would commonly be read privately or consulted.

Yet another important medieval term distinguishes between *The Golden Legend* (and its ilk—for it is not the only work of its kind; far from it) and the older hagiographic compilation: this term is *legenda nova.*[13] What is "new" here is not the saints—these are only rarely recent saints—but the text itself. That is, Jacobus has not merely compiled saints' lives; he has also, to some degree, rewritten earlier lives—though it is true that on the whole the lives that Jacobus transmits seem to retain the major features of his sources. At any rate there is here some effort at stylistic homogenization of—and at authorial mastery over—disparate material.

It is in many respects difficult to generalize about *The Golden Legend,* which is a vast work: 843 pages in the Graesse edition.[14] (It is also impossible to be sure which lives were actually written by Jacobus and which were added in later versions.) The nature of the accounts that it contains—like that of the saints themselves—varies considerably. Some stories contain highly dramatic and powerful scenes and a substantial proportion of dialogue, in direct discourse: one thinks of Saint Juliana, who carries on vivid converse with the demon who was sent to oppress her, beats him with the chains with which she is bound, and throws him in a latrine; or of James the Dismembered, who as his limbs are cut off, one by one, praises God:[15]

discussing the discursive and demonstrative dimensions of the work (p. 14), focusing instead on the narrative, whereas my concerns bear largely on hagiographical discourse, as broadly construed, and on its relation to hagiographical narrative. To put it a bit differently: Jacobus may very well have intended that his compilation be preached *from*—but what interests me is that as he wrote it, *The Golden Legend* does *not* preach; Jacobus does not preach *in* it. What he does is to tell stories about the saints in a dry, dogmatic, (semi)scholarly fashion.

12. See Guy Philippart, *Les légendiers latins et autres manuscrits hagiographiques,* Typologie des sources, fasc. 24–25 (Brepols, 1977), p. 23.

13. Philippart, *Les légendiers latins,* p. 24.

14. Theodore Graesse, *Jacobi a Voragine, Legenda aurea,* 3d ed. (Bratislava, 1890).

15. The translations here and below are based on those of Granger Ryan and Helmut

Then the torturers cut off the thumb of his right hand, and James cried out: "O Nazarene, Who has set us free, accept this branch of the tree of your mercy; for the husbandman cuts off the dried twigs of the vine, in order that it may flourish and bear fruit more abundantly." "If you will but yield," said the executioner, "I shall still spare you and bring remedies to your wound." "Have you never seen the stock of the vine?" answered James. "When the tendrils are cut away, and the earth grows warm, the knot that is left at each pruning brings forth new shoots. If the vine must be pruned with the recurring seasons, in order to bear fruit, how much more the man of faith, who is grafted upon Christ, the true Vine." Then the executioner cut off his second finger, and the blessed James said: "Accept, O Lord, the two branches which your right hand has planted." The third finger was cut off, and he said: "Now I am liberated from the threefold temptation, and I bless the Father and the Son and the Holy Ghost. With the three children who were rescued from the fiery furnace shall I confess unto you, O Lord, and with the choir of the martyrs I shall praise your name, O Christ." (Pp. 717–18; p. 800)

The description continues for several more pages, full of gore and eloquence. It all makes for very dramatic (also didactic) reading, as the narrative builds to its climax. There are a good many other tales of similar drama.

Another variant feature in the work—whether it is there intentionally or due to the variety of sources is unclear—relates to the pace. Many stories—indeed the majority—are short, ranging in length, in the Graesse edition, from one page or less to four pages, but some are longer and a few are quite long indeed: Saint Dominic receives sixteen pages; Francis of Assisi, twelve.[16]

While there are many dramatic and memorable accounts in *The Golden Legend,* others are anything but vivid, being totally devoid of dialogue or concrete details. A few are really very flat, included merely, one suspects, *par esprit de système,* for example: "The virgins Praxedes and Pudentiana were sisters of Saints Donatus and Timothy, who were

Ripperger, given in *The Golden Legend of Jacobus de Voragine* (London, 1941; repr. New York, 1969). I have, however, eliminated their paragraph divisions and exclamation points, which were not in their source, the Graesse text. I have also modernized their language somewhat, e.g., eliminating "thee's" and "thou's" and a few other archaisms. It should be noted that they have a tendency to dramatize the narrative and to cut out long discussions. After each quotation, I give the page number first to the Ryan and Ripperger translation, then to the Graesse Latin edition.

16. The life of Elizabeth of Hungary (the only recent female saint) is also long—nineteen pages—but this life was apparently not composed by Jacobus himself but added later. See Boureau, *La légende dorée,* pp. 28–29.

instructed in the faith by the apostles. In the midst of the persecutions they gave burial to the bodies of many Christians. They also distributed all their goods to the poor. And finally they fell asleep in the Lord, about the year 165, in the reign of the Emperors Marcus and Antonius II" (p. 354; p. 407). Some are not only flat but confused and confusing:

> The Four Crowned Martyrs were Severus, Severianus, Carpophorus, and Victorinus, who were beaten to death with leaded scourges by order of Diocletian. Their names were unknown at the time, and were not discovered until many years later, when the Lord revealed them. Consequently it was decreed that their memory should be honored under the names of five other martyrs, Claudius, Castorius, Symphorianus, Nicostratus, and Simplicius, who suffered death two years after the martyrdom of the first four. The latter five were skilled in the art of sculpture, and when they refused to carve an idol for Diocletian, or to offer sacrifice, he ordered them to be placed alive in leaden chests and thrown into the sea, about the year of the Lord 287. Pope Melchiades then decreed that the former four should be honored under the names of the latter five, and should be called the Four Crowned Martyrs. Hence, although at a later time their names came to light, the custom obtained of calling them by that common title. (P. 662; pp. 739–40)

Scholars build up a tolerance for this sort of account—though surely this story could have been told somewhat more clearly. Still, it is not a narrative that a truly committed storyteller (or preacher?) would even bother with.

Thus Jacobus's mode of narration varies quite a lot in *The Golden Legend*. But one important feature in which it does not vary is the impersonal way in which each story is introduced. Sometimes Jacobus leaps right into the story: "Margaret the virgin, who was also known as Pelagius, was most fair, rich and noble. She was guarded by her parents with zealous care, and taught to live virtuously; and so great were her probity and modesty that she refused to appear before the eyes of men" (p. 613; p. 676). Often he precedes his account with one of his famous (or infamous) etymologies, which are almost invariably of most dubious linguistic, but rather high mnemonic, value. Thus:

> Catherine comes from *catha*, total, and *ruina*, ruin; for the edifice of the Devil was wholly destroyed in her. The edifice of pride was destroyed by her humility, the edifice of carnal lust by her virginity, and the edifice of worldly greed by her contempt of worldly goods. Or Catherine is the same as *catenula*, a chain; for of her good works she fashioned a chain, whereby she climbed to Heaven. Such a chain or ladder has four degrees, which are innocence of life, cleanness of heart, contempt of vanity, and the speaking of the truth; and all these are stated by the

prophet, who says: "Who shall ascend into the mountain of the Lord?" and answers: "The innocent in hands, and clean of heart, who has not taken his soul in vain, nor sworn deceitfully to his neighbor." That these four degrees were present in Catherine, will be manifest from her legend. (Pp. 708–9; p. 789)

Catherine, like a good many other saints, is linked to a didactic message that is presented systematically, numerically: here, the four degrees of the chain. (Such a didactic—or catechetical—element was also present in the story of James the Dismembered, since as he lost limb after limb he rehearsed many of the basic teachings of the faith.) But at any rate, this presentation is completely impersonal: it speaks explicitly neither of an "I" nor a "you."

Jacobus's presentation is invariably impersonal—but this is not to say that he never uses the first-person singular or plural. When he does so, however, it is purely an editorial or scholarly "I" or "we," not a prayerful nor indeed an explicitly Christian one. For example, after giving the various names of John the Baptist, Jacobus goes on to refer to his sources: "The birth of Saint John the Baptist was announced by an archangel in the manner we shall now set forth. King David wished, as we read in the *Scholastic History,* to expand and embellish the divine worship. . . . We may point out in passing that, according to the *Gloss,* it is proper to the good angels to reassure by kindly words those whom their appearance frightens" (pp. 321–22; p. 357).

In some stories Jacobus comments, in an authorial—authoritative—manner, on his sources or on the story. Here, there is a certain tension, for Jacobus occasionally introduces into an account comments that put its truthfulness into question—and yet he goes right ahead and tells the story anyway, as though his remarks made no difference to the reader's reaction to the saint or his story. Here is how Jacobus closes his account of the Seven Sleepers: "The saints are said to have slept for three hundred and seventy-seven years; but this may be doubted, because they rose from the dead in the year 448, and Decius only reigned for one year and three months, namely in the year 252. Thus they slept for only one hundred and ninety-six years" (p. 386; p. 438). Still more striking, in his story of Saint Thomas the Apostle he recounts an episode in which the saint and a companion arrive in a town where a king's daughter is getting married, and they are obliged to attend the wedding. During the course of the feast a wine steward,

> seeing that the apostle neither ate nor drank, struck him on the cheek. And the apostle said to him: "It is better for you to be punished at once with a punishment which will be quickly over, and to be pardoned in

the life to come. Know then that before I leave this table, the hand that struck me will be borne hither by dogs." And indeed the wine-steward was on his way to draw water when a lion threw himself upon him and slew him; and the dogs tore his body to shreds, and one of them carried his right hand into the banquet hall. The guests were greatly frightened. But the Hebrew maiden [with whom the saint had been speaking earlier, and who had heard what the saint said to the wine steward] told them the words Saint Thomas had spoken, cast her flute on the ground, and threw herself at the apostle's feet.

But Jacobus goes on: "This act of vengeance is condemned by Saint Augustine in his book *Against Faustus*, and the story declared apocryphal; whence it is that many consider the legend as suspect" (p. 41; p. 33). (This discourse on Augustine and the authenticity of the story goes on for another page, eliminated in the Ryan and Ripperger translation.) Thus Jacobus tells this dramatic episode—presumably because it is a "good story"—and then blandly discredits it. If we can say that in Jacobus there is a contest between the storyteller, the scholar, and the preacher, the first two are often neck and neck—here the scholar pulls ahead—but the preacher invariably comes in last. By this I mean that Jacobus does not himself preach; I am not denying that he provided a vast warehouse of narrative and dogmatic source material for other, future preachers. (He also provided material for storytellers such as Chaucer.)[17]

In a few lives of saints, Jacobus briefly takes on the "I" of a narrator warmer and more prayerful than himself, such as Ambrose or Augustine.[18] Jacobus closes his account of Saint Euphemia with these words:

> Saint Euphemia was buried with honor in Chalcedon, where by her merits all the Jews and the pagans believed in Christ. She suffered about the year of the Lord 280. Of her Saint Ambrose says in his Preface: "The gentle and triumphant virgin Euphemia, guarding the mitre of virginity, merited to put on the crown of martyrdom. Let this sacred virgin, O Lord, commend your church to you; let her intercede for us sinners; and let her, a spotless virgin born, as it were, in your house, present to you our vows." (P. 553; p. 622)

But when Jacobus is speaking in his own voice—when the ink is flowing from his own pen—he never refers to "us sinners," "us Christians." He does not pray in his own voice in *The Golden Legend*. Need I say that my point is not that he was not a prayerful man, or a prayerful

17. One of Chaucer's sources for his story involving Saint Cecelia—the Nun's Tale— is *The Golden Legend*, which he apparently read in Latin.

18. See, for example, "A Virgin of Antioch," "Thomas the Apostle," "Saint Agnes," "Saint Vaast."

bishop, but merely that (for whatever reasons) he was not a prayerful narrator and compiler.

Be that as it may, there is a strange tension in *The Golden Legend* between the nature of the narrative material itself and the way in which this material is handled discursively by Voragine. On the one hand, we have many extraordinary stories, often with roots deep in traditions of oral narrative (including pious fiction), stories packed with highly dramatic and miraculous material, stories whose inner logic is to compel belief. But the stories are told in a fashion that tends to discourage readers from being moved to piety or even, some of the time, from believing what they read. The saints' often-eloquent invitations to sanctity are not echoed and reinforced in a direct personal fashion by the narrator. We would surely do Jacobus an injustice if we thought he did not intend his readers to be devoted to the saints—and he certainly gives stories in which figures who fail to honor the saints, or believe their miracles, are severely punished (despite Augustine's condemnation of the act of vengeance in the Thomas story). But he does not himself *preach* devotion to the saints, nor does he suggest that he has, or that his readers should have, any personal relationship with the saints—though Christians understand them to be alive in heaven. What is more, Jacobus invites his readers to adopt his own critical attitude toward traditional lives of the saints. The very fact that he sometimes questions the authenticity of the lives he recounts on chronological or theological grounds can hardly discourage his reader from doing the same, from joining Jacobus in this "deconstructive" project: like the author, the reader may not wish to be moved too readily by the accounts of the lives and miracles of saints, but may choose to enroll in a school of skepticism in their regard.

It was not long after its publication that *The Golden Legend* became widely read and consulted: the mass of late medieval manuscripts of this work is nothing less than enormous and is, as yet, poorly studied. *The Golden Legend* appears to have been read not only by clerics and religious but by some laymen as well (such as Chaucer) a fair sprinkling of whom now read Latin. The reasons for its popularity—in comparison with other more or less similar books—remain to this day somewhat mysterious.[19] At any rate, to its admirers (who were not

19. Sherry L. Reames, in her *The Legenda Aurea: A Reexamination of Its Paradoxical History* (Madison, Wis., 1985), has examined this issue carefully—and remains puzzled.

necessarily the most discerning or demanding readers of the period)[20] it may have represented the best of two worlds: it had the prestige of written tradition, especially Latin, and of prose historiography. And it had something more than a veneer of scholarliness, which appealed to an increasingly scholastic age: it had, one suspects, snob appeal. But it also had much of the old charm—the high drama, the vigor—of stories from the oral tradition. It was a "good read": exciting and entertaining, if not prayerful or even a reliable stimulus to devotion.

The Golden Legend—whatever its possibilities in the hands of other preachers, playwrights, and storytellers—was not, as it stood in Latin, real devotional reading: it lacked unction, it did not move to compunction. It was story—and history—with a certain pious cachet.

Whatever its appeal, something very important from the older tradition of both Latin and vernacular works is gone in *The Golden Legend*. What is gone is the warmth of the narrative treatment, a warmth that was concomitant with oral presentation, with the insertion of the narrative into the liturgy (or some other prayerful context), or its enactment in a living performance. Hagiography is increasingly written in books intended to be read privately, and consulted, leafed through, weighed with respect to their accuracy—rather than, as previously, composed in lives whose primary purpose was to seize the heart, mind, and will of a listener.

The coolness of Jacobus's Latin text was not infrequently palliated by its translators. Those who put the work (or parts of it) into their own vernacular often set it into verse and often added various sorts of narrative interventions, such as exhortations and prayers to enhance its personal appeal. For example, the early-fourteenth-century French writer Nicholas Bozon, in his loose translation of some of the lives from *The Golden Legend,* put the stories into the old octosyllabic rhymed couplet. Moreover, he prefaced his lives by lines such as the following, which precede his life of Saint Juliana:

> Now listen to a story,
> That is worthy of being remembered:
> It is short, joyful, simple, and beautiful,
> About Juliana, the virgin.

20. It seems not to have been appreciated by the Dominican Order: it is not listed in the late Middle Ages among great Dominican works. (See Reames, *The Legenda Aurea,* pp. 39–40.) Thus, it seems not to have been intended for, or to have satisfied, the highest ranks of *clergie,* but to have pleased a lower-order public.

And he concluded this 175-line poem with the lines:

> The saintly woman is beheaded
> And nobly passed to God.
> To pray for her would be wrong,
> A great outrage and strong error.
> But I pray to her, for the nobility [of soul]
> That God gave her in her youth
> [With which] to conquer the world and the devil,
> So that by her prayer we may be saved.
> Amen.[21]

In short, Bozon framed his story with a personal appeal both to the saint and to his listeners (or readers).

When in the fifteenth century Caxton translated *The Golden Legend* into prose, he, like Bozon, generally framed his narrative with prayerful reflection. He concludes in this way (and it is quite typical) his account of the life of Saint Catherine:

> All these things together were in this blessed virgin S. Katherine as it appeareth in her legend. Then let us devoutly worship this holy virgin and humbly pray her to be our advocatrice in all our needs bodily and ghostly, that by the merits of her prayers we may after this short and transitory life come unto the everlasting bliss and joy in heaven whereas is life perdurable. Quod ipse praestare dignetur qui cum patre et spiritu sancto vivit et regnat deus per omnia secula seculorum. Amen.[22]

Other translators, however, such as Jean de Vignay (in the fourteenth century), did remain close to the cool Latin model in their vernacular prose translations—and it may well be that the move to prose in vernacular hagiography, which in French occurred quite late in comparison with other "historical" genres, took place largely under the influence of *The Golden Legend*.[23]

By the end of the fifteenth century the immense popular success of

21. From *Seven More Poems by Nicholas Bozon,* by Sister M. Amelia Klenke (St. Bonaventure, N.Y., 1951), pp. 85, 90. The translation is mine but is informed by that provided by Sister Klenke.

22. *The Golden Legend, or Lives of the Saints, as Englished by William Caxton* (London, 1900), 7:30.

23. The Pierpont Morgan Library, New York, has a beautiful four-volume manuscript of the Vignay translation of *The Golden Legend;* it is no accident, I believe, that it was made for the chancellor of John the Good at the court of Burgundy—a court deeply involved in historiography throughout the later medieval period. The very fact that most prose vernacular lives are found in compilations (legendaries) rather than in works devoted to a single saint suggests that the models for such prose lives were themselves compilations.

The Golden Legend (there were more early printed texts of it than of the Bible) was beginning to sag.[24] By the mid-sixteenth century its popularity was essentially over. In the disfavor into which Jacobus's work fell in the sixteenth century it is hard to pry loose matters of theological substance from issues of orality and literacy. Not only was the cult of the saints under heavy assault across the board by the Protestant Reformers, but many Catholic Reformers as well showed little enthusiasm for it. And *The Golden Legend* excited a particular disgust among Catholic humanist scholars of an Erasmian stripe: it is Juan Luis Vives (1492–1540), a lifelong Catholic, who is famous for calling Voragine and his *Legend* not *aurea* but *ferrei oris, plumbei cordis:* "iron-mouthed and leaden-hearted." He said, "What could be more abominable [*foedius*] than this book? What a disgrace to us Christians that the preeminent deeds of our saints have not been more truly and accurately preserved, so that we might know or imitate such virtue, when the Greek and Roman authors have written with such care about their generals, philosphers and sages!"[25]

Vives's objections bore on several features of *The Golden Legend* (and other similar works). He considered it defective as historiography. It is interesting to note that it is *as* historiography that he judged it, for this would confirm one's impression that *The Golden Legend* was read largely as historical and not as devotional reading. Vives was disappointed that it did not truthfully tell the stories of the saints, for several reasons. Because of the unreliability of *The Golden Legend,* Vives said, the early history of Christianity remained largely unknown. Moreover, great examples of virtue were thereby lost. Vives, strongly opposed to war, considered that the saints would have made better models for emulation than did the great warriors and generals of antiquity, whom Plutarch and others proposed. Finally, the many errors that *The Golden Legend* contained—errors that had recently been pointed out and were gloated over by Reformers—took away "confidence in what was true."

Vives also considered the language of *The Golden Legend*—the quality both of its Latin and of its rhetorical style—to be highly deficient, far inferior to the elegant Ciceronian Latin appreciated and practiced by

24. See Reames, *The Legenda Aurea,* pp. 27–43; also see Robert F. Seybolt, "Fifteenth Century Editions of the *Legenda aurea,*" *Speculum* 21 (July, 1946): 327–38.

25. From *De causis corruptarum artium,* trans. Reames in *The Legenda Aurea,* p. 234 nn. 18, 19, and p. 52. This passage and a longer, rather similar but more detailed one are also translated in Foster Watson, *Vives on Education: A Translation of the De Tradendis Disciplinis of Juan Luis Vives* (Totawa, N.J., 1971), p. cxlviii; see also pp. 248–49.

the humanists. The language of *The Golden Legend* was, he said, "sordissimus," "spurcissimus."

There is a certain paradox in Vives's revulsion to *The Golden Legend*. On the one hand, I think we can safely say, borrowing Walter Ong's terminology, that he rejected it from the perspective of a period that had "deeply interiorized" private (and silent) reading and that had become acquainted with the great works of written history produced in antiquity. That is, to Vives *The Golden Legend* was textually inadequate: inadequate as text, inadequate as history. On the other hand, there is something curiously "oral" about Vives's objections to *The Golden Legend*. After all, he calls it iron-*mouthed*, and leaden-*hearted*—and oral tradition is nothing if not famous for its commitment to the mouth and for its ability to engage the heart. Moreover, part of Vives's complaint about Voragine's work is that it did not propose the saints as models of virtue: it was not, then, persuasive in its rhetoric. Does Vives wish to return to a more oral mode: in particular, an oral eloquence?

To some degree, yes. Vives, like other men of his generation, was deeply impressed with the eloquence of antiquity and was well aware that this eloquence was rooted in oral declamation. He certainly expected works of literature and history to sound attractive when read aloud. But *The Golden Legend* does not *sound* attractive; though it was massively used by late medieval playwrights, it is not, as written, suited to oral performance. Moreover, by Renaissance standards its old church Latin was totally unprepossessing.

But it is important to keep in mind one curious, and central, feature of Vives's involvement in something we could loosely call "orality." Vives seems to have had no use whatsoever for medieval, Catholic, oral traditions, only for those of classical antiquity—which (paradoxically) he knew only through books. Which means that he expected saints' lives to be able to do nothing less, but also nothing *more,* than what classical lives did: to be elegant, to be true, and to inspire virtue—but not to call for devotion or prayer to the saints. He would have wanted saints' lives to have rhetorical usefulness—but only in classical, and for that matter, pagan terms. It is as though he wanted to graft the branch of Catholic hagiography onto the tree of classical historiography. Pruning away the anecdotal and the personal oral elements of hagiography, he wished to retain from hagiography's oral dimensions only its rhetorical character, now enhanced and elaborated. Though Vives, like Erasmus, remained a Catholic, he seems to have

shared with his friend (and various other reformers) a lack of enthu-
siasm for the Catholic tradition of prayer to the saints: quite another
sort of orality! All Vives was prepared to retain was imitation of the
saints' holiness, or perhaps more accurately, of *saintly* holiness. He did
not propose as models only the canonized but included his mother
and (*mirabile dictu!*) his mother-in-law among the saints to be imi-
tated.[26] This admiration of heroic Christians was a feature of Catholic
tradition that Luther too was willing to accept. All in all, despite a
certain involvement in oral eloquence, Vives's implicit models for ha-
giography are firmly written and historiographical.

Vives's contribution to hagiography and hagiology is essentially neg-
ative: he attacked *The Golden Legend*. The early Renaissance period is,
however, the moment at which hagiology as a science arose. The great
contribution of the Renaissance—and in many respects the Renaissance
is still with us today—is surely less in the composition of *new* hagio-
graphic texts than in the production of, or at least the quest for, de-
finitive editions of ancient texts.[27] Indeed, might one not argue that
what humanist editors and compilers really wanted was to publish the
version to end all versions? To publish, for any saint, the *first*, the most
ancient, account (which would never be that of *The Golden Legend*)
and the *last* account: no further tampering with history, no more
"fabrications," no more rewriting, no new retellings. Their purpose
was (and has remained over the centuries) to find and publish not the
"best" account in the sense of the greatest or most effective *story*, but
the "best" in the sense of the oldest or most authentic written *document*.

At any rate, with this period come the great editors and scholars:
Bonino Mombritius (1424–82/1502?) and his successors in scientific
hagiology, such as Jacques Lefèvre d'Etaples (c. 1455–1536), Luigi
Lippomano (1500–59), Georg Witzel (1501–73), Melchor Cano
(1509–60), Laurentius Surius (1522–78), Cesare Baronio (1538–
1607), Heribert Rosweyde (1569–1629), John van Bolland (1596–
1665). These men began a tradition that lives on in our own century
in the work of figures such as Hippolyte Delehaye.[28] They sought out
early *acta*, texts that had (or claimed to have) unquestioned historical
authenticity. In these, on occasion, the saints still could be heard to
speak in their ancient trial records, often in language found all the

26. Watson, *Vives on Education*, p. ixxxiii.
27. Contemporary saints did of course have their lives written: for example, Teresa
of Avila, Ignatius of Loyola, and Thomas More.
28. René Aigrain, *L'hagiographie: Ses sources, ses méthodes, son histoire* (Paris, 1953).

more moving perhaps for its sobriety, as well as attractive to humanists because of its classical Latinity.

These figures were not storytellers or writers but scholars; they did not recount the lives of the saints but examined written documents and weighed evidence. The Bollandists have continued to carry out for centuries the function of these humanist scholars, to prune the hagiographical garden, rooting out spurious acts and pious romances.

The shifts that occurred in the progressive elimination, or marginalization, of orality in hagiography over the course of the later medieval centuries and in the Renaissance were generally positive, or at least neutral. In the move from oral performance to private reading, there were surely both losses and gains. What was lost in immediacy and interpersonal warmth was often gained in the development of a deeper, more reflective piety. (There is no question that silent saintly voices have sometimes spoken eloquently to the hearts of readers.) All scholars who work on the saints—and all Catholics and Orthodox—are, to be sure, deeply in debt to the generations of scholars, launched by the humanists, who have done so much painstaking research on the saints and their legends.

And yet, this great shift from voiced to read, from lectionary to legendary, from storytelling to text editing—from hagiography to hagiology—entailed real losses as well, losses that bear on the central purpose of hagiography in a Catholic and Orthodox perspective. The function of hagiography is not merely—perhaps even not *primarily*— to tell historically accurate things about particular historical figures but to move hearts to God. When and insofar as hagiographers became so involved in the historiographic and text-criticism side of their activity that they lost sight of this central purpose of hagiography, the victory over "pious romance" was an empty one indeed. Those old stories that jongleurs sang and monks read aloud were not completely true (some of them were not true at all). But they provided more than just entertainment and pleasure to a largely nonliterate, nonreading public: these stories *spoke* to people, inspiring many to a leap of faith, to a new life. The scholar's victory may itself be, however, somewhat illusory. Today Catholic and Orthodox bookstores are still filled with lives of the saints for children and for the simple faithful, books that many hagiologists no doubt despise. But these books—in which the stories of the saints are sometimes intended to be read aloud, and where they are often framed with prayers and inexpensive icons—continue to per-

form their centuries-old function of inspiration and pious enter-
tainment.

As the heirs to humanist hagiography, we as scholars need to come
to a deeper appreciation of the importance and the power of the oral
tradition, as broadly construed—of the voice, of all that is persuasive
and interpersonal—in the history of the lives of the saints.

Martyrdom and the Female Voice:
Saint Christine in the *Cité des dames*

The third and final part of Christine de Pizan's *Livre de la cité des dames* (1404–1405) is the culmination of the book's basic rhetorical and ideological strategy: an explicit and systematic defense of women against the standard charges of the misogynistic tradition, effected by adducing specific female examples of superlative achievement in virtually every area of human endeavor.[1] In part 1 of the *Cité des dames* the allegorical character Raison initiates this process with a series of female exempla—drawn largely from the classical world—in politics, law, war, and the arts and sciences. In part 2, the allegorical character Droitture (Rectitude) continues the process with an extensive list of women who were exemplary embodiments of moral virtue. In part 3, the allegorical character Justice completes the project by narrating the stories of women who are exemplary in the spiritual realm, that is, in terms of the highest Christian values. This group of spiritually superlative women begins and ends with figures who are directly linked to Christ and the Apostles: the Virgin Mary and Mary Magdalene (in chap. 2), and a set of eight exceptional "handmaidens" (in chap. 18). Within this frame, the primary focus of part 3 is on a group of female saints and holy women.

In this essay, I will concentrate on the saint who is—from a variety of interrelated perspectives—the central figure of this group: Saint

1. For the status of the *Cité des dames* as a *compilatio*, see the important article by Joël Blanchard, "Compilation et légitimation au XVe siècle," *Poétique* 74 (1988): 139–57.

Christine. For this saint functions as a privileged empowering model for the author of the *Cité des dames:* it is Saint Christine who authorizes the voice of Christine de Pizan as *auctor.*

In order to see how this construct works, it is first necessary to show how Pizan privileges the story of Saint Christine in several important structural ways. First of all, it occupies the central chapter in part 3 of the book: chapter 10 in a series of nineteen; it is thus preceded by nine chapters and followed by nine chapters. This is all the more striking in that part 3 as a whole is carefully constructed in terms of symmetrically paired chapters, which constitute a series of frames: most important, chapters 1 and 19 form a pair as prologue and epilogue, as do chapters 2 and 18, which both focus explicitly on New Testament figures. The structurally central position of the Saint Christine story also carries with it important generic implications. Medieval French narrative—beginning with twelfth-century romance—traditionally utilized the midpoint sequence to treat matters of naming, identity, and authority. The most famous example of this from Christine's perspective as a late medieval reader would have been, of course, the *Romance of the Rose.* At the approximate midpoint of the conjoined *Rose* text, the work's two authors are named for the first time, and the romance itself is renamed. As we shall see, the issue of naming—linked to that of authorial identity and authority—is of fundamental importance in Christine de Pizan's story of Saint Christine.[2]

In addition to its central position within the overall structure of part 3, this hagiographic narrative is itself framed in a particularly significant way. It is introduced by the only reference to be found in all of part

2. For the structural significance of the midpoint in medieval French literature, see Karl D. Uitti, "From *Clerc* to *Poète:* The Relevance of the *Romance of the Rose* to Machaut's World," in *Machaut's World: Science and Art in the Fourteenth Century,* ed. Madeleine Pelner Cosman and Bruce Chandler, *Annals of the New York Academy of Sciences* 314 (1978), pp. 212–14; and "*Le chevalier au lion (Yvain),*" in Douglas Kelly, ed., *The Romances of Chrétien de Troyes: A Symposium,* Edward C. Armstrong Monographs on Medieval Literature, 3 (Lexington, Ky., 1985), pp. 207–8, 223. For Christine as reader of the *Rose,* see Kevin Brownlee, "Discourses of the Self: Christine de Pizan and the *Roman de la Rose,*" *Romanic Review* 79 (1988): 199–221. For authorial naming in the *Rose,* see Kevin Brownlee, "Jean de Meun and the Limits of Romance: Genius as Rewriter of Guillaume de Lorris," in *Romance: Generic Transformation from Chrétien de Troyes to Cervantes,* ed. Kevin Brownlee and Marina Scordilis Brownlee (Hanover, N.H., 1985), pp. 114–34. For an excellent reading of the Saint Christine story in the *Cité des dames* that complements the present article in a number of important ways, see Maureen Quilligan, "Allegory and the Textual Body: Female Authority in Christine de Pizan's *Livre de la Cité des Dames,*" *Romanic Review* 79 (1988): 222–48.

3 to the authoritative written source for the *Cité des dames*'s stories of holy women. Following her narration of the story of Saint Dorothy at the end of chapter 9, Justice says to Christine the character:

> Se de toutes les saintes vierges qui sont ou ciel par constance de martire te vouloye racompter, longue hystoire y couvendroit... Et se plus en veulx avoir, ne t'estuet que regarder ou *Mirouer historial:* la assez en trouveras. Sy te diray encores de sainte Christine; et pource qu'elle est ta marraine et moult est vierge de grant dignité, plus a plain t'en diray de la vie, qui moult est belle et devotte. (P. 1000)

> [If you want me to tell you about all the holy virgins who are in Heaven because of their constancy during martyrdom, it would require a long history.... If you want more examples, you need only look at the *Mirouer historial,* and there you will find a great many. However, I will tell you about Saint Christine, both because she is your patron and because she is a virgin of great dignity. Let me tell you at greater length about her beautiful and pious life. (P. 234)][3]

The Latin *auctor* here invoked is Vincent de Beauvais. His *Speculum historiale* (cited—and most likely consulted—by Christine in the French translation of Jean de Vignay) contains all the stories that appear in part 3 of the *Cité des dames,* for which it thus serves as the primary source.[4] The fact that Vincent's book is explicitly named only in the context of the story of Saint Christine gives that story a privileged link to written authority. At the same time, Christine's departures from her source in this context take on an enhanced significance.[5]

3. Quotations are from Maureen Curnow, ed., "The 'Livre de la Cité des Dames' of Christine de Pisan: A Critical Edition" (Ph.D. diss., Vanderbilt University, 1975); translations (selectively emended) are from Earl Jeffrey Richards, *"The Book of the City of Ladies": Christine de Pizan* (New York, 1982). Page numbers from Curnow precede those from the translation in text citations.

4. See Curnow, "The 'Livre de la Cité des Dames,' " pp. 189–93, for a discussion of the relative importance for part 3 of Jean de Vignay's French translation as compared with Vincent de Beauvais's Latin original, as well as of the minor role played by the *Legenda aurea* as source for Christine's hagiographic narratives (either in Jacobus de Voragine's Latin original or in Jean de Vignay's French translation). For the source of the *Cité des dames*'s story of Saint Christine in particular, see Curnow, "The 'Livre de la Cité des Dames,' " p. 1122.

5. Quilligan, "Allegory," argues that by naming Vincent de Beauvais "just before she tells the story of her own patron saint, Christine distinguishes her own authority from his" (p. 236), and sees a parallel with the strategy Christine uses vis-à-vis Boccaccio, whose *De claris mulieribus* is the major source for parts 1 and 2 (pp. 232–33). Richards, in his discussion of the significance of Christine's modifications of her Boccaccian source (pp. xxxv–xli), remarks that Christine's inclusion of Christian holy women in part 3 of the *Cité des dames* constitutes an implicit "correction" of the program laid out in *De*

The conclusion of Saint Christine's story is framed by a particularly important intervention by the voice of Christine de Pizan speaking as vernacular *auctor,* the author of the *Livre de la cité des dames.* This is the only time that Christine-author speaks in her own voice during the entire narrative sequence of part 3. The only other time this authorial voice appears is in the final chapter, which serves as epilogue both to part 3 and to the book as a whole.

Having identified—albeit in a somewhat cursory fashion—the various structural features that serve to privilege the exemplum of Saint Christine, let us now turn to a consideration of the narrative itself.

The story of Saint Christine in the *Cité des dames* is divided into three parts, each centering on one of the saint's three persecutors. The first of these is her father, Urban. The religious confrontation between this Christian virgin and her pagan father begins when she is twelve and involves an elaborate displacement of her fleshly by her spiritual identity.[6] At the same time, there is the proleptic establishment of what will emerge as the key feature of her martyrdom: her voice, both physical and spiritual. In her first passage of direct discourse in the story—that is, the first moment at which we hear her voice directly— she rejects her father's attempt to kiss her. This attempt results from her father's pagan misunderstanding of Christine's declaration that she will gladly worship "Dieu du ciel [God in heaven]"; her father is delighted because he thinks—incorrectly, of course—that she means Jupiter. When he attempts a physical demonstration of his approval, Christine stops him, saying: " 'Ne touches a ma bouche, car je vueil offrir offrande nette a Dieu celestre' ['Do not touch my mouth, for I wish to offer a pure offering to the celestial God']" (p. 1002; p. 235). A program is thus initiated: As we shall see, Christine's desire will be fulfilled both literally and spiritually in the final episode of her biog-

claris mulieribus, where Christian exempla were explicitly excluded. Quilligan refers to the *Cité des dames*'s "martyrology" in part 3 as Christine's "greatest resistance to her *auctor* Boccaccio" (p. 232). For an important recent treatment of the *Cité des dames*'s rewritings of *De claris mulieribus,* see Patricia A. Phillippy, "Establishing Authority: Boccaccio's *De Claris Mulieribus* and Christine de Pizan's *Le Livre de la Cité des Dames,*" *Romanic Review* 77 (1986): 167–93. The first modern consideration of this question— in almost exclusively quantitative terms—is Alfred Jeanroy, "Boccace et Christine de Pisan: Le *De claris mulieribus,* principale source du *Livre de la cité des dames,*" *Romania* 48 (1922): 93–105.

6. For the significance of virginity as a component in the depiction of female heroism in the *Cité des dames,* see Christine Reno, "Virginity as an Ideal in Christine de Pizan's *Cité des Dames,*" in *Ideals for Women in the Works of Christine de Pizan,* ed. Diane Bornstein (Detroit, 1981), pp. 69–90.

raphy. Her mouth, tongue, and voice will indeed be her ultimate offering to God.

When Urban is unable to move his daughter by words, he resorts to torture in an attempt to make her worship his idols, claiming that his pagan religious devotion takes precedence over his fleshly link to his daughter, although this fact causes him to suffer. In her response (her second direct discourse in the narrative), Christine both renounces her earthly father in favor of her heavenly one and affirms the precedence of her spiritual over her physical being:

> "Tirant, que je ne doy appeller pere, ains annemy de ma beneurté, tourmentes hardiement la char que tu as engendree, car ce puez tu bien faire; mais a l'esperit, cree de mon Pere qui est ou ciel, n'as tu povoir d'atouchier par nulle temptacion: car Jhesu Crist, mon sauveur, la garde."
> (P. 1003)

> ["Tyrant who should not be called my father but rather enemy of my happiness, you boldly torture the flesh which you engendered, for you can easily do this, but as for my soul created by my Father in Heaven, you have no power to touch it with the slightest temptation, for it is protected by my Savior, Jesus Christ." (Pp. 235–36)]

Christine's final confrontation with Urban involves a classic case of the inversion effected by Christian martyrdom: the persecutors' attempt to harm the saint physically is miraculously transformed into a demonstration of the saint's spiritual power.[7] When her earthly father attempts to kill her by drowning, her heavenly father enables her to perform a literal *imitatio Christi* by walking on water (cf. Matt. 14:25–26; Mark 6:48–49). Finally, this pagan perversion of natural paternity is correctively inverted as the very water intended to cause Christine's physical death enables her to be spiritually reborn through baptism:

> Mais ainsi comme on [la] tresbuschoit [en la mer] les anges la prisdrent et elle s'en alloit sur l'eaue avecques eulx. Adonc pria Christine a Jhesu Crist, levant les yeux au ciel, que il luy pleust qu'en celle eaue receust le saint sacrement de baptesme qu'elle desiroit moult a avoir. Et adonc descendi Jhesu Crist en propre personne a grant compagnie d'anges et la baptisa et nomma de son nom Christine. (Pp. 1004–1005)

> [But as she was being thrown... into the sea..., the angels took her, and she walked on the water with them. Then, raising her eyes to heaven,

7. See in this context, Brigitte Cazelles, *Le corps de sainteté* (Geneva, 1982), pp. 47–61, 74–75. See also André Vauchez, *La sainteté en Occident aux derniers siècles du moyen âge, d'après les procès de canonisation et les documents hagiographiques* (Rome, 1981).

> Christine prayed to Jesus Christ, that it please Him for her to receive in this water the holy sacrament of baptism which she greatly desired to have; whereupon Jesus Christ descended in His own person with a large company of angels and baptized her and named her Christine, from His own name. (P. 236)]

Of fundamental importance here is the direct and explicit onomastic link between Jesus Christ and Saint Christine. The saint's name duplicates, imitates, the name of the Savior, who had earlier been explicitly presented—in Saint Christine's third passage of direct discourse in Pizan's text—as her true father: " 'mon pere Jhesu Crist' [my Father, Jesus Christ']" (p. 1004; p. 236).[8] At the level of plot, this onomastic authorization is initiated by the figure of Christ himself: the saint's name is the sign of her election, which is implicitly presented as a kind of corrected, spiritual genealogy: in the spirit, she is the true daughter of the true father, who claims her at the moment of ultimate rejection by her earthly father. At the same time, the saint's baptismal name involves, of course, a simple morphological regendering, a marking for the feminine, of the divine onomastic model.

The importance of this moment for Christine de Pizan's treatment of the Saint Christine story is underscored by the way in which Pizan carefully and consistently refrains from allowing the saint to be named at the level of plot until she receives her name directly from Christ. Before her baptism, she is called "fille" (daughter) in the only passage of direct discourse addressed to her (by Urban). After her baptism, she is publicly referred to repeatedly as "Christine" (by both Dyon and Julian). This strategy is all the more noticeable as such because of the contrast between the characters' practice and that of the narrator's voice in the *Cité des dames,* which refers to the saintly protagonist as "Christine" from the very first line of her story.

Finally, it is important to note in this context that the episode in which Christ explicitly bestows his name upon Saint Christine as part of the ceremony of her baptism does not take place in Vincent de

8. This explicitly paternal description of Christ by Saint Christine is not found in Vincent de Beauvais, where the saint simply refers to "Jesuschrist" (fol. lxxiii v°). Interestingly, in Vincent, the saint—rather than speaking of a blessed spiritual genealogy with Christ as father and herself as daughter, as she does in the *Cité des dames*—makes use of an infernal genealogy, as she concludes her defiant speech to her father by saying: 'Je vaincz toutes tes vertus avec le dyable ton pere' ['I defeat all of your powers derived from the devil, your father']" (fol. clxxiii v°).

Beauvais, where the saint's baptism is not linked to her name in any way:[9]

> Et sicomme Urben pourpensoit comment il la destruyroit il envoya par nuyct sept sergens et commanda une pierre estre lyee au col de celle et quelle fust ainsi gectee en la mer. Et sicomme len la trebuschoit les anges la receurent et elle sen alla sus leaue avec les anges. Et icelle levante ses yeulx au ciel deprioit nostre seigneur Jesuchrist que ces eaues luy fussent signacle de baptesme. Et une voix vint du ciel disante que nostre seigneur avoit ouye son oraison. Et une nue clere vint sus son chief et veit la gloire Jesuchrist venante sus soy et une couronne et une estolle de pourpre dessus son chief et les anges estoient devant elle a grant odeur et souefve doignemens et chantoient louenges. (Fol. cIxxiii v°)

> [And after Urban considered how to destroy her, he sent for seven sergeants at night and ordered them to tie a stone around her neck and throw her into the sea. And when they had dropped her, the angels received her and she walked upon the water with the angels. And raising her eyes to heaven, she prayed our lord Jesus Christ that this water be a sign of her baptism. And a voice from heaven said that our lord had heard her prayer. And a bright cloud came over her head, and she saw the glory of Jesus Christ coming upon her, and a crown and a purple stole upon her head, and the angels were before her exhaling a marvelous, sweet odor and singing praises.]

In Vincent de Beauvais's story, Saint Christine does not receive her name as part of the plot—that is, as part of her martyrdom—but rather seems to have possessed it from birth, that is, from a moment of origin antedating the narrative. This is clear from the sequence in Vincent in which the saint's name is first mentioned at the level of plot. In this passage, the saint responds to her mother's attempt to use the natural filial bond between them in order to make her daughter abandon God:

> "Comment me appelles tu fille Comme tu nas eu en tout ton lignage nulle qui soit appellee chrestienne. Ne sces tu pas que ie ay le nom de Christ mon saulveur. Cest celluy qui ma esprouvee a celestielle chevalerie et ma armee a vaincre celuy qui ne le congnoissent." (Fol. clxxiii v°)

9. Indeed, as Quilligan suggestively points out, Vincent's narrative does not even present the saint's baptism as a "literal event," for her prayer has been only that the water serve as a "signacle de baptesme" for her ("Allegory," pp. 237–38). The following and all other quotations of Vincent de Beauvais are from *Le second volume de Vincent miroir hystorial*, translated into French by Jean de Vignay (Paris, 1531); the translations are mine.

["How can you call me daughter when there is no woman in your whole family who can be called a Christian? Don't you know that I have the name of Christ my saviour? It is he who has tested me in celestial chivalry, and armed me in order to vanquish those who do not recognize him."]

In her reworking of Vincent de Beauvais, Christine de Pizan has suppressed this entire passage along with the episode of which it is a part: the confrontation between the saint and her mother. As Maureen Quilligan has suggestively demonstrated, Pizan rewrites her source's treatment of the saint's (spiritually inadequate and definitively rejected) natural genealogy in a way that exclusively privileges the paternal.[10] Both the narrative logic and the "ideological" intent of Christine de Pizan's Saint Christine story in the *Cité des dames* require that the saint's name be given by her spiritual father as the sign of his definitive displacement of her natural father, and of the primacy of Christine's spiritual rebirth through baptism over her fleshly birth and filial identity. All these factors serve to emphasize the central importance of the onomastic link between Jesus Christ and Saint Christine, and its status as a sign of the saint's divine election and authorization.

During the night that follows the safe return of the newly baptized Christine to dry land in the *Cité des dames,* her father is tortured to death by the devil, in a kind of infernal parody of martyrdom, which is simultaneously a "deadly" literalization of Urban's negative spiritual paternity. His place is immediately taken by a second persecutor: the judge Dyon, who subjects Christine to a series of ineffective tortures in a vain attempt to force her to do his will. Finally, Dyon leads her before the idol of Jupiter in the temple, where, instead of worshiping the pagan god, Christine performs a miraculous speech act: she exorcizes the devil from the idol. Again, the emphasis is on the power of the saint's voice: her words function as deeds. When—in her fifth passage of direct discourse in the story—she says: " 'Je te commande, maling esperit que es en celle ydolle, ou nom de Jhesu Crist, que tu ysses hors' ['I command you in the name of Jesus Christ, oh evil spirit residing in this idol, to come out']" (p. 1006; p. 237), the effect is

10. See "Allegory," pp. 236–38, where Quilligan shows how Saint Christine's mother in Vincent de Beauvais is displaced by her father in Christine de Pizan's version. The implications of this suppression of a negative depiction of maternity in Christine's source for the overall feminist strategy of the *Cité des dames* are further developed in Quilligan's forthcoming book, *The Allegory of Female Authority: A Commentary on Christine de Pizan's "Livre de la Cité des Dames."* I am grateful to her for generously allowing me to consult it in manuscript form.

instantaneous: "Et tantost le dyable vint hors et fist grant et espovent-able tumulte [whereupon the Devil immediately came out and made a loud and frightening din]" (p. 1006; p. 237)." In terms of speech-act theory, the illocutionary act here performed by Saint Christine can be seen as a "directive" with the force of a "declaration."[12] The suppression of temporal distance between verbal cause and material effect both demonstrates and actualizes the close relationship between the saint and her empowering divine model. The onomastic link here figures the spiritual link of authorization, for Christine as speaking subject is underwritten by Christ. Because of her divinely conferred baptismal name, she literally speaks "ou nom de Jhesu Crist."

In reaction to what the text explicitly calls Dyon's "blindness," Christine performs a second miraculous speech act: her prayer that God reduce the idol to dust is instantly accomplished.[13] The double result further elaborates the drama of understanding and recognition that is unfolding around the figure of the saint: those who correctly understand the "parolles et signes de la vierge [words and signs of this virgin]" (p. 1006; p. 238)—that is, those who interpret her according to the spirit, no less than three thousand anonymous male spectators—are converted, and thus attain everlasting life; Dyon, who interprets her according to the letter, goes mad and dies.

Saint Christine's third and final persecutor is a judge named Julian, who vainly attempts first to move and then to silence her. In this sequence, a simple but powerful hermeneutic construct is employed, in which the literal consistently figures the spiritual. Thus when Julian initially boasts that he will move Christine's spirit by forcing her to worship his idols, he is literally unable to make even her body move: "mais pour toute la force que il y peust mettre, il ne la pot faire remouvoir du lieu ou elle estoit [in spite of all the force he could apply, he was unable physically to move her from the spot where she was standing]" (p. 1007; p. 238). The fire that he has built around her immobile body simply emphasizes the power of her voice, which is

11. This seems in part to recall Christ casting out demons (from possessed people rather than from idols) in the Gospels. See, e.g., Matt. 9:32–33; Luke 4:33–36.

12. See John Searle, "A Classification of Illocutionary Acts," *Language in Society* 5 (1973): 1–23; Elizabeth Closs Traugott and Mary Louise Pratt, *Linguistics for Students of Literature* (New York, 1980), pp. 229–31.

13. Dyon's stubbornly pagan misunderstanding of the miracle provokes Christine's anger: "le reprist durement de ce qu'il estoit tant *aveuglez* qu'il ne congnoissoit la vertu divine [she reproached him harshly for being too *blind* to recognize divine virtue]" (p. 1006; p. 238; my emphasis).

heard singing "doulces melodies" (sweet melodies) for as long as the fire burns.

Julian next tries to torture Christine with poisonous snakes, which he has set upon her. The first four snakes (two asps [*aspis*] and two adders [*couleuvres*]) "se laissierent cheoir a ses pies, les testes enclinés, sans luy mal faire [dropped down at her feet, their heads bowed, and did not harm her at all]." The final two snakes (a pair of vipers [*gievres*]) "se pendirent a ses mamelles et la lechoyent [hung from her breasts and licked her]" (p. 1007; p. 238). This sequence involves, of course, a corrective—literal—rewriting of the spiritual drama of Eve in Genesis 3: these snakes cannot physically harm Saint Christine as their serpentine protoancestor spiritually harmed her maternal protoancestor. The episode closes as the female saint performs yet another miraculous imitation of her divine namesake, bringing Julian's snake tender back to life after his own snakes have killed him.[14] Julian's inability to understand is described as a figurative and spiritual blindness: he is "aveuglez du diable si que il n'appercevoit le mistere divine" [blinded by the Devil so that he was unable to perceive the divine mystery]" (p. 1008; p. 239). In her penultimate direct discourse, Christine reproaches her persecutor by means of this figure: " 'Se tes yeux veissent le[s] vertus de Dieu, tu les creusses' ['if your eyes would see the powers of God, you would believe in them']."

Having failed to effect any change in Christine's faith, Julian—in the final episode of the story—attempts to silence the saint: "Et pource que elle sans cesser nommoit le nom de Jhesu Crist, il luy fist coupper la langue; mais mieulx que devant et plus cler parloit adés des choses divines et beneyssoit Dieu, en le regraciant des benefices que il luy donnoit [And because she unceasingly pronounced the name of Jesus Christ, he had her tongue cut out, but then she spoke even better and more clearly than before of divine things and of the one blessed God, thanking Him for the bounties which He had given to her]" (p. 1008; p. 239). As if to confirm the power of Christine's spiritual voice, a voice from heaven (*une voix du ciel*) responds to the saint's request for martyrdom: " 'Christine, pure et nette, les cieux te sont ouvers, et le raigne sans fin t'est appareillié . . . car tu as des ton enffance soustenu le nom de ton Crist' ['Christine, pure and clean, the heavens are opened to you and the eternal kingdom waits, prepared for you . . . for you

14. Cf. Christ's raising of the dead in, e.g., Mark 5:35–42, Luke 7:12–16, and John 11:1–44 (the encounter with Lazarus).

have upheld—from childhood on—the name of your Christ']" (p. 1008; p. 239). This divine appellation involves, first of all, a fulfillment at the level of plot of Christine's initial intention—expressed, we remember, in her first passage of direct discourse in the story, addressed to her wicked earthly father—to offer her mouth to God. This offering is now accomplished at the literal level with the sacrifice of her tongue, which simultaneously figures the dedication of her physical voice to God and the triumphant primacy of her spiritual voice.[15] Not only is this offering explicitly accepted by God, but the saint's tongue functions metonymically to figure her entire person: she had offered her "bouche" as an "offrande nette a Dieu celestre" (p. 1002), and the offering God accepts is "Christine, pure et nette."

At the same time, the Christomimesis involved in her name is reaffirmed by the chiastic structure of the divine discourse: the first word uttered by the divine voice is "Christine," the last word is "Crist." This onomastic *imitatio Christi* is further emphasized by the phrase used to summarize Christine's saintly life: "tu as des ton enffance soustenu le nom de ton Crist." From the moment of her baptism, the saint's very name has both represented and confirmed her vocation.

In a second and final intervention, the divine voice reveals itself to be that of Christ: " 'Viens Christine, ma tres amee et tres elitte fille, et reçoy la palme et couronne pardurable et le guerdon de ta passionnable vie en la confession de mon nom' ['Come, Christine, my most

15. In this context, it is interesting to recall contrastively the significance of the sacrifice of the female tongue as an act of pagan or secular virtue. In part 2, chap. 53, Droitture recounts the example of the Greek woman Leonce (Leaena), whose constancy is demonstrated by the fact that, in order to protect her comrades, she "couppa sa langue a ses dens devant le juge adfin qu'il n'eust esperance que par force de tormens luy faist dire [bit off her own tongue with her teeth in front of the judge so that he would have no chance of making her talk using torture]" (p. 923; p. 184). Significantly, this exemplum of virtuous female self-silencing on the literal, physical level is followed by an important discussion of the metaphorical silence of female writers on the subject of female virtue, as Christine-protagonist asks: "Sy me merveil trop comment tant de vaillans dames qui ont esté et de si saiges et de si lettrees et qui le bel stille ont eu de dictier et faire biaux livres ont souffert si longuement sans contredire tant de horreurs estre tesmoingnees contre elles par divers hommes quant bien savoyent que a grant tort estoit [I am surprised that so many valiant ladies, who were both extremely wise and literate and who could compose and dictate their beautiful books in such a fair style, suffered so long without protesting against the horrors charged by different men when they knew that these men were greatly mistaken]" (p. 924; pp. 184–85). Droitture's answer to this question involves an investiture of the voice of Christine-author, whose literary-feminist mission in the *Cité des dames* is affirmed vis-à-vis her female predecessors: "ceste oeuvre a bastir estoit a toy reservé et non mie a elles [the composition of this work has been reserved for you, and not for them]" (p. 924; p. 185).

beloved and elect daughter, receive the palm and everlasting crown and the reward for your life spent suffering to confess My name']" (pp. 1008–1009; p. 239). A kind of summarizing reaffirmation of Saint Christine's authority and identity is at issue here. First, the onomastic chiasmus established in the preceding divine discourse is here repeated, but with a significant variation, which emphasizes the privileged speech situation obtaining between the saint and her divine namesake and interlocutor: an opening second-person singular imperative ("viens") introduces the name "Christine" in the vocative, while the passage closes with a first-person onomastic reference on behalf of the speaking Christ ("mon nom"). Second, the spiritual paternity linking saint and savior—which, we remember, had supplanted Urban's inadequate and noxious natural paternity—is here explicitly reiterated: Christ calls Christine his "tres amee et tres elitte *fille*" (my emphasis). In terms both of identity and authority, the saint's natural genealogy is displaced by a spiritual genealogical link with Christ, which guarantees and is simultaneously figured by its onomastic articulation.[16] At the same time, the power of Saint Christine's voice is repeatedly emphasized.

Julian, meanwhile, continues to misunderstand the nature of this voice. Because he interprets only according to the letter, he thinks he can silence the saint through physical means, though this has already been demonstrated to be impossible. Adducing a fleshly cause for the spiritual vocalization he uncomprehendingly witnesses, Julian simply repeats his initial mistake: "Et le faulx Julien, qui ceste voix ot ouye, blasma les bourriaulx et leur dist que ilz n'avoyent pas assez pres coup-pee la langue de Christine; si luy couppassent si pres que tant ne peust parler a son Crist. Si luy errachierent hors la langue et luy coupperent jusques au gavion [The treacherous Julian, who heard this voice, cas-tigated the executioners and said they had not cut Christine's tongue short enough and ordered them to cut it so short that she could not speak to her Christ, whereupon they ripped out her tongue and cut it off at the root]" (p. 1009; p. 239). What follows is a literal figuration of Julian's spiritual blindness, the culmination of the programmatic opposition between letter and spirit that has characterized Christine's

16. None of this is to be found in Vincent de Beauvais's model text, in which the heavenly voice does not—the second time it speaks—identify itself as that of Christ, and in which there is no mention of a spiritual father-daughter relationship: "Vien Christine recoy la couronne pardurable et le guerdon de ta confession [Come, Chris-tine, receive the everlasting crown and the reward for your profession of faith]" (fol. clxxiiii v°).

confrontation with her third persecutor. This is linked to the definitive confirmation of the power of Christine's spiritual voice, as the saint

> cracha le couppon de sa langue au visaige du tirant et luy en creva l'ueil. Et luy dist aussi sainement que oncques mais: "Tirant, que te vault avoir couppee ma langue adfin que elle ne beneysse Dieu, quant mon esperit a tousjours le beneystra et le tien demourera perpetuel en maleysson? Et pource que tu ne congnois ma parolle, c'est bien raison que ma langue t'ait aveuglé." (P. 1009)

> [spat this cut-off piece of her tongue into the tyrant's face, putting out one of his eyes. She then said to him, speaking as clearly as ever, "Tyrant, what does it profit you to have my tongue cut out so that it cannot bless God, when my soul will bless Him forever while yours languishes forever in eternal damnation? And because you do not understand my words, it is highly fitting that my tongue has blinded you." (Pp. 239–40)]

Once again, the product of Saint Christine's tongue is not "mere" words but deeds, in this ironically literal inscription of Julian's spiritual blindness.[17] At the same time, we see how the Christian construct of martyrdom provides an absolute guarantee for Saint Christine's voice. When a misguided male representative of secular institutional power cuts out this woman's tongue, he cannot silence her. Instead, she is empowered to speak with even greater authority.

It is in this context that I would like to suggest, in a somewhat speculative manner, that there is an important Ovidian subtext for the exemplum of Saint Christine in the *Cité des dames:* the story of Philomela from *Metamorphoses* 6.[18] In the Ovidian narrative, Tereus, king of Thrace, marries Procne, daughter of the king of Athens, but falls desperately in love with his new wife's sister, Philomela. After he shamefully rapes his resisting sister-in-law, she threatens to reveal the story of his crime, and Tereus cuts out her tongue in order to silence her:

17. For irony as the privileged trope of the "letter that kills," see John Freccero, "Infernal Irony: The Gates of Hell," *Modern Language Notes* 98 (1983): 769–86. For the figure of pagan "blindness" as a convention in the medieval French hagiographic tradition, see Phyllis Johnson and Brigitte Cazelles, *'Le Vain Siècle Guerpir': A Literary Approach to Sainthood through Old French Hagiography of the Twelfth Century* (Chapel Hill, N.C., 1979), pp. 111–37.

18. For an important modern feminist reading of Philomela as a parable about the silencing of women, see Patricia Klindienst Joplin, "The Voice of the Shuttle Is Ours," *Stanford Literature Review* 1 (1984): 25–53.

ille indignantem et nomen patris usque vocantem
luctantemque loqui conprensam forcipe linguam
abstulit ense fero; radix micat ultima linguae,
ipsa iacet terraeque tremens inmurmurat atrae,
utque salire solet mutilatae cauda colubrae,
palpitat et moriens dominae vestigia quaerit.

[But he seized her tongue with pincers, as it protested against the out-
rage, calling ever on the name of her father and struggling to speak, and
cut it off with his merciless blade. The mangled root quivers, while the
severed tongue lies palpitating on the dark earth, faintly murmuring;
and, as the severed tail of a mangled snake is wont to writhe, it twitches
convulsively, and with its last dying movement it seeks its mistress's
feet.][19]

In Ovid, the elaborately personified death of her severed tongue is a
miniature dramatization of the death of Philomela's voice.[20] In Chris-
tine de Pizan's exemplum, the removal of Saint Christine's tongue does
not, of course, succeed in silencing her voice.

19. Ovid, *Metamorphoses* 6.555–60. Quotations are from William S. Anderson,
ed., *Ovid's "Metamorphoses," Books 6–10* (Norman, Okla., 1972); translations are from
Frank Justus Miller, trans., *Ovid: Metamorphoses,* Loeb Classical Library (Cambridge,
Mass., 1977). For Christine's use of the *Metamorphoses* in the context of authorial self-
representation, see Kevin Brownlee, "Ovide et le Moi poétique 'moderne' à la fin du
moyen âge: Jean Froissart et Christine de Pizan," in *Modernité au moyen âge: Le défi
du passé, ed.* Charles Méla and Brigitte Cazelles (Geneva, 1990), pp. 153–73.

20. Curnow, "The 'Livre de la Cité des Dames," pp. 177–79, adduces convincing
evidence for Christine's use of the fourteenth-century French verse *Ovide moralisé* rather
than the Latin *Metamorphoses* as her primary source for several of the key Ovidian
exempla treated in the *Cité des Dames*. It is nonetheless useful to consider case by case
the relative importance of the French and the Latin Ovid in Christine's various re-
workings. Thus the *Ovide moralisé*'s rather restrained treatment of the crucial mutilation
episode from the Philomela story seems less relevant than does the Ovidian Latin model
to the *Cité des dames*'s Saint Christine: "Un canivet tranchant [Tereus] a pris, /
Et por ce que cele ne puisse / Conter a home qu'ele truisse / Ceste honte ne cest reproche, /
Dist que la langue de la boche / Li tranchera tot a un fes, / Si n'an sera parlé ja mes. /
Cui avient une n'avient sole: / La langue li tret de la gole, / S'an tranche pres de la
meitié. / Or a il mout mal espleité [In order to prevent her from telling anyone the
shame and the reproach that had befallen her, Terceus took a sharp knife and said that
he would cut her tongue out of her mouth with one blow, so that she would never
speak about it. Misfortunes never come singly; he pulled her tongue out of her throat
and cut off nearly half of it. This was his foul deed]" (*Ovide moralisé* 6.3062–72).
Quotations from the *Ovide moralisé* are taken from Cornelis de Boer, ed., *Ovide moralisé,
poème du commencement du quatorzième siècle,* 5 vols. (Amsterdam, 1915–38). For Chris-
tine's relative familiarity with the *Ovide moralisé* and the *Metamorphoses,* see Charity
Cannon Willard, *Christine de Pizan: Her Life and Works* (New York, 1984), pp. 92–
93; Suzanne Solente, ed., *Le livre de la mutacion de Fortune par Christine de Pisan* (Paris,
1959), 1:xxxi–xxxiv; P. G. C. Campbell, *L'épître d'Othéa: Étude sur les sources de Christine
de Pisan* (Paris, 1924), p. 110.

Several further textual parallels are worth noting in this context. First, there is the Ovidian simile comparing Philomela's severed tongue to the "mutilatae cauda *colubrae*" (line 559; my emphasis), after which the tongue is personified as "dying [*moriens*]" at its "mistress's feet [*dominae vestigia*]" (line 560). This elaborate and striking figure of Philomela's physical impotence suggests the real snakes (especially the "deux grosses *couleuvres*" [p. 1007; my emphasis]), who figure Saint Christine's spiritual power by dropping harmlessly "at her feet [*a ses pies*]" (p. 1007). Second, Philomela's ineffective cries to her genealogical father (in a strikingly "proto-Christian" phrase, she is seized "nomen patris usque vocantem" [line 555]) contrast suggestively with Saint Christine, who "sans cesser nommoit le nom de Jhesu Crist" (p. 1008).[21] In the case of the Athenian princess, her absent physical father is powerless to prevent his daughter's silencing. In the case of the Christian saint, her omnipresent spiritual father guarantees her voice against even the most damaging physical mutilation. Third, the same two-part anatomical division of the tongue is explicitly evoked in both cases, with dramatically contrary results. For Philomela, a single cut is sufficient: her physical voice is definitively silenced when her tongue ("linguam" [line 556]) is severed; the root ("radix" [line 557]) that remains cannot produce speech. Saint Christine, on the other hand, continues to speak effortlessly not only after her tongue ("langue") has been severed ("couppee") but even after it has been cut off at the root ("jusques au gavion" [p. 1009]).

In terms of the central common motif of the severed female tongue, the *Cité des dames*'s Saint Christine is a corrective Christine rewriting of the Ovidian Philomela. The hagiographic model operative in the *Cité des dames* enables the silenced woman to speak.

At the end of the Saint Christine exemplum, this process is taken one step further: the voice of Christine de Pizan speaking as author appears for the only time in the entire narrative sequence of part 3, praying to her patron saint:

> O! benoite Christine, vierge digne et beneuree de Dieu, tres elitte martire glorieuse, vueilles par la sainteté dont Dieux t'a faitte digne prier pour moy, pecharresce, nommee par ton nom, et me soyes propice et piteuse marraine. Si voir que je m'esjoys de avoir cause de enexer et mettre ta

21. It is interesting to note that the allegorical "exposicion" (6.3687) to the Philomela story in the *Ovide moralisé* glosses her father as "Diex, rois d'immortalité, / Tous poissans et rois pardurables [God, the immortal king, the omnipotent and everlasting king]" (6.3722–23).

sainte legende en mes escriptures, laquelle pour ta reverence ay recordee assez au long. Ce te soit aggreable, pries pour toutes femmes, auxquelles ta sainte vie, soit cause de bon exemple de bien finer leur vie. Amen. (Pp. 1009–10)

[O blessed Christine, worthy virgin favored of God, most elect and glorious martyr, in the holiness with which God has made you worthy, pray for me, a sinner, named with your name, and be my kind and merciful guardian. Behold my joy at being able to make use of your holy legend and to include it in my writings, which I have recorded here at such length out of reverence for you. May this be ever pleasing to you! Pray for all women, for whom your holy life may serve as an example for ending their lives well. Amen. (P. 240)]

In this prayer, Pizan the author imitates the speech act that had empowered her saintly namesake at the height of her martyrdom, at the same time as she explicitly—though "humbly"—affirms the onomastic link between them. This involves, in effect, a request that the authorizing link established in the narrative between Christ and Saint Christine be extended to include Christine de Pizan.[22] The miraculous voicing of the martyred female saint is thus presented as an empowering model for the voicing of the female writer. Further, this model is itself inscribed within the very book whose global composition it guarantees. The configuration is thus, in an important sense, self-authorizing: By means of articulating Saint Christine's story—about the spiritual empowerment of the female voice—the power of Christine de Pizan's authorial voice is simultaneously demonstrated and authorized.[23]

22. For Pizan's awareness and utilization of the "Christological" root of her first name see the "autobiographical" part 1 of Solente, *La mutacion de Fortune:* "Or vous diray quel est mon nom, / Qui le vouldra savoir ou non, / Combien qu'il soit pou renommé, / Mais, quant pour estre a droit nommé / Le nom du plus parfait homme, / Qui oncques fu, le mien nomme, / .I. .N. .E. faut avec mettre, / Plus n'y affiert autre lettre [Now I will tell you what my name is, whether you want to hear it or not, even though it is not very famous. For my correct name you must add .I. .N. .E. to the name of the most perfect man who ever was, and not a single other letter]" (lines 371–78). See also Jacqueline Cerquiglini, "Le pouvoir du nom," in the introduction to her edition of Christine de Pizan, *Cent ballades d'amant et de dame* (Paris, 1982), pp. 22–23; and Quilligan, "Allegory," p. 240.

23. In light of Christine's important evocations of Dante as a model (especially in the *Débat sur le "Roman de la Rose"* and the *Chemin de Long Estude*), it is interesting to contrast this authorizing female link (involving martyrdom and an onomastic relationship) in the *Cité des dames* with the *Divine Comedy*'s key male genealogical relationship, which stages an authorization of the authorial voice in terms of what Jeffrey Schnapp has called "Dante's poetic of martyrdom" (*The Transfiguration of History at the Center of Dante's "Paradise"* [Princeton, 1986], pp. 170–238). In the central cantos of the *Paradiso,* Dante-protagonist meets an exemplary male ancestor, his great-great-

This is particularly important in light of the overall strategy of the *Cité des dames,* in terms of the progressive development of the narrator-protagonist configuration. At the beginning of part 1, Christine-protagonist's initial reaction to her reading of misogynist authors was presented as a kind of silence.[24] The work's first-person story line recounts how this silenced female protagonist becomes—through an extended act of corrective rereading—an empowered speaking subject, the female author of a new kind of book: the *Cité des dames* itself. This is why the explicit reference to Vincent de Beauvais as written source, which introduces the *Cité des dames*'s Saint Christine exemplum—the last time a written source is mentioned in the work—is so important. *This* act of reading will empower the *je* of Christine-author to speak in her own voice, within the text's unfolding fabula of first-person development. The break in the fictional structure of part 3 that provides a concluding frame for the Saint Christine story is thus deliberate and functional: it is the now fully voiced Christine-*auctor* who explicitly emerges.[25] It is not the allegorical character Justice, but Christine de Pizan as author, empowered by Saint Christine, who bears witness to the saint's "holy legend [*ta* sainte legende]" (my emphasis) which she puts into *her own* writings ("en *mes* escriptures" [my emphasis]).

At the same time, Christine de Pizan—as writer—is implicitly claiming the authority of the hagiographer, as is evident from a comparison with her source. In Jean de Vignay's translation of Vincent de Beauvais,

grandfather Cacciaguida, a crusader and martyr (*Par.* 15.148), who explicitly invests Dante-poet with his prophetic/poetic mission (esp. in *Par.* 17.124–42). An important part of Dante's strategy here involves his "appropriation" of the martyrdom of his ancestor in order to present his own poetic activity as *his* version of martyrdom: testifying, bearing witness to the truth (in the *Commedia*) in spite of suffering the consequences (persecution and, especially, exile).

24. The ongoing progress of her own scholarly work is dramatically brought to a halt and her female identity causes her to suffer paralyzing self-doubt: "En ceste pensee fus tant et si longuement fort fichiee que il sembloit que je fusse si comme personne en etargie [I was so transfixed in this line of thinking for such a long time that it seemed as if I were in a stupor]" (p. 619; p. 4).

25. In the final chapter of part 2, Christine speaks as author figure within the unfolding allegorical structure of the *Cité des dames*. This direct address to her audience also has a structural function, for it is simultaneously an explicit statement of how much of the book has been finished: "Suis venue jusques cy esperant de aller oultre a la conclusion de mon oeuvre par l'aide et reconfort de dame Justice [I have come this far hoping to reach the conclusion of my work with the aid and comfort of Lady Justice]" (p. 971; p. 215). Christine ends this authorial intervention—and part 2—with a request to her readers: "priez pour moy, mes tres redoubtees [pray for me, my most honored ladies]" (p. 971; p. 215).

the final sentence of the Saint Christine story reads as follows: "Adonc vint ung homme de son lignage qui par elle avoit creu en Jesuchrist et celebra son martyre et lenfouyt au temple Dapolin [then a man of her lineage came who had believed in Jesus Christ because of her; and he celebrated her martyrdom and buried her in the temple of Apollo] (Fol. clxiiiiv°)." Christine de Pizan modifies her source in order to emphasize both the corporeal identity of the saint and the writerly identity of the hagiographer: "Et un sien parent que elle avoit converti enseveli le saint corps et *escript* sa glorieuse legende [and one of her relatives whom she had converted buried her holy body and *wrote down* her glorious legend]" (p. 1009; p. 240; my emphasis; cf. Quilligan, "Allegory," p.240)

By the end of the *Cité des dames*'s Saint Christine story, Christine de Pizan as author has—in a striking gesture of self-authorization— incorporated the authority both of the clerkly hagiographer—the witness to the saint's martyrdom—and of the female martyr herself. The female voice of Christine-*auctor* is thus doubly guaranteed.

The central structural position of the Saint Christine story in part 3 of the *Cité des dames* reinforces this presentation by suggesting links with the opening and concluding chapters of part 3. At the same time, a progression is involved. First of all, there is the implication that Christine's prayer to her patron saint at the end of chapter 10 will be answered. Chapter 1 provides an inscribed model of the efficacy of "female" prayer within the context of the *Cité des dames,* as Justice prays to the Virgin Mary, invoking her aid, approval, support, and authorization in the enterprise represented by the construction of the city and the book. Justice thus explains that in order to complete the project, "Et desormais est temps que je m'entremette du surplus, si que je te promis, c'est assavoir d'y amener et logier la Royne tres excellente . . . si que la cité puist estre dominee et seigneurie par elle [it is time for me to undertake the rest, just as I promised you, that is, to bring and to lodge here the most excellent Queen . . . so that she may rule and govern the city]" (p. 974; p. 217). Her prayer is meant to be a collective one: "Supplie humblement a toy tout le devot sexe des femmes qu'en horreur ne te soit habiter entre elles. . . . Or viens donc-ques a nous, Royne celeste. . . . O! Dame, qui est celluy tant oultrageux qui jamais ose pensser ne gitter hors de sa bouche que le sexe femenin soit vil, consideree ta dignité? [May all the devout sex of women humbly beseech you that it please you well to reside among them. . . . Now come to us, Heavenly Queen. . . . My Lady, what man is so brazen to

dare think or say that the feminine sex is vile in beholding your dignity?]" (p. 976; p. 218).

Within the plot line of the *Cité des dames,* this prayer is "literally" answered: "La responce de la Vierge est telle: 'Justice, la tres amee de mon filz, tres voulentiers je habiteray et demeureray entre mes suers et amies, les femmes, et avecques elles. Car Raison, Droitture, toy, et aussi Nature m'y encline...suys et seray a tousjours chief du sexe femenin' [The Virgin replied as follows: 'O Justice, greatly beloved by my Son, I will live and abide most happily among my sisters and friends, among women and with them. For Reason, Rectitude, and you, as well as Nature, urge me to do so...I am and will always be the head of the feminine sex']" (pp. 976-77; p. 218). Part 3 thus opens with a staging of its own Christian authorization. The voice of Christine-author is "indirectly" authorized by means of this initial construct in which the efficacy of "female" prayer is demonstrated within the framework of the allegorical fiction of the text. This both anticipates and underwrites the prayer to Saint Christine made by Christine de Pizan at the end of chapter 10, where she speaks in her own voice as author of the *Cité des dames.*

The final stage in this progression occurs in chapter 19, where Christine, having successfully completed her book, addresses her readership, a kind of universal female public. Here, the authorial voice has become that of an authoritative preacher. Christine instructs her female readers on virtue and morality, advising them to take the *Cité des dames* itself as a model and to disprove by their behavior the accusations found in misogynistic books. With this final corrective reference to the texts that had caused Christine-protagonist to despair in part 1, chapter 1, the *Cité des dames* has now come full circle. And the final words of Christine-author involve an act of prayer:[26] "Et moy, vostre servante, vous soit recommandee en priant Dieu, qui par sa grace en cestuy monde me doint vivre et perseverer en son saint service, et a la fin soit piteables a mes grans deffaulx et m'ottroit la joye qui a tousjours dure, laquelle ainsi par sa grace vous face. Amen [And may I, your servant, commend myself to you, praying to God who by His grace has granted me to live in this world and to persevere in His holy service. May He

26. This "positive" prayer by an empowered female authorial voice, which concludes the final chapter of the *Cité des dames,* may also be seen as the definitive response to the "negative" prayer that concludes the work's first chapter, in which the despairing protagonist asks God why she was born into the world as a woman.

in the end have mercy on my great sins and grant to me the joy which lasts forever, which I may, by His grace, afford to you. Amen]" (pp. 1035–36; p. 257).

The structure of the three prayers that punctuate the beginning, middle, and end of part 3 provide a progressively more explicit revelation of the voice of Christine-author, at the same time as they authorize her voice in the context of the most privileged Christian speech situation. Within this progressive structure, it is the centrally located prayer to her patron saint that both illustrates and guarantees the process of authorial voicing.

The figure of Saint Christine thus empowers the author of the *Cité des dames* in two key ways. The text presents Christine de Pizan as enabled to speak in her own (female) voice both by means of her special relationship to the martyred saint and by means of her appropriation of the authoritative role of the hagiographer who bears written witness to the saint's martyrdom. The *Cité des dames*'s most explicit staging of female authorial voicing is thus derived from a fundamental New Testament model. It is highly significant to note, by way of conclusion to the present essay, that a remarkably complementary construct is at issue in Christine's last work, the *Ditié de Jehanne d'Arc*, but derived, this time, from a basic Old Testament model, and anchored in contemporary history. In the *Ditié*, the figure of Joan of Arc is portrayed as a holy female warrior, a combination of Joshua and Deborah.[27] Joan of Arc's appearance authorizes the authorial voice of Christine de Pizan, who both bears witness to Joan's fulfillment of earlier prophecies and makes her own prophecies concerning the future exploits of the Maid.[28] Joan as God's chosen warrior thus authorizes Christine to speak as a new prophet figure, a new Ezekiel or Isaiah. The French forces in this construct become the new Israelites. Furthermore, the arrival of Joan of Arc on the scene of contemporary French history empowered Christine de Pizan's authorial voice in a very literal way. With the Anglo-Burgundian occupation of Paris in 1418, Christine had withdrawn to the seclusion of a convent, and

27. The *Ditié* was completed on July 31, 1429, that is, before the beginning of Joan's setbacks. From the temporal perspective of Christine de Pizan's last work, Joan of Arc was a victorious military and spiritual leader, whose future promised even greater triumphs.

28. In terms of the *Ditié*'s remotivation of classical models, Christine figures as a new Christian Sibyl, and Joan as a new Christian Camilla/Penthesilea.

(with one possible exception) had ceased to write.[29] She had, in a very real sense, been silenced by historical events. It was only Joan's advent in 1429 that gave Christine back her voice after a silence of eleven years.[30] The fictional, metaphorical, staging of the empowerment of Christine de Pizan's authorial voice by Saint Christine in the *Cité des dames* (in 1405) is thus "answered" by the literal, historical, restaging of the same drama of empowerment, as Joan of Arc gives the resilenced Christine back her voice at the beginning of the *Ditié* (in 1429).[31]

29. The exception was the *Heures de contemplation sur la Passion de Nostre Seigneur* (c. 1420).

30. The breaking of this silence is depicted primarily in terms of the opposition between tears and laughter: "Je, Christine, qui ay plouré / XI ans en abbaye close / . . . Ore à prime me prens à rire / . . . or changeray mon langage / De pleur en chant [I, Christine, who have wept for eleven years in a walled abbey . . . now, for the first time, begin to laugh . . . now I shall change my language from one of tears to one of song]" (lines 1–2, 8, 13–14; text and translation from Angus J. Kennedy and Kenneth Varty, eds., *Christine de Pisan. Ditié de Jehanne d'Arc* [Oxford, 1977]).

31. For a more elaborate consideration of the relationship between Christine and Joan in the *Ditié* in terms of empowerment, see Kevin Brownlee, "Structures of Authority in Christine de Pizan's *Ditié de Jehanne d'Arc,*" in *Discourses of Authority in Medieval and Renaissance Literature,* ed. Kevin Brownlee and Walter Stephens (Hanover, N.H., 1989), pp. 131–50.

Saints, Nuns, and Speech in the *Canterbury Tales*

Saints and their legends are given prominence in the *Canterbury Tales,* not by their number, but by their exclusive association with the work's religious female tellers of tales. The Second Nun recounts the legend of Cecelia, and the Prioress tells of an anonymous "little clergeoun" (pupil or choirboy), associated with Saint Nicholas, the Holy Innocents, and Hugh of Lincoln.[1] Two of the work's female speakers avail themselves of the authorized discourse of hagiography, and the third—the Wife of Bath—explicitly grounds her speech in "experience, and noon auctorite."[2] These female tellers of tales apparently have one of two relations to authority: they either reject it or reproduce it in their speech, in either case leaving the hierarchy of experience and "auctorite" undisturbed. What is the effect of restricting authorized,

An earlier version of a part of this essay was given at the annual meeting of the Modern Language Association in Chicago, 1984. I thank Elizabeth Kirk, Linda Lomperis, and Larry Scanlon, as well as the students in my Chaucer classes, for countless opportunities for discussion of Chaucerian subjects.

1. The Prioress's tale is generically a miracle, not a saint's life, yet, like the Second Nun's tale, it celebrates a holy woman; thematically, the two works share at least a focus on speech and a martyr's death. On the generic significance of the terms the Second Nun employs, see Paul Strohm, "Passioun, Lyf, Miracle, Legend: Some Generic Terms in Middle English Hagiographic Narrative," *Chaucer Review* 10 (1975): 62–75; 154–71, esp. p. 166. Strohm argues that the use of such terms gives the author "firm control over the tone of his narrative" and that such advance warning forecloses the possibility of irreverent reactions from the audience.

2. Wife of Bath's Prologue, line 1. All quotations from *The Canterbury Tales* in the body of this essay are cited from *The Riverside Chaucer,* ed. Larry Benson (Boston, 1987). Most line references will be given parenthetically in the text.

hagiographic discourse to female speakers? In response to that question, I want here to explore the connections among saints, nuns, speech, and stories, arguing that the nuns' hagiographic tales refigure our understanding of salvific storytelling and the relations between narrative, truth, and gender in Chaucerian discourse.

Hagiographic speech in the *Canterbury Tales* is restricted to female religious pilgrims. No male pilgrim, religious or secular, tells such a tale. The Clerk's Griselda may be saintly in her patience, and the Man of Law's Custance a lamblike innocent, but neither Custance nor Griselda is more than an exemplary figure—neither can function as a "meene" (intermediary) in prayer, for example.[3] The Physician's historical tale of Virginia shares with the Prioress's and the Nun's tales an insistence on veracity over fabula, but Virginia is a pagan, and ineligible for sainthood. Chaucer's own Dame Prudence is an allegorical feminine figure, not a saint. Furthermore, none of these tales told by secular male pilgrims claims, as do the Second Nun's and the Prioress's, to translate sacred experience through authorized language.[4] One might expect a hagiographic focus in tales by the male religious pilgrims; but the Parson and the Pardoner preach, the Monk recounts exempla, and the Summoner's tale is parodic rather than hagiographic. The male religious character most closely associated with Prioress and Nun, the Nun's Priest, tells, not a saint's legend, but arguably the most sophisticated, fabulous, and artificed of all the tales.[5]

How does hagiographic discourse function in the *Canterbury Tales*? What difference does it make that its appearance is linked to a specific gender and religious status? The nuns' hagiographic tales apparently make their claims on the audience by offering it transparent, plenitudinous speech, speech that annuls the distinction between thought and

3. Thus, the Prioress prays, not to the "clergeoun," but to Hugh of Lincoln in closing her narrative.

4. James Dean, in "Dismantling the Canterbury Book," *PMLA* 100 (1985): 746–62, stresses the ideal nature of the Second Nun's tale, treating it as a contrast to the explorations of the nature of fiction that make up the rest of fragment 8. Saul Nathaniel Brody, in "Chaucer's Rhyme Royal Tales and the Secularization of the Saint," *Chaucer Review* 20 (1985): 113–21, singles out the Second Nun's Tale as the only tale written in rhyme royal that expresses an ascetic ideal with no apology; in his view, it establishes a norm from which the other rhyme royal tales depart.

5. Considering the Second Nun's tale and the Prioress's tale against the Wife of Bath's demonstrates the relations between feminine speakers and authorized speech in *The Canterbury Tales;* and analyzing the interplay between the Nun's Priest's tale and those of the Prioress and Second Nun reveals the relations among fiction, authorized speech, and gender; I will discuss these topics in a longer study.

language, that translates ineffable truth. The Prioress explicitly asserts
that her tale—or "song" as she calls it—will express the inexpressible,
and the Second Nun endows her hagiographic speech with the effi-
cacious status of an act, identifying it with the "bisynesse" and labor
that characterize the preaching and converting saint of whom she
speaks. Both nuns rely on ecclesiastically authorized speech in making
these claims. Both condition their entrance into speech with an in-
vocation to Mary, the virgin female bearer of the Word. Both, like
Mary, represent themselves as vehicles of the Word. Like the Second
Nun's female saint, the Prioress's protagonist is a verbal innocent; the
"little clergeoun," as a child, is a feminized speaker in an economy that
grants only male subjects the right to authorized speech. Both protag-
onists speak most efficaciously when apparently most unable to speak.
The clergeoun's verbal utterance is facilitated by a bodily condition
that seems to obstruct speech: his cut throat, and the mysterious grain
on his tongue, like Cecelia's wounded neck, are literally (though not
allegorically or spiritually) obstacles to speech.[6] Both protagonists share
with their narrators obstacles to speech that they overcome, rendering
them, like their narrators, privileged, efficacious speakers.[7] Both tales,
through their narrators and protagonists, assert the authority of the
spirit over the letter; both assert the ability of the dead letter guaranteed
by the Logos to point beyond itself to a nonverbal meaning.

Yet why is the representation of efficacious, salvific speech in nar-
rative form restricted to female speakers? One would expect efficacious
speech—that which claims to enact what it represents, that is, salva-
tion—to be assigned to the pilgrim who has the most cultural authority
to speak, the Parson. How does gender play into Chaucer's exploration
of the salvific potential of narrative? I suggest that it does so by inter-
rogating the claims to transparent, plenitudinous, perfectly spiritual
speech made by the nuns' tales, by calling our attention to the feminine

6. Manuscript illuminations of Cecelia's, and Valerian's and Tiburce's, deaths by
beheading represent salvific speech as the signal difference between apparently identical
martyrdoms; the Word, in the form of Christ's hand, appears only in the scene of
Cecelia's beheading; see V. A. Kolve, "Chaucer's *Second Nun's Tale* and the Iconography
of St. Cecelia," in *New Perspectives in Chaucer Criticism*, ed. Donald Rose (Norman,
Okla., 1981), p. 140, figs. 1 and 2. Kolve does not discuss this difference in repre-
sentation.

7. The anti-Semitism of the Prioress's tale problemizes any view of the Prioress as
a "privileged speaker." By using the phrase, I mean to emphasize that her tale claims
privilege, claims to speak the ineffable. Even if the Prioress fails to realize that claim,
as I think she does, I do not think we can therefore rescue Chaucer from the charge
of sharing the anti-Semitism, religiously rather than racially defined, of his age.

and the literal, the repressed enablers of spiritual, "masculine" speech. Both tales enact the necessity of repressing the literal to enable the appearance of the spiritual meaning. Both point to the role of the feminine (or feminized) speaker as the support of authorized male speech. Both demonstrate the importance of the letter, of writing, in Chaucer's fiction of potentially redemptive storytelling.

In marked contrast to the Wife of Bath, or even female characters in the pilgrims' tales, the gender of the speakers has received little attention in discussion of these two tales. Discussing the General Prologue portrait of the Prioress, John Livingstone Lowes referred to "the engagingly imperfect submergence of the feminine in the ecclesiastical."[8] (Lowes, of course, meant by this simply to suggest that Chaucer was more than a little taken by the woman who was the Prioress, just as he was taken in by Criseyde, a less veiled, though more troubling, instance of the feminine). But for critics, "the feminine" seems to have been completely submerged in the ecclesiastical.[9] John Fisher suggests, for example, that "the assignment of a bloody tale to the Prioress and the equally paradoxical martyrdom story to the Second Nun can hardly avoid being seen as some sort of comment on the way their institution distorted the humanity of these well-meaning women."[10] The lack of attention to gender is curious, given that the Second Nun's tale represents a unique instance in the *Canterbury Tales* of the pairing of a female speaker and a female protagonist, and that the Prioress and Second Nun link their tales to Mary, associating themselves with the holiest of women. But the critical displacement of gender issues onto the Wife of Bath is understandable, for it is, of course, Alisoun who discusses both the social status and the literary representation of women, exempting from her attack on male narrators of women's stories only those clerks who wrote "hooly seintes lyves." Neither the Second Nun's nor the Prioress's tales bear out the Wife of Bath's assertion,

8. John Livingston Lowes, *Convention and Revolt in Poetry* (New York, 1919), p. 60; quoted by Chauncy Wood, "Chaucer's Use of Signs in His Portrait of the Prioress," in *Signs and Symbols in Chaucer's Poetry*, ed. John P. Hermann and John J. Burke (University, Ala., 1981), p. 83.

9. See, for example, Ann Haskell, *Essays on Chaucer's Saints* (The Hague, 1976); Roger Ellis, *Patterns of Religious Narrative in the Canterbury Tales* (London, 1986); C. David Benson, *Chaucer's Drama of Style: Poetic Variation and Contrast in the Canterbury Tales* (Chapel Hill, N.C., 1986).

10. John H. Fisher, *The Complete Poetry and Prose of Geoffrey Chaucer* (New York, 1977), p. 233.

> By God, if wommen hadde writen stories,
> As clerkes han withinne her oratories
> They would han writen of men moore wikkednesse
> Than al the mark of Adam may redresse.
>
> (Lines 693–96)"

Chaucer's religious women speak not of men, but of a woman and a child. Although neither writes "wikkedness" of (Christian) men or discusses the social status of women, both tales meditate on the notion of the feminine, by representing two feminine figures, Cecelia and Mary.

The notion of "the feminine" is one that I find it useful to reexamine from the point of view of recent psychological theory, especially that of Julia Kristeva, trained as a medievalist and more aware than most post-Lacanian thinkers that Western thought on men, women, and their psyches did not begin in the nineteenth century. "The feminine" has been understood by Kristeva as a figure for what the twentieth century, after Freud, calls the pre-Oedipal, for what medievalists can recognize as the construct or fantasy of unified preverbal knowledge that ultimately guarantees or "authorizes" verbal speech.[12] In "Stabat Mater" Kristeva argues that "the Mother and her attributes . . . are metaphors of non-language, of a 'semiotic' that does not coincide with linguistic communication. . . . [Mary] occupies the vast territory that lies on either side of the parenthesis of language" (pp. 109–10). The Mother, who brings forth the Word, evokes the notion of a unity of knowledge before the expression of the Word. Representations of the Mother and Child evoke both the Word and the notion of a linguistically inexpressible unified knowledge beyond or before the Word. This notion of the Virgin accords with that of the figure to whom the Prioress prays that her "song" express the inexpressible. But what is repressed in the figures of Virgin and Child, those representations of preverbal nonlinguistic knowledge and expressed Word, is the bloody

11. Alisoun's assertion seems to have closed off the question of the degree to which the other female pilgrims' narratives accord with the Wife's literary theory. Roger Ellis suggests that the Second Nun's tale does respond to the Wife of Bath: the Second Nun's tale "offers a clear and unambiguous answer to the question whether 'experience' or 'auctoritee' should be the measure of the fictional world"; see Ellis, *Patterns,* p. 100.

12. See Julia Kristeva, "Stabat Mater," in Susan Rubin Suleiman, *The Female Body in Western Culture* (Cambridge, Mass., 1986); hereafter cited parenthetically in the text. See further, Kristeva, "Motherhood According to Giovanni Bellini," in *Desire in Language,* trans. Leon S. Roudiez (New York, 1980), pp. 237–70. For a useful discussion of Kristeva, see Mary Jacobus, *Reading Woman: Essays in Feminist Theory* (New York, 1986), pp. 144–70.

knowledge of separation, of the gap between human language and knowledge, of the split process of language, of the splitting off, the division and difference that make knowledge, communication, and fiction possible. The shared gruesome physical detail in the tales of the "clergeoun" and Cecelia points to a Chaucerian exploration of the split process of language; the attribution of these tales to female speakers names gender division as one of the forms of difference that enables knowledge.

To bring my argument back to Fisher's comment, the "institution" that "distorted the humanity" of Second Nun and Prioress is that of gender and language, more than it is the nunnery. But the nunnery plays a role as well. The attribution of these tales to female speakers makes a gesture toward tearing the veil off the feminine as the figure for the difference that enables Word, knowledge, and fiction, but the attribution of these tales to religious female speakers literally veiled by their ecclesiastical institution restores that necessary veil, enabling the fiction of the *Canterbury Tales* to unfold. I am not making an argument of morality, Christian or feminist, but one of poetics: I am arguing that the fiction of the feminine is necessary for the project of Chaucerian poetics, a poetics that affirms and denies the powerlessness of language by representing fantasies both of a unified, preverbal mother and of ruptured feminine (or feminized) bodies. Such a necessity further demands that its necessity be veiled, either in the simple, unpleated wimple appropriate to nuns (that is, the apparently simple, authorized language of saint's legend), or in the Prioress's "semyly ... pynched" wimple, the more stylistically elaborate Miracle of the Virgin.

How does this veiling and unveiling gesture take place? Let me look first at the representations of the two speakers in the General Prologue. Critics have had a field day with the portrait of the Prioress, unraveling the threads of romance convention and biblical allusion, trying to "find" the Prioress, and usually moving to moral condemnation or approbation. One critic—moving toward condemnation—concludes, "As a nun who wants to be a fashionable lady, she [the Prioress] ends up being nothing."[13] This is a stunning statement: a female figure who occupies the rhetorical space of neither Eva nor Ave is—nothing. She is rhetorically canceled out, absent, empty. Such a view of the Prioress links her most emphatically with her ecclesiastical cohort—the Second Nun, that pilgrim of whom we learn nothing more than her name,

13. Wood, "Chaucer's Use of Signs," p. 100.

which tells us merely that she is a function of the first nun, she is a "Second Nonne," that is, another no one or nothing. The Second Nun is purely a production of the tale she tells—a tale that has been called impersonal, bland, and unsophisticated, a tale for which she is only a vehicle, a tale that opens and closes with no reference to any interaction with the pilgrim audience. The Prioress may be annulled by the conflicting conventions by which she is portrayed, but the Second Nun begins and ends as a virtual absence in the text. Women can be annulled ("nunned") by being represented as the mutually exclusive images of woman—sexualized being or nonsexual (maternal) being—or by figuring as the nonrepresented other, the nonrepresentable, preverbal unity.

How can such representations of the feminine enter into speech? The Prioress and the Nun do so with prologues that address the issues of women and language. The Prioress prays Mary to guide her song, to enable her to express the inexpressible, although she compares herself to a twelve-month-old child, unable to express a word. The Prioress makes of herself an *infans,* a nonspeaker, whose linguistic incapacity will be repaired by the Virgin bearer of the Word. The Second Nun's prologue, more complex, falls into three parts: a meditation on an unproductive allegorical woman called idleness, an invocation to Mary, and an etymological representation of Cecelia. In her opening meditation on idleness, the Second Nun addresses Saint Cecelia, not the sinners in her audience. It is this failure to address others, to enter into public, efficacious speech, that she prays Mary to amend in the second part of the prologue. With Mary as her advocate, that is, with Mary speaking in her place, the Second Nun is enabled to deliver the third part of the Prologue, that is, the etymology of Cecelia's name, which the Second Nun asserts is the same as the meaning of the legend she will then tell. The Second Nun initially evokes a double image of woman, both as "Ydelnesse," the gatekeeper of a realm that produces "no good n'encrees," and as Mary, the verbally and spiritually productive bearer of the Logos. This split representation is akin to the Eva/Ave model of woman found in other medieval writers, but Chaucer's text gives the double representation a particularly linguistic emphasis and reinforces that emphasis with a linguistic analysis of the name of the saint. In its final etymological section, whose meaning the Nun identifies with the tale, the prologue linguistically dismembers Cecelia, analytically making of her name an adequate human signifier

of the (w)ho(l)ly Other.[14] Her name speaks the Word. That is, the etymology identifies Cecelia as another virgin mother. Like Mary, she points toward the fantasy of a preverbal mother who brings forth an authorized Word, a figure that defends against our knowledge of the split nature and powerlessness of language. But the etymological dismemberment of Cecelia in the prologue, like the beheading scene in the tale, points to the very knowledge of rupture that it denies.[15]

Chaucer's dramatic deployment of the tale of Cecelia unsettles the stable bases of discourse and meaning on which the hagiographic tale—that most conventional of genres—apparently rests. Challenging the conventional view of the Second Nun's tale as a simplistic, transparent narrative—the most ideal of the tales—this reading of the tale suggests a dynamic relation between experience and "auctoritee," gender, authority, and speech. For the Second Nun speaks apparently only authorized words: she claims merely to transmit a saint's legend, to represent an authorized view of woman's experience. But what her tale transmits is not merely the representation of the feminine as virgin bearer of the Word; the saint's legend also enacts the literal mutilation of physical women on whom "the feminine" is projected. Her tale, and that of the Prioress, take up, in veiled form, the issues, blatantly set forth by the Wife of Bath, of the contest of experience and "auctoritee" and the silencing of the feminine voice.

Let me develop this argument first in relation to the Prioress's tale. Unlike the tale of Cecelia—the tale of a female protagonist told by a female teller—the tale of the clergeoun does not apparently link a female protagonist and female teller, although the protagonist here might well be not the clergeoun but Mary, the hidden actor who controls the plot of the Prioress's tale. I will return to Mary's veiled power, but first let me focus on the clergeoun. Like the Second Nun's, this tale focuses

14. See Paul M. Clogan, "The Figural Style and Meaning of the Second Nun's Prologue and Tale," *Medievalia et Humanistica*, n.s. 3 (1972): 231, who explicates the medieval understanding of etymology, as sanctioned by Matt. 16:18, Jerome's *Liber De Nominibus Hebraicis*, and Isidore's *Etymologies*. See also Roger Dragonetti, *La vie de la lettre au moyen âge* (Paris, 1980), pp. 22–40, 43, on names, etymology, and fiction.

15. Kolve notes, in his discussion of the power of Cecelia's chastity in the penultimate scene of the legend, Cecelia's survival in the bath, that "through an act of grace, a metaphor . . . is made literal; her survival is never in doubt" ("Chaucer's *Second Nun's Tale*," p. 150). But metaphor is equally made literal in the legend's final scene, when the prologue's linguistic cutting apart of "Cecelia" becomes the cutting apart of Cecelia—and her survival is very much in doubt, in all but the spiritual sense. When metaphor is literalized, the literal perishes.

on a protagonist who is not an adult male, a protagonist who lacks authority over language. His relation to the authorized language of Latin is problematic: he is able "to syngen and to rede" (line 500), but he cannot translate from Latin to a language he understands. Listening to the "Alma Redemptoris Mater," a hymn to Mary, he learns to repeat "the firste vers . . . al by rote" (line 522). He reproduces the words of the hymn without conscious volition; the Prioress asserts that "He kan nat stynte of syngyng by the weye" (line 557). Even when he is alive, he cannot stop singing, as, more amazingly, he cannot stop when he is dead; with his vehicular relation to the Word, he is, dead or alive, a feminized speaker—not a male speaking subject in control of the language he utters, but a speaking body like Cecelia, a vehicle that bears, without conscious volition, words of praise for Mary, the bearer of the Word. Furthermore, what he utters without rational understanding is not merely speech, but song, an emblem of harmony, of unison, of consonance and order, that makes the world—that is, chaotic "experience"—intelligible and beautiful. He and his linguistic performance refigure the unrepresentable, the unknowable, the ineffable—that unspeakable unity that the Prioress both represents herself as unequal to, and prays Mary to enable her to express. She prays "as a child of twelf monthe oold or lesse / That kan unnethe any word expresse" (lines 484–85). Here the female speaker makes of herself a child, identifying child and woman, and inverting the gesture of her tale that makes of a child a feminized speaker. She dramatizes the apparent incapacity that characterizes the feminine speaker by calling herself an *infans,* a child unable to speak, identifying herself with the baby mothered by the Virgin, but simultaneously putting herself in the place of the Virgin bearing the Word, that is, in the place of the feminine, which masks the knowledge of the split in language.[16] By identifying both with the Mother and the child, by playing the role both of *infans* and bearer of the Word, the Prioress veils the knowledge of the split process of language.

But the knowledge of the separation and opening that bearing the word entails reenters the tale as the opening in the clergeoun's neck.

16. See Peggy Schine Gold, *The Lady and the Virgin* (Chicago, 1985), p. 149. In her conclusion Gold argues that the Gothic "humanizing" of Mary and Jesus, mother and child, responded more directly to male needs than female, that the female response was more ambiguous: "Was she to identify with the male child . . . or with the Virgin?" The Prioress apparently "identifies" with both.

His throat is cut—as no contemporary reader can forget—by the Jews. The anti-Semitism of the tale is theological and hermeneutic: the Jews in this tale are a figure for the letter, which kills. The "little clergeoun" is their victim—but he is also literally the victim of the Virgin, whose song he sings, willy-nilly, and whose power he manifests more effectively in death than in life. The tale becomes the story of the contest between the Jews and the Virgin for the speaking body of the clergeoun, the one agent causing it to be physically silenced, the other causing it to sing—but only as a dead body.

Whether Chaucer knew any Jews, and whatever versions of the story of Hugh of Lincoln he had encountered, it is clear that Jews played a singular symbolic role in Christian epistemology and linguistics. In the Christian view of language and meaning, Jews stand resolutely for the letter, even more markedly than do women. If Mary, the Christian paradigm of the feminine, in Kristeva's terms, "occupies the vast territory that lies on either side of the parenthesis of language," the Jews could be said, in the Christian view, to constitute that parenthesis. Mary may seem to offer a singularly consoling view of authority— because hers is constituted apparently outside the Law of the Father; symbolically, the Jews offer the sharpest challenge to that authority because they represent the unmitigated Law of the Father and the insistence on the split process of language, the unredeemed separation of human linguistic utterance from the ground of reality. By insisting that human language, without the incarnate mediation of the word, translate the ground of reality for human beings, the Jews, in a Christian view, challenge the linguistic efficacy of both the clergeoun's recitation of the letter and the Prioress's claim to speak as an *infans*.[17] The contest in the tale is linguistic and epistemological: the Jews represent, in a Christian view, the possession of a kind of knowledge that denies both the efficacy and the necessity of the Virgin bearing the Word. But in the tale, the Jews, and not the Christian clergeoun, are represented as reacting to the "sentence" of the "letter" that the boy sings.[18] Ironically,

17. See Florence Ridley, *The Prioress and the Critics* (Berkeley and Los Angeles, 1965), for discussion of the Prioress's (and Chaucer's) anti-Semitism; see Paul G. Ruggiers, ed., *A Variorum Edition of the Works of Geoffrey Chaucer*, vol. 2, part 20, *The Prioress's Tale*, ed. Beverly Boyd (Norman, Okla., 1987), pp. 43–50.

18. The motivation for the killing of the boy is said to be "Sathanas," who questions whether the Jews can let the boy "synge of swich sentence / Which is against youre lawes reverence" (lines 563–64).

the Prioress endows the Jews with more spiritual understanding than she allows her childish martyr. Robbing her clergeoun of literal understanding, the Prioress opens him to attack by the figure of the literal.

Yet this tale, like Cecelia's, interrogates the spirit-letter hierarchy that it overtly establishes and upholds—for it is the Virgin who ultimately silences and entombs the singing body of the clergeoun by commanding (through the involuntary speech of the boy) her deputy the abbot to remove the mysterious "greyn" from his tongue. Telling a miracle tale of the irruption of the Virgin's power in the world, but blind to the literal gap opened in the body in and of her text, blind to the power of the literal, the Prioress, like the Second Nun, figures an authorial fantasy of the feminine. Represented as enabled to speak by a virgin mother, the Prioress and the Second Nun mediate representations of ruptured bodies; their prologues and tales affirm and deny the necessary fiction of a unified, preverbal mother bearing the Word, tracing the limits of poetic authority. I turn now to the Second Nun's tale, long dismissed as early work, imperfectly adapted to its setting in the *Canterbury Tales,* now more often passed over as simplistic, stylistically uninteresting, a perfect match for its perfectly anonymous narrator.[19] Neither critical interest in irony nor the scholarly focus on medieval aesthetics rescued this tale from the Canterbury wayside. Early feminist critics found little to interest them in the depiction of a militant female martyr, too easily assimilated to a medieval *in bono* view of woman. What has made this tale interesting to me is the view that the work of psychoanalytic feminist literary theorists, with its focus on gender, women, and language, affords us of Cecelia, the Second Nun, and Chaucer.[20] Prologue, hagiographic narrative, and mar-

19. An important exception is Anne Middleton, "The Physician's Tale and Love's Martyrs: 'Ensamples Mo than Ten' in the *Canterbury Tales*," *Chaucer Review* 8 (1973): 15–32. Middleton finds significant parallels between Cecelia and Virginia in their "early-cultivated sense of purpose" (p. 17) and between Almachius and Virginius as "ministre[s] of deeth."

20. In addition to Kristeva and Jacobus, these theorists include Luce Irigaray, especially *This Sex Which Is Not One,* trans. Catherine Porter (Ithaca, N.Y., 1977), pp. 68–105; Jane Gallop, especially *The Daughter's Seduction* (Ithaca, N.Y., 1982); and Hélène Cixous, especially "Sorties," in *The Newly Born Woman,* trans. Betsy Wing (Minneapolis, 1986). Sheila Delany's recent article, while not psychoanalytic in orientation, provides a useful questioning of "feminism" in the Middle Ages: " 'Mothers to Think Back Through': Who Are They? The Ambiguous Example of Christine de Pizan," in *Medieval Texts and Contemporary Readers,* ed. Laurie Finke and Martin Schichtman (Ithaca, N.Y., 1987), pp. 177–97.

tyrdom scene foreground the question of salvific speech, central to the exploration, in the *Canterbury Tales,* of the issues around gender, logos, and fiction.

The eighth fragment of the *Canterbury Tales* begins without reference to the pilgrimage framework, or the Nun's Priest's tale, which precedes it; the tale itself concludes with no comment by the pilgrim audience; and the Second Nun speaks nowhere else in the *Canterbury Tales.*[21] Within the work, her prologue and tale are seen as responding obliquely to the "marriage group," or providing a temporal referent for the entrance of the nameless Canon's Yeoman.[22] Like the Nun's Priest, the Second Nun is a function of another character. In the General Prologue, she is introduced in tandem with the Prioress:

21. Ellesmere places the Nun's Priest's tale before Fragment VIII; in Hengwrt, the Franklin's tale precedes the Second Nun's tale. See N. F. Blake, "The Relationship between the Hengwrt and the Ellesmere Manuscripts of the 'Canterbury Tales,' " *Essays and Studies* 32 (1979): 1–18; *English Studies* 64 (1983): 385–400.

22. Several critics have related this tale to the marriage debate: see, for example, Donald Howard, "The Conclusion of the Marriage Group," *Modern Philology* 57 (1960): 223–32. Clogan, "The Figural Style," argues that the prologue, "generally considered oblique, fragmented, and ill-suited to the legend" serves to focus and epitomize the figural meaning of the legend (218) and that continence is the final word on the marriage debate. Marc Glasser, "Marriage and the *Second Nun's Tale,*" *Tennessee Studies in Literature* 23 (1978): 1–14, argues that marriage, serving to move Cecelia from a contemplative state to active "bisynesse," emblematizes the first step toward the greater good of heroic martyrdom. John Hirsh, "The Politics of Spirituality: The Second Nun and the Manciple," *Chaucer Review* 12 (1977): 129–46, finds a historical location for the composition of the Second Nun's tale in Adam Easton's nomination to the position of Cardinal Priest of Saint Cecilia in Trastavere, and argues that Cecelia's absolute view of authority is modified by Chaucer's "meditation [in the Manciple's tale] upon the problem of morality in a contingent, deceptive, and not infrequently ruthless world" (p. 141). Carolyn Collette, "A Closer Look at Seinte Cecile's Special Vision," *Chaucer Review* 10 (1976): 337–49, accepts a negative view of the tale but suggests that, with the prologue, it forms a "texturally complex and thematically unified work of art" that emphasizes contempt for the world and the value of supraexperiential wisdom (p. 337). Paul Beichner, "Confrontation, Contempt of Court, and Chaucer's Cecelia," *Chaucer Review* 8 (1974): 198–204, demonstrates that Chaucer, in comparison with his sources, emphasizes Cecelia's verbal prowess in the trial scene with Almachius. See also Bruce Rosenberg, "The Contrary Tales of the Second Nun and the Yeoman," *Chaucer Review* 2 (1968): 278–91, and Russell Peck, "The Ideas of 'Entente' and Translation in Chaucer's Second Nun's Tale," *Annuale Mediaevale* 8 (1967): 17–37. Joseph Grennan finds thematic connections between the Second Nun's tale and the Canon's Yeoman's tale in "Saint Cecelia's 'Chemical Wedding': The Unity of the *Canterbury Tales,* Fragment VIII," *Journal of English and Germanic Philology* 65 (1966): 466–81. The important related work of Beth Robertson came to my attention only after this essay was completed.

> Another Nonne with hir hadde she
> That was hir chapelayne.
> (Lines 163–64)[23]

The Second Nun and the Nun's Priest are the only pilgrim storytellers represented anonymously, facelessly, and as a function of another in the General Prologue; the nun is one of the few pilgrim narrators whose prologue represents no interaction with the pilgrim audience. She is in truth the "Second Nonne," the "other no one," the anonymous vehicle for, and creation of, the language attributed to her.

The Second Nun's prologue opens an interrogation of woman, language, and authority. In the course of this triple prologue, the relationships between speaker and audience, speaking subject and (w)ho(l)ly Other, speech and body, faith and deeds, Latin and English, are called into question. The speaker represents herself as beginning anew with each part of the prologue—a rhetorical strategy that mirrors the prologue's three separate forays into speech, each insufficient, each a different kind of prologue, preface to the speech that is the legend of Cecelia.

The prologue to the saint's legend, emblem of "bisy" salvific speech, begins with its contrary, "ydelnesse." Idleness, like the Second Nun, Mary, and Cecelia, is a woman, "the ministre and the norice unto vices." The prologue asserts the proper hierarchic ordering of "ydelnesse," which we are bound "To eschue and by hir contrarie oppresse— / That is to seyn, by leveful bisynesse" (lines 4–5) As a negative representation of woman, "ydelnesse" is a candidate for oppression, which is immediately recommended and apparently enacted. Traditionally, in the monastic context, idleness was suppressed through a specific form of "bisynesse": at first the straightforward productivity of manual labor, but later the more metaphysically productive labor of copying, translating, and illuminating manuscripts, that is to say, linguistic productivity. "Ydelnesse . . . of which ther never cometh no good n'encrees," is converted by this monetary metaphor into sterility, the sign of an interchange that produces no offspring, no excess. Such an opposition between sterility and production underlies the Nun's assertion: "I have heer doon my feithful bisyness / After the legende in translacioun" (lines 24–25). Physically sterile, the Nun stakes her claim to produc-

23. Note that the Nun's Priest, whose tale is seen as central and as pure "game" (much as the Second Nun's is taken as pure "ernest"), is another character introduced—equally anonymously—as an attendant of the Prioress.

tivity in verbal soil. Notable here is the Nun's proprietary attitude to what she calls "my feithful bisynesse": "bisynesse," linguistic productivity, is in this discourse claimed to be a thing one can own—but also a thing that must enter into exchange, something one must give up, in order for it to do its work of translating the telling, the "legende." At issue is *translatio,* the structure that converts the sterile words of idleness into the fruitful language of the legend, the movement from private prayer into authorized, public speech. At issue is the *translatio* of the salvific word from speaker to audience, a central issue for the *Canterbury Tales* itself.[24]

Yet this *translatio* is not effected smoothly. Although the Nun's discourse seems to be open, public, addressed to the pilgrim/reader audience at large, as she asserts proprietary rights over her discourse, she simultaneously limits the audience:

> After the legende of translacioun
> Right of *thy* glorious lyf and passioun—
> *Thou* with *thy* gerland wroght of rose and lilie
> *Thee* meene I, mayde and martyr, Seint Cecile.
> (Lines 25–28; my emphasis)

The use of the second-person-singular pronoun signals that the prologue is no public speech, no open discourse, but a private meditation on the saint the speaker addresses. The closure of audience here implied renders problematic the opposition between linguistic sterility and fruitfulness on which our judgment of this discourse depends. The nun claims that her speech is "bisy," that it effects an exchange that produces "good and encrees." Until this point in the prologue, we have been free to assume that this is public speech, enacted for the benefit of others, that it works its effect on the pilgrim/reader audience, but it is precisely that audience from which the speaker cuts herself off by addressing the saint alone. Linguistic "bisyness," the salvific operation of the word, depends on exchange, which the nun's words restrict to an economy of saint and individual petitioner. If the prologue addresses itself to saint rather than sinner, in what sense can it speak publicly, efficaciously, to an audience? As private speech, a meditation can work

24. Roger Ellis argues, in *Patterns,* that as a translation the Second Nun's tale has less appeal for modern readers than do other narratives in the work; that "as a translation, it raises fundamental literary questions in a way that the Clerk's and the Prioress's tales could not"; that "it argues absolute faithfulness to 'auctoritee' "; and that it subordinates art to morality (pp. 96, 99, 100, 101). Ellis sees in the tale no problem of *translatio* more broadly defined.

salvific transformation only for the meditator. If this language is "bisy," it can apparently be efficacious only for the speaker, the Second Nun. The address to Cecelia, which closes the first part of the prologue, closes off the nun's discourse from public interchange: it reenacts the cloistering of the nun, functioning as a sign of her distance, her displacement, from social and linguistic interchange.

So the first movement of the prologue terminates in a dead end. Having raised the issue of the salvific functioning of language, the speaker is represented as closed off from the profitable interchange that would rescue language from idle sterility. The female speaker, the Second Nun, that "other no one," is unable to speak efficaciously, except perhaps for herself—an unverifiable, indeterminate proposition. But the discourse of the prologue enlarges its audience by addressing another "thou": "the flour of virgines alle," that is, Mary, the preeminent exemplar of woman cut off from intercourse, of womanhood celebrated by male writing. The prologue here represents itself as starting again: "To thee at my bigynnyng first I calle" (line 31). The second opening, the second prologue—speech before speech—begins with an abandonment of responsibility: "do me endite," cause me to tell, the speaker begs of Mary, making of the woman celebrated in male writing the authority of her speech. "Be myn advocat," she later prays, working a double displacement of her own speech onto Mary, who now must speak for her, speak in her place. Mary is the Second Nun's, the faceless woman's, guarantor and vehicle of discourse: her "advocacy" enables the nun, in the third and final part of the prologue, to address the pilgrim-reader audience, and finally, to communicate the tale of Cecelia's salvific speech. How does the *Invocacio ad Mariam* function to enable the fiction of salvific language to be enacted? Mary is at the center of the invocation because, as the speaker puts it,

> thou, virgin wemmelees,
> Baar of thy body—and dweltest mayden pure—
> the creatour of every creature.
>
> (Lines 47–49)

Mary is represented here as the prototype and model of Cecelia, and the Second Nun, bearers of the salvific word. To woman is attributed the bearing of the Logos—language, which is "the creatour of every creature." The representation of Mary as bearer of the Word enables the Second Nun's salvific speech. The problem of the Second Nun as

female speaker, the problem represented in the tale, is broached here. For Mary, the bearer of the Word, speaks and acts "wemmelees"— without blemish or spot, but also, punningly, without womb, that is, not as a physical woman.[25] Cecelia, the representation of a female saint, speaks and acts efficaciously when cut off from the physical intercourse of marriage (that is, when virgin, like Mary) and best of all with "hir nekke ycorven" (that is, when her female physical body is mutilated, opened). Like the mutilated body of Cecelia, the language of the Second Nun herself falls into fragments. The proper relation of "bisynesse" and "ydlenesse" is upset by the speaker's initial inability to speak publicly. The speaker's appropriation of language is, in turn, undone by her abandonment of language to Mary, her advocate. Finally, the etymological analysis, the linguistic cutting open of the saint's name, foreshadows the tale's representation of effective female speech.

The faceless, anonymous female speaker's relationship to language is thoroughly problemized in the invocation to Mary. Mary, whose body is first celebrated as the "cloistre blisful" (line 43) of the Logos, is metaphorically stripped of her womb ("wemmelees") and then masculinized, as is the speaker. Mary is apostrophized as the "sonne of excellence" (line 52), a verbal strategy that renders her both bodiless, part of the natural order, and oddly bodied as masculine. As "sonne" and "lyves leche" (line 56), she is invested with the common imagery of the divine Christ, losing, in the process, her feminine attributes but gaining the access to language that the feminine speaker, a "flemmed wreche" (line 58), does not possess. Not surprisingly, this exile from language shortly becomes masculine herself: she is, she says, an "unworthy sone of Eve" (line 52). This line has puzzled commentators, despite Pratt's commonsensical observation that it echoes the "Salve Regina," which any nun would have sung daily. In my reading, the Second Nun's enlistment of herself in the line of male progeny of woman reenacts her problematic relation to speech: she is an exile, she speaks as "none," as a woman silenced by a masculine institution that cuts her off from linguistic intercourse, that requires her to find a masculinized advocate to speak for her, that makes her body and its "contagioun" (line 72) an obstacle to speech, that makes her masculine as a speaker and thus represents the muting of the female voice. The semi-Manichaean overtones of the reference to the "contagioun" of the

25. Under its alternate entry of "wame" for "womb" the *Oxford English Dictionary* lists as alternate forms "wem, wemb; weme, weem, wyme."

body underscore the hierarchical ordering of spirit over flesh, man over woman, and Logos over word that both enables and undoes the discourse of the Second Nun. That hierarchy, is not, however, left undisturbed. At the heart of this stanza is an allusion to the parable found in Matthew (15:21–28) of the miracle performed for the Canaanite woman. The rhyme scheme highlights the detail of this parable that is significant for the Second Nun's purposes: the Canaanite woman's desire is fulfilled because of what she "sayde"—a word given prominence because it rhymes with "mayde," that is, Mary, the focus of this section of the prologue.[26] Furthermore, what the Canaanite woman desires, and speaks for, is that her daughter be healed; that is, she speaks efficaciously, on behalf of an absent, silent, impaired female. At the heart of the invocation to Mary, then, is an allusion that replicates the dependent relationship of the nun and Mary, but one that annuls the masculinizing of the efficacious speaker and recognizes, implicitly, the absence of the silent female.

The final stanza of the invocation to Mary exemplifies the problematic relations among speaker, audience, and language:

> Yet preye I yow that reden that I write,
> Foryeve me that I do no diligence
> This ilke storie subtilly for to endite,
> For both have I the wordes and sentence
> Of hym that at the seintes reverence
> The storie wroot, and folwen hire legende,
> And I pray yow that ye wol my werk amende.
> (Lines 78–84)

To some critics, it has appeared that the Second Nun merely uses "common sense . . . when she talks about rhetoric and inner meaning" in this stanza.[27] The nun's assertion here is conventional: this is her version of the humility topos familiar to readers of medieval literature. In it, she claims unqualified grasp of the "wordes and sentence" of Cecelia's legend and apologizes for her lack of style. The topos rests on the doctrine of the plenitude of language, and its corollaries, the vehicular nature of the (female) speaker and the neglect of style. A

26. See Clogan, "The Figural Style," p. 229, who points out that "the pure faith and witty reply of the Canaanite woman bring about the miracle she sought."

27. Grennan, "Saint Cecelia's Chemical Wedding," p. 479; Grennan goes on to commend the nun for "refusing to be drawn into subtleties which obscure and delay the narrative," an odd comment to make about the speaker of the elaborate tripartite prologue.

closer look, however, reveals that the stanza disturbs the valorization of truth in transparent language even while asserting it. Just before this address, the Second Nun begs the Virgin for help: "for to my werk I wol me dresse" (line 77). This prayer enlists what follows in the ranks of work rather than faith, reenacting an opposition stated earlier (line 64), where work is said to be that without which faith is dead. The interplay of mortality, life, and the Logos here buttresses the notion of living salvific language, for which the speaker claims no responsibility.

We have already seen that it is the masculinized Virgin who facilitates the Second Nun's entry into the realm of salvific language, and her approach to the tale of Cecelia is mediated by another masculine figure: "hym that at the seintes reverence / The storie wroot" (lines 82–83). The Second Nun is at least doubly displaced from the tale she tells: first, she has prayed the Virgin to cause her to tell it, and furthermore, she says she has both "wordes and sentence" from another authority. The latter assertion undoes its imputation of authority in at least two ways. First, the identity of the (masculine) authority here referred to is not entirely clear. He "that at the seintes reverence / The storie wroot" could refer either to Jacobus de Voragine, the name itself a figure for whatever hagiographic source the Second Nun—or Chaucer—relies on, or to a masculine Author of language.[28] More important, however, this attribution applies only to "the wordes and sentence" of the story the Second Nun is—finally—about to tell. She apologizes for not telling "this ilke storie subtilly." She has no style, she says. Instead, she will speak the "bisy" words of truth, she will "folwen hire legende."[29] In other words, the Second Nun's assertion of her simplicity makes the source of her tale double: she has "the wordes and sentence / Of *hym* that ... / The storie wroot" and she will "folwen *hire* legende" (my emphasis). The interplay of pronouns here creates an oscillation of authority between "hym that ... / The storie wroot" and the female (or plural) original of "*hire* legende," Cecelia herself as the unrepresentable repository of truth and author of her own legend. The apparent

28. On sources, and for an argument on Augustinianism in Chaucer's version of the tale, see Sherry L. Reames, "The Sources of Chaucer's 'Second Nun's Tale,' " *Modern Philology* 76 (1978–79): 111–35; cf. her argument in "The Cecelia Legend as Chaucer Inherited It and Retold It: The Disappearance of an Augustinian Ideal," *Speculum* 55 (1980): 38–57.

29. "Hire" can mean both "her" and "their"; either way, and especially because of the pronoun's duplicity, the Second Nun's claim to a single, authorized origin is made problematical.

plenitude of speech, the univocality of the tale here told and the "leg-ende," is here both asserted and rent asunder.

This stanza is the first explicitly to open the discourse to its audience. By substituting the plural pronoun "yow" for "thou," it signals the speaker's address to the pilgrim-reader audience—the first moment of such address in the triple prologue. Furthermore, it invites that audience's action upon language. My reading of this passage suggests that when the Second Nun invites "yow that reden that I write" to "my werk amende," Chaucer's language does more than reflect a stage in which this tale stood alone rather than as part of the *Canterbury Tales*. The invitation to the audience to amend a styleless conveyance of truth functions within an economy of language that asserts and already has split the unity of signifier and signified, of the legend of Cecelia and Cecelia as bearer of the Word. The disavowal of responsibility for style in an elaborately ordered prologue questions the speaker's claim to a vehicular relation to truth, a stylistically innocent representation of a "legende." The feminine speaker of Woman as bearer of the Word implicitly acknowledges her problematic relation to "bisy," salvific speech by calling it writing. What we have here is writing, whose distance from salvific speech can only be "amended" by the audience's willful entrance into the order that makes Woman the bearer of the Word without seeing Cecelia's dismemberment as the condition and content of such utterance. That dismemberment is figuratively enacted in the prologue by the etymological analysis of Cecelia's name.

The etymology that follows, much of which also appears in *The Golden Legend*, foregrounds the issue of translation, the movement of meaning from one language to another, from one speaker to another. It explicitly asserts that the meaning accorded Cecelia in the prologue is the same as that revealed in the tale. By doing so, it brings together linguistic analysis and the cutting-up depicted in the narrative. Understanding Cecelia's name, her meaning, the relation of signifier to signified, depends again upon a dichotomized hierarchy of opposites, this time between "hevene" and "Lia" (line 96), which signify, respectively, "hoolynesse" and "bisynesse."[30] Asserting opposition between these terms constitutes another step in the text's progressive

30. For a more conventional version of this opposition, see, e.g., Richard of St. Victor's *Benjamin Minor,* in which Rachel is taken as a symbol of the contemplative life, Leah ("Lia") as that of the active life.

interrogation of stable oppositions. Whereas "bisynesse" and "hooly-
nesse" were united in the first part of the prologue, in opposition to
"ydelnesse," now they are pulled apart. If Cecelia is indeed "the weye
to blynde," she is the path of the blind in both senses: the corrective
guide for the blind, and the blinding figure that conceals the necessity
of the repressed or subordinated term in any construction of meaning
built on hierarchy: sight over blindness, the Word over writing, mas-
culine over feminine, "auctoritee" over experience, spiritual over literal,
stasis over movement.

One apparently stable linguistic pair, "hoolynesse" and "bisynesse,"
rent asunder, the etymological prologue turns to other ways of taking
apart Cecelia's name.

> Or elles, loo, this maydens name bryght
> Of "hevene" and "leos" comth, for whych by ryght
> Men myghte hire wel "the hevene of peple" calle . . .
> For "leos" "peple" in English is to seye.
>
> (Lines 102–106)

"Leos"—here related to "lia"—is the Greek word for "people," as the
prologue asserts; but it is also the etymological root of "leod," the
Anglo-Saxon word for people.[31] So it is doubly true that " 'leos' 'peple'
in English is to seye." Such slippage between Greek and English is
exceedingly problematic in a passage emphatic in its insistence on
propriety ("By ryght," "wel . . . calle"). The passage expounds the mean-
ing of a Latin name by recourse to an older authorized language, which
has produced a word in an upstart vernacular tongue. To make sense
of Cecelia, in other words, requires upsetting hierarchies upon which
meaning seems to rest. But, continues the prologue, this action merely
transposes into "goostly" (spiritual) terms the natural order:

> And righte as men may in the hevene see
> The sonne and moone and sterres every wey,
> Righte so men goostly in this mayden free
> Seyen of feith the magnanymytee,
> And eek the cleernesse hool of sapience,
> And sondry werkes, bright of excellence.
>
> (Lines 107–12)

Wisdom is here declared visible in Cecelia just as the heavenly bodies
are visible in the sky: no interpretive effort—no *translatio,* no analysis—

31. Joseph Bosworth and T. N. Toller, *An Anglo-Saxon Dictionary* (Oxford, 1882–
98), s.v. "leod."

is necessary. Cecelia is the corporeal manifestation of her meaning, a transparent sign of the "cleerness hool of sapience." But what the text declares differs from what it enacts. People see faith and works united in Cecelia only by the contamination—or "contagioun," to use the prologue's language—of Latin by English, by an upsetting of hierarchy, by an interpenetration and exchange of linguistic signs, by analysis and interpretation. We see in Cecelia "the cleerness hool of sapience," the perfect unity of wisdom, only by a process of analysis. Cecelia's meaning, asserted to be whole, (w)hol(l)y Other, pure, and unified, is represented by linguistic strategies of dismemberment, scattering, contamination, doubling, and disturbing.[32] The prologue foretells the (meaning of) the tale by interrogating and upsetting the stable bases on which meaning rests. Wholeness is undone by the rhetorical and intellectual strategy of analysis, "cleerness" by repetition and substitution. Cecelia's single, clear meaning is represented as one thing after another: Cecelia is "the weye to blynde," "hevenes lilie," "hoolynesse" and "bisynesse," "wantynge of blyndnesse," or "the hevene of peple." Asserting unity, clarity, and wholeness, discourse here enacts alienation, repetition, and difference.

The relations of language, speaker, and audience having been rendered problematic by the prologue, the tale is told as an exemplar of "bisy," salvific speech. Its telling claims to reenact the salvific actions it relates, and so it is particularly important to understand the role of speech in the legend of Cecelia.

Discourse originates in the tale on the eve of the wedding of Cecelia and Valerian. Like the speech of the first and second parts of the prologue, Cecelia's first speech is private, addressed not to other human beings but to "God allone." Like the Second Nun's first efforts at discourse, it is private, interior speech:

> to God allone in herte thus sayde she
> "O lord, my soule and eek my body gye
> Unwemmed, lest that it confounded be."
> (Lines 136–37)

Like the Second Nun's opening discourse in its dislocation from social intercourse, this speech functions as an exemplar of Augustine's silent inner word, perfect speech, a representation of the Logos within the

32. For another treatment of dismemberment in *The Canterbury Tales,* see John P. Hermann, "Dismemberment, Dissemination, and Discourse: Sign and Symbol in the Shipman's Tale," *Chaucer Review* 19 (1984–85): 302–37.

human being.[33] All further speech in the tale originates in this perfect, internal, nonexchanging mode of speech. Note what this speech expresses: a desire to be "unwemmed" (line 137; unblemished and unwombed) both spiritually and physically. This speech takes up the Marian imagery of the prologue and associates it with Cecelia, who, like the Virgin, is represented as the bearer of the Logos: she "bar his gospel in hir mynde" (line 123) and converted others by her speech.

The tale's representation of direct discourse involving social interchange, however, originates with the wedding night, with the introduction of sexuality, division, and desire. A verbal exchange substitutes for and displaces sexual intercourse.[34] The "angel" that guards Cecelia's body from the "improper" opening that marital consummation would offer thereby facilitates the violent opening of the woman's body in the closing scene of the tale, for Cecelia's representation of this angel sets in motion the series of conversions worked by language that culminates in her martyrdom.

The first in the series of conversions, Valerian's, raises the issues of (male) speech, writing, and authority. Impelled by Cecelia's words, Valerian makes his way to a (physical) man, Urban, who enables him to see a ("goostly"—spiritual) man who holds out to him a book from which Valerian reads his creed and is converted. Conversion is mediated through writing and enacted by speech: hierarchy is maintained. Cecelia's authority is buttressed by the appearance of red and white

33. Augustine, *De Trinitate* XV, xi: "The word which sounds without is a sign of the word that shines within, to which the name of word more properly belongs. For that which is produced by the mouth of the flesh is the sound of the word and is itself also called the word, for that inner word assumed it in order that it might appear outwardly. For just as our word in some way becomes a bodily sound by assuming that in which it may be manifested to the senses of men, so the Word of God was made flesh by assuming that in which He might also be manifested to the senses of men." On some implications of this view of language, see Joseph A. Mazzeo, "Augustine's Rhetoric of Silence," *Journal of the History of Ideas* 23 (1962): 175–96. For a discussion of Platonic and Augustinian theories of language, though without reference to the question of gender, see Margaret W. Ferguson, "St. Augustine's Region of Unlikeness: The Crossing of Exile and Language," *Georgia Review* 29 (1975): 842–64.

34. The speech that Cecelia makes to Valerian is an even odder pillow lecture than that read to the knight by the hag in the Wife of Bath's tale, but the two lectures have in common their view of proper hierarchy. Anne Eggebroten has argued the comic nature of this scene and others in the tale, hoping to demonstrate the importance of "comic hagiography" in this and other tales within *The Canterbury Tales;* "Laughter in the *Second Nun's Tale:* A Redefinition of the Genre," *Chaucer Review* 19 (1984–85): 55–61.

crowns, signifying virginity and martyrdom, which are to be kept with "unwemmed thoght" (line 225). What does it mean for thought to be kept pure, undefiled, and unwounded? Among other things, the assertion suggests that it is the linguistic content—the transcendental signified—and not the vehicle of language—the body, the signifier—which is to be protected. Cecelia's body, that "foul contagioun," will indeed not be protected but wounded and then "worked" into a church, the church, a more satisfactory vehicle for "unwemmed thoght." More paradoxically, "unwemmed thoght," pure as it is, is able to participate in a promiscuous mingling of verbal "bodies" that effects the conversion of Valerian's brother Tiburce. After Valerian's verbal intercourse with his wife on their wedding night, Valerian prays,

> The fruyte of thilke seed of chastitee
> That thou hast sowe in Cecelie, taak to the.
> (Lines 193–94)

Valerian prays that Cecelia no longer be chaste, but his words are enacted differently. After the verbal intercourse of the wedding night, Cecelia is pregnant with the redemption of Valerian: she is delivered, not of chastity, but of the newly converted Valerian. Cecelia, like Mary, bears the Word, metaphorically, not literally; unlike Mary, her body is literally opened, in the metaphorical parturition of the beheading scene. The substitution of verbal for sexual promiscuity is further played out in Tiburce's conversion. Having begun with suspicions of his wife's fidelity (lines 167–68), a familiar mode in the *Canterbury Tales,* Valerian, newly redeemed, finds a new solution to the woe that is in marriage. In a speech that plays on the biblical sense of "knowing" as sexual intercourse, Valerian urges his wife to salvific (verbal) promiscuity:

> "I praye yow that my brother may han grace
> To knowe the truth, as I do, in this place."
> (Lines 237–38)

Valerian urges Cecelia upon his brother so that he too may have intellectual intercourse with the human, female bearer of the Word. Marriage is converted in this figure from the legal institution that unites husband and wife to a spiritual union, a sign of the redemptive union of God and soul, the familiar doctrine of the marriage of Christ and the church, of the unified mystical body. But, as John Hermann notes of a different marriage, "such a unity of two different elements is

produced by metaphor that masks its own ideality. The originary plen-
itude dismantled in the 'Shipman's Tale' [and in the Second Nun's
legend] is itself based on a utopian myth of presence which rhetorically
produces the fullness of being in the unity of husband and wife. The
notion of two become one flesh, a metaphoric reconstitution of the
myth of an originary unity, has no existence apart from its own rhet-
oricity."[35] In the Second Nun's legend, ideality is more apparent than
in the "Shipman's Tale": husband and wife become "one" only through
the mediacy of the (W)word.

But also in the nun's tale it seems as though woman is the privileged
speaker of the (W)word. Cecelia's speech motivates first Valerian's,
then Tiburce's conversion; her battle speech to Maximus and his cohort
enables their martyrdom; and her exchange with Almachius in the trial
scene (on which Chaucer places narrative emphasis) apparently rep-
resents a woman's victory over a powerful, if singularly obtuse, male
judge. Her exchange with Almachius clarifies the tale's representations
of woman, speech, and authority. First, Cecelia employs scholastic
precision of speech to undo Almachius's ability as questioner. Then
she demonstrates the unavailability of authority to anyone who ex-
plicitly claims it, as Almachius does. Referring her own authoritative
speech to "thilke name . . . vertuous" (lines 456–57), Cecelia reveals as
hollow his claim to be master of life and death: he is but a "ministre
of deeth" (line 485).

Cecelia here speaks triumphantly and powerfully; but does she speak
as and for woman? As Luce Irigaray says, "In order to prevent the
other—not the inverted alter ego of the masculine subject or its com-
plement, or its supplement, but that other, woman—from being caught
up again in systems of representation whose goal or teleology is to
reduce her within the same, it is of course necessary to interpret any
process of reversal, of overturning, also as an attempt to duplicate the
exclusion of what exceeds representation: the other, woman. . . . To put
a woman in a Socratic position [or a scholastic position] amounts to
assigning the mastery of discourse to her. Putting her in the traditional
position of the (masculine) subject." Has the woman simply been
annulled, "nunned" in the Second Nun's discourse?[36] Despite the nar-

35. Hermann, "Dismemberment," p. 313.

36. Irigaray, *This Sex,* p. 159. One of the few critics to raise the issue of gender in
this tale, Kolve asks, in "Chaucer's *Second Nun's Tale,*" "Where are we to find the woman
in Cecile?" (p. 151); he defines the gender issue in the context of a struggle to see
Cecelia as more than an abstract sign of the power of chastity, and answers his question

rative emphasis given the trial scene and its representation of woman as triumphant speaking subject, the tale does not end here. It closes instead with a recapitulation of the meaning of Cecelia given in the etymology: Cecelia dismembered, Cecelia, "hir nekke ycorven," speaking with perfect efficacity, most effectively when apparently least able to speak. Her words issue out of the violently opened body of woman, that logically mute thing that here no human agency can silence. Representing first a masculinized feminine speaker and then an opened body spewing forth speech, the words of the (masculine) author and the (feminine) speaker blindly interrogate the conditions that enable logocentric speech: woman as bearer of the Word, as the "flat mirror" of the masculine subject.[37]

It is Cecelia as speaking body who has the last word. The scene of her martyrdom interrogates the subordination of the signifier to the transcendental signified that it apparently manifests. To return to Fisher's comment about the distortion of the humanity of Prioress and Second Nun by "their institution," the institution that distorts is not the nunnery but the gendered construction of a system of meaning. What is distorted is not so much the "humanity" of Second Nun and Prioress, but their "femininity," which is revealed not as femininity but as inverted masculinity, a fantasy of difference; sameness, not otherness. Their tales, which purport to speak the Word, instead delineate the "rule of the signifier—the dead, alien, stubborn material which is the necessary and inevitable support for a concrete discourse and act of speaking—over the speaker."[38] By representing—and allowing the pilgrims no comment on—the hagiographic discourse of the faceless, feminine, "Second Nonne," the "other no one," and by allowing the Prioress to identify with both Word and bearer of the Word (while denying their separation), Chaucer's text interrogates the doctrines of the unity of thought and language, the hierarchies of male and female, "auctoritee" and experience, speech and writing, salvific word and redemptive act, on which it apparently rests.

as if "woman" were synonymous with "mother": "The chaste virgin . . . becomes spiritual mother" (p. 152).

37. Irigaray, *This Sex,* p. 129.
38. Gallop, *Daughter's Seduction,* p. 114.

Cynthia Hahn 8

Speaking without Tongues:
The Martyr Romanus and Augustine's
Theory of Language in Illustrations
of Bern Burgerbibliothek Codex 264

Saints conform to types. A saint's nature as martyr, virgin, or con-
fessor controls his or her place, status, and actions. For a simple dem-
onstration of this fact, one need look no farther than medieval
gatherings of texts or pictures; any collection not organized by feast
day was organized according to category. Legendaries, litanies, and
the illustration of the All Saints' Feast (Figure 8.1), each were com-
posed according to the basic types of saints.[1] As hagiographic genres
developed, categories that were more specific but just as type-bound
appeared: bishop, monk, or royal saint.[2] All these saintly classes are of
crucial importance to the reader or viewer because saintly lives conform

1. For legendaries, see Guy Philippart, *Les légendiers latins et autres manuscrits ha-
giographiques,* Typologie des sources du moyen âge occidental, 24–25 (Turnhout,
1977); for litanies, see Maurice Coens, *Recueil d'études bollandiennes,* Subsidia Hagio-
graphica, 37 (Brussels, 1963); and for All Saints' images, see "Allerheiligenbild," in
Lexikon der christlichen Ikonographie (Rome, 1968–), 1:101–103. This essay was com-
pleted in the spring of 1988 and, unfortunately, does not take into consideration some
of the new and apparently very interesting scholarship on the work of Prudentius.

2. These types are not recognized in lists or collections but reveal themselves in the
vitae and their illustrations. For bishops, see Frantisek Graus, *Volk, Herrscher, und
Heiliger im Reich der Merowinger: Studien zur Hagiographie der Merowingerzeit* (Prague,
1965), and Cynthia Hahn, *Passio Kiliani...Passio Margaretae: Faksimile-Ausgabe des
Codex,...MS. I 189...aus dem Besitz der Niedersächsischen Landesbibliothek Hannover,*
Codices Selecti, 83 (Graz, 1988), pp. 39–74; for monks, see scattered material in
Barbara Abou-el-Haj, "The First Illustrated Life of Saint Amand: Valenciennes, Bibl.
Mun. 502" (Ph.D. diss., University of California at Los Angeles, 1975); for kings, see
my article on St. Edmund (forthcoming, *Gesta*), and Robert Folz, *Les saints rois au
moyen âge en occident (VIe–XIIIe siècles),* Subsidia Hagiographica, 68 (Brussels, 1984).

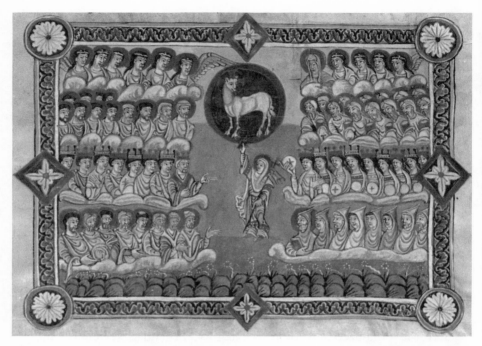

Figure 8.1. All Saints Feast illustration. Fulda Sacramentary, Göttingen Niedersächsische Staats- und Universitätsbibliothek Cod. theol. 231, fol. IIIr.

to saintly types. Types help readers to understand the saints because each saint's life develops according to expectations of his or her class.

The passion of Romanus of Antioch, the subject of this essay, cannot be understood without a comprehension of the workings of saintly type, or in his case, types. Romanus is of the type "martyr" but also of the more complex type "rhetor." As that of a martyr, the passion of Romanus follows Christ's example in his life, torture and death.[3] As that of a rhetor, the passion of Romanus reveals truths about Christian speech. Although one aspect of his life promises narrative and the other discourse, the two types are unified in the concept of witness, witness that encompasses both word and action. Although uniquely presented in the passion of Romanus, the concept is an ancient one. The Greek *martureo* means "to bear witness . . . in favor of another," the "other" here being, of course, Christ.[4]

3. Hippolyte Delehaye, *Les passions des martyrs et les genres littéraires*, Subsidia Hagiographica, 13b (Brussels, 1921).

4. Henry Liddell and Robert Scott, *A Greek-English Lexicon* (Oxford, 1968), p. 1082.

The miniatures of the saintly *passio* of Romanus of Antioch in Bern codex 264 (probably from Reichenau, about 900) illustrate the tenth poem of Prudentius's *Peristephanon*.[5] In his text, the fifth-century Christian poet uses the narrative of the passion of Romanus to explore speech as it applies to the problem of Christian rhetoric. Unjust, just, and sanctified speech are all present. Indeed, Prudentius concerns himself with the same controversies over the status of Christian speech that compelled his contemporary, Saint Augustine, to write one of his most influential treatises, *De doctrina Christiana*.[6] The problems of speech that both Augustine and Prudentius address include the possibility of pure and holy speech, the relationship of speech to the church, and the authority to preach. Unlike Augustine, however, but as he recommended, Prudentius used narrative to make his argument, and this narrative supplied the vivid story that is illustrated in the Bern manuscript.[7]

Prudentius situates his problem of speech with a long discourse on the production of speech in and by the body; he discusses the functions of the tongue, lips, teeth, palate, throat, and lungs as tools in the production of speech.[8] Through this discourse we are introduced to

5. Otto Homburger, *Die Illustrierten Handschriften der Bibliothek Bern: Die vorkarolingischen und karolingischen Handschriften* (Bern, 1962), pp. 136–58; and Ellen J. Beer, "Überlegungen zu Stil und Herkunft des Berner Prudentius—Codex 264," *Florilegium Sangallense: Festschrift für Johannes Duft zum 65. Geburtstag*, ed. O. P. Clavadetscher, H. Maurer, and S. Sonderegger (St. Gall, 1980), pp. 15–57. There is no earlier cycle of Romanus but Bern may be a copy: Hahn, *Passio Kiliani*, p.82, n.2. Two later illustrations of the life exist. One is thirteenth-century French: E. Brassart, *Les peintures murales du moyen âge et de la Renaissance en Forez, ouvrage publié par la Société de la Diana* (Montbrison, 1900); the other is Byzantine: Cosimo Stornajolo, *Menologio di Basilio II*, Codices e Vaticanis selecti, 8 (Turin, 1907), p. 190.

6. Augustine, *On Christian Doctrine* [*De doctrina Christiana*], trans. D. W. Robertson, Jr. (Indianapolis, 1958); James J. Murphy, *Rhetoric in the Middle Ages: A History of Rhetorical Theory from St. Augustine to the Renaissance* (Berkeley, 1974), p. 47; and Marcia Colish, *The Mirror of Language: A Study in the Medieval Theory of Knowledge*, 2d ed. (Lincoln, Neb., 1983). The text of Prudentius's *Peristephanon* can be found in *Prudentius*, 2 vols., trans. H. J. Thomson, Loeb Classical Library (London, 1949); all citations will be to this edition, and quotations will be cited in the text by page and line numbers of the Latin, and page numbers of the English text, following the abbreviation *Prud*.

7. Augustine, *De doctrina Christiana*, 4.4.6, p. 121. In the Latin text, Augustine recommends that the teacher or preacher expand (*narrare*).

8. Here Prudentius in the *Peristephanon* gives a scientific introduction to the organs of speech: "the potency of the voice, forced out from the depths of the lung and launched in the vault of the mouth, now gives out sounds that reverberate from the palate, and again is modified by the row of teeth, and that for these processes the tongue plays the part of the nimble quill . . . that the throat blow like a set of pipes in concert with harmonious breath so as to make articulate words in the passages them-

God's own tool for speech, Romanus, a deacon, the Christian spokes-man ready to debate a pagan prefect. In the opening harangues of the text, the discourse of the opponents ranges across the usual topics for Christian apologetics, including a discussion by Romanus in astonish-ing antiquarian detail of the vanity of the pagan gods.

It is as the discourse progresses that Prudentius introduces elabo-rations into the debate that are of a quite remarkable character. Two are of particular significance: one involves miraculous production of speech and a second tells a martyr's story as an exemplum. The latter is especially notable because the martyrdom narrated in the exemplum actually occurs as Romanus speaks—Romanus explicates the martyr-dom of a Christian infant, Barulas, as it takes place "in reality." In fact, of course, this reality is only the rhetorical "effet de réel."[9] The episode is a later interpolation that does not even occur in the earliest lives of Romanus.[10]

The early medieval artist who created the illustrations is very per-ceptive of the fifth-century author's purposes and eloquently represents the problems of discourse that Prudentius raises. He is able to depict clearly both active narrative and the most abstract aspects of the prob-lems of speech. In addition, he is able to add ideas of his own: most important, that of representing sanctified speech taking on the qualities of revelation, reality, and presentness.[11]

The artist begins by establishing the locus of his narrative. The first miniature of the passion of Romanus depicts the confrontation of Christian and pagan as a confrontation of mundane and spiritual pow-ers (Figure 8.2). The artist represents the Roman emperor Galerius as a medieval king sending his emissary to subdue the troublesome Chris-tians. The depiction of Romanus is particularly interesting. Tonsured and seemingly clad in a cope and golden undergarment, he guards the entrance of his church, book in hand. His characterization as a monk

selves, or that in the orifice of the mouth the lips utter speech by being now slightly closed and again opened wide, like a pair of cymbals" (*Prud.* p. 290, lines 931–40; p. 291).

In this passage we see that the bodily organs of speech were understood in the early Middle Ages to be the lungs, palate, teeth, tongue, throat, and lips.

9. Nancy F. Regalado, "*Effet de réel, Effet du réel:* Representation and Reference in Villon's *Testament,*" *Images of Power: Medieval History, Discourse, Literature,* ed. S. Nichols and K. Brownlee, *Yale French Studies* 70 (1986): 64.

10. Hippolyte Delehaye, "S. Romain martyr d'Antioche," *Analecta Bollandiana* 50 (1932): 241–83.

11. See Cynthia Hahn, "Purification, Sacred Action, and the Vision of God: Viewing Medieval Narratives," *Word and Image* 5 (1989): 71–84.

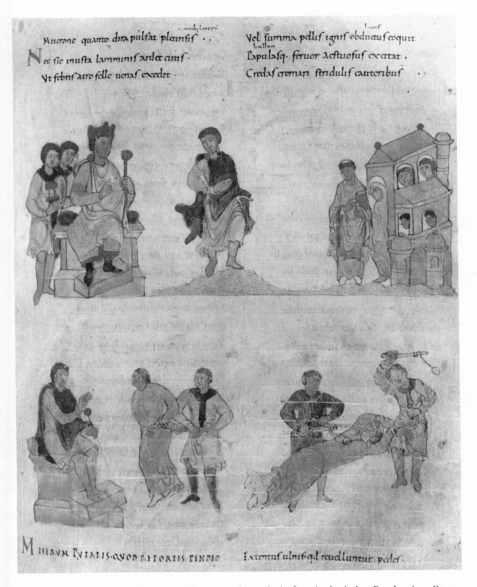

Figure 8.2. Romanus as deacon and Romanus brought before Asclepiades. Prudentius, *Opera*, Bern Burgerbibliothek Cod. 264, p. 131.

may derive from alternate versions of the passion, which portray him as a cenobite, but this may also be the addition of the ninth-century artist, who was certainly a monk.[12] Clearly, his position shows that Romanus speaks for the church as part of the ordained clergy. The book, as typically in saints' lives, may be understood as a symbol of Christian wisdom and doctrine. Romanus's position also indicates that he defends his church against the attacks of predators.

The Gospel metaphor of the shepherd protecting his flock from the wolf comes to mind as a comparison to this image.[13] One early Christian representation of this theme, on the fourth- or fifth-century Brescia casket, is similar in disposition to the Romanus illustration. On the ivory, Christ as the Good Shepherd guards the entrance of a rather grandly architectural fold (Figure 8.3). Recently, the Brescia Good Shepherd has been interpreted, I think rightly, as a representation of the bishop's duty to protect his flock: Ambrose used the story this way in his letters and his *Commentary on the Gospel of Luke*.[14] Since the Council of Nicaea, bishops had been at the center of discussions about Christian rhetoric and its possibilities for learning and preaching.[15] As a result, the power to preach came to be considered an elevated power of speech that Prudentius and Augustine in the fifth century accorded only to the clergy and specifically to bishops. By the Carolingian period, however, the clergy as a whole had achieved a much more sanctified position and had been elevated to the authority to preach.[16] In the Bern miniature, more than deacon or monk, Romanus is cast as the primary defender not only of his church but of *the* church. This characterization of the saint is pictorial, but it perfectly illustrates the sense of Romanus as Christian spokesman that Prudentius conveys in his text as a whole.

The woman who stands behind Romanus in the doorway of the church is also clearly an important figure. Other figures (or heads) are diminutive in comparison with Romanus and this woman. She could be merely a member of the church's congregation, but no woman is

12. Delehaye, "S. Romain," pp. 261 and 280.

13. *Prud.*, p. 236, line 106; p. 237. Romanus himself speaks of guarding the blessed doorway and denies Asclepiades entrance unless he becomes one of the "flock."

14. Carolyn J. Watson, "The Program of the Brescia Casket," *Gesta* 20 (1981): 283–98, esp. pp. 285–86.

15. J. J. Murphy, ed., *A Synoptic History of Classical Rhetoric* (Davis, Calif., 1983), p. 183.

16. Rosamund McKitterick, *The Frankish Church and the Carolingian Reforms, 789–895*, Royal Historical Society Studies in History (London, 1977), p. 68.

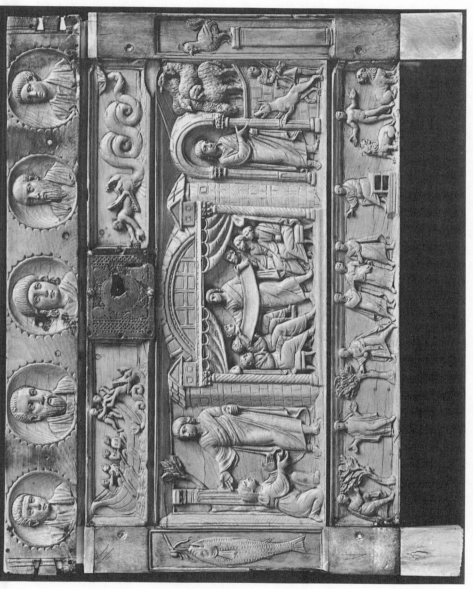

Figure 8.3. Christ as the Good Shepherd; detail from the front of the Brescia casket. By permission of the Civici Musei d'Arte e Storia di Brescia.

singled out in the text. Instead, she looks very much like a character who will be important in the second half of the narrative, the mother of the infant martyr Barulas. It should be understood, however, that Barulas's mother is not being introduced here in a form of prolepsis. Rather, both here and later in the illustrations, the woman, clad in a modest blue robe, is meant to represent Ecclesia, an identification that is implicitly but clearly advanced in the text of the Barulas exemplum.[17] The woman's significance is equally clear in this first miniature because of her position in the portal of the church. Furthermore, as Ecclesia she makes a natural pair with Romanus in his role as holy spokesman. Indeed, she will do her share of speaking. So, in the first miniature various themes have been introduced: Romanus's right to speak for the church, his protection of it, and the participation of the church itself in his discourse.

The visual narrative, the "action," gets under way with miniatures that purposefully conform to the type of a martyr's passion. The first scene following the introduction shows Romanus eagerly confronting Asclepiades, the prefect; indeed, he pulls his jailer in behind him (Figure 8.2). This scene might be compared to any number of martyrs' lives, for example, a scene from the passion of Agatha, in a somewhat later, tenth-century French manuscript (Figure 8.4).[18] The type in fact may be traced to a scene in the life of Christ, Christ brought before Pilate, as in the Fulda Sacramentary in Göttingen.[19]

The confrontation of Christian and pagan is followed by three tortures. The occurrence of three tortures is absolutely typical in martyrs' lives, reflecting the importance of that number for Christian symbolism.[20] Furthermore, the nature of the first two of Romanus's tortures is typical: He is first beaten and then scraped with claws. The Carolingian gloss on the text expands here—the *fidiculae* mentioned in the text are said to be iron claws that test the faith, the *fides* of the martyr.[21]

It is with the third torture that something out of the ordinary for a

17. Wolfgang Greisenegger, "Ecclesia," in *Lexikon der christlichen Ikonographie,* 1:562–69.

18. Magdalena Carrasco, "An Early Illustrated Manuscript of the Passion of St. Agatha (Paris, Bibl. Nat. MS Lat. 5594)," *Gesta* 24 (1985): 19–32.

19. Fol. 60r: *Sacramentarium Fuldense, Saeculi X, Cod. Theol. 231 der K. Universitätsbibliothek zu Göttingen,* ed. G. Richter and A. Schönfelder, Quellen und Abhandlungen zur Geschichte der Abtei und der Diözese Fulda, 9 (Fulda, 1912), Pl. 22.

20. For topoi in torture illustration, see Hahn, *Passio Kyliani,* pp. 106–10, and 120.

21. Hubert Silvestre, "Aperçu sur les commentaires carolingiens de Prudence," *Sacris Erudiri* 9 (1957): 50–74.

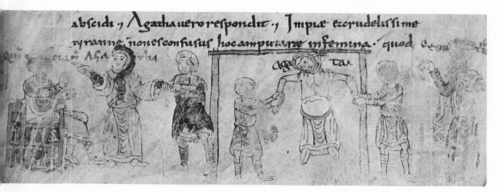

Figure 8.4. Agatha is brought before Quintianus. Collection of Saints' Lives, Paris, Bibliothèque Nationale, MS Lat. 5594, fol. 69r.

martyr's passion is introduced. After the veritable flood of Romanus's words in defense of the Christian faith, Asclepiades, the pagan, is so inflamed by the martyr's persistent speech that, thinking to quell the torrent, he has his agents torture Romanus's "very words" (*Prud.*, p. 266, line 555, and p. 267). The lictors score Romanus's cheeks with the claws, "the bristly bearded skin is torn in pieces and the whole countenance cleft down to the chin" (*Prud.*, p. 266, lines 558–60, and p. 267). But the martyr replies, "Much thanks I owe to you sir, because now I open many mouthes to speak of Christ. . . . For every wound I have, you see a mouth uttering praise." This last phrase signals Prudentius's singular representation of the conjunction of martyr and rhetor—any martyr's wounds of torture witness to Christ, Romanus's doubly so because each mouths his words.[22] The artist in this one case is not equal to the elevated abstraction (Figure 8.5). Avoiding the literal depiction of the metaphor, wounds as mouths, he depicts the lictors pulling on Romanus's lips; in attempting to illustrate the torture of the martyr's words, he has relied on the words of the glossarist, who has written, *verba id est labra* (words, that is, lips).[23]

In the economy of the narrative, however, this torture of Romanus the rhetor serves a purpose much more important than that of supplying Prudentius with the occasion for an apt metaphor. The torture of Romanus's words is made to serve as purification. Romanus's speech

22. This metaphor may seem familiar to many readers because Shakespeare uses it twice in *Julius Caesar*.

23. In the text, a recording angel does draw "exact pictures" of every wound, and these wounds will argue for Romanus before the heavenly court (*Prud.*, p. 302, lines 1121–30; p. 303).

Figure 8.5. Romanus's words, or lips, are tortured. Prudentius, *Opera*, Bern Burgerbibliothek Cod. 264, p. 133.

hereafter is pure and free from sin. As he says, "the pleasure of the flesh runs through the whole gamut of wickedness. Apply healing treatment to these great ills, I pray you, executioner. Cut up and rend that which is the prompter of sin. By cutting away the filthiness of the weakly flesh, bring about the survival of the spirit" (*Prud.*, p. 264, lines 516–19, and p. 265). Furthermore, his speech is even strengthened, or more specifically, multiplied by the torture that "cleft" his countenance.

After his purification, Romanus ceases to speak as a learned apologist. Instead, he makes a short speech on the sacramental nature of Christ's death on the cross, using a metaphor of God's light, which is invisible to the spiritually blind. Abruptly, he cuts off his discourse, disdaining to cast "pearls among unclean swine" (*Prud.*, p. 272, lines 648–50, and p. 273).

In the illustration of this text, the first miniature following the purification of Romanus's speech, the artist vividly demonstrates the power of that speech by depicting its reality (Figure 8.6). It is *realized* by the representation of Romanus holding a physical golden cross, an object that does not occur in the text. The cross is wielded by the saint as a kind of emblem of power that confounds the prefect's wise men and counselors (the men that stand behind the dais).

It is after Romanus disdains further explication of dogma, however, that a much more dramatic realization of his discourse occurs in both text and image. A second, embedded narrative ensues, which is not only a story, but purportedly, a series of events that actually takes place

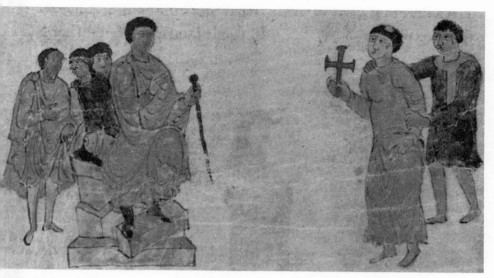

Figure 8.6. Romanus preaches of the cross. Prudentius, *Opera*, Bern Burgerbibliothek Cod. 264, p. 135.

as the two rhetors, Christian and pagan, discuss it. As striking as the presentation of this story is in the text, it is the pictures that represent the *exemplum* as a revelation of Christian truth.

The artist's means of representation of the martyrdom of the infant Barulas is deceptively simple. In certain of the Barulas miniatures (Figures 8.7 and 8.8, also p. 138) the image is either figuratively or literally "framed" by the figures of the pagan rhetor on the left and the Christian on the right. (In one case the infant's mother, as I have identified her, Ecclesia, speaks for the Christians.) In the center, speech is realized in pictorial narrative as Christian commonplaces come to life, for example: knowledge as the pure milk of mother church or truth from the mouths of babes.

In the first of the miniatures (Figure 8.7), the artist illustrates the challenge that initiated the martyrdom of Barulas, the infant. Romanus says, "Let us inquire of the verdict of the natural understanding." Asclepiades agrees and they choose "one not long weaned." The "innocent suckling," however, testifies to the one Christ and throws the prefect into a wild rage. He demands to know by whom the infant was taught. Barulas replies: "My mother, and God taught her. Instructed by the Spirit she drew from the Father that wherewith to feed me in my very infancy, and I in drinking as a babe the milk from the twin founts of her breasts drank

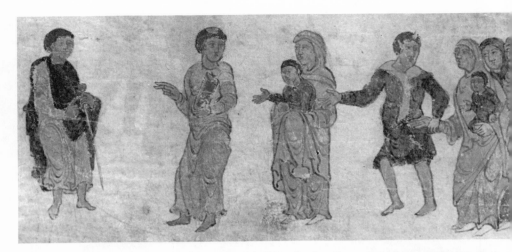

Figure 8.7. Barulas is chosen from the crowd. Prudentius, *Opera*, Bern Burgerbibliothek Cod. 264, p. 136.

in also the belief in Christ" (*Prud.*, p. 274, lines 681–85, and p. 275). Clearly, the mother is figured here as a type of the church. Also, rather than a child of seven that the text specifies, the artist represents the realized metaphor and depicts a babe in arms.

It is, however, a third commonplace, the sacrifice of an innocent life as the source for the church, which, through pictorialization, reveals that the narrative speaks divine truth (Figure 8.8). Again the artist uses the text as a framework upon which to build an expanded imagery. In the text, Asclepiades gave orders to lift up the boy, beat him, and whip him with switches. The strokes drew "more milk than blood" (*Prud.*, p. 276, line 700, and p. 277) from the suckling, and the spectators wept uncontrollably—except for the mother. When the baby cried out that he was thirsty, she scolded him: "You ask for water to drink, though you have near by the living spring which ever flows and alone waters all that has life, within and without, spirit and body both, bestowing on those who drink. You will soon reach that stream if only in your heart and inmost being your one eager, ardent longing is to see Christ, and one draught of it is ample to allay all the burning of the breast so that the blessed life can no longer thirst" (*Prud.*, pp. 276 and 278, lines 726–35, and pp. 277 and 279). The artist has used this text to elaborate the torture episode into a full-page representation of a vision of the earthly church.

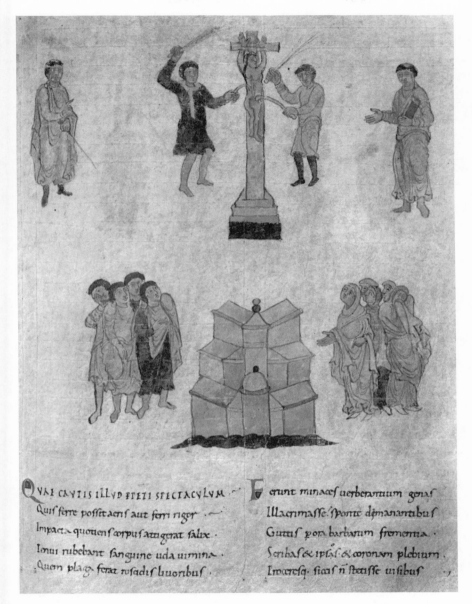

QVAE CANTIS ILLVD STETI SPECTACVLVM ·
Quis ferre possit acris aut ferri rigor ·
Impactu quotiens corpus attigerat salix ·
Imui rubebant sanguine uda uimina ·
Quem plaga ferat nsadis liuoribus ·

Ferunt minaces uerberantium genas
Illacrimasse. sponte demanantibus
Guttis porta barbarum frementia ·
Scribas & ipsas & coronam plebium ·
Imaresq. sicas n' stetisse uisibus

Figure 8.8. Barulas is whipped and scraped. Prudentius, *Opera*, Bern Burgerbibliothek Cod. 264, p. 137.

The cry for water recalls Christ's cry from the cross. In the upper part of the miniature, the infant Barulas is represented as suspended on stocks that are made to look remarkably like a cross, even down to the stepped pedestal. He is beaten with switches but also scraped with the *fidiculae* that test his faith. Furthermore, his hair, which before was cropped short, now is long and lies in wisps upon his naked shoulders. Clearly, the viewer is meant to realize that the child is likened to Christ.

The mother's homiletic response to her infant's cry evokes an important contemporary metaphor for Christ, the fountain of life. Rabanus Maurus wrote of the fountain and linked it not only to Christ but also to the church: "The river goes forth from Paradise carrying the image of Christ from the flowing source of the Father who waters His church with the word of preaching and the gift of Baptism."[24] In the miniature, as the mother talks, she gestures toward a large building. This edifice is surely a church; the faithful are even divided as if participating in the liturgy, with women to the left and men to the right. It is as if the blood of the infant martyr in his likeness to Christ waters the church, a "flowing source," and a similacrum to the sacrament of the Mass.[25]

We may understand why the artist has been encouraged to mix his metaphors in this way, depicting the fountain as a church, if we read earlier in Prudentius's text: "[God] has established [a temple] for himself in the soul of man, one that is living, clear, perceptive, spiritual, incapable of dissolution or destruction, beautiful, graceful, hightopped, coloured with different hues. There stands the priestess in the sacred doorway; the virgin Faith guards the first entrance, her hair bound with queenly ties, and calls for sacrifices to be offered to Christ and the Father which are pure and sincere, such as she knows are acceptable to them" (*Prud.*, p. 252, lines 346–55, and p. 253). The edifice of the church in Figure 8.2 could have illustrated this passage with "Faith guarding the entrance." But the passage applies equally well to this miniature (Figure 8.8), mixing the qualities of a fountain, "living, clear" and those of a church, multicolored, "hightopped" and guarded by a

24. "Fluvius de paradiso exiens, imaginem portat Christi de paterno fonte fluenti qui irrigat Ecclesiam suam verbo predicationis et dono baptismi" (cited by Paul Underwood, "The Fountain of Life in the Manuscripts of the Gospels," *Dumbarton Oaks Papers* 5 [1950]: 41–138).

25. A comparable image of a martyr from which flows the "fountain of life," or more literally in this case, the four rivers of paradise, can be seen in an early Christian (sixth cent.) silver reliquary from Carthage now in the Vatican (H. Buschhausen, *Die spätrömischen Metallscrinia und frühchristlichen Reliquiare*, Wiener byzantinische Studien, 9 [Vienna, 1971], 1:242–43, Pls. 48–49).

priestess who calls for sacrifices. In a very real sense in this illustration Ecclesia guards the entrance to the faith because it is she who calls for the sacrifice of the infant martyr that will convert the weeping spectators that stand on either side of the edifice.

Finally, let us not forget that the scene in Figure 8.8 is framed by the figures of Asclepiades and Romanus, each making a gesture of speech. As noted above, the entire Barulas narrative, as an embedded exemplum, can be considered simply as an illustration or realization of the efficacy of the rhetors' respective discourses, and it is by the framing device that the artist conveys this concept. Clearly, Asclepiades, who carries only the staff of mundane power in the scene, is vanquished here by Romanus, who holds a golden book that must symbolize his pure and perfect faith.[26] While the speech of faith, or Ecclesia, converts the people within the miniature, Romanus's speech moves the hearts of both the spectators within the text and the viewers without. His discourse is, as Rabanus would have it, the "word of preaching" that waters the church. Thus the imagery of fountain or source is multiplied in this miniature: it is the suffering of the martyrs, the sacrifice of an innocent as a parallel for the Mass, the proud edifice of faith, and the true speech of the preaching of the clergy.[27] Furthermore, the miniature ultimately makes a direct appeal to the viewer. Even while the infant martyr turns his back on us, that is, is neither literally nor figuratively presented as an iconic figure of pity, Romanus and Ecclesia call to us to find our own temple "within the soul" and to make sacrifices that are "pure and sincere" in imitation of the Christian saints.[28]

But the passion of Romanus does not end with this exegetical and affective visual narrative. In both text and illustrations, the child is further tortured, three times in all, as is Romanus.[29] Both are martyred. These scenes confirm the status of both Romanus and Barulas as witnesses.

26. *Prud.*, p. 238, lines 141–50; p. 239. Romanus ridicules the signs of mundane power, especially the ivory eagle.

27. A remarkable visual parallel to this idea of the clergy associated with fountain imagery may be found in Byzantium; see Christopher Walter, *Art and Ritual of the Byzantine Church* (London, 1982), pp. 111, 113.

28. For similar calls upon the viewer to make a personal sacrifice, usually in the form of the Mass, see Hahn, *Passio Kyliani*, pp. 115–19.

29. The second torture is the moment when the artist literally illustrates the mother's offer to drink the bitter cup—Asclepiades holds a gold chalice (p. 138 of the codex). Again the artist actualizes the metaphoric, not out of naïvete, but in order to show the power and substance of the Christian *verbum*. Also, for torture in triplicate see n. 20 above.

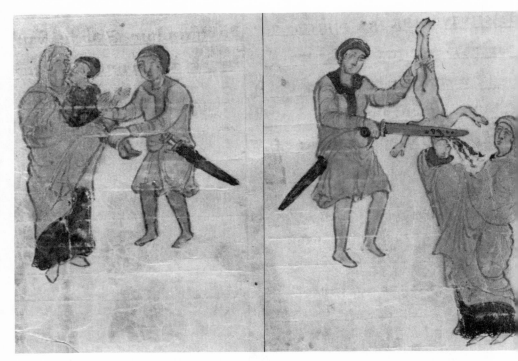

Figure 8.9. Barulas is martyred. Prudentius, *Opera*, Bern Burgerbibliothek Cod. 264, p. 142.

The depiction of his martyrdom further reinforces the child's identity as an innocent and the mother's as Ecclesia (Figure 8.9). She gives him a kiss of farewell that, in the tender touching of the mother's cheek to that of her child, may be compared to the pose of images of the virgin Elousa.[30] She then receives his head in covered hands, surely an image of his acceptance as a sacrifice worthy to join the ranks of the martyrs. Furthermore, he is martyred in a fashion very similar to the murder of the babies in some representations of the Massacre of the Innocents, that is, held up by the legs in rather awkward fashion and decapitated.[31] Thus his "innocence" is affirmed visually.

Similarly, the scenes of Romanus's torture and martyrdom reaffirm his status as Christian rhetor. After an unsuccessful attempt to burn Romanus, Asclepiades tries to silence the Christian spokesman first by

30. The Walters Art Gallery, *Early Christian and Byzantine Art* (Baltimore, 1947), fig. 160.

31. See Gertrud Schiller, *Ikonographie der christlichen Kunst* (Gütersloh, 1966), vol. 1, fig. 299, a miniature from the Rabula Gospels of 586.

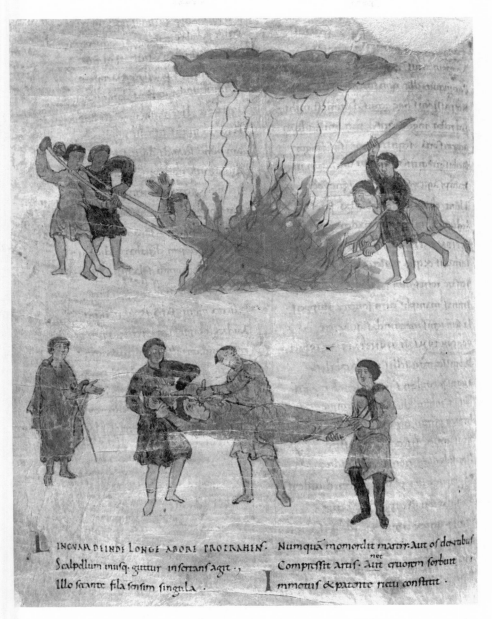

LINGVAM DEINDE LONGE ABORE PROTRAHINS· Numquā momordit martir·Aut os dentibus
Scalpellum inusq· guttur insertans agit·, Compressit artis· Aut cruorem sorbuit
Illo secante fila sensim singula· Immotus &patente rictu constitit·

Figure 8.10. A miraculous rain shower saves Romanus from death by fire, and Romanus's tongue is cut out. Prudentius, *Opera*, Bern Burgerbibliothek Cod. 264, p. 144.

cutting out his tongue at its very root (Figure 8.10) and then by strangling him. Again, in neither case is he successful and Romanus continues to speak, now miraculously without a tongue. As a number of other saints speak without tongues, the miracle is almost a hagiographic topos and one especially suited to bishops or clergymen as the evidence of Saint Leger of Autun suggests.[32] As Prudentius declares of Romanus in his introduction, even if a tongue is ripped out: "The voice that bears witness to the truth cannot be annihilated.... 'Seek not with forethought for words when my mystic doctrine is to be proclaimed' (Matt. 10:18–20).... In myself I am dumb, but Christ is a master of eloquence; He will be my tongue" (*Prud.*, pp. 228 and 230, lines 8–22, and pp. 229 and 231). Remarkably, the usual equivalence of martyr to Christ is changed here: now the martyr's tongue may serve as a representation of Christ.

At the outset I noted that Prudentius was concerned in the tenth poem of the *Peristephanon* with the same problems of rhetoric that Augustine addressed in *De doctrina Christiana*. The similarity is not a superficial one but one that addresses the basic problems of Christian speech: authority and truth. Because Augustine's rhetoric is the most influential of the Middle Ages, it is perhaps not surprising that the strategies that Prudentius and/or the Bern artist employed in seeking an imagery to depict the complexities of the life of a Christian rhetor often parallel Augustine's rhetorical ideas.[33]

Augustine and Prudentius use virtually the same imagery to create a figure for the purgation that must precede Christian wisdom and speech.[34] In the *Confessions* we read, "The tongue of Victorinus, that great and sharp sword ... had been taken from him and purified, made fitting to your honor and useful to the Lord for every good work."[35] Also, at the end of the *Confessions,* just before beginning his spiritual

32. See E. Cobham Brewer, *A Dictionary of Miracles* (Philadelphia, 1884; repr., Detroit, 1966), pp. 292–93, where other examples of tongueless speech are cited.

33. Prudentius is contemporary with Augustine and may be using Augustine himself. Although Augustine could not be called typical, however, he is representative of rhetorical discussions of the post-Nicaean period: see Murphy, *Rhetoric in the Middle Ages,* p. 47. Furthermore, it can be argued that many of the ideas that Augustine treats are already present in Pauline writings: see Eugene Vance, *Mervelous Signals: Poetics and Sign Theory in the Middle Ages* (Lincoln, Nebr., 1986), p. 34. For a discussion of the effects of rhetoric in Byzantine art, see Henry Maguire, *Art and Eloquence in Byzantium* (Princeton, 1981), and "The Art of Comparing in Byzantium," *Art Bulletin* 70 (1988): 88–103.

34. Vance, *Mervelous Signals,* p. 20, notes this as well.

35. Augustine, *Confessions,* 8.4.9; cited in Colish, *Mirror,* p. 31.

exegesis of Genesis, Augustine prays that his inner and outer lips be circumcised.[36] Repeatedly, it is the physical organs that must be purified before Christian speech can take place, because it is only through those physical tools of speech that the preacher will be able to convey truth to others. The audience is never forgotten; purified speech exists not for the sake of the speaker but for that of the listener-viewer. Romanus speaks to us.

But why is the moment of purification so important in validating Christian speech? Given that for Augustine human speech is empty and knowledge comes only from God's speech, the question of the acquisition of such knowledge is problematic. For Augustine truth is a process of achieving knowledge rather than a thing in itself; access to knowledge comes through purification or purgation and movement. In *De doctrina Christiana,* Augustine describes seven steps to wisdom. The fifth and sixth steps both involve purification; the fifth, the purgation of sin through Christian love, and the sixth, the cleansing of "the eye of the heart."[37] Only through having been purged himself and having made the ascent can Romanus assume his true vocation as a preacher and lead others to knowledge. Although the beginning of the path is, of course, the reading of the scriptures, the record of God's speech, Augustine also suggests that precept and preaching might inspire the Christian to his ascent.[38] In his status as martyr and rhetor, Romanus unites these two and is therefore doubly efficacious as a Christian spokesman.

In this exploration of Prudentius's poem and the Bern artist's illustration of it, we have seen that Romanus as rhetor and martyr possesses pure and holy speech because he has been tested and his body, especially the organs of speech, has been purified. The miniatures have also demonstrated that Romanus has the right to speak for the church. He protects and defends his flock and extends and promulgates the words of Ecclesia in his preaching. Thus far, the text and miniatures in their *imago* of the saint seek to re-present the saint and the nature of his sanctity.[39] Thereafter, the empowered *imago* of Romanus is able to

36. This is also like Paul's "circumcision of the heart." Romans 2:25–29, noted by Vance, *Mervelous Signals,* p. 8.

37. Augustine, *De doctrina Christiana,* 2.7.11, pp. 38–40.

38. Colish, *Mirror,* p. 24; also see Walter, *Art and Ritual,* p. 113, who describes texts where bishops are described as the "source" of wisdom, although the ultimate source is Christ. This is also interesting in light of the imagery of the fountain of life discussed above.

39. For a discussion of this sort of representation in text and image, see Cynthia

reach out to the viewer or listener, lifting them to true wisdom. In the exemplum of the infant Barulas, Romanus's speech can be seen to be full of affective truth. As an example, the sacrifice of the infant cleanses the soul of the viewer-listener through pity and leads one to a discovery of the "temple in the soul." In the miracle of his tongueless speech, however, Romanus's words rise above the limitations of imperfect language, and speak Christ's words directly. Finally, in his martyrdom, his *passio,* both text and images, is closed and sealed with a witness to faith that will never cease to speak to the Christian through both word and deed, discourse *and* narrative. In his *passio* and his passion, in representation and "reality," he has fulfilled the promise of both martyr and rhetor.

Hahn, "Picturing the Text: Narrative in the *Life* of the Saints," *Art History* 13 (1990): 1–32.

Non Alia Sed Aliter:
The Hermeneutics of Gender
in Bernard of Clairvaux

The image of the saint, in Bernard of Clairvaux, is a notably feminine image. In his sermons on the Song of Songs, we find what may be the most elaborate instance in the twelfth century of a feminization of religious language. In part, as Caroline Walker Bynum has argued, when Bernard represents both Jesus and abbots as mothers, he does so in order to feminize the idea of authority within the monastic community.[1] We might say that the old *metaphysics* of the soul as the bride of Christ now becomes a *politics*. This movement is central in Bernard's use of the feminine, but it is not the whole story. On the level of imagery, maternal images of nurturing and affectivity should be related to the fuller context of feminine imagery in the sermons; the maternal is not the only or even the dominant female imagery in the sermons, where, for instance, Bernard more often finds biblical role models in prostitutes than in the Virgin Mary and other mother figures. Second, the public or political aspect of Bernard's concerns can be complemented by further attention to the ways he uses feminine imagery in his representations of more private and personal relations of the soul to God.

To a certain degree, Bernard builds on the old metaphysical expository tradition stemming from Origen's commentary on the Song of Songs, in which the heroine of the Song is taken to be the soul, in its role as the bride of Christ. What is most distinctive in Bernard's ser-

1. Caroline Walker Bynum, *Jesus as Mother: Studies in the Spirituality of the High Middle Ages* (Berkeley and Los Angeles, 1982), chap. 4.

mons, however, is the particular way in which he seeks to link his metaphysical and his political concerns. In developing his ideas first and foremost through a sequence of sermons structured as biblical commentary—the sermons are by far his most extensive, as well as his most influential, work—Bernard presents his ideas in the mode of interpretation. The process of interpretation itself is one of the chief objects of Bernard's feminization, and his feminized politics is closely linked to a feminized *hermeneutics*.

The relations between Bernard's politics and his hermeneutics can be seen in differing ways. The feminized hermeneutics may be a tool developed to form a bridge between the traditional metaphysics of the soul as bride of Christ and the new feminized politics, which may be Bernard's real goal. Alternatively, the feminized politics may be an outgrowth of a more basic hermeneutical drive. The difficulty here of assigning priority either to the political or to the hermeneutical level is one aspect of the larger tension between the contemplative and active lives so widely found in the twelfth century in general and in Bernard in particular. However we assess the priority of levels, there is much to be gained from a joint examination of the personal, the political, and the hermeneutical "feminisms" in Bernard's thought.

This Is Not a Man, but a Woman

The sermons open by stressing the difference between the modes of interpretation most appropriate to the monastery and to the outside world: "Vobis, fratres, alia quam de aliis de saeculo, aut certe aliter dicenda sunt [To you, brothers, one should speak of different things, or at least in a different *way,* than to those in the world]."[2] Two themes are announced here and linked: that of brotherhood and that of otherness. It is the latter theme that structures the sentence, with the progression from the other things, *alia,* to the other people, *aliis,* to the other manner, *aliter,* in which one should speak. Throughout his sermons, Bernard will seek to give further definition to this monastic

2. Bernard of Clairvaux, *Sermones Super Cantica Canticorum,* vols. 1 and 2 of *Sancti Bernardi Opera,* ed. Jean Leclercq, C. H. Talbot, and H. M. Rochais (Rome, 1957–74); trans. Kilian Walsh and Irene Edmonds as *On the Song of Songs,* vols. 2–5 of *The Works of Bernard of Clairvaux,* Cistercian Fathers Series, 4, 7, 31, and 40 (Spencer, Mass., and Kalamazoo, Mich., 1971–80), Ser. 1, sec. 1. Henceforth, citations will be given in the text and will be to the number and section of a sermon.

otherness, the difference in manner by which the community can both be separate from the secular world and also epitomize it before God.

Women—or at any rate, the prevalent *images* of women—interest Bernard, then, for their otherness from men, and in particular for their ambiguous status as simultaneously essential members of society and second-class citizens, excluded from full participation in social life. As a result, women participate in many aspects of medieval society only indirectly, and this fact of women's lives has close parallels, for Bernard, in the various forms of indirect or mediated experience of God that are open to mortals. It is the indirectness of this experience that renders it a specifically hermeneutical issue, and it is in turn Bernard's attention to the means of mediation that renders his sermons so pregnant with hermeneutical observations, as he develops the double sense of intimate communion and alienation from full and direct experience, which is central to his perception of the presence of God in human life.

As one might expect, Bernard is deeply concerned to ground his feminization of interpretive activity in Scripture itself, and this very desire to stay close to Scripture repeatedly leads him to twist the sense, and the context, of quotations in order to support his analogies. The Bible contains a variety of women, like Wisdom and Mary Magdalen, whom he can use directly, as well as feminine metaphors, as when Paul describes himself as suffering labor pains for his churches (Gal. 4:19). Bernard makes the most of such moments, but he also goes beyond them and actually rewrites passages to give a feminine cast where none appears in the original text.

Thus, when Jesus tells his followers, "you have one teacher and you are all brethren" (Matt. 23:8), Bernard paraphrases this as: "Are you not all... like sons of the same mother, all brothers to each other?" (Ser. 29.3). Similarly, while Paul calls himself the father of the Corinthian community (1 Cor. 4:15), Bernard calls him the *mother* of the Corinthians, "whom she begot by preaching the Good News" (Ser. 10.2). In Ephesians, Paul speaks of spiritual development by analogy to biological growth, as a progress "to mature manhood... so that we may no longer be children" (Eph. 4:13); Bernard renders this maturation as a spiritual change of sex: the soul is to emerge "from womanhood to manhood, to mature manhood" (Ser. 12.8).

As Bernard pursues these analogies, he develops a remarkably comprehensive image of the feminine, taking into account not only qualities of character but also traditionally feminine types of activity. He takes up a whole range of feminine social and economic activities and applies

them all to the process of interpreting, preaching, and meditating on Scripture. Thus Bernard gives a newly feminine emphasis to the common motif of Scripture as food. He is particularly drawn to the action of the prostitute who anoints Jesus' feet with ointment (Luke 7:36–50; John 12:1–8), and he considers at length the culinary activity necessary to prepare this ointment: "A soul entangled in many sins can prepare for itself a certain ointment once it begins to reflect on its behavior, and collects its many and manifold sins, heaps them together and crushes them in the mortar of its conscience. It cooks them, as it were, within a breast that boils up like a pot over the fire of repentance and sorrow, so that it can exclaim with the Prophet: 'My heart became hot within me. As I mused the fire burned' " (10.5). Here it is personal meditation that is at work; but throughout the sermons, it is Scripture that provides the essential basis for fruitful meditation: "The word of God, winged with the Holy Spirit's fire, can cook the raw reflections of the sensual man, giving them a spiritual meaning that feeds the mind" (22.2). The first sermon opens with an announcement that he will feed his monks meat rather than milk; and later, like an anxious mother, he exhorts his audience to chew their food carefully: "As food is sweet to the palate, so does a psalm delight the heart. But the soul that is sincere and wise will not fail to chew the psalm with the teeth as it were of the mind, because if he swallows it in a lump, without proper mastication, the palate will be cheated of the delicious flavor, sweeter even than honey that drips from the comb" (7.5).

If the meditating soul in general, and Bernard in particular, is a woman giving food, he is also a maiden drawing water at a well, for his listeners to drink. Bernard uses this metaphor not simply as a general image of refreshment but interestingly as an image of women's labor: slow, patient, and tiring work: "I shall even pay myself a mild compliment in this matter, for no small effort and fatigue are involved in going out day by day to draw waters from the open streams of the Scriptures and provide for the needs of each of you, so that without exerting yourselves you may have at hand spiritual waters for every occasion, for washing, for drinking, for cooking of foods" (22.2). It can be noted that here it is not only Bernard who is feminine: so are his listeners as well, as they will in turn use the water for such feminine activities as washing and cooking. Elsewhere, we find that the slow, laborious activity of drawing water suits the modest (and implicitly feminine) intelligence of most of his audience: "I must warn those present whose agile minds outstrip my thoughts, and in every sermon

anticipate the end almost before they have grasped the beginning, that I am obliged to adapt myself primarily to minds that are less keen. But my purpose is not so much to explain words as to move hearts. I must both draw the water and offer it as a drink, a work that I shall not accomplish by a spate of rapid comments but by careful examination and frequent exhortation" (16.1).

Bernard's monks need not only to be fed but also to be clothed: "our Savior, or his salvation, will not rest in the naked soul until it is clothed with the teaching and discipline of the apostles" (27.3). It is Bernard who is the seamstress, as he tells us in justifying a digression in his exposition:

> But why the symbol of oil? I have yet to explain this. In the previous sermon I had begun to do so when another matter that seemed to demand mention suddenly presented itself, though I may have dallied with it longer than I intended. In this I resembled the valiant woman, Wisdom, who put her hand to the distaff, her fingers to the spindle. Skillfully she produced from her scanty stock of wool or flax a long spool of thread, out of which she wove the material that made warm clothes for the members of her household. (15.5)

Here, as often, Bernard sees women's work as taking place in a culture of poverty: the careful housewife must stretch her "scanty stock" (*modicum,* an astonishing term for Scripture!) as far as possible. The woman's poverty, like the monk's, is not necessarily a reflection of her husband's (God's) true wealth; rather, like the monk, and metaphorically like the soul in general, the woman has no direct earning power and must make do with whatever amount she is given.

Women's work has the dual characteristic of being exhausting while hardly looking like work at all, at least to the eyes of men, and Bernard plays on this masculine denigration of women's activity as he sets the monastic life of contemplation over against the more obvious work of the "man's world" of society at large. He tells us that critics have complained that

> I thought only of myself when, in their view, I could have been working for the welfare of others. . . . But let those who accuse me of indolence listen to the Lord who takes my part with the query: "Why are you upsetting this woman?" By this he means: "You are looking at the surface of things and therefore you judge superficially. This is not a man, as you think, who can handle great enterprises, but a woman. Why then try to impose on him a burden that to my mind he cannot endure? The

work that he performs for me is good, let him be satisfied with this
good until he finds strength to do better." (12.8)

Bernard concludes that he and his monks should not aspire to hold
episcopal authority in the world beyond the monastery: "Let us admit
that our powers are unequal to the task, that our soft effeminate shoul-
ders cannot be happy in supporting burdens made for men" (12.9).

Here and elsewhere, Bernard presents womanhood as a condition
of limitation, ideally one to be outgrown; but at the same time, it is
the mortal condition par excellence. As can be seen in the examples
discussed above, Bernard develops his feminine analogies in such a
way as to make use not only of women's work but also of women's
personal characteristics as traditionally conceived, and he is interested
not only in positive qualities (warmth, nurturing, modesty, fidelity)
but also in negative ones such as weakness and irrationality. He places
himself squarely in the camp of the helplessly passionate bride: " 'I
cannot rest,' she said, 'unless he kisses me with the kiss of his mouth.
. . . It is desire that drives me on, not reason [*Desiderio feror, non ra-
tione*].[3] Please do not accuse me of presumption if I yield to this impulse
of love. My shame indeed rebukes me, but love is stronger than all"
(9.2). Even women's love of gossip becomes a justification for the great
length of Bernard's commentary: "The love-inspired bride will go on
speaking, will chatter without end about her Bridegroom's excellence"
(19.1).

As infused as Bernard wishes both his commentary and his monastery
to be with these feminine qualities, he is very far from wanting to have
any actual *women* around, and he has only bitter sarcasm for a mixed
monastic community of monks and nuns:

> To be always in a woman's company without having carnal knowledge
> of her—is this not a greater miracle than raising the dead? You cannot
> perform the lesser feat; do you expect me to believe that you can do the
> greater? Every day your side touches the girl's side at table, your bed
> touches hers in your room, your eyes meet hers in conversation, your
> hands meet hers at work—do you expect to be thought chaste? It may
> be that you are, but I have my suspicions. To me you are an object of
> scandal. (65.4)

3. Though such a passage might suggest that Dante should have placed Bernard
closer to Francesca than to the celestial rose, Bernard's stress on passion actually carries
a hermeneutical emphasis: a criticism of the more philosophical modes of study, epit-
omized for Bernard by the teachings of his enemy Abelard, which would emphasize
reason at the expense of passion, of mystery, and (worst of all) of church authority.

Even in separate communities, women were scarcely equal, as can be seen by the difficulties the Cistercian convents had in achieving full monastic status in the twelfth century.[4]

It should not be thought, however, that Bernard uses feminine imagery *despite* his agreement in the exclusion of women from full social life and from his own monastery in particular; rather, he is drawn to feminine imagery *because* it stems from a class of people who are socially excluded but nonetheless omnipresent in society. In part, the status of women in this way mirrors the status of monks in the world around them; equally, the situation of women as both included and excluded from male society mirrors the metaphysical position of the human soul in relation to God. These two levels of experience meet on the hermeneutic level, in the struggle of the interpreter to know the departed Christ through the Scriptures that tell of him.

The Hermeneutics of Exile

At various points, Bernard evokes the problems of knowledge faced by righteous men before the coming of Christ, who brought to mankind the fuller knowledge of God now transmitted through the New Testament and the reinterpreted Hebrew Bible. Before the coming of Christ, mankind could not directly know their God: "his gifts pursued them without fail, but the benefactor's hand was hidden" (6.2). Consequently, the human condition was one of insensitivity to God's love, and alienation from his will: our ancestors "lived through him, but not for him. What understanding they possessed was from him, but him they failed to understand. They were alienated, ungrateful, irrational [*alienati, ingrati, insensati*]" (6.2). This "pagan" state is, however, all too similar to the modern condition: "During my frequent ponderings on the burning desire with which the patriarchs longed for the incarnation of Christ, I am stung with sorrow and shame. Even now I can scarcely restrain my tears, so filled with shame am I by the lukewarmness, the frigid unconcern of these miserable times. For which of us does the consummation of that event fill with as much joy as the mere promise of it inflamed the desires of the holy men of pre-Christian

4. See Micheline Pontenay de Fontette, *Les religieuses à l'âge classique du droit canon: Recherches sur les structures juridiques des branches féminines des ordres* (Paris, 1967), esp. chap. 1, and see Bynum, *Jesus as Mother*, pp. 139–46.

times?" (2.1). Our distance from the events recorded in Scripture, a distance as much emotional as historical, is the problem Bernard is most concerned to address through his interpretations. Bernard's hermeneutics is the hermeneutics of exile, and in its broad outlines his response to our exilic relation to sacred history is part of the long tradition of attempts to use Scripture to overcome the human separation from God in mortal life—the *longum exsilium nostrum* in Augustine's phrase. For Bernard, the exiled soul still mirrors the divine nature, but negatively, with truth, love, and eternal peace replaced by error, fear, and pain: "O truth! O love! O eternity! O blessed and beatifying Trinity! To you the wretched trinity that I bear within me sends up its doleful yearnings because of the unhappiness of its exile. Departing from you, in what errors, what pains, what fears it has involved itself! . . . O trinity of my soul, how utterly different the Trinity you have offended in your exile" (11.5). Specific to Bernard are the frequency and the intensity with which he presents this exilic state as an essentially feminine condition. He does this in a variety of ways. Most immediately, he identifies our exile with entrapment in our bodies: "Our bodily dwelling-place, therefore, is neither a citizen's residence nor one's native home, but rather a soldier's tent or traveller's hut. . . . Do you not see whence blackness appears on the Church's body, why persons of the greatest beauty are tainted by defects? It is because of the tents of Kedar, the waging of a wearisome war, a life of prolonged misery, the distresses of bitter exile, in a word, a body that is both frail and burdensome" (26.1, 2). This body is inherently feminine (frail, burdensome); shortly before this, Bernard has identified the spirit with Adam, the body with Eve (24.6). When the lover in the Song of Songs entreats, "Come my beautiful one," Bernard comments: "Since she is invited to come, she has not yet arrived. So no one should think that the invitation was addressed to a blessed one who reigns without stain in heaven, it was addressed to the dark lady who was still toiling along the way [*nigrae quae adhuc laborabat in via*]" (25.3).

The darkness of the "dark but comely" bride can in this way be seen as a reflection of the human alienation from God, the soul trapped within the feminine mortal body. At the same time, Bernard brings feminine emotional characteristics into play as well, suggesting that the bride's darkness is caused by her passionate response to the tantalizingly distant presence of God himself:

She can also say this: "Christ the Sun of Justice had made me swarthy in color, because I am faint with love of him." This languor drains the color from the countenance, and makes the soul swoon with desire, and therefore she says: "I remembered God and was delighted, I meditated and my spirit failed me." Just like a burning sun, therefore, the ardor of desire darkens her complexion while still a pilgrim in the body; rebuffs make her impatient, and delay torments her love, while she sighs for the brightness of his countenance. (28.13)

The bride's exile is not only spiritual and physical; it is also, and consequently, what we might call a *semiotic* exile, a wandering in what Bernard calls the *regione dissimilitudinis*: "What can be a clearer sign of [the bride's] heavenly origin than that she retains a natural likeness to it in the land of unlikeness, than that as an exile on earth she enjoys the glory of the celibate life, than that she lives like an angel in an animal body?" (27.6). The soul's burning desire, as Bernard pictures it, is to escape from this realm of unlikeness, and from all the forms of mediation standing between the soul and God—including even Scripture itself. As Bernard says concerning the opening line of the Song, "let him kiss me with the kiss of his mouth,"

The conscientious man of those days might repeat to himself: "Of what use to me the wordy effusions of the prophets? Rather let him who is the most handsome of the sons of men, let him kiss me with the kiss of his mouth. No longer am I satisfied to listen to Moses, for he is a slow speaker and not able to speak well. Isaiah is 'a man of unclean lips,' Jeremiah does not know how to speak, he is a child; not one of the prophets makes an impact on me with his words. . . . I want no part with parables and figures of speech [*figuras et enigmata nolo*]; even the very beauty of the angels can only leave me wearied. For my Jesus utterly surpasses these in his majesty and splendor. Therefore I ask of him what I ask of neither man nor angel: that he kiss me with the kiss of his mouth." (2.2)

To some extent, of course, the prophet's impatience for Christ is allayed for the Christian, for whom Christ has come; the problem is that, having come, he soon departed again, leaving behind a body of teachings, a new set of "parables and figures of speech" not so very different from those that failed to satisfy the conscientious man of old. In general even the faithful Christian still lacks the "unreserved infusion of joys, a revealing of mysteries, a marvellous and indistinguishable mingling of the divine light with the enlightened mind," for which the consci-

entious man prays (2.2). The modern Christian does have the opportunity for direct experience of God, but this is only granted rarely:

> His heart's desire will be given to him, even while still a pilgrim on earth, though not in its fullness and only for a time, a short time. For when after vigils and prayers and a great shower of tears he who was sought presents himself, suddenly he is gone again, just when we think we hold him fast.... And so, even in this body we can often enjoy the happiness of the Bridegroom's presence, but it is a happiness that is never complete because the joy of the visit is followed by the pain at his departure. (32.2)

Even so, the situation of the Christian is vastly better than that of the pagan, but not so much individually as collectively: the faithful Christian can now share in the mingling of divine light, not privately but as a member of the church, the true bride, which does enjoy the steady infusion of joys for which the soul longs. "For what all of us simultaneously possess in a full and perfect manner, that each single one of us undoubtedly possesses by participation" (12.11). Bernard develops this idea through the image of the kiss, and gives a remarkable interpretation of the phrase "let him kiss me with the kiss of his mouth." He argues that the superfluous phrase "the kiss of" his mouth conceals a distinction: Christ alone received the direct kiss from God's mouth, but the revelation he transmits to us is a stage removed:

> this revelation—what can you call it but a kiss? But it was the kiss of the kiss, not of the mouth. Listen if you will know what the kiss of the mouth is: "The Father and I are one."... He [Christ] who received the fullness is given the kiss of the mouth, but he who received from the fullness is given the kiss of the kiss.... For Christ, therefore, the kiss meant a totality, for Paul only a participation [*Christo igitur osculum est plenitudo, Paulo participatio*]; Christ rejoiced in the kiss of the mouth, Paul only in that he was kissed by the kiss. (8.7, 8)

The one true man, Christ, enjoys plenitude, while his bride, the human soul, enjoys this plenitude indirectly, through participation. One may recall Milton's later version of this idea as applied to Adam and Eve: "Hee for God only, shee for God in him" (*Paradise Lost,* 4.297). The difference is that, in Bernard, we are squarely in Eve's position, and hers alone.

It should be emphasized that the soul's feminine situation is by no means tragic in Bernard's view. Rather, the emphasis on the feminine model provides a means whereby he can treat the limitations of mortal life positively and constructively:

Felicitous, however, is this kiss of participation that enables us not only to know God but to love the Father. . . . Let that man who feels that he is moved by the same Spirit as the Son, let him know that he too is loved by the Father. Whoever he be let him be of good heart, let his confidence never waver. Living in the Spirit of the Son, let such a soul recognize herself as a daughter of the Father, a bride or even a sister of the Son, for you will find that the soul who enjoys this privilege is called by either of these names. (8.9)

Bernard adduces a variety of the soul's feminine characteristics in order to explain and justify God's choice to give his followers a life of participation rather than of plenitude. Speaking historically, in the twelfth sermon, he emphasizes Jesus's interaction with women at the time of his resurrection. He cites the scene in Mark 16 in which Mary Magdalen and two other women bring spices to anoint Christ's body but find his body gone: "he eluded the women's devout purpose only to give it new direction. Mercy and not contempt was the reason for this refusal; the service was not spurned but postponed that others might benefit" (12.7). Thus as individuals we are in Mary Magdalen's position, denied direct contact with Christ's body in order for the church as a whole to receive that contact by becoming the Body of Christ itself—"she is the more precious Body of Christ that was not to taste death's bitterness" (12.7).[5] Women, Bernard indicates, are supposed to defer their own satisfaction in order to work for the good of the community as a whole.

In addition to this image of a historical injunction that the soul, as repentent Magdalen, should minister to the church, Bernard uses the idea of feminine modesty as a way to understand the need for indirection in relation to God: "The bride, therefore, becoming conscious of the Bridegroom's presence, grew suddenly silent. She is ashamed to think that he is aware of her presumption, for a certain modesty had prompted her to use intermediaries in achieving her purpose" (9.4). Women's weakness as well as their modesty requires a carefully delimited companionship with Christ: as Bernard pictures the church saying, "I know quite well that girls are delicate and tender, ill-equipped to endure temptations; so I want them to run in my company, but not to be drawn in my company." By this distinction Bernard indicates a

5. In an Easter sermon on this text, Bernard develops an extended allegory of the three women as representing three qualities that an abbot should possess: see Sermon 2, *Ad Abbates in Tempore Resurrectionis* (*Patrologiae Latina*, vol. 183), and the discussion by Suibert Gammersbach, "Das Abtsbild in Cluny und bei Bernhard von Clairvaux," *Cîteaux in de Nederlanden* 7 (1955): 85–101, esp. pp. 95–96.

partial but not complete sharing in the church's companionship with Christ: "I will have them as companions in hours of consolation, but not in times of trial. Why so? Because they are frail, and I fear they may tire and lag behind" (21.11). In this way, Bernard presents our limited participation in the experience of God as an outgrowth of God's tender concern for our feminine frailty: by his mercy, we are granted the hours of consolation, and spared the times of trial.

Women, Jews, and Heretics

As the examples discussed above indicate, the figure, or the *figura,* of woman forms a leitmotif in the sermons on the Song of Songs, and a principal means by which Bernard seeks to understand and to represent the hermeneutical situation of the saintly soul. Many other examples could be added to those given above, but it should also be kept in mind that women are not the only such model for Bernard. If it is ultimately the very fact of the exclusion of women from the monastic community that gives them central interest for Bernard, as images of participation without plenitude, women are not unique in this experience of exclusion. In the sermons, they share this dubious honor with two other groups in particular: Jews and heretics.

While a discussion of Bernard's complicated uses of these latter two groups is a subject for separate development, it is important to note here that Bernard's use of the image of woman is part of a larger project: to create his Cistercian community through a double process of exclusion and inclusion. At the first stage, the included group of saints is set off against the traditional objects of exclusion, women, Jews, and heretics, whose failings and limitations Bernard attacks in various ways over the course of his sermons. No direct rapprochement is ever envisioned among these groups; one cannot imagine Bernard ever being tempted even to give a serious representation of points of view outside that of his community, in the style of Abelard's *Dialogus inter philosophum, Judaeum et Christianum.*

Yet this first stage of direct exclusion is followed by a second stage of reappropriation of many of the values associated with the excluded groups—including negative as well as positive qualities, as we have seen in the case of women. To take the example of the Jews, their situation in antiquity closely mirrors that of the saint in modern times: the prophet longs for the coming of Christ in much the way that the

saint longs for Christ's second coming. Beyond this, even the negative qualities that Bernard associates with Jews are useful to him. The Jews in part represent qualities he hopes to cast out of his community, like obstinate pride, trust in literal reading, and denial of the need for grace; but all the same, as the realist he is, Bernard must deal with the fact that his community of saints itself still exhibits "Judaic" failings aplenty. With this in mind, the Jews become a valuable model of God's mercy toward his chosen people despite their ongoing faults.

The Jews' faults are at once moral and hermeneutic. They obstinately insist on the letter of the Law, ethically trusting in their own righteousness and hermeneutically insisting on a literal reading of Scripture—in other words, denying the typological allegory of Christ and the church, which Bernard sees as the entire point of the Song of Songs, indeed of the Hebrew Bible as a whole. In the fourteenth sermon, Bernard uses a striking image to locate the shift in modes of reading at the moment of Christ's death on the cross, the moment at which the veil of the temple was rent asunder: "But when the veil of the written letter that brings death is torn in two at the death of the crucified Word, the true Church, led by the Spirit of liberty, daringly penetrates to his inmost depths, acknowledges and takes delight in him, occupies the place of her rival to become his bride, to enjoy the embraces of his newly-emptied arms" (14.4).[6]

If the Jews err through overliteralism, a too "public" reading of the sense of the text, the heretics who most disturb Bernard err through esoterism, a too *private* reading of the text. In the sixty-fifth sermon, he attacks a group of professed Christians who insist on a variety of privately sanctioned practices. This is the group that believes monks and nuns can share a monastery together; they also refuse to take oaths and in general appear to regard church authority as secondary to their own reading of Scripture. Their readings are, however, not all expounded in public, and this private character of their faith is the focus of Bernard's attack: "When they dismiss everyone within the Church as dogs and swine, is this not an open admission that they themselves are not within the Church? They consider that their secret, whatever it is, should be kept from everyone, without exception, who does not belong to their sect. . . . Let them either disclose their secret to the glory of God or else admit that it is not a mystery of God and cease to deny

6. In an interesting typographical error, Walsh's translation loses the crucial image of the "veil of the letter," rendering *velo,* "veil," as "the *evil* of the letter."

that they are heretics" (65.3). Too far "inside" the text, too involved in their private reading to share fully in the community as a whole, these heretics are the mirror image of the Jews, who stay on the surface of the literal text, unwilling or unable to penetrate far enough into the mysteries concealed behind the veil of the letter. Bernard has only contempt for these groups, but even the heretics display virtues he cannot ignore. Indeed, if the Jews represent qualities he would like to cast out of his community but must acknowledge as still present, in many ways the heretics exhibit qualities Bernard finds all too *lacking* among his own flock. The heretics are passionately committed believers; they are close and intensive readers of Scripture, which guides their every step; they are even highly moral in their behavior (Ser. 65, passim). Even as he insists on the heretics' exclusion, Bernard must struggle to infuse many of their values into his own community.

Bernard is aware of the multiple challenges posed to his community by the competing norms represented by heretics, Jews, and women. At the same time, the existence of differing sorts of excluded groups gives Bernard the opportunity to use the positive features he appropriates from one group to criticize negative features of another. Two apparently contradictory examples can illustrate the fluidity with which Bernard plays off the excluded groups against one another. When he wishes to use the image of Moses positively, he can associate him with the feminized faithful soul. Discussing Moses' reaction to the making of the Golden Calf, Bernard selectively emphasizes his "gentleness," *mansuetudine,* and says that when Moses pleads for God to spare the people, "clearly he speaks as a mother would for whom there is no delight or happiness that is not shared by her children" (12.4).

When, on the other hand, Bernard wishes to condemn the Jews, he uses the feminine theme against them, and even against Moses himself. In the thirtieth sermon, after stressing Moses' loyalty and all-surpassing love for his people, Bernard turns to the question of Moses' inadequacy as a bearer of the full Christian revelation:

> The idea strikes me, however, that by a secret design of Providence, this magnificent project was reserved for the bride: she, and not Moses, would beget a mighty race. . . . what a difference between grace and the law! What a contrast of features as they present themselves to the conscience, the one so pleasant, the other so austere! Who can look with equal regard on one who condemns and one who counsels, one who holds to account and one who pardons, one who punishes and one who embraces? One does not welcome with equal ardor the darkness and

the light. . . . The hands of Moses were heavy, as Aaron and Hur well knew. . . . Moses, therefore, was not destined to produce a mighty race. But you, the Church who is our mother, holding out the reward of life here and now and of the future life as well, will find ready welcome everywhere. (30.5)

Here, then, Moses is not at all a tender mother but only a stern father. In either instance, indeed, his limited spiritual state falls short of the androgyny of the true Body of Christ, "the one and same Lord who as head of the Church is the bridegroom, as body is the bride" (27.7).[7]

The images of woman, Jew, and heretic thus have an overall structural similarity in Bernard's exposition, while in particular details the differing qualities of these groups complement each other and can even be used against each other. This is often important to Bernard, especially just when he is most actively engaged in appropriating the image of one or another group for his use, since he must also assert the categorical superiority of the orthodox Christian community of saints over any other community. At one and the same time, then, Bernard both appropriates the qualities of the groups he excludes and distances himself from them, creating a community that is both unique and universal in its qualities. The rhetoric of gender is central in this effort, as Bernard finds in the image of woman (as sinner, as worker, as reader) a means to transform the hermeneutics of exile into the hermeneutics of participation. In this way Bernard can hope to link personal piety and communal authority through a way of reading that becomes, as well, a way of life.

7. Compare the remarkable image in Sermon 14.3, in which the oil of salvation flows down from Aaron's beard onto the waiting breasts of the church, "until she is totally bedewed with grace." In a similar vein, in Letter 322, Bernard writes: "If you feel the stings of temptation . . . suck not so much the wounds as the breasts of the Crucified. He will be your mother and you will be his son" (quoted in Bynum, *Jesus as Mother,* p. 117). These statements can be compared to the (much more abstract) emphasis on androgyny found in Abelard, who says, for example: "In the body of Christ, which is the Church, difference of sex, therefore, conveys no dignity; for Christ looks not to the conditions of sex, but to the equality of merits" (Ser. 13; see the discussion in Mary McLaughlin, "Peter Abelard and the Dignity of Women: Twelfth Century 'Feminism' in Theory and Practice," in *Pierre Abélard, Pierre le Vénérable: Les Courants philosophiques, littéraires et artistiques en occident au milieu du XIIe siècle,* Colloques internationaux du C.N.R.S., 546 [Paris, 1975], pp. 287–334).

PART III

SAINTLINESS AND GENDER

The Need to Give:
Suffering and Female Sanctity
in the Middle Ages

The alternation of loot and gifts linked the power to take and the power to give in the early Middle Ages. In its simplest form, this power structure relegated women to passive roles. Warlords took them as loot from their vanquished kindred, parading them as battle trophies. They bestowed their daughters and their captives on their peers, who displayed them, richly adorned, as status symbols. Barbarian chiefs showered fortunes in gifts upon women to demonstrate their own power, but even their queens were rarely free to construct networks of political and military patronage for themselves.[1] Instead, women became patrons of the poor and dependent, redistributing major portions of men's loot back to the victims of war and misfortune. They used sanctity as an alternative avenue to power.

Female patronage had long been central to the success of Christianity. The men of the early church were often drawn from the poor and

Portions of this essay were previously given at a conference on medieval monasticism held by Fordham University, New York, March 21, 1986; at the annual meeting of the Medieval Institute, Kalamazoo, Mich., May 1987; and at the Columbia University Seminar on Women and Society, New York, 1987. I am grateful to the participants in all these meetings for their helpful comments and criticism.

1. An exception was the slave girl Fredegund, who manipulated her husband's sexual desires to gain the Merovingian throne and boasted that the cartloads of treasure she sent as a dowry with her daughter into Spain had not come from the Frankish treasury but from the gifts he showered upon her (Gregory of Tours, *Historia Francorum*, 6.45, ed. W. Arndt, *Monumenta Germaniae Historica: Scriptores rerum Merovingicarum*, vol. 1 [Hanover, 1885]). Though she did succeed in ruling her husband's kingdom after his death, even she was unable to protect the wealth once her daughter was on the road.

powerless classes, whereas wealthy women supported the community, often maintaining churches in their own homes.[2] Once the religion was legalized in the fourth and fifth centuries, great Roman ladies and particularly the empresses of the Theodosian house shaped the ritual of queenship out of their patronage of religion and of the poor.[3] Roman bishops and Gallic saints like Genovefa helped to translate these rituals into the barbarian kingdoms.[4] Repeatedly enacted scenes of public intercession with their warrior lords for mercy to prisoners, help to the poor, or donations to the church enabled women to express the merciful side of power without softening the fierce warrior image of the king. Women's power to give was, therefore, crucial to the process of bridging the gulf between the barbarian conquerors and the native poor. The Catholic clergy, who generally represented the indigenous Romanized populations, channeled and rewarded women's efforts by promoting their cults as saints. Bishops served as intermediaries for religious women with their angry husbands and families. They validated their designs by promoting their miracles and encouraged their worship.

The conquerors were soon educated to the advantages of indulging feminine sanctity. A rough gender division of powers and responsibilities developed. What Clovis and his Frankish warriors amassed in loot, his queen and her successors seemed determined to dissipate. Clothild gave lavishly to monastic institutions for both women and men.[5] Clothar plied his captive and queen, Radegund, with handsome gifts to compensate her for his violent abuses. She systematically diverted food to the poor who gathered at the back door while her husband and his companions were drinking in the hall.[6] Sometimes she went out in search of needy hermits upon whom to shower gifts. When she finally fled from her husband, she frequently stopped on the road and ostentatiously heaped up gold and jewelry on the al-

2. See Jo Ann McNamara, *A New Song: Celibate Women in the First Three Christian Centuries* (New York, 1983).

3. Kenneth Holum, *Theodosian Empresses: Women and Imperial Dominion in Late Antiquity* (Berkeley and Los Angeles, 1982).

4. Saint Genovefa rescued prisoners from Chilperic while he was still a pagan and gained permission to bring food into besieged Paris to feed the poor (*Vita sanctae Genovefae virginis Parisiis in Gallia*, 6.21; 7.40, in *Acta sanctorum*, 3 Jan. [Paris, 1863], 137–53).

5. Gregory of Tours, *Historia Francorum*, 3.18.

6. Venantius Fortunatus, *De vita sanctae Radegundis*, 4, ed. Bruno Krusch, *Monumenta Germaniae Historica: Scriptores rerum Merovingicarum*, vol. 2 (rpt. Hanover, 1966), p. 367.

tars of the saints.[7] Still, Clothar's sense of fitness apparently obliged him to endow her handsomely in a convent. There she served daily banquets to the poor, supplied the sick with medicine and bathing facilities, and gave new clothes and money to anyone who came to the door.

It may well have been hostility to their warrior husbands that caused many women to devote themselves to the redistribution of barbarian wealth, but their charity helped to validate the violence of their men in gathering loot and even taxes. Secular lords of the sixth and seventh centuries could not risk compromising their warlike qualities. Women, on the other side, used the saintly role to participate in the dialectic of taking and giving. In this way, they became innovators of a new brand of lay sanctity that would be taken up by men also in the Carolingian age.[8]

When the society became more settled and the power to take was translated into less violent forms of revenue, the power to give was also translated into more formalized systems of inheritance and patronage. Women ranked highly in the inheritance system, taking precedence over all men except legitimate sons. Germanic laws protected their right to share in the estates of both fathers and husbands as well as to accumulate gifts of unlimited size.[9] This independent wealth made women of the propertied class highly attractive candidates for sainthood if they chose to pursue the prize. When the abbess Liliola saved the child Rusticula from a kidnapper who had designs to marry her and control her fortune, she persuaded her to remain in the monastery, which sheltered her. Though her mother complained bitterly to the king and to the bishop, she was unable to prevent the loss of both daughter and fortune.[10]

At first, aristocratic families were actively hostile to this open-handed generosity to people outside the usual circles of exchange. They had to be bombarded with stories of miracles that illustrated God's love for the reckless giver. Thus, while her biographer criticized her prudent

7. Ibid., 13.

8. In this sense they are the forerunners for the models of lay sanctity discussed by André Vauchez in Chapter 1.

9. Jo Ann McNamara and Suzanne Wemple, "The Power of Women through the Family in Medieval Europe, 500–1100," in *Women and Power in the Middle Ages,* ed. Mary Erler and Maryanne Kowaleski (Athens, Ga., 1983), pp. 83–101.

10. Florentius Tricastinae, *De vita sanctae Rusticulae sive Marciae,* 5, ed. Bruno Krusch, *Monumenta Germaniae Historica: Scriptores rerum Merovingicarum,* vol. 4 (rpt. Hanover, 1977), p. 342.

mother, he praised the open-handed Aldegund, whose scanty supplies of money and clothing were multiplied as she gave them out to beggars at the door.[11] Indeed he plainly stated that it was her own fault if Aldegund celebrated her mother's death by giving away all the ready money she had hidden from her charitable daughter, taking her land, and other immovables for a convent.

Hagiographers extolled the advantages of an immortal husband and a heavenly kingdom. Monastic leaders and missionaries urged and even commanded girls to refuse to marry in defiance of their families, diverting their inheritances to monasteries.[12] With their help, Burgundofara, Glodesind, and many other determined women escaped the marriages planned for them and gave their wealth to the church in the form of a monastery.[13] On earth, noble women could enjoy independent authority and honor as the foundresses and directors of monasteries, where their generosity with money and food was enhanced by the further power to work miracles.

In the final analysis, the construction of a widespread system of monastic charity could not have been successful if it had not also held out benefits to the new rulers in exchange for the loss of their women and their wealth. Noble families came to imagine that property taken by a daughter to a convent remained their own regardless of the fact that they had donated it to God as dowry. The monastery became the founding family's benefice, especially where a girl was an oblate, vowed from childhood.[14] The convent offered a convenient assignment to a

11. *Vita sanctae Aldegundis,* 16, in *Acta sanctorum,* 30 Jan. (Paris, 1863), 649–62.

12. This theme emerges in the hagiography associated with Saint Columbanus and his followers, particularly Eustatius, Waldebert, and Amand, who both inspired and assisted Saints Burgundofara, Sadalberga, Rictrude, Aldegund, Waldetrude, and Gertrude of Nivelles to defy their fathers or their sovereigns to devote themselves to God. See Jonas of Bobbio, *Vita Columbani Abbatis disciplinorum eius, Liber II,* ed. Bruno Krusch, *Monumenta Germaniae Historica: Scriptores rerum Merovingicarum,* vol. 4 (Hanover, rpt., 1977), for Burgundofara and Sadalberga; *Vita sanctae Aldegundis; Vita sanctae Geretrudis Nivialensis,* ed. Bruno Krusch, *Monumenta Germaniae Historica: Scriptores rerum Merovingicarum,* 2: (Hanover, 1966) 453–64; *Vita sanctae Rictrudis,* in *Acta sanctorum,* 12 May (Paris, 1866), 83.

13. *Vita antiquior sanctae Glodesindis,* in *Acta sanctorum,* 26 July (Paris, 1868), 203–10.

14. At Nivelles, Gertrude appointed as her successor Wulftrude, a niece she had brought up herself, and the succession continued through several noble ladies connected to what was to become the imperial family (*De Virtutibus sanctae Geretrudis Nivialensis,* 4, ed. Bruno Krusch, *Monumenta Germaniae Historica: Scriptores rerum Merovingicarum,* 2:464). Sadalberga passed her monastery to her daughter Anstrude (*Vita Anstrudis*

daughter as the administrator of lands and an advocate before the heavenly powers. In some cases, it sheltered family wealth from the king's designs to bestow women and their property as rewards for their own followers. No less than three saints, Gertrude of Nivelles, Rictrude, and Sadalberga, were celebrated for thus thwarting the ambitions of King Dagobert in the late seventh century.

With the evolution of the proprietary church as a recognized instrument of noble power, sanctity emerged as a fitting attribute of their women, expressed particularly in charity with earthly goods and heavenly patronage. In Frankland, Queen Balthild demonstrated her power by her lavish gifts to the church and the endowment of Chelles, where she retired when her political fortunes faded. The grateful nuns promoted her cult as a saint and produced a biography, which drew a tactful veil over the less saintly aspects of her spectacular career.[15] Queen Etheldreda of Northumbria endowed her monastery at Ely with the whole of her first husband's wealth. Riches gained from her second husband, whom she deserted, also ended at Ely, as did the wealth of yet another Anglo-Saxon kingdom when her widowed sister succeeded her in 680, bringing her virgin daughter, Werburg, with her. These richly endowed female monasteries became refuges for ransomed slaves, poor women, widows, orphans, and invalids.

This system reached its apogee in the tenth and eleventh centuries, when sainthood continued to reward women who expressed their high status by generosity to the church and to the poor. The empresses and princesses of the German empire continued the rituals of mercy and charity associated with early Frankish queens and thereby assured themselves of a heavenly place commensurate with their high status on earth. The Empress Mathilda, who retired during her widowhood to the royal monastery she founded at Quedlinberg, celebrated her husband's memory and her own prestige annually with a display of charity that once drew so many crowds that she had to climb up on a nearby

abbatissae Laudunensis, 4, ed. W. Levison, Monumenta Germaniae Historica: Scriptores rerum Merovingicarum [Hanover, 1913], 6: 64–78). Aldegund raised her niece Aldetrude as her successor (Vita sanctae Aldegundis). Gertrude of Hamaye willed her monastery to her niece Eusebia (Vita sanctae Rictrudis, p. 87). As a double monastery, Hasnon drew both abbots and abbesses from brothers and sisters in the founding family.

15. Vita sanctae Balthildis, ed. Bruno Krusch, Monumenta Germaniae Historica: Scriptores rerum Merovingicarum, 2: 477–508.

promontory in order to shower down the food she had prepared for them.[16]

Between 1050 and 1150, the configuration of power changed. Catholic prelates were no longer aligned with a conquered class, seeking a bridge into the ranks of their oppressors. The masculinized Gregorian church sought to disentangle itself from the power of lay patrons, bringing the system that had produced so many saintly women into disrepute. The old proprietary monasteries were attacked as corrupt by a clergy who were neither particularly sympathetic to the ambitions of women nor anxious for their support.[17]

Simultaneously, women found their bargaining power greatly diminished. The increasingly complex society of the twelfth century required a more institutionalized structure, which devalued the role of women in public life. The family structure was redefined and the status of women was reduced as primogeniture tended to supplant a wider kinship network. As a group, women were being systematically deprived of control over their own wealth and reduced to dependency upon their families or their husbands. Thus, if we divide society into alms givers and alms takers, many women of the ruling classes who had been securely placed among the givers suffered a decisive loss of status and were once more reduced to takers.[18]

Noblemen aimed at careers in the clerical hierarchy, which could enhance the stature and wealth of their families. Their sisters were consigned to convents, which were often insufficiently endowed to support their own inmates, far less to cater to their desire to patronize the poor.[19] Noble families who were anxious to preserve and concentrate their wealth no longer could or would supply the resources for lavish new monastic foundations to support their unmarried or widowed women. Convents were increasingly forced to demand dowries

16. *Vita Mahthildis Reginae, Monumenta Germaniae Historica: Scriptores,* 4: 282–302. See also Chapter 1 in this volume.

17. Great foundations like Nivelles or the proprietary monasteries of Germany still commanded money enough to maintain hospices for the poor. Jean J. Hoebanx, *L'Abbaye de Nivelles des origines au XIVe siècle* (Brussels, 1952), demonstrates that in fact the nuns' prebends grew at the expense of the abbess's because the nuns were in charge of the hospice and attracted gifts of gratitude. But reformed preachers generally condemned such houses as hotbeds of "corruption."

18. Michel Mollat, "Pauvres et pauvreté à la fin du XIIe siècle," *Revue d'ascétique et de mystique* 41 (1965): 305–23.

19. Frederick M. Stein, "The Religious Women of Cologne, 1120–1320" (Ph.D. diss., Yale University, 1977), p. 148.

to support new members, which priced out lower-income women. Even so, they had to draw on the initial endowment for more general expenses. In the end, admissions fees could not even be set in any rational manner because the Fourth Lateran Council defined the practice as simony.[20] In 1221, Pope Honorius addressed the problem by limiting the number of novices, even from wealthy and powerful families, who could be received in any community.

The convent's capacity for enhancing its income through shrewd business dealings or by promoting the cults of their resident saints was seriously inhibited by tighter laws enclosing nuns and withdrawing them from public life. As a result, growing numbers of houses suffered real poverty, indicated by letters of indulgence forgiving tithes and letters supporting fund drives. Even well-established nunneries had difficulty in keeping up their customary alms, and sometimes the problem was to feed the nuns themselves.[21] In the mid-thirteenth century, Saint Louis endowed the beguinage in Paris, not to serve the poor but to provide shelter for impoverished noble women.[22] An inspection of Umbrian testaments about 1300 indicates that women's monasteries were designated among the "humble" as objects of charity rather than among the clergy as objects of legacies.[23] Nevertheless, many women of pride and spirit were determined to remain in the almsgiving class though they no longer enjoyed the power to alienate their family's wealth. Perhaps it was the need to rebel against the oppression they felt in their own lives that drew their attention to new forms of giving.

Economic and social conditions in the High Middle Ages resembled those of Jesus' world more closely than did the frontier world of the early Middle Ages. Among the outcast poor the pious observer could discern the halt and the lame, the publicans, lepers, Samaritans, and prostitutes who surrounded Jesus. Women anxious to emulate their

20. C. 64 (*Constitutiones Concilii quarti Lateranensis una cum commentariis glossatorum,* ed. Antonio Garcia y Garcia, Monumenta Iuris Canonici, A: Corpus Glossatorum, 2 [Vatican City, 1981]).

21. For example, see the visitation books of Eudes, the archbishop of Rouen, *The Register of Eudes of Rouen,* trans. Sydney M. Brown (New York, 1964).

22. Cited by Gottfried Koch, *Frauenfrage und Ketzertum im Mittelalter* (Berlin, 1962), p. 12A.

23. Robert Brentano, "Il movimenti religioso femminile a Rieti nei secoli XIII–XIV," in *Il movimento religioso femminile in Umbria nei secoli XIII–XIV. Atti del Convegno internazionale di Studio nell'ambito delle celebrazione per l'VIII centenario della nascità di San Francesco d'Assisi,* ed. Roberto Rusconi, Quaderni del Centro per il Collegamento degli Studi Medievo e Umanistica nell'Università di Perugia, 12 (Florence, 1984), pp. 69–83.

biblical predecessors eagerly listened to preachers who urged them to leave all that they had and follow the example of Christ. They seized on the distinction between voluntary and involuntary poverty implicit in the exhortation to strip themselves of what property they had and joined the ranks of the poor as volunteers rather than as unwilling victims.[24] At the great house of Nivelles, for example, the hospice for the poor was expanded during this period, but one nun, Clementia, preferred to give up all her own goods rather than participate in the traditional communal effort to support charity.[25] Noble women, like the group around Robert d'Arbrissel at Fontevraud, sought immediate contact with those who needed them most.[26] They threw themselves into direct service to the poor, and wandering preachers defended the presence of women among their disciples by references to the women who had ministered to the apostles.

The miserable poor included many women forced out of their original communities, unable to command a sufficient livelihood without relying on prostitution, or former prostitutes whose careers were ended by disease, age, or even repentance.[27] Lowest of all on the list were the lepers, victims of a disease or series of diseases that medievals associated with the biblical affliction but which may have been understood to be one or more venereal diseases.[28] Women who identified

24. See Ernest W. McDonnell, *The Beguines and Beghards in Medieval Culture* (New Brunswick, N.J., 1954), and Herbert Grundmann, *Religiöse Bewegungen im Mittelalter* (Berlin, 1935); Grundmann goes so far as to call the entire movement a "woman's movement." They were first publicized by Jacques de Vitry, *Historia Occidentalis*, ed. J. F. Hinnebusch (Fribourg, 1972), and *Life of Marie d'Oignies*, trans. Margot King (Saskatoon, Sask., 1986). For their broader relationship to the local Cistercians, see Brian Maguire, "The Cistercians and the Transformation of Monastic Friendships," *Analecta Cisterciensia* 37, no. 4 (1981): 1–63; Simone Roisin, "L'efflorescence cistercienne et le courant féminin," *Revue d'Histoire Écclésiastique* 39 (1943): 342–78; and Simone Roisin, *L'hagiographie cistercienne dans le diocèse de Liège au XIIIe siècle* (Louvain, 1947).

25. Caesarius of Heisterbach, *Dialogus miraculorum* 11.28.

26. The heroic beginnings of Fontevraud were recounted by Baldric of Dol, *Vita Roberti de Arbrissello*, 22, *Patrologia Latina*, 166:1054.

27. See James A. Brundage, "Prostitution in the Medieval Canon Law," in *Sexual Practices and the Medieval Church*, ed. Vern L. Bullough and James Brundage (Buffalo, 1972), pp. 149–60.

28. Unlike other ailments, leprosy was not easily diagnosed by medievals and it was often peculiarly associated with immorality. See Stephen R. Ell, "Blood and Sexuality in Medieval Leprosy," *Janus: Revue Internationale de l'Histoire des Sciences, de la Médecine, de la Pharmacie et de la Technique* 71 (1984): 156–63; also see Luke Demaitre, "The Description and Diagnosis of Leprosy by Fourteenth-Century Physicians," *Bulletin of the History of Medicine* 59 (1985): 327–44. The question is placed in a larger context

with these outcasts, or perhaps feared that they had contributed to their plight, reversed the older process of almsgiving by moving out of their places in the social structure into the actual ranks of the poor, where they struggled to sustain themselves and their companions by manual labor.²⁹ Having moved from the prosperous commercial class through self-impoverishment, Yvetta of Huy turned to the service of lepers and prayed regularly that she might become one of them.³⁰ Marie d'Oignies convinced her husband that they should give away all they had and go to live in a leprosarium. Care of lepers was also a central activity for the hostel at Fontevraud.

The whole evolution from the old to the new style of giving was reflected in the life of Elisabeth, wife and then widow of the Landgrave of Thuringia, a somewhat archaic figure by birth and training. Sprung from the royal family of Hungary, a newly Christianized area whose social conditions more closely resembled those of Merovingian Europe than of the emerging capitalistic West, she was one of a whole family whose women were recognized as saints.³¹ Her impulses to charity were therefore highly developed when she came as a girl to Germany, and she and her husband were already generous contributors to charitable causes before his death on crusade.

After her husband died, Elisabeth's brother-in-law, who had already been in the habit of diverting her income to his own projects, withheld her dower land and incomes. Perhaps his illegal act was inspired by fear that Elisabeth herself would act illegally and give away goods to which she only had the use during her lifetime. In any case, Elisabeth responded by fleeing from the castle, "to avoid participating in the exploitation of the poor too often practised at princely courts."³² Thus, dramatically, she threw herself into a new kind of exemplary life, living in want herself, needing to work not only to earn charity but to support

by Danielle Jacquart and Claude Thomasset, *Sexuality and Medicine in the Middle Ages* (Princeton, 1989).

29. Otto G. Oexle, "Armut und Armenfürsorge um 1200," in *Sankt Elisabeth, Fürstin, Dienerin, Heilige* (Sigmaringen, 1981), p. 90.

30. Hugo of Floreffe, *De B. Yvetta vidua reclusa Hui in Belgio*, 3:11, in *Acta sanctorum*, Jan. (Paris, 1863), 2:863–86.

31. Lina Eckenstein, *Women under Monasticism* (New York, 1963), p. 290.

32. Testimony from two of her ladies-in-waiting and two servants who worked with her in the hospital of Marburg, 1228–31 (A. Huyskens, ed., *Der sog. Libellus de dictis quatuor ancillarum s. Elisabeth confectus* [Munich, 1911]). Elisabeth of Thuringia is a particularly valuable example because sources were assembled for her canonization within a year after her death in 1231 by Conrad of Marburg (Matthias Werner, "Die heilige Elisabeth und Konrad von Marburg," in *Sankt Elisabeth*, pp. 45–69).

herself. This revolutionary compassion helped set a new moral standard, which equated poverty with morality and wealth with immorality.[33]

Ecclesiastical authorities were rarely sympathetic to the claims of women who wished to gain sainthood by imitating Mary and Martha, mixing with men in the apostolic life.[34] Elisabeth's total poverty lasted only a few months before her confessor came to an amicable agreement with her brother-in-law and recovered a substantial portion of her dowry income. He channeled her passions into the construction of a hospital.[35] Nevertheless, during her life of active sanctity between 1221 and 1231 she was not only generous with alms but stressed her personal identity with the poor by serving them herself, entering their houses, and sharing their lives.[36]

So practiced, voluntary poverty became a bridge between rich and poor. This was a form of giving that sought to alleviate not only the corporal needs of the poor but the moral stigma that seemed to accompany poverty. The saints who practiced it gave of themselves as well as of their goods. At the beginning of the thirteenth century, poverty was considered dishonorable, and manual labor was despised as ignoble. The poor, particularly the amorphous group of the leprous, were confused with the immoral. Voluntary poverty brought saints from the upper classes into the midst of the dangerous pariah poor. In turn, the passage into the ranks of the voluntary or virtuous poor became possible for the involuntary poor. Margaret of Cortona, an impoverished repentant prostitute who was determined to become a saint and therefore a member of the giving class, contrived to reverse

33. Matthias Werner, "Die heilige Elisabeth und die Anfänge des deutschen Ordens in Marburg," in *Marburger Geschichte*, ed. E. Dettmering and R. Grenz (Marburg, 1980), pp. 121–64.

34. Marbod of Rennes and Geoffrey of Vendôme pushed Robert d'Arbrissel to cloister the women at Fontevraud away from the poor, according to Johannes von Walter, *Der Ersten Wanderprediger Frankreichs. Studien zur Geschichte der Theologie und der Kirche* 3 (Leipzig, 1903), pp. 181–89, and *Patrologia Latina*, 171. The Premonstratensians likewise removed them from active hospital work and finally drove them from their order. Bernard of Clairvaux, in his famous Sermon 65 (*Patrologia Latina*, vol. 183), issued a general condemnation of men who thought they could work with women without falling into fornication. See also André Vauchez's essay in this volume.

35. W. Marer, "Die heilige Elisabeth und ihr Marburger Hospital," *Jahrbuch d. Hessischen Kirchengeschichte Vereinigung* 7 (1956): 36–69.

36. André Vauchez, "La pauvreté volontaire au moyen âge," in *Religion et société dans l'occident médiéval* (Turin, 1981), citing Saint Francis and others, feels that Elisabeth surpassed all the thirteenth-century saints in her determination to go beyond institutional forms of assistance to establish close relations with the world of the poor.

her status by starving herself and her son while giving away nearly everything that was given to her in alms.[37]

As always, charity was a powerful weapon for criticism of the wealthy and powerful. Women often used it to attack their own families. Within a month of her wedding, Umiliana de Cerchi had joined forces with her brother-in-law's wife against their husbands' family. She cut down sheets and petticoats, stole food from the table, and sold her husband's belongings to give to the poor.[38] After she was widowed, her own father punished her refusal to remarry by cheating her of her dowry (without which she could not fulfill her ambition to enter the order of Saint Claire) and locking her into the family tower. She had even lost her two daughters, whom she had been obliged to leave with their father's family. Still, she maintained her status as an almsgiver by starving herself and contriving to give the meals she did not eat to the poor. With the connivance of female friends, she managed to give them her dead body as well, depriving her family of control of her relics.[39]

While powerful forces continued to reduce women to the level of the involuntary poor, equally powerful forces moved to block their entry into the ranks of the voluntary poor. By the end of the thirteenth century, female communities were systematically pressured to embrace a cloistered rule and withdraw into dependency, conceivably because their right to the goods they renounced was somewhat ambiguous in a society increasingly bent on channeling wealth to and through men. Yvetta of Huy practiced such extravagant charity after the death of her husband that her father feared she would destroy her sons' inheritance.[40] At first, she yielded to his advice and let him guide her in

37. Juncta Bevagnate, *De B. Margarita Poenit. Tert. OSF de Cortona*, 26, in *Acta sanctorum*, III Feb., (Paris, 1865), pp. 308–9.

38. Adriana Benvenuti Papi, "Umiliana dei Cerchi: Nascità di un culto nella Firenze de dugento," *Studi Francescani* 77, nos. 1–2 (1980): 87–117. Umiliana's situation is a dramatic illustration of the repressive Italian gender system exposed by the various articles of Christiane Klapisch-Zuber in her collection *Women, Family, and Ritual in Renaissance Italy* (Chicago, 1985), particularly "The Griselda Complex," pp. 213–45, showing that the clothes and other items were probably never really hers. Rudolph M. Bell, *Holy Anorexia* (Chicago, 1986), p. 88, sees her as a classic case of the type of anorexia associated with female sanctity in the Middle Ages.

39. Her body was torn apart for relics by a mob of worshipers assembled by her friends. The same sort of demonstration (with a slightly less spectacular conclusion) occurred on the death of the Provençal beguine Douceline de Digne, according to J. H. Albanes, *La vie de sainte Douceline, fondatrice des béguines de Marseille* (Marseille, 1879), p. 13.

40. Hugo of Floreffe, *De B. Yvetta*, 9:25.

investing her funds for their sake, but ultimately she became revolted by her involvement in the profit economy and renewed her program of dismantling her possessions.[41]

In the burgeoning cities where new enterprises were providing opportunities for the rising population, the losers often outnumbered the winners. Nothing grew so swiftly, relentlessly, and frighteningly as poverty.[42] The critique of wealth, perhaps, seemed even more socially corrosive when it originated with women who were paupers in the bosom of the prosperous classes. Successful men who had amassed commercial fortunes were often attacked by a sense of guilt and renounced them in mid-life.[43] Women, who were torn between an alternating sense of guilt because they enjoyed the fruit of ill-gotten gains and victimization because of their loss of control, often came to detest goods that their men had acquired, denouncing them as a product of sinful usury.[44] Marie d'Oignies, who felt that her mother's business dealings had been unjust and usurious, chose to live on herbs and soups made from vegetables she gathered herself in order to avoid eating food that might have been purchased with "unjust" profits. Likewise, Elisabeth of Thuringia imposed certain food prohibitions upon herself, which may be explained as avoidance of food obtained through the exactions of mercenary officials. Ida of Louvain denounced her father's possessions as "poisoned things, germs of death."[45]

Francis of Assisi systematized the new poverty into a broad range of social services and preaching activities for men. For women, however, it became increasingly difficult to satisfy the need to give through service. Their passion for renunciation was held suspect even by men-

41. Ibid., 9:26–27.

42. Oexle, "Armut," pp. 87–88. Between 1100 and 1300 the population at least doubled and at least half of the urban population was poor. Hunger was pervasive, and three great famines in the years 1125–26, 1144–46, and 1196–97 aggravated the situation.

43. For a systematic examination of the tension between the emerging capitalist system and the poverty movement, see Lester K. Little, *Religious Poverty and the Profit Economy in Medieval Europe* (Ithaca, N.Y., 1978).

44. The belief that the original beguines came from the lower classes of society has been decisively disproved by recent writers from Ernest W. McDonnell, *The Beguines and Beghards in Medieval Culture with Special Emphasis on the Belgian Scene* (New Brunswick, N.J., 1954), through Stein, "The Religious Women of Cologne."

45. De Vitry, *Life of Marie d'Oignies*, 2.44. Vauchez, "La pauvreté volontaire," thinks Elisabeth's prohibitions were in opposition to the landgrave's state-building activities, an insistence that he live on his own. This suggests that she thought his seigneurial regime a form of brigandage. The example of Ida of Louvain and others are multiplied by McDonnell, *The Beguines and Beghards*, p. 152.

dicant friars with a professional interest in cultivating it. Elisabeth of Thuringia admired Francis of Assisi and corresponded with him concerning her ambition to emulate him by becoming a permanent beggar. Her Franciscan confessor, however, following the prohibitive laws of the church, frustrated her design and limited it to her hospital service. Nor did Francis's friend and companion of the early years, Claire, receive sympathetic support in her vain effort to create a female fellowship to the Friars Minor. She began with a clear intention to embrace voluntary poverty in the same reckless and radical manner as Francis and Elisabeth. She fought to establish a genuine Franciscan order for women and fiercely clung to her privilege of poverty though neither the Roman curia nor Francis himself regarded women as eligible partners in the preaching mission. Francis placed Claire in a Benedictine cloister and when she had repeatedly protested that her vocation was being thwarted, he moved her to a cloister of her own. Finally he allowed the mother house of her order, Saint Damien in Assisi, to practice Franciscan poverty but refused the sisters the right to beg or preach and promised the order's protector, the future pope Gregory IX, that the privilege of poverty for women should never be extended beyond Saint Damien.[46] To compensate for this strangulation of her mission, Claire promoted greater fasting among her nuns. Despite her lifelong struggle, her order gradually succumbed to the pressure to institutionalize along Benedictine lines.[47]

Gregory IX consistently tried to transform recluses and independent holy women into cloistered nuns as he had done to Claire. Eremetical women established in Italy by Filippa Mareri were restructured into a monastic establishment on the Benedictine model as the price of papal approval. German synods of the 1230s prohibited wandering women from preaching poverty. The bishop of Mainz ordered women to cloister themselves at home and live by handwork if they were poor. In 1273 the Dominican general Humbert of Romans said that begging was dangerous to women and no woman should be regarded as a religious who could not support herself in a cloister without begging.

46. Luke Wadding, *Annales minorum* (Lyons: 1628–35) 1:311 n. 44. The chronicler Thomas of Pavia reported that Francis said women were a cancer in the flesh that would kill the order.

47. The outstanding Franciscan women of the later thirteenth century and fourteenth century are generally tertiaries, living outside conventual conditions (Donald Weinstein and Rudolph M. Bell, *Saints and Society: The Two Worlds of Western Christendom, 1000–1700* [Chicago, 1982], pp. 175–79).

The beguines of Bruges were prohibited from caring for the sick except when, in cases of public necessity, their headmistress gave them permission to tend relatives and certain friends. Thus by the end of the thirteenth century, women found the channels for their charity even more restricted than in the late twelfth century. In England, where recluses flourished, various rules were compiled which prescribed continual prayer and recommended that they were not to involve themselves in almsgiving. The author of the widely read *Ancren Riwle* repeatedly warned anchoresses against too much conversation, gossiping, giving of advice, and dispensing of alms. He maintained that a recluse should not have enough of her own to give and that she should not take on the task of dispensing the gifts of others for fear that the responsibility would lead her to become greedy. This unrelenting pressure against the charitable work of women seems to betray a deep panic on the part of both clergy and secular officials. Beguinages and hospitals came to be viewed as hotbeds of heresy, largely because of their commitment to poverty and care of the poor.[48] Gregory IX was the first in a line of popes culminating with Boniface VIII who demanded that religious women be silent and cloistered.

These restrictions inspired women to experiment with spiritual almsgiving to complement or replace corporal charity.[49] Alice of Scarbeck, for example, offered the inroads of her leprosy for various causes. Ida of Louvain supported the preaching mission of the Dominicans with

48. A typical example of Gregory's approach was chronicled by P. Höhler, "Il monastero di S. Maria in Monteluci in Perugia dalle origini alla metà del secolo XIV," in Rusconi, *Il movimento religioso femminile*. On Mareri, see Brentano, "Il movimento religioso femminile." On the German orders; see Grundmann, *Religiöse Bewegungen*, pp. 391, 326, 335. On Bruges, McDonnell, *The Beguines and Beghards*, 136. On England, Aelred of Rievaulx, *A Rule of Life for a Recluse*, trans. Mary P. MacPherson in *Treatises: The Pastoral Prayer Works*, vol. 1, ed. David Knowles (Spencer, Mass.: 1971), 1:47–48; Grimlac, *Rule for solitaries*, c. 39; *Patrologia Latina*, 103:5, expresses fear that those seeking alms and even other sisters seeking hospitality will be the means of injecting corruption through flattery or gossip or romance; for an overview see Ann K. Warren, *Anchorites and Their Patrons in Medieval England* (Berkeley and Los Angeles, 1986). *The Nuns' Rule, or Ancren Riwle*, trans. James Morton (New York, 1966), p. 67. M. Mollat, *Les pauvres dans la société médiévale* (Paris, 1977), p. 220. See also Jean-Claude Schmitt, *Mort d'une hérésie: L'église et les clercs face aux béguines et aux béghards du Rhin supérieur du XIVe au XVe siècle* (Paris, 1978).

49. Roisin, *L'hagiographie cistercienne*, associates spiritual almsgiving with the partnership of Cistercians and the early generations of northern beguines as complementary to the order's commitment to corporal charity, but it seems to me that the concept is more widespread and perhaps independent of male origination.

her prayers as Marie d'Oignies contributed her physical illness to the success of the Albigensian Crusade.[50] As a child, Anna de Winegge devoted herself to helping the blind and the lame whom she met in the streets. As a nun at Unterlinden, she was particularly good at serving the sick and cleaning up their putrescence. When her three chronic patients died she consoled herself for their loss, "knowing that even if she could not heal the sick she could make them well spiritually, constructing three hospitals in her mind where she collected three types of people: sinners in the world, those in danger of death and finally the dead suffering in purgatory."[51]

Clearly, prayers for the living did not satisfy the intense need for contact with the recipients that gives charity its dialectical tension. Gradually, cloistered women began to make contact with the needy dead as objects of their patronage. Prayer to assist the dead in purgatory was nothing new. It constituted the basis of much of the elaborate ritual practiced in Cluniac houses and explains the eagerness of wealthy people to contribute their wealth to monasteries in the early Middle Ages. Before the twelfth century, however, it did not entail a direct dialogue with the dead. About 1125, Guibert de Nogent said that his mother saw her deceased husband and the child he had begotten adulterously suffering in purgatory and tried to redress their sin by raising an orphan who tormented her by crying all night and other naughtiness. About 1150, the mystic Elizabeth of Schönau entered into a dialogue with the souls of dead nuns who requested the assistance of her convent in paying the penalties that remained from their earthly sojourn. In England, her contemporary Aelred of Rievaulx praised the Gilbertine nuns of Watton for their practice of praying for the soul of each dead nun until she appeared to them and assured them that she had been saved. In the early thirteenth century, Marie d'Oignies had a vision of hands praying for release from purgatory.[52] Ida of Nivelles,

50. Alice gave her right eye for the success of William of Holland against Aachen in 1247 and her left for Louis IX at Damietta (*The Life of Alice the Leper [Vita B. Aleidis Scharembecanae]*, ed. and trans. Martinus Cawley [Lafayette, Ore., 1987]). De Vitry, *The Life of Marie d'Oignies.*

51. "Les vitae sororum d'Unterlinden: Edition critique du manuscrit 508 de la Bibliothèque de Colmar," 31, ed. Jeanne Ancelet-Hustache, *Archives d'histoire doctrinale et littéraire du moyen âge* 5, (1930) p. 425.

52. Guibert de Nogent, *Autobiography*, 18, ed. John F. Benton as *Self and Society in Medieval France* (New York, 1970), p. 93. Elizabeth of Schönau, *Revelations*, book 2, cited in Elizabeth A. Petroff, *Medieval Women's Visionary Literature* (New York, 1986), p. 161. Aelred of Rievaulx, *De Sanctimoniali de Wattun, Patrologia Latina*, 195, col. 790. It is worth noting that all of this activity predated the Fourth Lateran Council,

a cloistered Cistercian nun who was given the stigmata, developed a generalized power to see suffering souls in purgatory and save them by her prayers. Thus deprived of an outlet in corporal alms, religious women turned their personal suffering and self-deprivation to the uses of the spiritually needy.

Thomas de Cantimpré depicted Lutgard of Aywières as a specialist in liberating souls from purgatory.[53] Her career began with a peremptory sense of divine compulsion. One day she felt ill and intended to stay in bed, but she was aroused by a voice that demanded her attendance at matins for the redemption of sinners.[54] She applied herself vigorously to prayers and mortifications, which resulted in her helping her own sister, who prayed for help from purgatory, and other friends who had died. Then assorted priests and abbots and even the great cardinal Jacques de Vitry were added to her clientele. Finally Lutgard had a vision of Pope Innocent III just after his death begging for her prayers because he had been condemned to purgatory until Judgment Day. Lutgard's widely publicized vision reduced the greatest pope of the age to dependency on her spiritual alms. Thus, by developing their power to assist the dead, women of limited means and worldly prospects put themselves firmly among society's benefactors and outside the realm of the abject and needy poor.

These pragmatic contributions to the developing doctrine of purgatory from women obsessed with the need to give were ultimately systematized by theologians, chiefly Dominicans, who took a particular interest in female mystics. Preaching friars were often the closest confidants of women involved in purgatorial experiments. Studies of sermons delivered in 1272–73 by mendicant friars to the Beguines of Paris include several exhortations by bishops to pray for their relatives

whereas Jacques LeGoff, *The Birth of Purgatory* (Chicago, 1987), claims that purgatory was systematized as a penitential system only in the twelfth century and did not receive its full theological development until after the Fourth Lateran Council produced a new approach to the whole question of sin and punishment.

53. LeGoff, *The Birth of Purgatory*, p. 324, calls Lutgard of Aywières a saint of purgatory. Her power was also confirmed by the liberated soul of de Vitry in a vision, and indeed her influence seems to have been so highly regarded that the saintly Marie d'Oignies appeared to her after death to intercede for help for the prior of Oignies, former chaplain of Aywières.

54. Thomas de Cantimpré, *Life of Lutgard of Aywières*, 1.13, ed. and trans. Martinus Cawley (Lafayette, Ore. 1987). Thereafter she was roused from sleep to attend matins by a voice crying out: "Get up quickly! Why are you lying in this bed? Do not just lie there in your own sweat! You must do penance now for sinners lying in their own filth."

and other souls in purgatory and even for living relatives and friends against their future there.[55]

Christina of Saint Trond set forth a practical system for dealing with purgatory that seems slightly to predate the question of pain as a source of merit, developed by Alexander of Hales between 1216 and 1238 (though it does not antedate Thomas de Cantimpré's biography of her).[56] Hales argued that the pain of the militant on behalf of the church's suffering members could help to provide merit for their release.[57] Christina awoke during her own funeral and said she had been raised from the dead to complete her purgatory on earth so that all her contemporaries might be instructed as to its gravity. For some period thereafter she suffered spectacular tortures combined with levitation and other supernatural feats. Then she announced that she had completed her sentence, and thereafter she was able to lead the souls of the dead to purgatory or through purgatory to heaven with no harm to herself.[58] Jacques de Vitry, who may have known her, and Thomas de Cantimpré, who relied on the testimony of her friends, say that after some years of relative calm, she determined to attempt to repeat her suffering for the sake of her dead patron, and her spectacular supernatural manifestations resumed.[59] Christina's experiments in the transfer of purgatorial penalties to herself, therefore, paralleled Hales's theological exposition of the possibility.

To begin with, suffering, like poverty, was often involuntary. Soon, however, many saints showed themselves anxious to volunteer for additional trials. Cantimpré says Lutgard of Aywières prayed to share the martyrdom of Saint Agnes and was rewarded by a physical blow that left a scar. She lived for eleven more years, during which time she regularly expressed gratitude for her blindness. The ultimate expression of this dynamic was the stigmata that was visited upon both women and men for the first time in the early thirteenth century.[60]

After the First Council of Lyons in 1254, the economy of purgatory

55. LeGoff, *The Birth of Purgatory*, p. 318.
56. Thomas de Cantimpré, *Life of Christina of St. Trond*, trans. Margot H. King (Saskatoon, Sask., 1986).
57. LeGoff, *The Birth of Purgatory*, p. 12.
58. Cantimpré, *Life of Christina of St. Trond*. Christina is also described by Jacques de Vitry in his *Life of Marie d'Oignies*, prologue 8, which Thomas quotes.
59. Cantimpré, *Life of Christina of St. Trond*, 3:7; 34:45.
60. Caroline W. Bynum, "Women Mystics and Eucharistic Devotion in the Thirteenth Century," *Women's Studies* 11, nos. 1–2 (1984): 179–214, thinks that suffering stigmata and penitential pain was associated more with women.

became more carefully rationalized. Gertrude of Helfta recorded the visions of her sister nun Mechtild of Hackeborn, who was assured that her prayers secured the release of innumerable souls from purgatory. Although she was inclined to believe that the justice of God prohibited too much interference with the process of purgation, she offered her own merits with apologies for her indigence. God assured her that it was his habit to repay every gift of charity with an equal store of charity, preventing the spiritual almsgiver from ever becoming impoverished. Other women, who felt themselves to be far from assured of their own salvation, still became convinced that they had spiritual wealth enough to save others. In the middle of the thirteenth century the Dominican Jacobus de Voragine freed spiritual alms from dependence on the virtue of the giver. This made it possible for Margaret of Cortona to save her mother from purgatory while she was still doing penance for her sins as the mistress of a local nobleman.[61]

Purgatorial alms sometimes acted as a creative way of converting involuntary suffering into voluntary suffering. Christine of Stommeln was frequently thrown violently about by hostile demons; fearful pains were inflicted upon her and then cured by superlative consolations of a spiritual nature. The young woman seemed unable at first to understand or direct the nature of her experience. But once the Dominican Peter of Dacia presented the idea of purgatory to her, Christina's spiritual experiences took meaningful shape. Thereafter, she embarked on a systematic program of actively praying for suffering to be inflicted on her to relieve the pains of particular persons.[62] Her prayer was granted and soon afterward she refined her request by asking that her torments

61. LeGoff, *The Birth of Purgatory*, p. 283, dubbed the papal definition at that council as the "birth certificate" of purgatory. For a more complete examination of the spirituality of the nuns of Helfta, see Caroline W. Bynum, "Women Mystics in the Thirteenth Century: The Case of the Nuns of Helfta," in *Jesus as Mother* (Berkeley, 1982), pp. 170–261. "Revelations of Saint Gertrude," c. 3, trans. William J. Doheny (1978, typescript), pp. 281–85. Jacobus de Voragine, *The Golden Legend*, trans. Granger Ryan and Helmut Ripperger (New York, 1969), p. 656. Bell, *Holy Anorexia*, p. 93.

62. Peter of Dacia says that early in their acquaintance, "the virgin often called me from silence by name and asked to hear something from me about God.... [I told her a tale which] concerned the liberation of a preaching friar from fifteen years in Purgatory thanks to an older brother's mass who was familiar with him and his life" (Peter of Dacia, *De gratia naturam ditante sive de virtutibus Christinae Stumbelensis*, ed. Monika Askalos [Stockholm, 1982], p. 33). He probably told her the same story that Gerard de Frachet mentions in his history of the Dominican order from 1203 to 1254, an account of two friars from Cologne who appeared to their living brothers to assure them of their salvation (cited by LeGoff, *The Birth of Purgatory*, p. 316); Peter of Dacia, pp. 33, 34.

no longer be visible to others. This broadened the range of her suffering, which she graphically described to Peter and to her confessor, and the scope of her patronage.

The most dramatic of her feats was the salvation of the souls of seven thieves whom she converted to penitence after an army of devils had dragged her by night into a forest said to be three hundred miles from her home, mashed her body under several fallen trees, and left her supernaturally dismembered for the outlaws to discover. This weird tale culminated with her promise that if the outlaws gave themselves up to the secular courts for their well-deserved punishments, she would go bail for them with the heavenly courts and take their purgatorial pains upon herself. The thieves were duly executed and Christina then plunged into an extravagant orgy of suffering imposed by platoons of demons who visited her nightly, only to be routed every morning in the face of her courage and determination. After months of being burned and frozen, beaten and dismembered, stuffed with toads and snakes and spitted over a roasting fire, she was gratified by a visit from her grateful thieves who had reached heaven by her efforts.

After that nothing could restrain her. Having gotten the hang of it, she went on to give her sufferings to spare the pains of purgatory to various dead relatives, local dignitaries, and finally a whole series of anonymous souls who regularly went to swell her clientele in heaven.[63] Christina came to feel that if God did not send demons to torment her (and then, of course, his angels and himself to comfort her for her sufferings) that he was punishing her for some terrible fault on her side. In this respect, these suffering women can be said to be involved in a relationship between the gift of Christ's suffering and the reciprocal gift of their own suffering.[64] But going further, one can compare this passionate relationship between Christ and his brides to the more mundane struggle between Clothar and Radegund. Christ gave them pain and they took it as a gift to bestow on beggars in the afterworld.

There is even a certain competitive edge to the process as it developed. Adellheit du Rittrin, a nun of Katarinental, took pride in having rescued from purgatory a burgher of Nineveh who claimed to have suffered there longer than any other soul.[65] Thomas Aquinas thought that the dead could return to solicit the help of the living and argued

63. Peter of Dacia, *De gratia naturam*, p. 56.
64. Bell, *Holy Anorexia*, 93.
65. "Leben Heiliger Alemannischer Frauen des Mittelalters: 5. Die Nonnen von St. Katarinental bei Dieszenhofen," ed. A Birlinger, *Alemannia* 9 (1881): 160.

that prayers assigned to specific individuals were more useful than those randomly distributed.[66] Christina took up the case of a nobleman who had died in a state of mortal sin that would have condemned him to hell had he not prayed for forgiveness at the last possible second and gained her attention in a vision. The former Beguine Mechthild of Magdeburg, who found shelter at Helfta in her declining years, made frenzied efforts to free souls from purgatory and even, against all justice, from hell and was grudgingly granted success in the end by Christ.[67]

Women became more anxious than ever to increase their store of spiritual alms and to surround themselves in their cloisters with their grateful clientele. From the translation of involuntary suffering imposed by divine agency into voluntary suffering obtained as a reward for prayer, it is a short step to self-imposed suffering, and many women came to anticipate divine intervention. When she had exhausted all the means at her disposal, Yvetta of Huy continued to put herself among the almsgivers by adding self-inflicted sufferings to her store of alms. The *Ancren Riwle* warned its practitioners against excessive self-mortification, which was increasingly associated with charity among female saints of the thirteenth century. Indeed, the clergy in general pressured enthusiastic women vainly to moderate their passion for self-torment. With unswerving determination, singly in their hermitages or as a group in their convents, women mapped a continuum of mortification that ran from fasting and vigils to flagellation and more bizarre tortures.[68]

In the late thirteenth century, prudent people with an eye to their salvation invested in prayers for their souls much as they invested in earthly securities. Thus at the end of the Middle Ages, as at the beginning, monasteries became the focus for the redistribution of this

66. LeGoff, *The Birth of Purgatory*, 275–76, from the *Supplement* to the *Summa Theologica* by Thomas's students compiled after his death from his various writings.

67. Bynum, "Helfta," thinks that Mechthild's spirituality reflected the dangers and threats she had experienced in the world as compared to the self-assurance of Gertrude, who had grown up in the monastery.

68. *Vita Yvetta*, 31. Morton, *The Nun's Rule, or Ancren Riwle*. On pressure from the clergy, Caroline W. Bynum, *Holy Feast and Holy Fast* (Berkeley and Los Angeles, 1987), 237–44. In addition to accounts of the torments of individual saints, these mortifications are recounted in a series of collective biographies written by German nuns in the late thirteenth and fourteenth centuries. At Töss, group flagellation was a common practice (Elsbeth Stägel, *Das Leben der Schwestern zu Töss*, ed. F. Vetter [Berlin, 1906], p. 14). At Unterlinden and Kirchberg individual sisters are described as binding themselves with nail-studded chains. Other practices include jumping fully clothed into freezing water in the wintertime and placing stones in bed.

new sort of wealth. Those houses that were best known for the efficacy of their intercession were also targeted for the greatest donations. By the early fourteenth century, convents associated with the Dominicans produced written records of their communal efforts for the sake of their relatives, their patrons, their spiritual associates in the preaching order, and for the anonymous poor.[69] Such records probably helped to attract donations to the communities beyond the rather meager customary dowries of the sisters. Thus we sometimes hear that the very convents most distinguished for their austerity and generosity to the souls in purgatory were also able to provide generous temporal alms despite the customary difficulties of convents in defending themselves against the financial depredations of worldly powers.[70] Moreover, the visionary powers that reached into purgatory were sometimes complemented by visions granted to lay patrons to relieve the needs of cloistered nuns.[71]

A reasonably typical example is Aemilia de Bicchieri, prioress of a Dominican convent in Vercelli about 1273. Her father opposed her vocation but finally gave way before her determination and provided her with a suitable dower to enter the convent. He was well rewarded when he died and her prayers swiftly gained him remission of his sentence in purgatory. But Aemilia was not content to pray only for her kin. Her convent became a depository for spiritual wealth that the nuns dispersed, not only to their immediate patrons, but to the anonymous poor who thronged purgatory. Aemilia made a practice of restricting drink as well as food in her house between meals. The happy result was revealed in a vision of a dead nun who announced that all the drinks voluntarily forgone on earth were given to her by her angel to extinguish fires in purgatory. Aemilia's own fasting and mortifications are specifically connected to the alms she was able to send out

69. Bynum, "Helfta," p. 242, cites a brother who left money for the ladies who prayed for him, suggesting that the prayers of such women had special value. LeGoff, *The Birth of Purgatory,* p. 325, follows his discussion of Lutgard by a discussion of purgatory in wills.

70. In the early fourteenth century, Katherine Guebeswihr says that the strictly enclosed nuns of Unterlinden in Colmar added several poor and dowerless nuns to their community of noble ladies. In 1282 there was a great famine at Colmar and the Dominican nuns at Underlinden fed 1,600 poor people for six weeks. These, of course, are medieval numbers and should only be read to mean "many" ("Les *Vitae sororum* d'Unterlinden," prologue).

71. Thus a wealthy man was moved by a vision to bring money to the nuns of Unterlinden when they feared that lack of wages for their harvesters would result in the loss of their crops.

from her closed convent to the poor.[72] It is well worth pondering too that a saint like Aemilia, whose biography was widely dispersed soon after her death, could thus reach beyond the cloister and demonstrate the profits that donors might expect from a community as holy as hers.

Margarethe Ebner saw herself surrounded by dead souls clamoring for her help as the poor on earth clamored for alms from the rich.[73] Though provided with a plain and substantial diet, the ladies at Unterlinden in Colmar competed with one another to devise privations for themselves.[74] At first, several nuns had visions of the sufferings of the dead. Then Sister Mechtildis de Wicenhein, who was anxious about two of her brothers, undertook a rigorous program that resulted in their ultimate salvation. Similarly the prioress, Adelheid de Rivelden, had a visit of thanks from her dead brother. Like her contemporary Dante Alighieri, the sister had a vision of purgatory in which she saw many of her former acquaintances suffering. But her vision served only to reassure her of the worth and efficacy of her sisters' efforts.[75]

Similarly the sisters of Töss, near Zurich, Switzerland, were immortalized by Sister Elsbeth Stägel, friend and confidante of the mystic Heinrich Suso. The sisters competed regularly with one another to reduce themselves to poverty and to increase the offerings at their command. Mezzi Sidwibrin, a sister who was not only poor but feebleminded, had little to contribute but her industriousness at the common work. "And so she sat and spun and did it devoutly so that she sat and spoke with our lord as though there were no one there but she and he. She would say, 'Lord, I will dedicate every thread that I spin, a soul rises to you,' and then the tears ran freely down her cheeks."[76]

Visions and encouraging manifestations of success spurred the sisters of Töss on to heights of spiritual accomplishment. Finally, Sister Beli von Liebenberg prayed "that she might know how many souls had been redeemed that morning by the sisters' prayers. And she saw four bright lights shining at the window and a voice said to her, 'These are four of your sisters who have been saved by your prayers but the

72. Anna Mechthild Fuaza, *De B. Aemilia Biccheria*, in *Acta sanctorum*, pp. 557–71, c. 13, 16, 19.

73. *Offenbarung der Margaretha Ebner*, ed. Phillip Strauch, in *Margaretha Ebner und Heinrich von Nördlingen* (Amsterdam, 1966), p. 6.

74. "Les *Vitae sororum* d'Unterlinden," C 5.

75. Ibid., c. 15, c. 23.

76. Stägel, *Das Leben der Schwestern zu Töss*, c. 23.

number of souls who are redeemed every day by your prayers is immeasurable.' And then a soul came particularly and said, 'Lady, God bless and reward you: I have been redeemed by your prayers.' "[77]

Nuns of the early fourteenth century found themselves generally constrained to a single expression of the spiritual life. In secular and ecclesiastical life, the increasingly restrictive property laws of the age had made even the wealthiest women dependent on men for whatever power to give remained to them. The complementary restrictions on their ability to lead an active religious life of service effectively blocked women from positions of heavenly prestige as they were blocked from earthly power. But, left with little to control but their own bodies, and faced with severe constraints on their physical powers, many proud and ambitious women turned to self-imposed deprivation and suffering to express their determination to remain in the giving class. Their efforts kept the doors open for women who wished not only to be holy but to have that holiness recognized as sanctity. Pride in their achievement was expressed by Sister Elli von Ellgo of Töss, who had a vision of a dead nun, Sister Margret von Hunikon, "in such an overwhelming light that it brightened the whole choir. Many souls were with her. And [Sr. Elli] thought she saw the heavens open and all the souls rise with her."[78]

77. Ibid., c. 26.
78. Ibid., c. 54.

11 JOHN COAKLEY

Friars as Confidants
of Holy Women in Medieval
Dominican Hagiography

The extensive contact of medieval Dominican friars with religious
and semireligious women is well known. It is true that in the mid-
thirteenth century the order made strenuous official efforts to divest
itself entirely of responsibility for pastoral care of such women. But
these met successful resistance from women themselves, with the pa-
pacy as their advocate, and locally, friars continued and expanded the
work even while such efforts were under way.[1] Duty itself goes a long
way toward explaining why this should be so; it was simply a necessity,
from the thirteenth century on, to maintain the increased numbers of
religious women under ecclesiastical discipline and protection, and part
of the task fell to the Dominicans. And yet a sense of duty was not all
that friars brought to their encounters with women. Those who min-
istered to women could also acquire a deeply admiring interest in their
lives, and thereby a personal involvement with them that transcended
duty entirely. Such was clearly the case with the friars I will discuss
here—namely, those who formed close relationships with female saints
as their confidants and in many cases confessors, and whose voices are
preserved directly (in most cases) or indirectly in the hagiographical

I thank Caroline Walker Bynum and Ernest McDonnell for commenting helpfully
on an earlier version of this essay.

1. Herbert Grundmann, *Religiöse Bewegungen im Mittelalter,* 2d ed. (Hildesheim,
1961), pp. 284–303; Ernest W. McDonnell, *The Beguines and Beghards in Medieval
Culture* (New Brunswick, N.J., 1954), pp. 187–95; Brenda Bolton, "Mulieres Sanctae,"
in Derek Baker, ed., *Sanctity and Secularity: The Church and the World,* Studies in
Church History, 10 (Oxford, 1973), pp. 90–92; John B. Freed, "Urban Development
and the 'Cura Monialium' in Thirteenth-Century Germany," *Viator* 3 (1972):311–27.

literature from the mid-thirteenth century to the early sixteenth. These voices speak of the men's perceptions of the women, their interactions with them, and the significance these interactions held for the men—in short, of their experience of women as an aspect of their religious experience as men.

A word is in order about these Dominican confidants as a group. The figures I will discuss have in common that they either wrote, or provided information for, vitae of the women with whom they were associated. As confidants they have no counterparts in vitae of Dominican men.[2] On the other hand, neither are they unique to their order; Dominicans had no monopoly on attachment to holy women, and a broader study would also examine non-Dominican figures.[3] Nonetheless attachment to holy women has a substantial place in Dominican tradition; the vitae that serve as my sources account for more than a third of the extant vitae known to me of female saints associated

2. This is my conclusion from examining the vitae of eighteen of the nineteen male Dominican saints for whom I know of extant vitae dating from the period of the thirteenth through the sixteenth centuries. (The vita I have not examined is that of Wichmann of Arnstein; see Felix Vernet, "Biographies spirituelles," *Dictionnaire de Spiritualité*, vol. 1, col. 1665.) Indeed the one hagiographer who both had and described familiar interaction with the male saint of whom he wrote nonetheless remained a stranger to the saint's inner life: this was Francesco Castiglione, secretary and hagiographer of the bishop Antoninus of Florence (d. 1459); vita in *Acta sanctorum*, May (Paris, 1866), 1:317–30.

3. No such general study exists, but the phenomenon of close male devotees of female saints has been often noted. On men as members of female saints' entourages, see André Vauchez, *La sainteté en Occident aux derniers siècles du moyen âge, d'après les procès de canonisation et les documents hagiographiques* (Rome, 1981), pp. 439–40. On early thirteenth-century vitae of Flemish holy women written by admiring men (with special reference to Jacques de Vitry, who pioneered the type of vita I am discussing), see Brenda M. Bolton, "Vitae Matrum: A Further Aspect of the Frauenfrage," in *Medieval Women*, ed. Derek Baker, Studies in Church History, Subsidia 1 (Oxford, 1978), pp. 253–73. On the difficulties presented for the study of women's own experience by fact of the predominantly male authorship of accounts of women, see Caroline Walker Bynum, *Holy Feast and Holy Fast: The Religious Significance of Food to Medieval Women* (Berkeley and Los Angeles, 1987), pp. 28–29; I wish to stress that I will be specifically concerned here with men's experience *of* women. On the phenomenon of vitae written by persons close to the saints themselves and drawing on privileged knowledge of their experience, see Richard Kieckhefer, *Unquiet Souls: Fourteenth-Century Saints and Their Religious Milieu* (Chicago, 1984), pp. 6–7. But to follow Kieckhefer in labeling these works "quasi-autobiographical" in the sense of representing "oral autohagiography" gathered by the authors in their conversations with the saints could obscure the fact that the most precise witness of these vitae is to the hagiographers' experience of their saints rather than to the saints' experience itself (a distinction Kieckhefer elsewhere employs [p. 4]).

with the Dominican order.[4] The female subjects have in common that
they were urban tertiaries or Beguines, that is, laywomen not strictly
cloistered but under religious discipline; the male confidants encoun-
tered them in the course of their public ministries in the towns. The
fact is crucial, and helps place these figures in the context of recent
scholarship on medieval sanctity. The women display, for instance,
remarkably extreme asceticism and sense of adversity. Richard Kieck-
hefer has noted such tendencies as a widespread feature of fourteenth-
century sanctity, suggesting that they may arise from the tension of
the attempt to pursue monastic ideals without being separated from
society.[5] André Vauchez, moreover, has noted a general effort among
mendicants, particularly from the late thirteenth century on, to promote
an ideal of female lay sanctity in which ascetic themes abounded. Such
an effort suggests an attempt to clericalize lay spirituality; but thereby
it also presupposes an encounter with laywomen in the world.[6]

Fundamental to that encounter, in the cases I will consider, was the
men's sense of the difference between women's experience and their
own. The difference has also impressed modern scholarship. Various
studies have shown, for instance, that women were more likely than
men to cultivate eucharistic devotion and that mystical and paramystical
experiences were attributed to women much more often than to men.[7]
Vauchez has noticed a certain polarization among mendicant saints in
particular, for whom intellectual and mystical activity seems to have

4. Specifically, they comprise eight out of nineteen women's vitae by friars of the
Order of Preachers. I have considered only individually produced vitae, i.e., products
of individual saints' cults, and thus not collections of vitae, as, e.g., those of German
Dominican nuns (see Felix Vernet, "Allemande [Spiritualité]," *Dictionnaire de Spiri-
tualité*, vol. 1, col. 325. The vita of at least one other of the nineteen, namely Giovanna
of Orvieto (d. 1306), was probably written by her confessor James Scalza, but he makes
no reference to himself or to his interaction with her (Vincent Marredu, ed., *Leggenda
Latina della B. Giovanna Detta Vanna D'Orvieto* [Orvieto, 1853]). There is also a vita
of the Dominican tertiary Osanna of Mantua by the Olivetan monk Jerome of Mantua,
which I have not included in this essay because Jerome was not a Dominican, even
though he is a fine example of a confidant. See n. 41.

5. Kieckhefer, *Unquiet Souls*, pp. 85–88, 189–96.

6. Vauchez, *La sainteté*, pp. 243–56, 426–27.

7. Simone Roisin, *L'hagiographie cistercienne dans le diocèse de Liège au XIIIe siècle*
(Louvain, 1947), pp. 106–23; Donald Weinstein and Rudolph Bell, *Saints and Society:
The Two Worlds of Western Christendom* (Chicago, 1982), pp. 227–323; Peter Dinzel-
bacher, "Europäische Frauenmystik des Mittelalters: Ein Überblick," in Peter Dinzel-
bacher and Dieter Bauer, eds., *Frauenmystik im Mittelalter* (Ostfildern bei Stuttgart,
1985), pp. 11–23; Caroline Walker Bynum, "Women Mystics and Eucharistic Devotion
in the Thirteenth Century," *Women's Studies* 11 (1984):179–214; and especially, as
reviewing and evaluating the state of research, Bynum, *Holy Feast*, pp. 13–30.

formed distinct masculine and feminine preserves, respectively.[8] And recent work by Caroline Walker Bynum suggests a deepening twist on these differences: a tendency of women and men to have had different perspectives on gender itself. For women writers, she finds, "the female was a less marked category" than for men. For men, the genders were quite distinct and opposite and thus when men applied female imagery to themselves, for example, they were expressing a "symbolic reversal," such as a renunciation of the power they would have associated with their own maleness.[9]

Such strong awareness of the distinction of gender is at work in the friars I will be discussing. In this case it was not a matter of working a symbolic reversal by applying female imagery to themselves (although there is at least one example of this), but rather of encountering real embodiments of the female, who retained an otherness both symbolic and literal. Through that very otherness the women signified to these men the presence of the divine. In some cases at least, this was a presence of which the men demonstrably felt otherwise deprived. Unable to experience it through their own ecclesiastical office or theological expertise, they found it only outside themselves, in the women, those opposite creatures to whom they happily had access, who lacked the office or schooled knowledge they possessed, and possessed the charismatic gifts they lacked. The women's mediation of the divine presence for the men, however, presented a potential problem: how it was to be related to the men's own priestly authority, which itself served as mediation of the divine. The answer varied over time: the question was not addressed at first, then the two mediations were perceived as harmonious, and finally, they appeared as somewhat discordant.

The first of the male confidants to appear in Dominican hagiography was the friar Siger of Lille, confessor of the young laywoman Margaret of Ypres (d. 1237) and sole informant of his fellow Dominican Thomas de Cantimpré, who wrote her vita in 1240.[10] Indeed Thomas, as the

8. Vauchez, *La sainteté*, p. 409.

9. Caroline Walker Bynum, " '. . . And Woman His Humanity': Female Imagery in the Religious Writing of the Later Middle Ages," in *Gender and Religion: On the Complexity of Symbols*, ed. Caroline Walker Bynum, Stevan Harrell, and Paula Richman (Boston, 1986), pp. 277, 269; Bynum, *Holy Feast*, pp. 277–302.

10. *Vita Margarete de Ypris*, in Gilles Meersseman, "Les Frères Prêcheurs et le mouvement dévot en Flandre au XIIIe siècle," *Archivum Fratrum Praedicatorum* 17 (1947):69–130, hereafter cited as *V.M.*, followed by chapter number. Translations are mine. On dating see ibid., p. 71.

author also of vitae of other holy women, would be of interest in his own right as a fascinated observer; but for present purposes it is what his work tells us of Siger, as Margaret's actual partner, that concerns us.[11]

The fact of the vita, built as it was solely on the information he provided, shows Siger convinced of Margaret's sanctity. He had first spotted her as "apt for receiving the grace of God and the surety of election" when she was eighteen. For the next three years until her death, he witnessed her asceticism, constant prayer, revelations, visions, and ecstasies and the formation of a group of devout "spiritual friends" around her. When she died, it was as a saint in the eyes of her circle; there were miracles, some of the friends had visions of her reception into heaven, and Siger himself sought out her personal effects as relics (V.M. 6, 50–54). And he was aware of his own share in the divine favor she enjoyed: once, after she had told him that Christ had assured her his direction would not harm her, he devised the test of requiring her to walk a league with him on Easter Day when she was weak from strenuous fasting. She did it with ease (V.M. 26).

If the incident of the test illustrates Margaret's supernatural favor, it also illustrates the importance Siger attached—or rather reported Margaret as attaching—to himself as her patron. It was he who brought her to conversion, at that first encounter when he exhorted her to a rejection of the things of the world and she quickly agreed. He seems to have taken the place of an uncle recently deceased, a priest, with whom she had spent her precociously pious childhood and adolescence. Since his death she had been adrift, dressing fashionably and allowing herself to fall in love—until the mention of marriage, when she had fallen ill. This was when Siger came on the scene as her rescuer (V.M. 5–7). From then on he monopolized her affections. "There was no one so beloved by her as not to weary her with even a little talk—excepting only her spiritual father [Siger] who had led her to salvation. His words she would hang upon, and her soul took in his conversation as a body takes in the food it lives by" (V.M. 13). Likewise even when

11. On the place of the vita of Margaret in the body of Thomas's hagiographical work (which included vitae of Christina Mirabilis and Lutgard of Aywières [see n. 13], and a supplement to the vita of Mary of Oignies by Jacques de Vitry) as signifying his shift toward greater concern with interior graces, see Simone Roisin, "La méthode hagiographique de Thomas de Cantimpré," in *Miscellanea historica in honorem Alberti de Meyer,* 2 vols. (Louvain, 1946), 1:546–57.

he was not with her, she felt him to be so spiritually present that she could consult him inwardly and intuit his answer (*V.M.* 24).

Apparently there had been some objection to their closeness to one another, for Thomas de Cantimpré was at some pains to vindicate it. Thus he had her praying to Christ:

> "you know that more than anything I love you and, on account of you, the one [i.e., Siger] who made me to recognize you and schooled me in loving you. But because mutual love and frequent conversation of a man with a woman appear suspect to our superiors [*maioribus nostris*], I beg of you by your surpassing humility mercifully to show your hand-maiden if in loving and talking with your servant I will incur any loss of your love, and I vow that if I find I have impugned your charity I will never talk with him again." (*V.M.* 25)

The *maiores* are not identified, but it is plausible to think that they included Margaret's parish priest and Siger's superiors, who might be expected to express the order's ambivalence about the pastoral care of women.[12] In any case, her appeal to Christ was a private circumvention of their authority, and it was, so to speak, successful; the response was that divine assurance that Siger tested on Easter Day. Other signs too affirmed their relationship: once when he was five leagues away in Lille and she was missing him, she suddenly could see him across the distance, and another time when he was saying a mass for her in her absence she knew it by revelation (*V.M.* 34, 30).

In some ways the case of Siger anticipates those of the later figures to be discussed here; in other ways it stands over and against them. The hint of the future lies in Siger's evident fascination with the holy woman he attended and in the hint, though ever so slight here, that the woman's contact with God carried with it an authority distinct from ecclesiastical authority. What we will not see again, however, is the straightforwardness and lack of ambiguity that characterize Siger's position as spiritual adviser to Margaret: for all her extraordinary gifts, he did not go to her for access to God. Thomas himself, between six and eight years after writing the vita of Margaret, was to portray himself as going to a saintly woman, Lutgard of Aywières, to seek her prayers to remove the temptations he was experiencing when he heard confessions.[13] But in Margaret's case, it was the woman who went to the

12. On the *maiores* see Meersseman, "Les Frères," p. 73.

13. Thomas de Cantimpré, *Vita* [Lutgardis] 2.3.38, in *Acta sanctorum*, June (Paris, 1867) 4:187–209. On the dating of this work, see Roisin, *L'hagiographie*, p. 52.

friar—that is, for her conversion—and she remained thoroughly under his authority and radically dependent upon him until her death (*V.M.* 13, 19, 42, 20).

Two late thirteenth-century figures concern us: Peter of Dacia (d. 1289), friend of the German Beguine Christine of Stommeln (1242–1312), and Conrad of Castillerio, confessor of the Italian tertiary Benvenuta Boiani (1255–92). Both of them viewed the women they served as less exclusively objects of direction than did Siger, and more explicitly as also objects of devotion.

Thus in the richly documented relations between Peter of Dacia and Christine of Stommeln we find devotion that was long-lived and mutual. The documents include Peter's meticulous accounts of nineteen visits he made to Christine and sixty-three letters exchanged with her and her circle at Stommeln near Cologne.[14] The first thirteen visits took place in Stommeln between December 1267 and April 1269, when Peter was attached to the Dominican school at Cologne; the next three, in 1270, when he returned to his native Sweden from his stint as a student in Paris; and the final three, during a brief return to Cologne in 1279. The exchange of letters began when he was in Paris and continued through his years in Sweden until his death in 1289, as prior of the Dominican house at Visby. He began writing the accounts of the visits in 1278.[15]

14. Peter's accounts of his visits and the collection of letters, which together comprise the second and largest part of the the *Codex Iuliacensis,* have been edited by Johannes Paulson, *Petri de Dacia Vita Christinae Stumbelensis,* Scriptores latini medii aevi Suecani, 1 (Gothenburg, 1896), cited hereafter as *V. Chr.* Translations are mine. An edition is also to be found in *Acta sanctorum,* June (Paris, 1867), 5:236–94 and 349–62, the work of the Bollandist Daniel Papebroek (ca. 1707) who, however, derived it from a faulty copy of the manuscript and considerably altered the order of materials, ostensibly to reflect chronology. Papebroek also published portions of the first and third parts of the manuscript (*Acta sanctorum* June, 5:294–348). The former is a treatise by Peter on Christine's virtues, now available in full as *De Gratia Naturam Ditante sive De Virtutibus Christinae Stumbelensis,* ed. Monika Asztalos (Stockholm, 1982). The latter is an account of Christine's life written at Peter's request by the schoolmaster John of Stommeln; other portions of it are included in *In tertiam partem libri Juliacensis annotationes,* ed. Johannes Paulson (Gothenburg, 1896). On these sources see Peter Nieveler, *Codex Iuliacensis: Christina von Stommeln und Petrus von Dacien, ihr Leben und Nachleben in Geschichte, Kunst und Literatur* (Mönchengladbach, 1975) and bibliography there; also Thomas Kaeppeli, *Scriptores Ordinis Praedicatorum Medii Aevi,* 3 vols. to date (Rome, 1970–80), 3:224–25.

15. I follow the chronology established by Jarl Gallen, *La province de Dacie de l'Ordre des Frères Prècheurs,* Istituto storico Santa Sabina, Dissertationes historicae, 12 (Helsingfors, 1946), pp. 225–44.

Peter saw his connection with Christine as momentous and providential. A self-revealing passage at the beginning of his account of the first visit explains that in his early youth, when he had first heard of the saints and first thought of renouncing the world, he asked God to "show me some one of his servants from whom I might learn the ways of his saints not just through words but through deeds and examples sure and clear; to whom I might be joined and united in heartfelt love; whose actions might instruct me; whose devotion might kindle me and rouse me from the torpor that had oppressed me since childhood; whose conversation might enlighten me; whose friendship might console me; whose examples might clear up all my doubts, especially about the ways of the saints." For more than twenty years afterward, although "the Lord showed me many persons of both sexes by whom he often gladdened my heart," none satisfied the desire (*V.Chr.*, p. 2). Then in December 1276 he watched Christine at the house of the parish priest of Stommeln, while a demon threw her backward, causing her to hit her head against the wall. The event caused a general uproar in the room, and everyone else was troubled and fearful, but Peter found himself elated (*V.Chr.*, p. 4). He stayed in vigil at the priest's house through that night, fascinated with the indignities that the demon kept inflicting upon her. The next day he returned to Cologne convinced that he had for the first time seen a "bride of my Lord" (*V.Chr.*, p. 8).

Then and afterward, although he did not ignore Christine's exemplary virtues of patience and humility (e.g., *V.Chr.*, pp. 10–11), what fascinated Peter mainly were the wonders that attended her. He was on the alert for these even as he set out for his first visit (*V.Chr.*, p. 3). He wept for joy at his first sight of Christine going into a rapture, her body stiffening (*V.Chr.*, p. 11). He was similarly enthusiastic about her stigmata, as well as lesser wonders such as a heavenly voice emitting from her breast or heavenly dew accumulating in her veil during ecstasies.[16] But when the narratives are taken together, the prodigy that dominates is the demons' treatment of her. The most notable and bizarre instances occurred during Peter's ninth and tenth visits, when a demon defecated repeatedly on her and several others keeping vigil around her bed. Peter recorded these indignities in minute detail (*V.Chr.*, pp. 38–55), edified at the effects of Christine's encouragement on the others and at the sweet smell that replaced the fetor when the

16. *V.Chr.*, p. 16 (third visit), pp. 19–23 (fourth visit), p. 48 (ninth visit), pp. 57–64 (twelfth visit), pp. 38, 56.

demon was once dispatched (*V.Chr.*, pp. 46–48,55). Later in their letters the demons' vexations were to be a constant theme, partly at Peter's request.[17]

Underlying Peter's fascination with wonders and graces visited on Christine was a dismay that none had been visited on him. He expressed his dejection in low-spirited letters from Paris, where he missed her especially.[18] In October 1269 he wrote her that in visiting her in Stommeln he had hoped to console her when she felt the absence of Christ as her bridegroom, "for although I do not know it by experience, I am acquainted from Scripture with how bitter and harsh it is to be denied such consolations [that is, of the bridegroom's presence] once tasted" (*V.Chr.*, p. 80 [letter 5]). In February he pined: "What is he [the bridegroom] to you, or you to him? O that I could perceive it! O, O that it was given to me to feel it! But since I know my measure, and understand that it is forbidden for the holy place to be entered by the unclean or a celestial secret be opened to the unworthy, and that the presumptuous intruder will be cast into the outer darkness, I choose to live secure in my poverty rather than to be cast out for the affront of grasping at what is above and beyond me" (*V.Chr.*, p. 89 [letter 9]). In another letter that same month he wove an elaborate metaphor of Christine and himself as sisters. He was the older and uglier sister, cold of heart, sterile, and unattractive to the heavenly bridegroom, who chose instead the younger Christine, beautiful in virtue. In order not to be left out, then, he resolved to "show myself intimate with my sister and devoted and obedient to her husband, so that she might at least tell me something of her flood of joys and her secrets, and he might come more willingly, more often and with more urgency and intimacy, since in one sister he finds the bedchamber of the heart all prepared,

17. An early example and a late one: *V.Chr.*, p. 87 (letter 6, from Christine, Dec. 1269) and pp. 88–92 (letter 9, Peter's reply, Feb. 1270); and pp. 165–82 (letter 25, from Christine, May 1280) and pp. 250–52 (letter 58, Peter's reply, Aug. 1280). For dating of the letters, see Gallen, *La province de Dacie*, pp. 240–44.

18. E.g., "in Paris are the most devout novices, the most learned students, the most conscientious colleagues in community (*conuentuales*), and the kindest superiors; among these men who shine like fiery rocks, I behave as though I were the reproach of men and the disgrace of the people, to the extent that whereas they are such that the world is not worthy of them, I am such as not to be worthy of the world. Therefore, dearest Christine, Christ's virgin, you who declare piety to Christ in your name, and prove it in your living, have mercy on me, for amid such great devotion on the part of so many I am dry, amid the fervent love of so many I am cold, amid such energetic activity I am subdued, and amid such strict religion I do not fear to behave laxly" (*V.Chr.*, p. 104 [letter 15, his last from Paris]).

in the other a ready obedience of the body, and in both, the desire of devout expectation."[19] He would have vicarious contact with Christ.

To the extent that Peter's letters draw this moral contrast between himself and Christine, the narratives do not show him up as enough of a sinner to illustrate the point. They do, however, illustrate his implied contrast between what he had from books and what she had from experience. Thus during his fifth visit to Stommeln he was giving a discourse on the stages of contemplation according to Richard of Saint Victor. His audience included Christine, who, as he spoke, "was brought through the said stages in such wonderful devotion and exultation that she could not hide her joy, but showed it in words and gestures." Later he held forth again, on the size of the heavens, and this time Christine entered one of her ecstasies on the spot, causing a sensation and disrupting the conference (*V.Chr.*, pp. 24, 25–26). The juxtaposition here of learning and experience calls to mind the divide that Vauchez has noted among late-thirteenth-century mendicants between female models of sanctity, which were ascetical and mystical, and male models, which emphasized "intellectual and doctrinal activity."[20] Peter's picture of himself suggests a man peering longingly across the same divide that separated those ideals.

As Peter's narrative shows Christine experiencing supernatural graces the friars lacked, so it also shows her exercising an authority they lacked. In his ninth visit, when the demon was sporadically dropping excrement on the company, the parish priest attempted an exorcism, at the instigation of Peter's fellow friar Wipertus, who repeated the priest's words after him. Christine warned them that their effort opposed the will of God, who was permitting the demon to try her, and indeed the ceremony only provoked the demon to take aim at Wipertus (*V.Chr.*, pp. 44–45). When Peter and another of his companions later said the office of the Blessed Virgin and laid hands on Christine's head during the reading of the Gospel, new excrement materialized beneath their fingers. The pressure that finally caused the demon to desist was not from them but from Christine, who commanded him to stop blaspheming (*V.Chr.*, pp. 52, 54–55).

As for Christine herself, she like Margaret of Ypres had a strong sense of attachment to her mentor, which in her case seems to have

19. *V.Chr.*, p. 97 (letter 9). Asztalos, *De gratia naturam ditante*, pp. 31–32, finds Peter implicitly assuming the role of older sister in that work also.
20. Vauchez, *La sainteté*, p. 409.

grown in intensity. In her letters to Paris in 1269–70, she chose him
to bury her when the time came and thanked him repeatedly for his
faithfulness (*V.Chr.* pp. 67, 70, 87 [letters 2, 4, 7]). Later, during the
last of the visits in 1270, she declared that already at their first meeting
she had received a revelation that he would be her friend and would
help her, that she would do something for him that she would do for
no one else (that is, give him a written relation of her experiences),
and that they would live together in eternity (*V.Chr.*, p. 107). In her
subsequent letters her feeling for him was more exclusive and passion-
ate.[21] Finally, when he visited her in 1279, she announced that she
had known him from infancy—that is, long before she actually met
him; that she loved him more than any other man, so much that she
feared temptation; that she always prayed for him; and that she had
him as her partner (*consors*) in her tribulations, in token of which she
had received a ring from God (*V.Chr.*, pp. 156–57).

Peter, by contrast, appears in his later letters less ardent, more dis-
tanced, than before. A letter written a few months after her protesta-
tions of love shows him at pains to stress that his love for her is *propter
Christum,* properly spiritualized.[22] He remained her devoted friend,
pressing her to come to Sweden to join the group of devout women
he had cultivated there, arranging for her brother to be received into
the order, and continuing to press for wonderful details.[23] But the
earlier breathless fascination is lacking, and the tone is sometimes now
petulant or imperious, as when he rebukes her for her morbidity or
commands her by his "paternal authority" to produce her long-delayed
memoir (*V.Chr.*, pp. 224–27, 218 [letters 38, 34]).

But even given this slight late cooling, what is particularly striking
about the documents when taken together is Peter's needy fascination
with Christine. The marvels that surrounded her, even the ones that
brought her misery, signified to him the favored status with God that
he longed for. Vicariously he found it through her, and for this he

21. For example, "I desire enormously to see you ... I must tell you many things
which I will reveal to no one but you" (*V.Chr.*, p. 134 [letter 16]); and "I beg of you,
dearest one, to be faithful to me, because I have faith in you more than any man, and
I desire to see you more than you believe" (*V.Chr.*, p. 142 [letter 19]).

22. *V.Chr.*, pp. 162–65. The visit was in Sept. 1279; this letter is dated Jan. 1280.
In Nov., however (pp. 227–29 [letter 39]), he had referred to her as his bride.

23. On coming to Sweden, *V.Chr.*, pp. 238 (letter 47), pp. 224–27 (letter 38); on
her brother, pp. 250–52 (letter 58), p. 238 (letter 47), pp. 224–27 (letter 38), and
pp. 215–18 (letter 34).

was as attached to her, especially early on, as, for his attentions, she was attached to him.

Compared with what is known of Peter, our information about the Italian friar Conrad of Castillerio is slight. What we do know, from the vita of Benvenuta written shortly after her death by an anonymous friar who used Conrad as a source, suggests at first glance that he had an importance for her like Siger's for Margaret.[24] Benvenuta was a pious girl who inflicted extreme mortifications on herself as an adolescent, became seriously ill, and after five years received a sudden cure, which she attributed to Saint Dominic. Conrad was already her confessor at the onset of the illness and remained her confidant until her death, even though in the last years he was no longer stationed at Cividale (*V.B.* 1.7; 3.30–31). As Christ had confirmed Siger's role, so Dominic confirmed Conrad's, telling Benvenuta before her illness, "you need to know that it is divinely ordained that you should have been born in this time and that he should have entered the Order of Preachers, for you to direct your life by his command. On account of him, it shall be well with you and on account of you, good things will come to him" (*V.B.* 1.7). After Conrad's departure from Cividale, she grieved the loss of his "rule and direction," and his services as confidant (*V.B.* 10.86).

Yet another glance shows Conrad's place as less exclusive than Siger's, and less purely priestly. Conrad was not the agent of Benvenuta's conversion, and her world of supernatural experience evolved itself independently of him. It was only after Dominic intervened that she told Conrad of her use of an iron chain. It was only after she had been healed that she told him of her secret austerities, struggles with demons, visits from the Virgin and various saints, and ecstasies—and only then when commanded (*V.B.* 10.86). She also had other associates, including a certain Sister Margaret, who experienced visits from demons with her, and a heavenly vision (*V.B.* 4.34–45; 9.73–76); and there are several references to the widow Jacobina, her "socia et secretaria" who, like Conrad, disclosed some of her secrets after she died.[25] Moreover,

24. *Vita Devotissimae Benevenutae*, in *Acta sanctorum*, Oct. (Paris, 1866–83), 13: 145–85; hereafter cited as *V.B.*, followed by chapter and paragraph number. Translations are mine. I accept the argument of the Bollandist editor Victor De Buck, p. 148, against ascribing authorship to Conrad himself. See also Kaeppeli, *Scriptores*, 1: 75.

25. *V.B.* 5.46, 49, 8.70, and epilogue; Conrad is also referred to as "*secretarius*" (*V.B.* 12.96).

Conrad made use of Benvenuta's powers: he asked her to use them to get his brother out of purgatory, and she complied (*V.B.* 5.47). Thus he was not just her director, but also, so to speak, her client and devotee. And on the Sunday after she died and her posthumous miracles had begun, he took on the role of chief propagator of her cult, telling her secrets to a church full of her devotees in Cividale (*V.B.* 12.96).

In Conrad, then, and more particularly in Peter, we see the confidant as someone acknowledging his need for the woman with whom he was associated and not only her need of him. She is clearly a point of access to the divine.

The next of the confidants who appear in the literature are Raymond of Capua (d. 1399), as confessor of Catherine of Siena (1347–80), and Raymond's associate Thomas Antonii, often called "Caffarini," of Siena (1350–1434), as confessor of the tertiary Mary Sturion of Venice (1380–99). Each wrote a vita. In them we see, as in Peter and Conrad, a tendency to experience the women as loci of supernatural favor and power in their own right, and therefore as something more than their own exemplary disciples and subjects. The tendency is, if anything, even more pronounced here, and, in Raymond's case, something new is paired with it. This is an ecclesiastical tone and thrust, whereby the constituted authority of the church asserts itself at center stage, in a harmonious and momentous partnership with the saint's charismatic power.

Raymond wrote the *Legenda maior,* the first and principal vita of Catherine, between 1385 and 1395 while he was master general of his order. This portrait of Catherine is more explicit in its aim and probably more highly calculated in its appropriation of the saint for certain uses than any of the vitae discussed so far.[26] The overall aim was to promote

26. Raymond of Capua, *Vita* [Catherinae], in *Acta sanctorum,* Apr. (Paris, 1865–66), 3: 862–967. The work is commonly known as the *Legenda maior* (ostensibly to distinguish it from the *Legenda minor* composed by Thomas Caffarini of Siena). I cite it as *L.M.,* followed by book, chapter, and paragraph numbers. Translations are mine. On the dating see A. W. Van Ree, "Raymond de Capoue: Eléments biographiques," *Archivum Fratrum Praedicatorum* 33 (1963): 196, 213, 221. On Raymond's purposes in the *Legenda maior,* see Robert Fawtier, *Ste. Catherine de Sienne: Essai critique des sources,* 2 vols., Bibliothèque des écoles françaises d'Athènes et de Rome, 121 and 125 (Paris, 1921–30), 1: 121–23; Sofia Boesch Gajano and Odile Redon, "La *Legenda Maior* di Raimundo da Capua, costruzione di una santa," in *Atti del Simposio Internazionale Cateriniano-Bernardiniano, Siena 17–20 Aprile 1980,* ed. Domenico Maffei and Paolo Nardi (Siena, 1982), pp. 15–35; Bynum, *Holy Feast,* pp. 166–67; and Rudolph Bell, *Holy Anorexia* (Chicago, 1985), p. 24.

her canonization, as is stated outright in the last chapter, and to that
end the work displays a methodical plan. Catherine's spiritual progress
is traced step by step, punctuated by supernatural events to confirm it
and spur it on.[27] The final chapter systematically reviews the whole
work, to highlight the virtue of patience, which, as is carefully pointed
out, qualified Catherine especially for canonization (L.M. 3.6.396). As
for the uses to which Raymond applied her memory, one was the
Urbanist papacy, for which, he judged, she was literally martyred at
the hands of demons.[28] Another was the enhancement of his order;
her Dominican associations come far to the fore, and there is perhaps
a deliberate attempt here to supply the order with a stigmatized saint
of sufficient stature to rival Saint Francis.[29] The overall effect, at any
rate, is of a much more deft and systematic exposition of a saint's
sanctity than in the earlier vitae discussed.

One hallmark of Raymond's deft technique is his self-inclusion; re-
minders of his own relationship with the saint are continual, including
forty-four scattered passages of varying lengths, in which he is shown
interacting with Catherine as a participant in the events described. The
self-inclusion served Raymond's purposes in somewhat the way that
psychotherapists' interaction with patients becomes the stuff of ther-
apeutic insight. A case in point occurs in the course of his narrative
of Catherine's adolescent resistance to her family's efforts to see her
married. Here a digression describes her extreme remorse, in confes-
sion, at the memory of having briefly acquiesced to her sister Bon-
aventura's urging that she make herself pretty, and gives a transcript
of a conversation he had with her on the subject. Probing for the real
extent of her sin, he asked her whether in attending to her looks she
had intended to break her vow of virginity or even just to make herself
pleasing to men. After she denied any such intentions and he asked
then why she thought her actions merited eternal punishment, she
replied that her love for her sister had been excessive, had seemed even
to exceed her love for God. When he responded that in the absence
of ill intention even such excess did not violate divine law, she ex-

27. L.M. 3.6.396–97. For an analysis of the structure of the Legenda maior, see John
W. Coakley, "The Representation of Sanctity in Late Medieval Hagiography: Evidence
from Lives of Saints of the Dominican Order" (Th.D. diss., Harvard University, 1980),
pp. 73–89. Boesch Gajano and Redon, in "La Legenda Maior di Raimundo," pp. 34–
35, see Raymond's emphasis on Catherine's spiritual life as downplaying the political
activity to which her letters bear abundant witness.

28. Fawtier, Catherine de Sienne, 1:121; L.M., 3.6.428.

29. Fawtier, Catherine de Sienne, 1:123.

claimed, "Oh my Lord God! What sort of spiritual father have I got, who excuses my sins?" and lectured him on the ingratitude to God inherent in her self-adornment, thus silencing Raymond and apparently closing the subject (*L.M.* 1.4.42–43). The description of the conversation, however, serves as illustration and starting point for Raymond's ensuing discussion of Catherine's spiritual state, which, in spite of his having allowed her the last word, asserts her lack of sin. In all her confessions, according to him, he never found her to have done anything against divine law, "unless it was what I have just discussed, but I do not believe so, nor I think would any reasonable person." By her protestations she was "ingeniously" taking on herself a guilt that was not hers—a ploy that could easily have fooled an unwary confessor (not himself!) (*L.M.* 1.4.44).

The self-inclusion that thus serves Raymond's hagiographical purpose also permits a glimpse at his interactions with her in their own right. These are remarkable for an apparent reversal of roles, whereby Raymond the confessor and spiritual director becomes the object of his penitent's rebuke and advice. The scolding she gave him for belittling her sins, as just quoted, is an example. Again, on learning that he had directed sugar to be added to her drinking water (since she had been ill without ceasing her usual abstinence from food) she accused him of poisoning her (*L.M.* 1.5.58). Or again, when her long monologues on matters divine put him to sleep, she "made a loud sound to wake me up, saying, 'can it be that for the sake of sleep you would lose something good for your soul? Am I speaking words of God to the wall rather than you?'" (*L.M.* 1.6.62). And at various times she gave him instruction: to set up a "cell" in his mind as a refuge against external pressures (*L.M.* 1.4.49), never to respond to temptation by arguing with Satan (*L.M.* 1.11.106), always to resolve to profit from what befell him (*L.M.* 2.5.177). The role of instructor was apparently always Catherine's, never Raymond's; and he was particularly harsh in criticizing his predecessor Thomas and others around her who did presume to advise her, specifically in the matter of her abstinence from food. If these had considered "how frequently and perfectly Catherine had been instructed by the Lord [during Christ's appearances to her] about all the Enemy's deceptions . . . they would not have presumed, as imperfect disciples, to raise themselves above a perfect mistress (*magistram*)" (*L.M.* 2.5.169; cf. 1.9.80). He, at least, kept quiet.

Such a reversal of roles is remarkable enough; but Catherine's dominance over Raymond in the *Legenda maior* goes even a step further.

If she was free from mortal sin and practically free from venial sin, as Raymond reckoned from her confessions (*L.M.* 1.4.44), then the sacrament of penance of which he was the agent seems in a certain sense irrelevant. Her divine connections were such that she could bypass a priest without needing to compromise him, as when her prayers caused God to change the mind of one of her earlier confessors about counsel she considered wrong (*L.M.* 2.5.169), or when Christ himself (as she hinted to Raymond) brought her a fallen fragment of the host that Raymond had consecrated while unaware of her presence in the church (*L.M.* 2.12.317–22). In these instances she transcended altogether the relationship of layperson to priest.

The most striking example of Catherine's transcendence of the terms, even reversed, of the relationship of layperson to priest or penitent to priest is Raymond's famous account of seeing her face become the face of God. This occurred when she had been describing revelations and he had been inwardly doubting her.

> While I was thinking such thoughts, I also looked over at the face talking to me. Suddenly her face was transformed into the face of a bearded man, who, looking at me fixedly, frightened me very much. It was an oblong, middle-aged face, with a short wheat-colored beard and a look of majesty, which showed it clearly to be the Lord; nor could I discern in that moment any other face besides that one. Trembling and terrified, I raised my hands and exclaimed, "who is this, looking at me?" The virgin replied, "He who is." Soon after these words, the face disappeared and I clearly saw the face of the virgin, which a moment earlier I had not been able to discern at all. (*L.M.* 1.9.90)

This passage appears immediately after Raymond's account of an earlier occasion when, also to resolve personal doubts about her, he had asked her not only to pray for forgiveness of his sins but also to secure for him, as a sign of it, a heaven-sent experience of deep contrition—which she proceeded to do (*L.M.* 1.9.87–89). An apparent aim of the two stories is forcefully to convey Raymond's conviction of Catherine's intimacy with God and consequently of God's accessibility to him through her.

Nonetheless, for all that Catherine appears in the *Legenda maior* as a locus of the supernatural bar none, it is fundamental to the work that she never appears challenging his, or any priest's, sacerdotal authority. On the contrary, she comes across as the most solid of supporters of ecclesiastical authority. The climax of the work is her martyrdom for the cause of the Roman papacy (*L.M.* 3.6.430). Sim-

ilarly on an individual level, the vita quotes and defends her deathbed
assertion that she could not remember having been disobedient even
once to her superiors.[30] Furthermore one of her main uses of the
supernatural power arising from her intimacy with Christ—that same
power that caused her to appear to Raymond as God and that would
have obvious potential for challenging the necessity of the church's
channels of grace—was to provoke in people the contrition that
brought them to make confession to priests. Thus the first of the six
chapters in the vita devoted to her miracles (given pride of place as
pertaining to souls rather than bodies) includes four extended stories
of reprobates being converted suddenly from blasphemy to contrition
at the very moment Catherine was praying for them and immediately
seeking the ear of a priest, in one case Raymond himself (*L.M.* 2.7.220–
38). Nor were such events uncommon. "Such," he wrote, "was the
crowd of people wanting to confess, that many times I was oppressed
and annoyed by overwork. But she prayed without ceasing, and like
a conqueror, exulted more and more over her spoils, directing others
of her sons and daughters to give over what she had captured to those
of us who had the net."[31] Thus her enormous charismatic power not
only did not challenge but also specifically served the sacramental min-
istry of the church. She the saint and Raymond the priest, however
awed by her he professed to be, were partners hand in hand.

In Thomas Caffarini's vita of Mary of Venice, we find no such grand
vision of an alliance of the powers of saint and priest.[32] Mary was an

30. *L.M.* 1.9.80. Raymond acknowledged detractors on this point.

31. *L.M.* 2.7.240. On "the delicate problem of acknowledging a role for women in
the field of public apostolate and preaching, by now strictly tied to the priestly function,"
as evidenced in the *Legenda maior* as well as in the *Notebooks* of Catherine's earlier
confessor Thomas della Fonte and in the Catherinian works of Thomas Caffarini of
Siena, see Antonio Volpato, "Tra sante profetesse e santi dottori: Caterina da Siena,"
in *Women and Men in Spiritual Culture, XIV–XVII Centuries: A Meeting of North and
South,* ed. Elisja Schulte van Kessel (The Hague, 1986), pp. 149–61. In this essay I
am finding in the *L.M.* the sort of complementarity of saintly charisma and priestly
authority that, according to Volpato, Thomas Caffarini of Siena would have encoun-
tered in the examples (known to him) of Mechtilde of Hackeborn and Gertrude the
Great, but that he rejected in his own treatment of Catherine, in favor of picturing her
as a "holy doctor" (pp. 155–58); Volpato does not allude to this complementarity in
the *L.M.,* calling attention only to Raymond's assertion there of Catherine's prophetic
apostolate, i.e., active preaching (pp. 151–54).

32. On Thomas, see most recently Fernanda Sorelli, *La santità imitabile: "Leggenda
di Maria da Venezia" di Tommaso da Siena,* Series Deputazione di Storia Patria per le
Venezie Miscellanea di Studi e Memorie, 23 (Venice, 1984), pp. 3–9, and bibliography

obscure tertiary who had undergone a dramatic conversion on hearing the friars' preaching at the age of sixteen, after being deserted by her husband (*L. Mar.* 4.369). Her most notable claims to distinction were her ministry to victims of the plague and her cheerfulness when she herself became a victim, regarding it (as per Thomas's preaching) as an opportunity to imitate the passion of Christ (*L. Mar.* 11.389–91). She apparently had no circle of devotees, and among the friars it was only Thomas with whom she would speak (*L. Mar.* 10.383). This was a life immeasurably more obscure than Catherine's.

Nonetheless for Thomas, Catherine was a veritable obsession, and her presence is strong in the vita of Mary. During Catherine's lifetime he had belonged to her circle, later he had acted as Raymond's scribe for the final portions of the *Legenda maior,* had composed both a popular abridgment of that work (the *Legenda minor*) and a lengthy supplement to it, and had become chief promoter of the canonization.[33] Mary heard the Lenten sermons Thomas preached annually on Catherine and set about to imitate both her austerities and her active charity. She also acquired a painting of the saint and endowed memorial masses for her (*L. Mar.* 11.385; 7.375, 374; 11.387; 13.404).

But most fundamentally, Mary's relationship with Thomas resembles Catherine's with Raymond. For in her as in Catherine, absolute obedience paradoxically coexisted with a certain independence born of perfection. Thus, Thomas wrote that "anything from my mouth she

there. For a careful comparison of the hagiographical portraits of Catherine and Mary, see ibid., pp. 67, 127–28; though noting the similarities of spirituality between the two, Sorelli calls special attention to the contrast between Catherine's "profundity and vigor" as well as her supernatural prodigies, on the one hand, and Mary's complete imitability, on the other; she finds Thomas's portrayal of Mary to be "somewhat emblematic of the transition from a strong spirituality, open and vibrant, to a religiosity that is submissive, repetitive, withdrawn" (p. 133). See also Fernanda Sorelli, "La production hagiographique du Dominicain Tommaso Caffarini: Exemples de sainteté, sens et visées d'une propagande," in *Faire Croire: Modalités de la diffusion et de la réception des messages religieux du XIIe au XVe siècle,* Collection de l'École Française de Rome, 51 (Rome, 1981), pp. 189–200. On the dating of the *Legenda Mariae,* see Sorelli, *La santità,* p. 22. I am using the Latin version, in the edition of Flaminio Cornaro, *Ecclesiae Venetae antiquis monumentis, nunc etiam primum editis illustratae ac in decades distributae,* 18 vols. (Venice, 1749), 7:363–420, hereafter cited as *L.Mar.,* followed by chapter and page number. Translations are mine. An edition of the Italian version is to be found in Sorelli, *La santità,* pp. 151–225.

33. Marie Hyacinthe Laurent, "Praefazione: Vita e opere di Tommaso Caffarini," in Thomas Caffarini, *Vita di Santa Caterina da Siena,* ed. Giuseppe Tinagli (Siena, 1938), pp. 7–61.

received as though from God himself," and like Raymond made a point of not being able to recall a single lapse (*L. Mar.* 9.379)—yet the independence is also unmistakable:

> she achieved such perfection of love for neighbor as to forget her own ease in the matter of spiritual comfort—unlike many people, who out of desire for their own convenience cannot bear the absence of their spiritual Fathers for even a little while. Rather, being made like the mother of all through perfection of love, she would choose not only to be without my presence, but even to have me go to the infidels in the remotest regions of the world, just as our holy father Dominic wished for himself. (*L. Mar.* 10.384)

Here, even if there is no role reversal, still the message is clear that by means of her perfection she transcended the felt need for her confessor. The wish that he would go to the infidels was a death wish on his behalf, and not a veiled one; as he wrote elsewhere in the vita, she neither wished him good fortune nor gave him gifts but prayed instead for him to suffer "terrible martyrdom." This she did out of her love for him, according to Thomas, and if he saw irony here, he did not let on.[34]

Both Raymond and Thomas thus approvingly portrayed the women they served as having minds of their own. To be sure, they considered obedience to themselves as a component of the women's holiness. But the same holiness paradoxically implied a certain independence from them, born of their virtue and favor in the sight of God. It was an independence that does not seem to have threatened their own sense of priestly authority. On the contrary, in the case of Raymond, Catherine's holy discreteness from him only enhanced the power of the partnership he saw himself sharing with her.

A century later, we see the legacy of Catherine and Raymond at work in the friar Sebastian of Perugia (1445–1525), confessor of the tertiary Columba of Rieti (1467–1501), and Francis Silvestri of Ferrara (d. 1528), confessor of the tertiary Osanna of Mantua (1449–1505). In the vitae they wrote there are similarities of detail to Raymond's image of Catherine that suggest an almost slavish imitation on the saint's part and/or their own.[35] Yet there had been a change: the

34. *L.Mar.* 10.382; on her wish for martyrdom, see also 11.387.

35. See Gabriella Zarri, "Le sante vive: Per una tipologia della santità femminile nel primo Cinquecento," *Annali dell' Istituto Storico Italo-germanico in Trento* 6 (1980): 371–445.

disappearance of the explicit partnership, so essential to Raymond, between ecclesiastical authority and the saint's charismatic power. Sebastian and Francis did not perceive these women as specifically in the service of the church or its sacramental ministry, or as therefore pressing at the boundaries between charismatic power and sacerdotal authority.

Columba's affinity with Catherine is unmistakable in Sebastian's account. She is shown imitating Catherine from childhood—for example, depleting her family's food supply by giving it to the poor, vowing virginity privately, cutting off her hair as a sign of defiance of her parents' wish to see her married, and incurring ridicule and suspicion by abstaining from food.[36] After settling in Perugia as a young adult (having made a mysterious departure from her home in Rieti through the walls of a locked room) and finding a popular following there, she set up a convent of tertiaries, which she dedicated to Catherine (*V.Col.* 9.79). She claimed to have been cured of plague by Catherine and Dominic (*V.Col.* 10.89–90), advised the Perugians to pray to Catherine, and attributed to her one of the city's military victories (*V.Col.* 16.156).

Just as Columba was in Catherine's mold, so Sebastian was in Raymond's. He told Pope Alexander VI that "if one were to substitute the name of Sister Columba in the Legend of St. Catherine of Siena, the essentials of her life and all her deeds would still hold entirely true" (*V.Col.* 12.107). The vita appears as just such an experiment, not only in details but also in its overall intent to present the saint as a locus of supernatural favor and power. As in the *Legenda maior,* signs and miracles pervade the narrative.[37] Furthermore, like Raymond, Sebastian became associated with his saint when she was already well known, and he adopted a superior tone in speaking of his predecessors in the role of her confessor (*V.Col.* 10.88). Sebastian himself assumed his role on the illness of her previous confessor, confident at first that he could expose her ecstasies and abstinence as a sham. On hearing her confession, however, he found himself affected to the point of tears by her lack of sin, called a meeting of her previous confessors to cor-

36. Sebastian of Perugia, *Vita* [Columbae] 1.8 (Catherine's legend); 2.10 (food to poor); 2.11 (vow of virginity); 3.15 (hair); 9.80, 12.110, 13.120 (abstinence), in *Acta sanctorum,* May (Paris, 1866) 5: 149*–228*; hereafter cited as *V.Col.,* followed by chapter and paragraph numbers. Translations are mine. On the vita, of which Sebastian also composed an Italian version, see Astorre Baglioni, *Colomba da Rieti: "La seconda Caterina da Siena"* (Rome, 1967), pp. 16–18.

37. On the placement of these, see Coakley, "The Representation of Sanctity," pp. 71–89 and 169–79.

roborate his impression, and became her solid devotee and champion (*V.Col.* 11.100–101).

Sebastian's activity as confessor, however, had a consequence that Raymond's did not, namely to bring him under official suspicion.[38] High figures in his order and the curia accused him at Rome of "contaminating" Columba's prophecies with his own mathematical prognostications. They also questioned his morals; he heard that the pope expressed surprise at Columba's choice of a confessor who had a reputation for relishing ease and pleasure (*V.Col.* 17.161, 166). Sebastian defended himself in writing and in person and, although pressure from some of her Perugian detractors did later oblige him to give up his role as her confessor, he was at least exonerated by the pope (*V.Col.* 18.173, 17.167–68). Even so, his position in the vita as an object of the suspicion and judgment of ecclesiastical authority contrasts sharply with Raymond's position as representative of that authority, that is, Dominican master general and agent of the Urbanist papacy. The very prominence, in the *Legenda maior,* of the message that Catherine was as much partner as object of ecclesiastical power makes the contrast significant: no such sense of partnership emerges from the *Vita Columbae.*

Just so, Columba's charismatic power did not specifically serve the church in the manner of Catherine's. In the *Vita Columbae* I count twenty-six separate public—that is, witnessed—miracles prior to her death: four manipulations of nature (e.g., stopping the rain, multiplying bread), eleven healings, and eleven prophecies (e.g., of the release of a murderer, the death of a child, Perugian military victories). With the exception of certain unspecified prophecies that she made at the request of the legate Giovanni Borgia, nephew of Alexander VI (*V.Col.* 15.145), none of the miracles specifically served either the ecclesiastical hierarchy or the order; they rather served the citizens of Rieti and Perugia, individually and collectively. And most significantly, none of the miracles as reported served the sacramental ministry of the church in the sense of inducing people to contrition and therefore to penance, as did many of the miracles of Catherine.

Just as Columba's charismatic power did not use the sacrament of penance as a public field of operation, so too it did not affect her own role as penitent in the manner of Catherine. Catherine seems always

38. Bell, *Holy Anorexia,* pp. 151–55.

to have been on the verge of transcending that role, as seen most strikingly in that scene in the *Legenda maior* in which her face became God's face for Raymond. Occurring just when Raymond had doubted her, that incident involved Catherine acting *as God* to alleviate his doubts. The *Vita Columbae* includes an analogous passage describing a vision that resolved Sebastian's doubts about Columba, in this case about her virginity. But it was a different sort of vision. In it Sebastian saw Catherine of Siena uncovering Columba's "intima" and he could thus observe there "something like a pomegranate blossom whose intertwined follicles had never been opened out," as proof of virginity (*V.Col.* 14.140). Columba meanwhile had supernatural knowledge of both his doubts and the vision, and she took the initiative the next day to swear to the truth of what he had seen. Even if we leave aside the remarkable voyeuristic tone of the passage, it contrasts decisively with the *Legenda maior* in excluding any blending or confusion of Columba with God, and therefore any potential bypassing of the channels of grace.

There is a role reversal of sorts reported in the vita of Columba by Sebastian, but again the contrast with the *Legenda maior* is instructive. In this case the confessor is not Sebastian himself but his successor, Michael of Geneva, who, according to Sebastian, imitated Columba's abstinence from food, with her approbation (*V.Col.* 20.189). Michael thus became in a sense her pupil; however, the relation between charismatic power and sacerdotal authority is not at stake here, as it was in the case of Catherine and Raymond. Sebastian himself does not appear to have shared Michael's desire to imitate. Still they had in common that they played almost exclusively the role of devotee— Michael trying to be like Columba, Sebastian pinning his fortunes on her. In this they differed from Raymond, for whom, however much he wished to associate Catherine with himself in his reader's mind, the juxtaposition of his role as agent of ecclesiastical authority and hers as embodiment of supernatural graces was firm. Without such discreteness of roles there could be no real partnership between saint and devotee— and indeed for Sebastian there was not.

As for Francis Silvestri, he seems to have been less closely associated with Osanna Andreasi than was Sebastian with Columba—or at least less willing to speak about his association. Thus though the vita by Francis makes a point of his firsthand experience of the saint, there are only a handful of references to himself, allowing only a glimpse of his

interaction with her.[39] A detailed, fairly dispassionate description of her saintly phenomena comprises the bulk of the work, covering, successively, her special graces, powers of intercessory prayer, prophecies and finally miracles deliberately performed.[40] The figure of the confessor-as-expert, embodied earlier by Raymond, has here acquired a detachment that would have been foreign to him.

Otherwise, however, Francis's portrayal of Osanna reminds us of Sebastian and Columba. Thus like Columba, Osanna is pictured as in effect a new Catherine; she saw Christ when she was six, then vowed virginity, later learned supernaturally to read and write, married Christ with an invisible ring as sign, and received invisible stigmata and a new heart (*V.O.* 1.1.7–9, 2.1.59, 3.1.95–97, 3.1.100–105, 3.1.98). She even had a Catherinian concern for the state of souls: her prayers caused one man to become a Dominican, protected another religious from a diabolical urge to leave his order, secured divine assurance of salvation for certain of her friends, effected a change of heart in another (*V.O.* 4.2.140, 4.2.142, 4.3.151, 4.2.145). Yet in these latter cases the prayers did not induce contrition to bring the person to the sacrament of penance. Rather the saint and God exhausted the transaction between themselves. And to the extent that the vita reveals anything of the interaction of confessor and saint, it lacks any suggestion of reversal or transcendence of roles. In the one episode in which the vita shows Osanna using her powers on Francis's behalf, the aim was not to produce contrition but to cure him of the colic.[41]

Francis's reserved detachment from Osanna, Sebastian's initial sus-

39. Francis Silvestri, *Vita* [Osannae], Proem. 3, 1.3.32, 1.3.42, 5.2.176, 5.2.177, 5.2.185, 5.3.193, in *Acta sanctorum*, June (Paris, 1867), 4: 557–601, hereafter cited as *V.O.*, followed by book, chapter, and paragraph numbers. On Francis see Daniel A. Mortier, *Histoire des Maîtres Généraux de l'Ordre des Frères Prêcheurs*, 8 vols. (Paris, 1904–14), 5:261–84.

40. Books 2 through 4 respectively; book 1 narrates her life.

41. *V.O.* 5.2.177. The other principal vita of Osanna, by Jerome of Mantua, *Vita Alia* [Osannae] in *Acta sanctorum*, June (Paris, 1867), 4:601–64 (see n. 4 above), offers an instructive contrast with the work of Francis. Jerome was anything but detached from her, recording in great detail their interactions. He also avoided asserting priestly authority over her, insisting, for instance, on her calling him "son" rather than "father" (*Vita Alia*, Tractate 2, chapter 1, paragraph 48). Both men, however, seem to have assumed the breakdown of the Raymondian partnership between the saint's charismatic power and the devotee's sacerdotal authority; and given that assumption, they nicely illustrate the only two options that were open to the priestly devotee: either to withdraw himself from the equation of sanctity as something in which his priesthood had no role and treat it as something objectifiable, distanced from himself, or else, remaining in the equation, allow the charismatic to supplant the sacerdotal.

picion of Columba, and the subsequent suspicion he aroused bear witness to the general, marked increase of male suspicion of extraordinary behavior among pious women, about 1500, as noted by Rudolph Bell. Bell suggests that whereas women had "succeeded in convincing male authorities of their holiness" beforehand, they were increasingly unable to do so when the "hierarchical male prelacy" asserted itself strongly in the context of emerging sixteenth-century Catholic reform.[42] If that is so, then the tradition I have been discussing would suggest that it was not only male assent to female sanctity that was being withdrawn. It was also male complicity. For in the previous two centuries and more, men had been not simply judges but also, and perhaps more importantly, their intimate devotees. That intimacy was becoming problematic.

Although in most cases it was the exercise of the pastoral care that brought these friars into the role of confidants, what they tell us of their relations with the women they served goes far beyond the performance of pastoral duty. In every case, these friars were actively fascinated with the women, with an acute sense of their marvelous strangeness and an untiring interest in the particulars of their lives, especially their inner lives. Moreover, Francis's case perhaps excepted, this fascination was not a detached, merely inquisitorial fascination. Instead we find repeated witness to mutual interaction between saint and confidant that suggests strong personal ties. In the best-documented cases, some personal needs that the confidants brought to their interactions come into view. The most graphic examples are Peter's image of himself experiencing vicariously Christ's visitations to his "sister" Christine, and Raymond's reliance on Catherine for an experience of contrition and for a direct encounter with God. These men felt a need for immediate experience of the divine and could not supply it by themselves through either their office or their knowledge. It was something to be received from outside themselves. The power of the women to represent the divine goes hand in hand, therefore, with their very differentness from the men, their strangeness of experience, their lack of office and schooling, their oppositeness of gender. And power it was; the women appear in these vitae as veritable loci of the divine.

What changes over time in these men's experience of the women

42. Bell, *Holy Anorexia*, pp. 150–51.

concerns the question of the relation of that power to be a locus of the divine to their own authority as priests. In Siger, in the early days of the order, the question is significant by its absence; there was no paradox involved in Margaret's being both pupil and "vessel of election." Nonetheless the hint is there that her favor in God's eyes could serve to bypass the authority of superiors; and a few decades later, in Peter of Dacia, we find similar hints and a stronger sense of his subject's discreteness as conveyor of the divine. In neither of these cases, however, is there any specific attempt to work out the relation between the saint's charismatic power and the priest's sacerdotal power. To do that was the achievement of Raymond, in whose scheme the saint's powers to supply the need for a felt presence of the divine are specifically coordinated with the external means of grace administered by the priest; and here we have the most harmonious and ambitious male vision of the female saint, in the sense that her powers complement those of the church, and she and Raymond form together a sort of androgynous unit for the salvation of Christendom. The achievement was temporary; a century after Raymond, in Francis and Sebastian, the complementary connection between saintly power and priestly office seems to have disappeared again, and somewhat ominously, as saint and priest operated in their own spheres. What was lost by then was not, however, the fascination that the female saint held for her priestly devotee, but a niche in his universe that would safely hold it.

Women Saints, the Vernacular, and History in Early Medieval France

IN MEMORIAM
Stephen Gilman, Jr., Princeton '40, *43

Let me begin by defining the terms in my title. "Early medieval France" is somewhat a misnomer in that I refer here rather to the whole of Gallo-Romance territory, which encompasses a much wider area than the kingdom of France and includes, of course, the languages both of *oïl* and *oc* as well as the written koine, or the *scripta* combining *oïl* and *oc,* of the tenth-century Clermont *Passion* and *Life of Saint Leodegar,* and the successor *scriptae* of north and south. My time frame thus reaches from the post–Council of Tours Carolingian period of about 815 through the Capetian and Plantagenet twelfth century. The fact that the Council of Tours sanctioned the use of the vernacular in homilies and certain religious songs throughout the empire is of exceptional significance to us: Romance literature on Gallo-Romance territory can be said to date from the time of this council, even though, to be sure, precious few ninth-century vernacular texts have survived.

The designation "women saints" is also highly problematic. What I mean by it, but not invariably, is persons of the female sex who are either generally recognized or, in some discernibly authoritative manner, *named* as holy—saintly—in a fashion analogous to the way certain men are so recognized. Thus, a woman who suffers violent and outlandish pain and death as a consequence of her witness to the Christian faith is quite as strong a candidate for designation as a holy martyr as

a man who undergoes a similarly harsh earthly destiny. The ascetic whose testimony to God is confirmed by his abandoning the world for an eremitic life of want and deprivation is usually male, but by no means exclusively. Saint Mary of Egypt immediately comes to mind, although, in her case, penance rather than flight from temptation compelled her to leave the world. Chastity is prized by saints of both genders, although, not surprisingly, the motifs of sexual bribery, violence, and threat are by and large more often present in the lives of women saints.[1] The male saint, meanwhile, is tempted by the pleasures of the flesh and/or by his impulse to procreate, or to participate, as Christ himself was tempted by the devil to participate, in some dominant fashion within the purview of genealogical history; Saint Alexis offers a case in point.

Although men and women saints have much in common, I shall focus in the present essay on the ways they differ. I shall attempt to specify how, in the early Gallo-Romance literary Old French and Old Provençal vernaculars, saintly women were depicted, and *understood,* as occupying a certain status and, more particularly, as fulfilling a certain historical—as well as historiographical—purpose. Let me add that the

1. The motif of sexual bribery spills over into domains tangential to that of the lives of women saints; one remembers Heloise fiercely stating her preference to be Abelard's harlot (*meretrix*) rather than empress-wife (*imperatrix*) to Augustus, the emperor of the "whole world"; her "disinterested" (i.e., pure) love is superior to the baser, material love that all too often reigns (she avers) within the worldly marriage contract: "Nec se minime venalem aestimet esse quae libentius ditiori quam pauperi nubit et plus in marito sua quam ipsum concupiscit." Disinterested love is favored, she adds, not so much by bodily continence as by what she calls *animorum pudicitia,* or "chastity of the spirit"; purity is at issue here ("The Personal Letters between Abelard and Heloise," "Letter I," ed. J. T. Muckle, *Mediaeval Studies* 15 [1953]: 71). Heloise seems to share the same disdain for masculine concepts of propriety and of business we find in women saints. Her authority would seem to derive from the same kind of fidelity (with respect to Abelard) and "wisdom of love" female saints had come to incarnate in their overriding and unswerving fidelity to their Spouse. For Heloise human love—hers, at least, for Abelard—partakes of the same grace and freedom, as well as of the same totality, that characterizes the saintly woman's unreserved gift of herself to God. Jean de Meun phrased this very well in speaking of Heloise begging Abelard "qu'il l'amast, / Mais que nul droit n'i reclamast / Fors que de grace e de franchise, / Senz seignorie et senz maistrise, / Si qu'il peüst estudier, / Touz siens, touz frans, senz sei lier," and "je ne crei mie, par m'ame, / Qu'onques puis fust nule tel fame" ("that he love her, but that he claim no right in this matter apart from what is given through grace and open freedom, without husbandship and mastership, so that he might continue studying, his own man, completely free, without being tied down" and "By my soul I do not believe that there has ever subsequently been a woman like her" [my translation]) (*Le Roman de la Rose, par Guillaume de Lorris et Jean de Meun,* ed. Ernest Langlois, vol. 3, Société des Anciens Textes Français [Paris, 1926], lines 8777–82, 8825–26).

veneration of which women saints were the object was composed, I believe, of an admixture of loving devotion and of a wonder sometimes bordering on fear, for the power of these saints was seen to be extraordinary. Holy women engendered feelings of adoring admiration; texts concerning them tended to underscore their compassionate charity, perhaps in order to mitigate—even to placate—the potential vengefulness and overwhelmingness of their redoubtable power.[2]

Paradoxical as this may sound, the power of the saintly woman was viewed as residing essentially in the truly *revolutionary* historical consequences, and historiographical implications, of her deeply conservative fidelity. The woman saint—and we must never forget this—is invariably assimilated to the figure of the bride of Christ. She is, either in fact or prototypically, a nun. The rights and privileges accruing to her—her very legitimacy—derive from her indissoluble status as his betrothed or even spouse, from her exemplarily *faithful* position in what I have elsewhere called the *copula sacra*—from what, in words attributed to Christ by a late twelfth-century metrical version of the Bible, was referred to as *copula sancta*.[3]

2. Words used by Henry Adams in order to describe how the Blessed Virgin was understood in twelfth-century France merit quotation here: "The Queen Mother was as majestic as you like; she was absolute; she could be stern; she was not above being angry; but she was still a woman, who loved grace, beauty, ornament,—her toilette, robes, jewels;—who considered the arrangements of her palace [Chartres] with attention, and liked both light and colour; who kept a keen eye on her Court, and exacted prompt and willing obedience from king and archbishops as well as from beggars and drunken priests. She protected her friends and punished her enemies. She required space, beyond what was known in the Courts of kings, because she was liable at all times to have ten thousand people begging her for favours—mostly inconsistent with law—and deaf to refusal. She was extremely sensitive to neglect, to disagreeable impressions, to want of intelligence in her surroundings. She was the greatest artist, as she was the greatest philosopher and musician and theologist, that ever lived on earth, except her Son, Who, at Chartres, is still an Infant under her guardianship. Her taste was infallible; her sentence eternally final. This church was built for her in this spirit of simple-minded, practical, utilitarian faith, in this singleness of thought, exactly as a little girl sets up a dollhouse for her favourite blonde doll. Unless you can get back to your dolls, you are out of place here" (*Mont-Saint-Michel and Chartres* [Princeton, 1981], pp. 90–91).

3. "Dicit enim quod carne duo reputantur in una, / Dimittique patres, *copula sancta* facit" ("He says that the two be recounted as forming one flesh, that he renounce his parents, that he constitute a *holy coupling*" [my translation]) (*Evangelium Aegidii* [lines 1679–80], in *Aurora Petri Rigae: A Verse Commentary on the Bible*, ed. Paul E. Beichner, part 2, Publications in Mediaeval Studies, 19 [Notre Dame, 1965], p. 576). One finds no mention of *copula sancta* in Matt. 19:4–10, or in Mark 10:7, where Jesus is depicted as quoting Gen. 2:24–25 on the marriage of man and woman. See also, in this same volume, the (largely) Bede-inspired allegorical commentary on the Song of Songs

The special coupling of God and woman is rooted in the history recounted by the Gospels. Christ's Incarnation, the first of the two fundamental mysteries of the Christian faith, is accomplished through the agency of a woman: Mary, the Spouse and Mother of God, as well as his Handmaiden and Daughter. The truth of the mystery of the Resurrection is, in all four Gospels, revealed first to the women at the tomb, whom Jesus commands to relate what they have just experienced to the disciples. (John singles out Mary Magdalene especially.) The women are thus the first human beings to witness Christ's rebirth and victory over death, and they are called upon to be the translators of this good news. According to Mark and Luke, the men, when informed of the good news, refused to believe the story, calling it, in Luke's words, a kind of hallucinatory babble: "Et visa sunt ante illos, sicut deliramentum verba ista: et non crediderunt illis" ("And their words seemed to them as idle tales, and they believed them not" [this, and subsequent translations from the Bible are taken from the Authorized King James Version]; 24:11). Jesus, we recall, subsequently scolds the men for their disbelief and weak faith.

The essentially erotic nature of the vocabulary representing this sacred coupling is emphasized also in the highly sensual marriage symbolism permeating the Song of Songs, with the Shulamite bride of that text, following upon the Jewish tradition identifying her with Israel, inevitably coming to be allegorically assimilated to Ecclesia, the bride of Christ.[4] This identification is particularly potent during the

(*Canticum canticorum*, pp. 703–61). In connection with what we have noted in respect of the woman saint's exemplary fidelity, it may be valuable at this juncture to remind ourselves of the absolution given by Jesus to Mary Magdalene: it is the strength and *purity* of her faith that prompts him (to the consternation of the witnesses present) to forgive her her sins: "Fides tua te salvam fecit: vade in pace" ("Thy faith hath saved thee: go in peace"; Luke 7:36–50).

4. The process of this kind of allegorical identification was first elaborated systematically, and applied, by Origen, especially in his highly influential *Commentaries on the Holy Scriptures* and, more particularly, in his extensive exegetical allegorizations (*Commentary* and *Homilies*) of the Song of Songs (ca. 240–44). (Two of these Homilies—the only ones to have reached us—were translated into Latin by Saint Jerome [ca. 383]; important fragments of the *Commentaries* have survived in the rather free Latin translation by Rufinus [early fifth century].) Authorization for the "chastely"—or "innocently"—erotic dimension of this tradition may be found also in Gen. 2:24–25: Eve has just been created, Adam has named her. The indissolubility of their couplehood, and of marriage in general, is affirmed: "Quamobrem relinquet homo patrem suum, et matrem, et adhaerebit uxori suae: et erunt duo in carne una" ("Therefore shall a man leave his father and his mother, and shall cleave unto his wife: and they shall be one flesh"). According to both Matthew and Mark, this language is quoted verbatim by

eleventh and twelfth centuries, as is evidenced by Saint Bernard's beautiful and influential commentary (*Sermones in Cantica* [1135–48]), and by such vernacular poems as the fragmentary Old French "Quant li solleiz converset en leon," or the 3,506 rhyming octosyllables of a twelfth-century Old French *Song of Songs* (ca. 1180) contained in manuscript 173 of the Municipal Library of Le Mans.[5] Given woman's identification as humanity, or church, as bride of Christ, it follows that, to the extent an individual woman on earth, in saintly fashion, remains steadfast and faithful to her very privileged role as indispensable member of the couple she and he form, her power is, in very significant ways, much the stronger of the two members of the purely human pair of male and female.[6] Meanwhile, we recall, Christ himself, in one of

Jesus in the context of his reply to the Pharisees on divorce (cf. Matt. 19:4: "Non legistis, quia qui fecit hominem ab initio, masculum et feminam fecit eos?" and "Propter hoc dimittet homo patrem, et matrem, et adhaerebit uxori suae, et erunt duo in carne una" ["Have ye not read, that he which made them at the beginning made them male and female.... For this cause shall a man leave father and mother, and shall cleave to his wife: and they twain shall be one flesh?"]). All this is followed immediately in Genesis by an allusion to the innocent, or *free*, sensuality of prelapsarian man and woman: "Erat autem uterque nudus, Adam scilicet et uxor eius: et non erubescebant" ("And they were both naked, the man and his wife, and were not ashamed"). Before the Fall the human couple was, so to speak, sensually unbounded in its perfect union of man and woman; the partial destruction of this union and the advent of both shame and death are, of course, due to sin. We recall the wording of the bride's cry of pain at learning of Alexis's departure in the *Life of Saint Alexis* (second half of the eleventh century): "Pechet le m'at tolut!" (line 108), meaning, surely, something to the effect that "the sinfulness of the world has undone our union" (cf. Alexis's earlier fear at being vanquished by his desire for his bride and "condemned" to place his trust in transitory earthly happiness: "Cum fort pecet m'apresset!" [line 59]). For Alexis, there can be no *parfit'amor* in this postlapsarian world.

5. The text of the fragment is printed in Karl Bartsch and Leo Wiese, eds., *Chrestomathie de l'ancien français (VIIIe–XVe siècles)*, 12th ed. (New York, 1951); the longer Song of Songs has been edited by Cedric E. Pickford (London, 1974). (Joining his voice to that of certain other reviewers, Tony Hunt has declared this edition and the accuracy of Pickford's twelfth-century dating to be "valueless as a basis for a close study of the [Song of Songs] commentary" in Old French [*Zeitschrift für romanische Philologie* 96, nos. 3–4 (1980): 267–97]. In Hunt's view the text "can scarcely be earlier than ca. 1200" [271]. According to him, Pickford's punctuation of the text is incorrect, and his edition contains "well over 200 errors of transcription" [278]. Hunt also provides much interesting commentary on other Old French and Anglo-Norman redactions belonging to the Song of Songs tradition.)

6. To use the biblical words quoted above, let us say that *homo* ("humanity"), formed by *masculus* and *femina* ("male" and "female"), is represented chiefly by "female" in its "coupling" with God, and that, in consequence, there devolves upon saintly women a very special role to play in the history of the salvation of all of us—to be achieved when Christ returns to claim his spouse. (Cf. Gen. 1:27: "Et creavit Deus hominem ad imaginem suam: ad imaginem Dei creavit illum, masculum et feminam creavit eos"

the very few "rules" promulgated by him (as recorded in the Gospels), reiterated in exact terms what the narrator of Genesis had previously said concerning the special bond uniting prelapsarian man and woman.

The term "vernacular" has lent itself to at least as much confusion as the other words making up my title. The edict promulgated by the Council of Tours speaks of a "rustic, Roman language (or tongue)," which it equates, within the spatial bounds of Charlemagne's empire, with a corresponding Germanic rustic speech (*in rusticam romanam linguam aut theotiscam*) and whose speakers, presumably, either do not, or no longer, understand the Latin language of literate clerics, even when "corruptions" are introduced into it. *Oïl* and *oc* speakers are thus placed in the same boat as unlettered native speakers of Germanic for whom Latin in any shape or form, classical or "vulgar," had *never* been comprehensible. Yet the self-consciously "correct" *latinitas* of given Carolingian and later texts composed in "Latin" hardly allows for blanket generalization; and, as the various forms of Romance *scripta* grew in variety and literary sophistication, vernacular poetic texts could less and less properly be identified purely and simply with "rustic speech." It would eventually come to be understood that—to employ Dante's terminology—the vernacular was susceptible of "grammaticalization," that is, of being made the illustrious vehicle of "good eloquence" and learning (what the French twelfth century referred to as *clergie*). As Latin, starting in the thirteenth century, came increasingly to be identified with the discourse of philosophical speculation, poetry took splendid refuge in the vernacular: the grammar of the thirteenth-century *modistae* was most definitely no longer the authorial, *literary* grammar of Priscian or of Bernard of Chartres. "Latin" and "vernacular" are enmeshed in one another in ways that require much further study if we are one day more truly to understand their respective natures and relationships. Poetic questions come here to the fore.[7] For now

["So God created man in his own image, in the image of God created he him; male and female created he them"].)

7. No problem, or set of related problems, in literary, linguistic, and cultural history is more in need of careful review and study at the present juncture than that of the extraordinarily complex relationships obtaining between what, for convenience's sake as well as for obvious reasons, we traditionally tag "Latin" and the "vernacular(s)." Notions such as that of *latinitas* (as idealized by Priscian), of *simplicitas* and *brevitas* (in the Augustinian sense), and the permutations of the three levels of style (e.g., Vergil's "wheel") all require new and close examination. Thus, the advent of Christianity brought about a thorough revaluation of what constituted the "noble" or the "humble" style (see bk. 4 of Augustine's *De doctrina christiana*). "Vernacular" and "literary" were categories even in Latin writing (one thinks of Saint Jerome burning his "pagan"

we shall be in a position merely to touch on a few of them; but they should constantly be kept in mind whenever one deals with Western literature from the ninth through the thirteenth centuries.

When we look at the handful of surviving texts devoted to women saints on Gallo-Romance territory from the late ninth century through about 1200 or so, a striking and recurrent narrative pattern manifests itself. I refer to the tale of a holy and beautiful Christian maiden who refuses both the blandishments and the threats of a pagan (usually Roman) ruler, and who maintains her chastity and her status as God's

treatises on rhetoric) and were closely linked with issues of truth (plain vs. ornamented language). Alongside the use of Latin as the clerkly language of historical record, we find, at various times (the Carolingian "Renaissance," eleventh- and twelfth-century "Chartrianism"), the revival of pagan learning effected in the service of a *translatio* (a "transfer," both of empire and of learning), in Latin, designed proudly in order to demonstrate modern vigor and intellectual prowess. The renewed *latinitas* of an Einhard provides for the glorification of a Charlemagne who is not only the equal of Suetonius's Caesars but their superior. And, we recall, Bernard of Chartres' moderns, though dwarfs and perched on the shoulders of the ancients, do see farther ahead than the very ancients whom they "imitate." One is led to speculate that the ostensible and self-confessed imperfect *latinitas* of a Gregory of Tours contained, precisely *because* of its vernacular-leaning "corruption," a directness and an experiential truth that rendered his *History of the Franks* more accurate and more authentically "historical" than a thorough rhetorical recasting would have permitted. One suspects—again this is a matter for thorough reexamination—that documents of record in Latin (many prose saints' lives, for example, though by no means all of them—Prudentius's *Eulalia* would certainly be a case in point) constituted *potentially* meaningful pieces of discourse but that they required further "vernacularization," either in the "modern" Latin literary mode of a Carolingian historian or of a Chartrian like John of Salisbury or in the newly written forms based, as well as imposed, upon vernacular speech (the *rusticam romanam linguam*). To put the matter briefly, the literariness of Latin (the *littera*) could be made to contain more or less numerous and adequate renderings of the experiential; however, its meaning-fulness was, in this respect, essentially a matter of potential. Meanwhile, the spoken language, characterized by experiential directness, could, thanks to the proper use of Latin models ("sources" and resources), be made (1) fully and contingently to express this potential (e.g., lateral *translatio* like the *Roman d'Enéas* in respect of Vergil's poem); and (2) to serve as the far more transparent and direct linguistic embodiment of experience and meaning. The new literary vernacular (cf. Dante's Illustrious Vulgar) glossed both "life" and the "letter." This, in my judgment, explains why, from the eleventh century on at least, readers and writers in, and of, the vernacular stressed *bookishness* itself—constant, ongoing reading and re-writing—over the production and esthetic appreciation of specific, or monumental, works. Even works by the *auctores*—Vergil's *Aeneid* or Statius's *Thebaid*—were, thanks to *translatio*, brought into this pro-cess. In this sense, the various lives of women saints we have examined here constitute manifestations of a generalized *"Life" of the Holy Bride of Christ* rather than, in any exclusive sense, specific redactions, or oeuvres, devoted to given holy women. (See nn. 10 and 15, below.)

betrothed to the point of accepting extraordinary physical suffering and a martyr's death. Her death and the signs accompanying it—signs of God's favor—convince witnesses of the truth of her faith;[8] conversions ensue and many miracles take place. The martyred girl is judged worthy of being begged by "us" to intercede with Christ, her (as well as "our") lord,[9] for the protection and the salvation of our souls.

This, no more, no less, is the story related in the earliest surviving literary text in a language identifiable as that of *oïl*, the little twenty-nine-line sequence called "The Sequence of Saint Eulalia" (ca. 880, MS Valenciennes Municipal Library 150 [old catalogue 143], fol. 141, originally composed at the monastery of Saint-Amand-les-Eaux), which, following Prudentius (348–ca. 415), relates the life and martyrdom of a third-century Spanish girl.[10]

The same pattern is to be found in Wace's *Life of Saint Margaret* (ca. 1145?), the story of a girl who, like Saint George, vanquishes a dragon who had come to violate her chastity, and then overcomes the dragon's brother, the devil himself.[11] Margaret remains faithful to Christ despite the cajolings and the menacings of the pagan provost of Antioch, who wishes to make her his wife or concubine, and she suffers terrible torture before, finally, accepting decapitation and death.

Another twelfth-century woman saint's life is attributed to the Anglo-Norman Benedictine nun Clemence of Barking Abbey: *The Life*

8. For example, with utmost brevity, Prudentius's poem states that Eulalia, subsequent to her praying to Christ, "in figure colomb volat a ciel" ("in the shape of a dove she flew up to heaven"; line 25); one is inevitably reminded of the groom's calls to his bride in the Song of Songs and his frequent likenings of her to a dove: "oculi tui columbarum" ("thou hast doves' eyes"; Cant. 1:14; 4:1); "Surge, propera, amica mea, columba mea, formosa mea, et veni" ("Rise up, my love, my dove, my fair one, and come away"; 2:10); "columba mea" ("O my dove"; 2:14; 5.2); "una est columba mea, perfecta mea" ("my dove, my undefiled is but one"; 6:8). The context of "Eulalia," line 25, strongly suggests, therefore, the maiden's being summoned to join her beloved in heaven.

9. *Dominus* and, especially, *seignor* (*sire*) signify "lord, master." The latter term also designates "husband," in the sense of the husband of a specific woman.

10. This codex contains eight sermons by Gregory of Nazianzen translated into Latin by Rufinus, two Latin elegaic pieces, two Latin sequences (one of which, the "Cantica Virginis Eulalie," treats of Saint Eulalia), the Romance vernacular "Eulalia," and the Old High German *Rithmus Teutonicus* (also known as the "Ludwigslied"). See Albert Louis Rossi's splendid "Vernacular Authority in the Late Ninth Century: Bilingual Juxtaposition in MS 150, Valenciennes" (Ph.D. diss., Princeton University, 1986).

11. Elizabeth A. Francis, ed., *Wace: "La Vie de sainte Marguerite,"* Classiques Français du Moyen Age, 71 (Paris, 1932).

of Saint Catherine of Alexandria (final quarter of the twelfth century).[12] Somewhat like Marie de France in the prologue to her *Lais,* Clemence starts her poem by referring to the obligation of "he who possesses the knowledge of Christ's example" to make the "fruit of his goodness" available to others. She prays to him that he aid her in "translating" the life of "une sue veraie amie." This will be the story of the eighteen-year-old Christian maid Catherine, the beautiful only daughter of a king, who lived in Alexandria before the time it was ruled by the cruel pagan Maxence, the rebellious enemy of Emperor Constantine and his consort Helen—a kind of "anti-emperor." The antagonism of Maxence and Catherine involves several levels: (1) the two debate the merits of their respective religions, and Catherine's eloquence (*bel parler* [line 199]) proves superior to his, as well as, with God's help, to that of fifty pagan clerics in Maxence's employ who, convinced by her, accept baptism and martyrdom; (2) Catherine rejects Maxence's proposal of marriage, thereby, in his eyes, "dishonoring" him—he throws her into prison, places her on a starvation diet, and sentences her to decapitation; (3) Catherine is visited by Porphyrus, Maxence's right-hand man, and by his queen, to whom she speaks of the fragility of earthly love and power and of the permanence of heaven (she stresses the blessed kindness of the virgin), and they, along with two hundred knights, are converted; (4) Maxence returns, is struck by Catherine's extraordinary beauty, and declares his love for her, but she refuses him and mocks his threats to torture her: her body will suffer, but her soul is immortal; (5) the many Christian converts of Alexandria, including the queen and Porphyrus, are put to death at Maxence's orders; (6) Maxence again asks Catherine to abandon her faith and to marry him, but she scorns him, reiterating her fidelity to her true husband and lord, so he orders her decapitation; (7) when she is beheaded, her blood turns to milk, the angels carry her off to Mount Sinai, and miracles cure the sick.

Chastity and wifely fidelity to Christ (an angel promises her that, after her martyrdom, "tun espus sen fin verras" ["you will see your eternal husband"; line 582]), a gift for "good eloquence," incorruptible beauty, the incarnation of truth, a sense of the utter vanity of worldly triumphs, a clear understanding of the frailty of relying upon earthly

12. See William Macbain, ed., *The Life of Saint Catherine,* Anglo-Norman Text Society, 18 (Oxford, 1964).

pleasures and values—all these characteristics blend in the womanly person of Catherine. Her life is construed, and presented, as a complete victory. Catherine knows that her *genuine* life—her true fulfillment— will begin at the moment of her earthly death. What is contained lyrically and celebratively in "Eulalia" is here rendered fully explicit both narratively (i.e., historically) and morally, within the fairly ample space of some 2,700 lines. But an important feature of the woman saint is brought explicitly to the fore: the saint's *eloquence,* her *natural* ability to speak well, and her aptitude for training in the arts. Her witness is an active one, and, of course, it is presented as specifically feminine. Catherine *defeats* Maxence (and everything "Maxence-ism" stands for), as not even the Christian emperor of Rome, Constantine, had been able to. Consequently, it is she who *completes* the Christianization of the Roman Empire.[13]

The Age of Constantine also provides the temporal backdrop for the mid-eleventh-century Old Provençal masterpiece, *The Song of Saint Fides,* a work often known by its French title, *La chanson de sainte Foi.*[14]

The peculiarly vernacular character of *Fides* is underscored by the poem's geography. Fides herself is from the "wicked city" of Agen (Lot-et-Garonne); her martyred remains are translated to Conques (Aveyron); the poem ends in Marseilles. Spatially, the poem refers to

13. In a very real sense Saint Catherine is at once the female counterpart and the opposite of the male *miles Christi* figure represented in such chansons de geste as *The Song of Roland.* The "history" in which the heroes of the *geste du roi* participate is ongoing: witness Thierry as Roland's successor, after the latter's death at Roncevaux. Roland's exemplarity extends over time; it will end only at the close of human history. Catherine's victory is definitive; she demonstrates the truth of her faith once and for all. Narrating her story, or that of other women saints like her, thus constitutes a kind of quasi-liturgical profession of faith, a ritual in which the audience's participation is every bit as essential as what, in fact, is being told.

14. We owe the most exhaustive paleographic study of the poem to Ernest Hoepffner who, in collaboration with Prosper Alfaric, published an edition of it (with modern French translation), a linguistic analysis and an extensive examination of sources, in two volumes: *"La chanson de sainte Foy,"* vol. 1, *Fac-similé du manuscrit et texte critique: Introduction et commentaire philologiques* (Hoepffner); vol. 2, *Traduction française et sources latines: Introduction et commentaire historiques* (Alfaric), Publications de la Faculté des Lettres de l'Université de Strasbourg, 32–33 (Paris, 1926). Quotations from the text of the poem in the present essay refer to Hoepffner's edition. (The manuscript text was obviously copied by an *oïl*-speaking scribe not entirely at home in Occitan, since a second scribe—a corrector who knew Occitan—effected a number of emendations designed to restore the poem's Occitan authenticity; this surely constitutes one of the earliest, if not *the* earliest, examples of a Romance language "critical edition"! The "philological" care already lavished on this text in 1100 bespeaks the respect in which the Fides story was held.)

the "country" of Occitania: the "land of Faith" corresponds to the area in which the language we call Provençal is spoken, the land of the troubadours.[15] The story, or so the poet-narrator informs us, derives from a *razon espanesca* ("a Spanish subject"; line 15); it is treated and to be performed in "the French (i.e, *oïl*) manner" (*a lei francesca* [line 20]); *he* heard it read from a Latin book (line 2).

Fides has given its readers no end of trouble, for the poem seems all mixed up. The first part appears familiar enough: it tells of a beautiful and noble young girl (named Fides, in Latin, in obedience to God's command [line 72]), from Agen, whose Christian faith disturbs the pagan Roman governor Dacian. Dacian, the bloodthirsty lieutenant of the cruel emperors Diocletian and Maximian, does all he can to convince Fides to renounce her belief in the Christian God and to worship Diana instead.[16] In terms calqued on those of the Shulamite bride, Fides expresses her fervent desire to wed Jesus:

> "Aqel volri' aver espos,
> Qualque plaid m'en fezess ab vos,
> Q'el si'm es belz *et* amoros.
> Lo seus noms es Adonaï [cf. Exod. 6:2–3];
> Aital lo diss a Moysi.
> Poderos es *per* ver aissi,
> De quant manded, res non'n falli.
> E qi *per* bon cor li servi,
> No*n* teg lo guadardon ab si.
> Humilitad e ben quesi
> *Et* a sos drudz honor aizi."
> (Lines 311–21)[17]

15. For a closer analysis of this spatial dimension, see my "The Old Provençal *Song of Saint Fides* and the Occitanian Concept of Poetic Space," *L'Esprit Créateur* 19, no. 4 (1979): 17–36. See also the in-depth study by Elizabeth Moriarty Work, "The Foundations of Vernacular Eloquence from 'Eulalia' to 'Fides' " (Ph.D. diss., Princeton University, 1982).

16. For our saintly girls, abjuring the faith is invariably linked with welcoming, or at least accepting, the sexual advances of the pagan (or diabolic) tempter; in exchange for giving herself—the girl retains her power to choose—she is offered material wealth, pleasure, and status. She will be "kept." It is interesting to note that our holy maidens reject these presents *both* on grounds of faith and honor *and* on the grounds of their inherent worthlessness: they are not lasting gifts, their "keeping" power is severely limited. (See n. 1 above and Heloise's application of this way of looking at things to the real *practice* of marriage, as she saw it in her time.)

17. "I wish to have him for my husband, whatever dire consequences may befall me on this account at your hands, for he is most fair to me and elicits my desire. His name is *Adonaï;* so he informed Moses. In truth he is so powerful that in no way does what he orders fail to measure up, and whoever serves him with a good heart is never denied

Like Saint Catherine, Fides is very eloquent, blessed with the invincible and *natural* simplicity of her maidenly purity and her passion for God.[18] The circumstances of her eventual martyrdom—she rejects Dacian's false blandishments as resolutely as she resists his threats—recall in virtually every detail those surrounding the martyrdoms of Eulalia, Catherine, and Margaret. Our pattern holds true.

But the poem does not stop there. Fides's story is linked at this juncture, though briefly, to that of Saint Caprasius. His only real role here, however, is to witness her death and apotheosis—to see himself as her *druz* (loving servant) and, one supposes, to communicate the fact of her martyrdom to us. First, Fides, noble "filla de cavaller" (line 341), is placed, "lo corps tot nud, cast *et* enter," on a kind of marriage bed of firewood, and the flame is kindled. But a winged angel, "whiter than a dove," appears from heaven, covers the girl's body with a golden sheet, and places a gold crown—of martyrdom and of marriage—upon her head: God thus responds to her desire for him.[19] The fire is extin-

his recompense by him. He sought out humility and goodness, and honor for those [*sos drudz*] who loved him well" (my translation).

18. Rhetorical *simplicitas*, even in classical times (e.g., Cicero), is prized as, perhaps, the highest form of art. It is closely related to *brevitas*. For Saint Augustine, a boy natively endowed with genuine *simplicitas* ought not to be spoiled by technical training in grammar and rhetoric; instead, every effort must be made in order to preserve this gift intact. A certain *directness* and, of course, purity are involved here: translated into discourse, *simplicitas* expresses in the most unmediated fashion possible the truth of experience, hence of witness. The speaker renders his or her involvement in what is being spoken about. Such, for example, must obviously have been the case with the language employed by the women who conveyed the news of Christ's Resurrection to the unbelieving disciples. They certainly told the truth, yet, as we observed, their words were characterized by those who heard them as "silly, insane" (*deliramentum*). The men failed to grasp the women's totally authentic, unadorned eloquence, their *simplicitas*. Similarly, Eulalia, Catherine, and Fides are, in and because of their simplicity, supremely eloquent. Furthermore, it is in such directness, purity, and simplicity that the undisguised truth of the vernacular may be said to reside. The very rendering of Christian faith in the *person* of the maid of Agen is, itself, a profound "simplification." We can be eyewitnesses to her.

19. Fides's nakedness, her being wrapped in a precious cloth, and her being carried to heaven pertain to, or perhaps even constitute, a kind of iconography that deserves further study. Alfred Jeanroy comments as follows on the last of three miniatures contained in the Toulouse manuscript of the (to him) mid-thirteenth-century (or earlier) Old Provençal *Life of Saint Margaret*: "La troisième a pour sujet la décollation de la sainte: à gauche du spectateur, le bourreau, jambes nues, coiffé d'un heaume; à droite, le démon, debout, représenté avec une tête de chat (ou de tigre), tire une langue énorme [surely an image of concupiscent lubricity]; il est vêtu de noir et de gris, et a des griffes aux pieds et aux mains; au milieu, la sainte déjà décapitée; sa tête à roulé à terre; *en*

guished. An enraged Basque pagan leaps up in order to cut off the saint's head; angels, rejoicing, bear her soul to heavenly bliss. A violent storm breaks out, a river of blood flows; Fides is buried but only temporarily and in secret.[20] Finally, she is interred in a proper marble sepulcher thanks to the intervention of the saintly bishop Dulcidius. (Saint Caprasius, meanwhile, has disappeared from the story.) Fides's uncorrupted body is removed to Conques, where her intervention cures the sick, including an unjustly blinded monk. The poet-narrator informs us that the situation, meanwhile, is improving for the Christians; the pagans are in retreat. Fides's story of witness thus *coincides* with this bettering of the Christian cause, and through the metonymy of coincidence can be understood as *contributing* to it. What happens next in the poem is most adequately seen as forming the narrative of the saintly maiden's principal miracles. These, significantly enough, are *historical* in nature.

At this point the story shifts to Rome and, especially, to Marseilles. These places constitute the historical stage upon which the consequences of the "life" of Saint Fides are acted out, or, to put the matter otherwise, where that "life" is lived, so to speak, by all of us in the world of human history, in the very specificity and reality of the Occitanian "vernacular" community.

The framework here corresponds by and large to the tripartite al-

haut, son âme, figurée par une petite femme nue, est emportée dans une serviette par deux anges" ("The third miniature has as its subject the beheading of the saint: to the left of the spectator there stands the executioner, bare-legged, helmeted; to the right, the devil, standing, shown with a cat's—or tiger's—head, sticks out his enormous tongue; he is dressed in black and gray, and has claws on his feet and hands; in the middle we see the saint already beheaded; her head has rolled to the ground; *above, her soul, represented by a little naked woman, is carried off in a towel by two angels*"; my translation, my emphasis). He further notes, with respect to the tiny naked woman: "On sait que c'est ainsi que, dans les mystères, était ordinairement figurée l'âme humaine" ("It is common knowledge that in the mystery plays the human soul was represented in this fashion") (*La Vie provençale de sainte Marguerite, d'après les manuscrits de Toulouse et de Madrid*, ed. A. Jeanroy [Toulouse, 1899], pp. 6–7). The human soul, or *anima*, is thus graphically depicted as feminine, in a "pure," or unadorned, feminine body; as such, it is (at least in the case of Saint Fides) personified in the "historical" girl-individual who is the protagonist of the poem. Fides's soul-body is brought, in a context of promised marital bliss, to her lord, her spouse. (As Tony Hunt reminds us [see n. 5], the human soul, or *anima*, is depicted frequently as yet another avatar of the Shulamite bride; he associates this depiction with Saint Bernard.)

20. The patently sexual overtones of this cosmic storm are particularly significant when, within the context of the male hagiographic *imitatio Christi*, one compares this event with what happened immediately after Christ gave up the ghost on Good Friday.

legorical commentary made by Origen upon the text of the Song of Songs.[21] Just as the Song of Songs tells the story of a marriage, so Fides's life is "literally" recounted as we have summarized it. Typologically, Fides, like the Shulamite, represents the church in her union with Christ, her bridegroom, and in this representation she generates a set of relationships that involve an entire community—what, to quote the Strasbourg Oaths (842), might be referred to as the *christian poblo*, which lives out and embodies God's historical plan. She is the "holy one." Spiritually, and in the manner in which poetically Fides reincarnates the Shulamite bride, she symbolizes the human soul (*anima*) in its and her desire for perfect union—*connubium diuum* or *copula sancta*—with her spouse.[22] Once again, in her *specific* case the union is achieved and celebrated; Fides thus acquires for all of us an exemplary status. She is rooted in our own "vernacularness," which, in turn, her story does much to define for us. We too are *of her*. This, I believe, is what justifies, indeed renders necessary, the telling of what happened in Rome and in Marseilles. Rather than constituting a merely gratuitous accretion to the story proper of Saint Fides, part 2 of the *Life* is indispensable to this biography, even though, as Alfaric has pointed out, nothing in the Latin tradition directly concerning Fides may be said to provide a direct "source" for it.[23]

21. See n. 4 above, also the Introduction by Manlio Simonetti to his annotated translation, *Commento al Cantico dei Cantici* (Rome, 1976), esp. pp. 24–27; and Jacques Chênevert, *L'église dans le Commentaire d'Origène sur le Cantique des Cantiques,* Studia, Travaux de Recherches, 24 (Brussels, 1969), esp. pp. 283–85.

22. *Connubium diuum,* along with *copula sacra deum,* is a term employed at the start of Martianus Capella's extraordinarily influential *De Nuptiis Mercurii et Philologiae* (ca. 410–29), the fable which treats of the marriage of Mercury and the maid Philology. (The major portion of this work, bks. 3–9, consists of expositions of the Seven Liberal Arts and was an immensely popular handbook throughout the Middle Ages.) Martianus's narrator, an old man, responds to the sarcasm of his son by declaring that his story, an encomium to the "copula sacra deum" (bk. 1, sec. 1), tells of the time when "love and marriages were universally celebrated" among the gods (bk. 1, sec. 5). (*De Nuptiis,* ed. Adolf Dick and J. Préaux [Stuttgart, 1978], and *Martianus Capella and the Seven Liberal Arts,* trans. William H. Stahl and Richard Johnson, with E. L. Burge, Records of Civilization, 84 [New York, 1971–77].) Martianus's *prosimetrum* deeply influenced Old French romance, at its very inception, particularly the first Arthurian romance, entitled *Erec et Enide* (ca. 1170), by Chrétien de Troyes; Chrétien's notion of *bele conjointure* ("beautiful conjoining") is largely a "translatio(n)" of Martianus's *copula.* See my "A propos de philologie," *Littérature* 41 (1981): 30–46, and "Vernacularization and Old French Mythopoesis, with Emphasis on Chrétien's *Erec et Enide,*" in *The Sower and His Seed: Essays on Chrétien de Troyes,* ed. Rupert T. Pickens (Lexington, Ky., 1983), pp. 81–115.

23. Alfaric suggests quite convincingly that the *Fides* poet's source was the *De mortibus*

In part 2 of the poem, the wicked Diocletian, persecutor of Christians, reigns as emperor in Rome with his colleague Maximian. By giving Constantine his daughter in marriage, Maximian sought to bring about the downfall of his son-in-law, the brave and upright lord of Marseilles.[24] Constantine deeply loves his wife, however, and she cherishes him to the utmost (lines 501–2). The solidity of their couplehood allows for no betrayal of the kind Maximian counted upon; the spouses remain *faithful* to one another, according to the strictures of both Genesis and the Gospels of Matthew and Luke.

Frustrated and angry, Maximian arms his son Maximinus, gathers a host of pagans collected from the four corners of the earth, and marches against Marseilles in order to crush Constantine. They systematically slaughter all the Christians they encounter: 6,600 drench the fields with their blood and cause the River Rhône to flood. Constantine, however, escapes the trap his enemy has set for him; instead he catches Maximian and throws him into prison in Marseilles. The daughter, after submitting her father to unspeakable torture, orders his remains to be hanged ignominiously outside in the wind.[25]

persecutorum by the North African Lactantius, a text known to us thanks to an eleventh-century manuscript from the Abbey of Moissac (Tarn-et-Garonne), which our poet could easily have seen. *Fides* modifies somewhat the data provided by Lactantius, e.g., the poem establishes a genealogical relationship between the Emperor Diocletian and Licinus as well as between Maximian and Maximinus, and he switches certain roles about: the adversaries at the Milvius Bridge become Licinus and Maximinus, replacing Constantine and "Maxence." That this story was intended by our poet to be integrated into the *Fides* narrative is supported by the first stanza of the poem, esp. lines 5–6 and 13: "Parled del pair' al rei Licin / E del linnadg' a Maximin," ("It spoke of the father of King Licinus and of Maximinus's lineage") and "Czo fo prob del temps Constantin" ("That was in about the time of Constantine" [my translations]) (Alfaric, *"La Chanson de sainte Foy": Traduction française,* pp. 27–30). In a very real sense, emphasis upon the conjoining, within the Latin *Fides* tradition, of Saints Fides and Caprasius is largely replaced by the importance our poem confers upon Fides's relationship with the Christian people.

24. This detail is not given by Lactantius; only later does the father (who here resembles Dacian in respect to Fides) attempt, through cajolery, to persuade his daughter to betray her husband ("nunc blandimentis sollicitat ad proditionem mariti" ["Now he solicits her through blandishments to betray her husband" (my translation)]).

25. This detail concerning the role played by the daughter in her father's punishment and demise is not given by Lactantius; according to the Latin version Maximian hangs himself from a crossbeam. The poem, however, makes a point of depicting its characters' systematically undermining the value of kinship and genealogy: these are viewed by them as vainglorious and quite susceptible of corruption (e.g., Maximian's attempted use of his daughter in his own scheme of revenge against her husband). Fleshly kinship— one of the foundations of feudalism, let us not forget—is very much of this world and

For Christians, then, the situation has indeed improved substantially. When Diocletian hears of his colleague's death, his heart bursts at the news; he joins Maximian in hell, alongside the wicked pharaoh, persecutor of the people of God (Exod. 15:4–5).

But Fides's story is not yet quite over. There remains one short, but very important, chapter to be recounted. The sons, respectively, of Diocletian and Maximian have a falling out. Of course this was to be expected, for "Folz es qi nemias se trebailla / Qe per mal far sos linz mais valla" (lines 576–77);[26] the continuity of lineage—a concern traditionally viewed as masculine—can be rightly assured only when it is conceived as fitting God's historical plan and placed at the service of this plan, never when woman—for example, Fides—is objectified as the plaything of egotistical male lust and pride. An ominous crow announces to Rome that the two sons will fight each other. Both are killed during their duel on the bridge; the poet, disgusted, declares that he wishes to add nothing further to this corrupt and false history.

The Christian Constantine succeeds to the imperial throne; his succession—perhaps his very conversion—is depicted, then, as both a chapter and a consequence of Fides's life. It is she—faith, the maiden, the Bride of Christ, the holy martyr, the miracle worker of Occitania, the human soul, above all, perhaps, the *saintly woman*—in *her* story and within the poeticohistoriographical context surrounding her story who revolutionizes, who *accounts for,* the course of human history as this history assumes vernacular shape and derives meaning from its vernacularness. And, clearly, it is by no means fortuitous that the link between her and the world is forged in the exemplary fidelity of her worldly counterpart, Constantine's wife. This noble woman *keeps* faith with *her* spouse, and nothing in the world will ever be the same again. Like Fides, whose fidelity she fulfills, she too deserves to be called *domna* ("mistress, lady").[27] Her steadfastness is miraculous in that it

of its dirty business. Despite its "cruel and unusual nature" (cf. line 543), Maximian's punishment is deserved.

26. A clear statement of the evil futility that resides in one's according an overriding importance to matters of lineage, of historical "importance": "A madman is he who dedicates himself entirely to making his crimes benefit his progeny." Not only is such dedication wrong, it is, by its very nature, condemned to failure. What might be termed "secular feudalism" is stingingly rebuked here. Similarly, great concern for matters of lineage—for tradition—also characterizes the "faith" of the tyrant Maxence in *The Life of Saint Catherine* (see lines 227–34, 360–66).

27. Many key terms (e.g., *domna, druz*) that will become the stock in trade of a much later Old Provençal love song—the troubadour lyric—are to be found in *Fides*.

constitutes part and parcel of Fides's miracles. The words spoken by Christ to the penitent Mary Magdalene ("Fides tua te salvam fecit"; see n. 3, above) apply to Christian Marseilles,[28] indeed, via the "imperial" personage of Constantine, to all Christendom.

It is time to conclude our *tour d'horizon*. Let me stress a few matters of general interest, return a last time to our initial definitions, and suggest avenues for future study.

First, the observations here, despite their sketchiness, ought to put paid to much that has been vulgarly assumed and repeated concerning "medieval" ideas of womanhood—assumptions that all too often reflect the prejudices of modern scholars far more accurately than the realities of the early High Middle Ages. What was represented by Fides, Eulalia, Catherine, Margaret, and the others is something quite central to a coherent understanding, within the Christian tradition, of humankind in both its atemporal essence and its historical variety. One begins to comprehend why, at the time concerning us, chivalric action itself seemed to require the sanction of woman in order to be complete and judged good.[29] We start to grasp the extent of the extraordinary devotion felt by the period for the Mother of God, and the unparalleled expenditures happily undertaken everywhere in Western Europe in order to build her "house": at Chartres, Paris, Bourges, and innumerable other towns and villages. The rationale for Robert d'Arbrissel's belief that through the understanding and through the prayer of woman, man would be saved becomes clearer; his founding of the feminine Abbey of Fontevraud about 1100 seems perfectly right, as

28. Traditions link the city of Marseilles—a kind of "new Rome" here—with the person of Saint Mary Magdalene, who, as some early legends would have it, was placed, along with her brother Lazarus (named bishop of Marseilles), her sister Martha, and Joseph of Arimathea, on a boat that mysteriously took them all to Marseilles, where she lived the rest of her life in great piety and faith, and where she was buried.

29. Over and over again in medieval narrative texts we observe the knight telling of his successes and, quite often, of his shames to a lady: Enéas to Dido, in the mid-twelfth-century *Roman d'Enéas;* Calogrenant to Guenevere, in Chrétien de Troyes's *Yvain* (ca. 1180); Joinville, in his account of the bravado of the count of Soissons at Mansourah ("Seneschaus, lessons huer ceste chiennaille; que par la quoife Dieu! [ainsi comme il juroit] encore en parlerons-nous, entre vous et moi, de ceste journee es chambres des dames" ["Senechal, let us let those mad dogs growl; for by God's bonnet (he used to swear in this manner) we shall speak again, you and I, about these things that are happening today in the ladies' chambers" (my translation)] [*Histoire de saint Louis,* sec. 242, ed. N. de Wailly (Paris, 1868)]). The lady's witness to chivalry has the power to validate that chivalry.

does Dante's utterly respectful praise, much later, of "ladies who possess the intellect of love."

Second, we have observed that our women saints function consistently in terms of the couple within which their identity resides and, no less significant, of which they are the recognized guardian and the soul. The destruction of the couple is, quite simply, the dreadful consequence of sin, whether through death or through any other agency. Moreover, woman is the acknowledged repository of human knowledge concerning the couple. It is her place; she is *its* place.[30]

Third, it is the woman saint—at least as she is depicted in the Gallo-Romance texts we have looked at—who keeps alive the fundamentally revolutionary character of Christianity. It is she who undermines historical sequentiality, the seemingly unending, but in fact quite accident-prone, line of genealogical business-as-usual. Through her, even *because* of her, the Old Rome makes way for the New Rome. Catherine and Fides, brides of Christ, are more *powerful* than their persecutors, and they bring joy—charity and delight—in their wake to all who know how to love them.

These saints are at once a part of history and yet somewhat separate from much historiography. To be sure, the bride's role in the Song of Songs is important; Mary and Mary Magdalene figure prominently in the Gospels. The presence of women in Holy Scripture therefore cannot be denied, and they—especially the Virgin—deserve our veneration.

30. The ramifications of this are manifold, and may be seen everywhere, on all levels: Aude and Roland, Guillaume and Guiborc, Heloise and Abelard, Yseut and Tristan, Alexis and his bride, Guillaume de Lorris and "she who must be proclaimed Rose." Mary the Egyptian, the "friend" of the overly proud monk Zosimas, is also the "friend" of the thirteenth-century French *clerc* Rutebeuf, who composed her life. Thanks to the hero's beautiful and "wise" wife, the romance narrative dealing with Erec and his earning a kingdom becomes even more fundamentally the story of the *bele conjointure* of *Erec et Enide* (ca. 1165). Even in death, Dané creates the couple made up of herself and Narcisus, and "saves" Ovid's doomed lover (in the Old French *Narcisus* [ca. 1160]); and it is Tisbé who, in death, consummates the couple she forms with Piramus (*Piramus et Tisbé* [ca. 1160]). And in the "Ditié de Jehanne d'Arc" of Christine de Pizan (1429) does not God himself come to the service of Saint Joan, who loves him, so as to enable her, in "conjunction" with the king of France, to save chivalry and "restore" France to her proper historical mission as defender of the faith in the Holy Land? Perhaps Louise Labé—a poet scorned by such contemporaries as Calvin for being a harlot and a bluestocking—is in fact lamenting the loss of couplehood when, in the sonnet that starts out "Baise-moi, rebaise-moi et baise m'encor," she declares her pain at having to live "discretely": "Toujours suis mal, vivant discrètement, / Et ne me puis donner contentement, / Si hors de moi ne fais quelque saillie" ("I feel sick when I live discretely, and I cannot achieve happiness if I do not sally forth from myself" [my translation]).

But traditionally (i.e., in most ecclesiastical redactions of history), these women were not seen as so central to the historiographic process as, say, Saint Peter and Saint James were. Furthermore, they do not so much constitute a part of the main, or authoritative (especially Latin), thread of narrative as they appear to interrupt it or hurry it along, often dramatically.[31] What I am saying also works on the level of biography. After all, it is his bride's interruption into his life (and his very great desire for her) that prompts Saint Alexis to undertake a life of holy abnegation and *askesis* in order, thereby, quite literally, to "save" his marriage: she is an indispensable given of his sanctity. In so doing Saint Alexis demonstrates that he can intercede for all of us with God. It is perhaps worth pointing out that the vernacular *Life* (roughly contemporary with *Fides*) has the voice calling upon the people to seek out the saint "who is in Rome" and to "pray to him that the city not collapse and its inhabitants not perish"; the Latin source, far more abstractly, has the people beseech the saint in order, merely, that "he might pray for Rome."[32] This is a good example of vernacular concreteness and specificity.

These interruptions are invariably happy ones. They testify, I think, to a new optimism—we might call it a "vernacular hope"—on the part of Frenchmen during the eleventh and twelfth centuries. The decisions taken by Fides and Catherine are the simple and the right ones. We must be proud to have human beings of such charity and beauty in our midst, in our own (that is, the spoken) language. Their free and loving choices speak well of what we are all at least potentially capable of. And we should be as protective of their memory as we are of our homes and families. Constantine's defeat of Maximian, accomplished *in the service of his wife* and of their couplehood, is consequently in great measure the chivalric victory of his marriage, the successful defense of his home; those things are one and the same with his universally important Christianizing mission.

Lastly, I believe, the sort of vernacular eloquence—the unencumbered simplicity—we are called upon to associate with the speech of our women saints will contribute a great deal to later identifications of the vernacular with the language of truth. We think immediately of

31. To my mind, it is not only highly insightful of Origen to have stressed, precisely, the dramatic, even theatrical, character of the Song of Songs, it is significant that he chose to begin his commentary on that text by stressing its dramatic structure.

32. See W. Foerster and E. Koschwitz, eds., *Altfranzösisches Übungsbuch*, 4th ed. (Leipzig, 1911), p. 133 (stanzas 59–60).

the poet who wrote the life of Saint Thomas Becket during the mid-1170s. Guernes de Pont-Sainte-Maxence asserted that his story was true because his language was good—he was born in France ("Mis langages est bons, car *en France* sui nez," he wrote). No translation in or out of Latin is involved: his language is that of his direct witness and experience, of his *dialogue* with—his *participation* within—the events he recounts. We also remember Jean de Meun, who promised to sing out the teachings of love, "selon le langage *de France*," at the crossroads and in the schools. A couple of decades later, in *De vulgari eloquentia*, Dante will describe the vernacular as that (potentially perfect and true) language that one imbibes with one's nurse's milk, that is, from woman.[33] This tradition of thought, which reaches back beyond Saints Jerome and Augustine, permeates the value systems that underlie our early Gallo-Romance female saints' lives, and it derives an indispensable sustenance from the poetic example of these texts. Fides, Margaret, and Catherine speak unadulteratedly the unadulterated truth. To say this is not all that remote from asserting that the province of lived truth stands in a relationship of equality with the vernacular language that *they* "spoke"—with *their* voice. Meanwhile, the tonality of this vernacular voice is deeply, overwhelmingly erotic. Although, over time, many would come to fear the power and the attraction of its feminine eloquence and would act accordingly in a clerkly conspiracy of censorship and repression, the voice could never be completely

33. I am also reminded at this point of Beatrice's speech to Vergil in *Inferno*, 2, as reported to Dante by Vergil, and of the Lady's truthful eloquence: "e donna mi chiamò beata e bella, / tal che di comandare io la richiesi. / Lucevan li occhi suoi più che la stella; / e cominciommi a dir soave e piana, / con angelica voce, *in sua favella*: / 'O anima cortese mantoana, / di cui la fama ancor nel mondo dura, / e durerá quanto 'l mondo lontana, / l'amico mio, e non de la ventura' " ("and a lady called me, so blessed and so fair that I prayed her to command me. Her eyes were more resplendent than the stars, and she began to say to me, sweetly and softly, in an angelic voice, 'O courteous Mantuan spirit, whose fame still lasts in the world, and shall last as long as the world, my friend—and not the friend of Fortune' " [*Inferno: 1-Italian Text and Translation*, ed. Charles S. Singleton (Princeton, 1977), lines 53–61]; my emphasis; translation by Singleton). *In sua favella* (not specifically translated by Singleton) clearly signifies Beatrice's idiosyncratic, perfectly feminine vernacular speech, and it suffices to move Vergil to action in guiding Dante's pilgrimage; one wonders at the resonances of *segnor mio* when Beatrice, obviously sanctified, promises to praise Vergil to "her lord" (" 'Quando sarò dinanzi al segnor mio, / di te mi loderò sovente a lui' " [" 'When I am before my Lord I will often praise you to Him' "] lines 73–74). Is the sense of "husband," like Old French *sire* or *seignor*, present in this term? In the spiritualized context of this speech, at any rate, the terms *donna, amico,* and *segnor* designate couple-type relationships no longer subject to sin.

silenced. What Chaucer's Wife of Bath called "hooly seintes' lyves" ("Prologue," line 670) would persist and would remain an indispensable fund without which *all* our poetry, and our stories, would have been—or would be—reduced to impoverishment, perhaps even to extinction.

13 ELIZABETH ROBERTSON

The Corporeality of Female Sanctity
in *The Life of Saint Margaret*

The thirteenth-century Middle English *Life of Saint Margaret* offers us an unusually rich source for a study of medieval concepts of female sanctity. This is true not only because its protagonist is a woman but also because it was translated from the Latin with a specific audience of female contemplatives in mind. Both paleographical evidence and comments within the work itself make it almost certain that this life was intended as a spiritual model, if not for the three anchoresses of the Deerfold for whom the *Ancrene Wisse* was also written, at least for a similar group of female contemplatives.[1]

Predominant in *The Life of Saint Margaret*—and I suspect in most female saints' lives—is an emphasis on physical experience. The life explores the saint's sexual temptation by the devil, her endurance of physical torture, her identification with Christ's suffering, her dependence on Christ for release from physical suffering, and finally her intimate acquaintance with both the inanimate and animate physical world. While such aspects of the saint's experience do, of course, appear in male and female saints' lives alike, their centrality in this one suggests that in its author's view physical experience was particularly important

A version of this essay appears as part of my book *Early English Devotional Prose and the Female Audience* (Knoxville, Tenn., 1990).

1. For the argument that the six middle English works including *The Life of Saint Margaret* known as the AB texts were originally intended for the three anchoresses of the Deerfold in Herefordshire, see E. J. Dobson, *The Origins of Ancrene Wisse* (Oxford, 1976).

to women. By looking at the alterations the English author made in his Latin source, we can see how he highlights the female saint's physical experiences. That an author writing for women should consistently highlight the physical in his representation of female sanctity suggests that sanctity, to this author at least, was not a gender-neutral concept.

The Life of Saint Margaret, we shall see, presents a model of female sanctity that assumes a woman's essential, inescapable corporeality. Because a woman can never escape her body, her achievement of sanctity has to be through the body. Her temptation by the devil will be through the body and most probably will be sexual. She can overcome that sexual temptation only through her body, primarily by countering her physicality with her endurance of extreme physical torture. A woman further achieves redemption through her identification with Christ's physical suffering, through her dependence on Christ, and most important, not through her transcendence of earthly desire, but through her transference of physical desire to Christ. That the essential corporeality of women is the defining characteristic of her sanctity is further reinforced by a focus on concrete imagery: that is, because women are portrayed as perceiving their relationship to God and the devil through the senses rather than through the mind, the images of this work, which are both domestic and concrete, reinforce a circumscribed view of female spiritual potential.

These defining characteristics of female sanctity reflect the age's more general views of the nature of women. The Middle Ages inherited two opposing views of woman's spiritual nature, the Platonic view of the soul's gender neutrality and the Aristotelian view of the soul as differentiated by gender. To Plato, the body was a hindrance to the freedom of the soul, but was relatively unimportant in comparison to the sexually undifferentiated soul. For Plato, it was excellence, or virtue, that mattered above all, and he viewed virtue as available equally to both sexes.[2] Aristotle, on the other hand, was much more interested in the body and believed that sexual differentiation was a primary distinction among individuals. That differentiation was more than merely physical to Aristotle, and his misogynistic views of women's physical nature extended to the nature of their souls as well. Conceiving of the soul as possessing nutritive, sensitive or appetitive, and reason-

2. See Martha Lee Osborne, ed., *Woman in Western Thought* (New York, 1979), p. 16.

able faculties, Aristotle saw women's souls as deficient in all three aspects, but especially in the faculty of reason.[3] Aristotle's opinions about the nature of the soul as well as his reproductive theories that associate women above all with matter, because they define women through their bodies alone, are fundamental to the development of the concept of female spirituality we see expressed in *The Life of Saint Margaret.*

Biblical commentary on female spiritual potential followed both Aristotelian and Platonic schools, yet Aristotelian views in the end become predominant.[4] His ideas permeate biblical commentary on the nature of women, especially in commentaries on Genesis. Adam is continually associated with the mind and reason, whereas Eve is associated with the body and willful appetite. As daughters of Eve, all women, even female saints, were alleged to inherit Eve's rootedness in the body, her incapacity for theory, and her dependence on the senses. The nature of her soul and hence her spiritual potential remained, however, ambiguous in commentary. Augustine attempted to reconcile Platonic and Aristotelian concepts of the soul. George Tavard, summarizing Augustine's results, notes that, "As souls, both man and woman are equally the image of God. As bodies, however, only the man is made in the image, for only he expresses in his body the power and superiority of God, the female body expressing, on the other hand, passivity and inferiority. Thus, man experiences no conflict between his body and his soul, whereas woman is caught in a permanent squeeze between her soul—image of God—and her body, which cannot image God."[5] The correspondence of women with the body persists in later medieval glosses, where "Man is the *spiritus* (masc.), the higher rational soul,

3. See Osborne, *Woman,* pp. 34–35, and Ian Maclean's discussion of medieval notions of the feminine in his book *The Renaissance Notion of Woman: A Study in the Fortunes of Scholasticism and Medical Science in European Intellectual Life* (Cambridge, 1980).

4. The general summary of biblical views that follows is based on Maclean's discussion, Joan Ferrante's chapter "Biblical Exegesis" in her book *Woman as Image in Medieval Literature* (New York, 1975), pp. 17–35, and Vern Bullough's "Medieval Medical and Scientific Views of Women," in *Five Papers on Marriage in the Middle Ages, Viator* 4 (1973): 485–501.

5. George H. Tavard, *Woman in Christian Tradition* (Notre Dame, 1973), p. 115. See also Rosemary Radford Ruether, "Misogynism and Virginal Feminism in the Fathers of the Church," and Eleanor Commo McLaughlin, "Equality of Souls, Inequality of Sexes: Woman in Medieval Theology," in Osborne, *Woman,* pp. 62–66 and 76–87.

woman the *anima* (fem.), the lower sensible soul."[6] As commentary developed, women came also to be correlated not only with matter in general but specifically with sense perception. To Philo, for example, because woman was matter and man spirit, the female soul was shaped not by her reasoning ability but by her sense perception.[7] This association with sense perception is crucial to the emphasis found in many female saints' lives on sensuality, a sensuality that is explored in *The Life of Saint Margaret,* especially through concrete imagery.

It can be argued, and often was, that women transcend their sensual natures through virginity. Some biblical commentators, including Jerome, lauded virginity as a state that allowed women virtually to alter their gender—that is, as Jerome writes, "if she wishes to serve Christ more than the world, then she will cease to be a woman and will be called man."[8] To many commentators, "Progress meant giving up the female gender, that is, the passive corporeal and sense perceptive, for the male gender that is the active incorporeal and rational thought."[9] While this masculinization of the female saint does appear from time to time, in *The Life of Saint Margaret* and in many other saints' lives of the period the emphasis on virginity and the physical in general suggests something rather different: female saints, because of their essentially Aristotelian soul, were perceived as incapable of the transcendence available to men.

Because the transcendence of the flesh is virtually impossible for women, female saints' lives tend to make issues of the body of primary significance in their accounts of the saint's trials. It is certainly significant that most female saints' lives place at the center of their work the female saint's temptation to lose her virginity. An exception, perhaps, is Aelfric's *Lives of the Saints,* where male and female saints are treated in the same way: that is, they are used for their historical importance as figures who represent salvation history as it is manifested in England. To my knowledge, however, in most other English saints' lives, where

6. Ferrante, *Woman as Image,* p. 17.

7. See Tavard's comments on Philo, in *Woman in Christian Tradition,* p. 62, Bullough's comments on Philo, in "Medieval Medical and Scientific Views," p. 497, and Maclean's more general discussion of woman's essential sensuality, in *Renaissance Notion,* pp. 16–17.

8. Quoted in Marina Warner, *Alone of All Her Sex: The Myth and the Cult of the Virgin Mary* (1976; repr., New York, 1983), p. 73, in a chapter that discusses medieval notions of virginity in general, pp. 68–78.

9. Bullough, "Medieval Medical and Scientific Views," p. 487.

sexual temptation may be one temptation for the male saint, it is subordinated to a progressive series of temptations, usually culminating in a temptation to pride. In female saints' lives, on the other hand, sexual temptation is either the sole temptation or the central temptation of the life.

In *The Life of Saint Margaret,* in contrast to Jerome's commentary, the author presents virginity, not as a means to transcend the flesh, but rather as a reflection of the view that her sanctity was intimately connected with her sexual identity. Caroline Bynum suggests that such an emphasis was common in male visions of female sanctity. As she writes, "Male biographers . . . were also far more likely to attribute sexual or bodily temptation to female nature than to male (men's sexual yearnings could always be blamed on the presence of women as temptresses) and to see women struggling unsuccessfully to overcome the flesh."[10] The centrality of sexual temptation in female saints' lives reflects the prevalent view of women as bound by their fundamentally guilty sexual natures. Unlike men, who can climb an allegorical ladder to God and who thereby transcend the body, women remain rooted in their bodies. Though women and men share a common experience of the temptation of the world, the flesh, and the devil, a woman's experience of the temptation of the world and the devil is conditioned by her continual experience of the temptation of the flesh.

Physicality is not only a woman's problem, however; it is also her solution. Physical suffering was the primary corrective to female sexual temptation. Marina Warner points out that an emphasis on torture is common in female saints' lives, arguing, "the particular focus on women's torn and broken flesh reveals the psychological obsession of the religion with sexual sin."[11] Bynum also indirectly notes the particular concern of female saints' lives with a woman's endurance of suffering, pointing out, "both men and women saw female saints as models of suffering and inner spirituality, male saints as models of action."[12] As we shall see, throughout *The Life of Saint Margaret,* the saint overcomes her inherent feminine fleshly weakness through the twin processes of physical identification with Christ's suffering and the endurance of extreme physical torture.

Having considered these general points about female sanctity, let us

10. Caroline Walker Bynum, *Holy Feast and Holy Fast: The Religious Significance of Food to Medieval Women* (Berkeley and Los Angeles, 1987), p. 29.
11. Warner, *Alone,* p. 71.
12. Bynum, *Holy Feast,* p. 25.

now turn to the specific life in question, *The Life of Saint Margaret,* to consider the ways in which it elucidates a corporeal notion of female sanctity. That the author of the *Ancrene Wisse,* a guide for women, believed that women could learn to deal with sexual temptation by following the model of Saint Margaret is suggested by the fact that the author recommends to his anchoresses, in a passage that addresses the particular problem of the temptation of the flesh, "ower englische boc of seinte Margarete [our English book of St. Margaret]."[13] *Hali Meidenhad,* a work on female virginity, advises its readers to "Pench o Seinte Katerine, o Seinte Margarete, Seinte Enneis, Seinte Iuliene, [Seinte Lucie], ant Seinte Cecille [think of Saint Katherine, Saint Margaret, Saint Agnes, Saint Juliana, Saint Lucy, and Saint Cecilia]."[14] Margaret's life itself proclaims that it is specifically addressed to women. The author opens his life, "Hercneð, alle þe earen ant herunge habbeð: widewen wið þa iweddede, ant te meidnes nomeliche [Hearken all you who have hearing and ears, widows and the married, and especially maidens]."[15] Later, Margaret asks God if she may overcome the devil specifically so the faith of women will be confirmed: "cuð þi mahte on me . . . þet ich him overcume mahe, swa þet alle meidnes eaver mare þurh me þe mare trusten on þe [Instill your might in me so that I may overcome him so that all maidens evermore because of me will trust in you the more]" (p. 16). The work's specific address to women suggests that the corporeal model of sanctity it provides was considered to be particularly appropriate for women.

It is my contention that in the Middle English *Life of Saint Margaret,* the figure of Margaret incorporates—quite literally—the contemporary view that a woman's relationship to God can be realized only through the body. Although the life opens conventionally by praising the martyrs who, after Christ's resurrection, overcame three foes, "þe veont,

13. J. R. R. Tolkien, *The Ancrene Wisse, Corpus Christi College MS 402,* Early English Text Society (EETS), 249 (London, 1962), p. 125. The translation is my own.

14. Bella Millett, ed., *Hali Meidhad,* EETS, 284 (Oxford, 1982), p. 23. The translation is my own.

15. Francis Mack, ed. *Seinte Marharete þc Meiden ant Martyr,* EETS, 193 (1934; repr., London 1958), p. 4. Mack's edition includes an edition of Ms. Bodley 34 and, on the facing page, an edition of Ms. Royal Axxvii. At the end of these editions are notes and a glossary, followed by a Latin version of the Life of Saint Margaret. All further references to the English Life will be taken from Mack's edition of Ms. Bodley 34 and page numbers will be cited in parentheses within the body of the text. All references to the Latin version will also be taken from Mack, and page numbers will be cited in parentheses within the body of the text. I have also substituted "ant" for the author's rendition of the tironian ampersand.

ant teos wake worlt, ant hare licomes lustes [the fiend, the wicked world and the lust of the body]" (p. 2), as the life develops the temptations of the flesh thematically take precedence over the other two. The author's alterations of the Latin version in which he expands and emphasizes physical suffering suggest that the Middle English version's emphasis on and exploration of the temptation of the flesh was deliberate.

That the fiend tempts women primarily through the flesh is stressed by the Middle English version's emphasis, not prominent in the Latin original, on the lust of Margaret's tormentor, Olibrius. Olibrius, is particularly attracted to Margaret's body which "schimede ant schan al of wlite ant of westume [shimmered and shone in face and form]" (p. 6). Because of her beauty alone, he tempts her with worldly goods: "hire wule freohin wið gersum ant wið golde, ant wel schal hire iwurðen for hire lufsume leor [he wishes to liberate her with treasure and gold and good shall come to her because of her lovely face]" (p. 6). When Margaret refuses to submit to Olibrius, he urges her to consider her threatened beauty, "nim ȝeme of þi ȝuheþe ant of þi semliche schape [take heed of your youth and your seemly shape]" (p. 10) and emphasizes the physical suffering she will undergo if she refuses to submit in a passage that threatens a sexually suggestive physical torture in response to her verbal resistance: "bute ȝif þu swike ham, mi swerd schal forswelten ant forswolhen þi flesc, ant þerefter þine ban schulen beon forbernde o berninde gleden" [unless you cease them (words of refusal) my sword shall destroy and devour thy flesh and afterwards your bones shall be burned with burning coals]" (pp. 10, 12).

Margaret herself fears her vulnerability to the lust of others. Yet in this life, lust is specifically overcome by her alliance with Christ; indeed, it is suggested that, rather than overcome lust, the female saint turns away from it because of the strength of a prior *bodily,* as well as spiritual commitment, to Christ. She prays to Christ that her body not be fouled, especially by the sin of lust. She asks Christ, "biwite mi bodi, þet is al bitaht to þe, from ulche fulþen; þet neaver mi sawle ne isuled beo in sunne, þurh þet licomes lust [protect my body, *that is completely committed to you,* from all defilements so that my soul never be soiled in sin because of the body's lust]" (p. 6; my emphasis). Margaret calls on Christ and his angels for aid in resisting sexual assaults, and specifically requests aid in maintaining her virginity: "Send mi þi sonde i culurene heowe, þe cume me to helpe, þet ich mi meiðhad mote wite to þe unwemmet; ant lef me ȝet i-seon, lauerd, ȝef þi wil is, þe awariede

wiht þe weorreð aзein me [Send me your messenger in the appearance of a dove who will come to me to *help me keep my maidenhood for you unspotted* and allow me to see, if that is your will, the accursed being who wars against me]" (p. 16; my emphasis). Thus, the work stresses the centrality of sexual temptation for women and offers a solution to that temptation in betrothal to Christ. The problem of the Aristotelian feminine nature, which is conditioned by desire for a male mate, is here answered by a transfer of that inherent and inescapable feminine characteristic to a desire for Christ.

The work's concern with the problem of the physicality of the saint is emphasized further by the fact that Margaret's own weakness and the weakness of sinners are cast in especially physical terms. She comments on the weak flesh of those who are born of sin and the physical suffering of birth. She describes the wicked as "al blodi biblodeget of sunne [completely bloody and made bloody by sin]" (p. 6). Here sinfulness is associated with birth, whose blood and pain are the result of femininity according to the gender-specific punishment of Eve. Further, she describes herself as "lomb wið wedde wulves, ant ase þe fuhel þe is ivon in þes fuheleres grune, ase fisc a-hon on hoke, ase ra inumen i nette [as a lamb among mad wolves, as a bird in the fowler's snare, as a fish hung on a hook, as a roe caught in a net]" (p. 8). These images both reinforce a woman's sense of her own physical vulnerability and reflect the history of female victimization.

The centrality of sexual temptation in the female saint's experience is further reinforced in Margaret's encounter with the devil, where we learn from the author's addition to the Latin original that the primary focus of the devil is to overcome a woman's resistance to sexual temptation. The Latin version says simply: "Ego enim pugno cum iustis, incendens renes eorum, et obceco sensus et oculos eorum, et facio eos oblivisci sapientiam celestem. Et cum dormierint, venio et excito eos a somno. . . . Quos vero movere de somno non potuero, facio eos somno peccare [For I fight against the just, enkindling their innards and blinding their senses and eyes, and I make them forget the wisdom of heaven. And when they are sleeping, I come and excite them from sleep . . . those indeed who I am not able to move from sleep, I make them sin in sleep]" (p. 136). The English version expands this passage and adds a hypothetical case of a pure man and a pure woman meeting. The subsequent description of the stages of temptation the couple will undergo in following the three stages of sin described by Saint Augustine, *suggestio* (suggestion), *delectatio* (delectation), and *consentio*

(consent), highlights the work's interest in sexual temptation. In a psychologically realistic passage, the devil explains that he leaves this couple alone so that they feel secure, and then, as he explains, "Ich leote ham talkin of Godd ant tevelin of godlec,... þet eiðer of his ahne, ant of þe oðres ba, treoweliche beo trusti, ant te sikerure... þenne ... ich... scheote swiðe dearnliche ant wundi,... hare unwarre heorte [I leave them talking of God and arguing about goodness... so that each of himself and of the other becomes trusting and secure... then ... I... shoot quickly and secretly and wound... their unwary hearts]" (p. 32).

Appropriate to the overall theme of the work, the devil particularly tempts through the body, that is, through lust. He desires to "in ham sparken of lustes se luðere, þet ha forberneð inwið ant þurh þet brune ablindeð... hare heorte mealteð þurh þe heate [spark in them lusts so fierce that they burn inwardly and are blinded through that burning ... their hearts melt through that heat]" (p. 36).[16] He leads the maiden "lutlen ant lutlen into se deope dunge þet ha druncnið [little by little into the deep dung in which they are swallowed up]" (p. 36). Finally, she "falleð, fule ant fenniliche i flescliche fulðen; ant for a lust þet alið in an hondwhile, leoseð ba þe luve of Godd ant te worldes wurdschipe [falls foully and filthily into fleshly filth and for the lust that perishes in a moment, loses both the love of God and the worship of the world]" (p. 36). Although both the man and the woman are subject to sexual sin in these passages, the author's association of the concrete images of flesh, filth, and dung with the woman's fall alone reinforces his negative picture of female sexuality.

The idea that a woman's temptation is in the main realized corporeally is again conveyed by the description of the other devil she confronts, one who appears in the form of a dragon. The English author's representation of the dragon is significant both for the density of its detail and for the emphasis of these details on the sensual and quotidian. The Latin version says:

Et ecce subito draco exivit de angulo carceris, totus horribilis, variis coloribus, deauratis capillis, et barba aurea, et ferrei dentes; et oculi eius splendebant sicut margarite, et de naribus eius ignis et fumus exiebat, et lingua eius ignem anhelabat, et fetorem faciebat in carcere; et erexit

16. In female mystical visions, as has been pointed out by Simone de Beauvoir and Luce Irigaray, such burning is a characteristic image of the mystic's union with Christ.

se in medio carceris, et fortiter sibillavit, et lumen factum est in carcere ab igne qui exiebat de ore draconis. (p. 133)

[And behold at once a dragon came out of a corner of the prison, completely horrible, of various colors, with gold hair and a gold beard, and with teeth of iron, and his eyes were shining like pearls, and from his nostrils came fumes and fire and his tongue exhaled fire, and he made a stench, and light shone in the prison, and he raised himself in the middle of the prison and hissed loudly, and the prison was lit up with the light which came out of the mouth of the dragon.]

The English version is considerably longer:

Com ut of an hurne hihendliche towart hire an unwiht of helle on ane drakes liche, se grislich þet ham gras wið þet sehen: þet unselhðe glistinde as þah he al overguld were. His lockes ant his longe berd blikeden al of golde, ant his grisliche teð semden of swart irn. His twa ehnen steareden steappre þen þe steoren ant ten ӡimstanes, brade ase bascins, in his ihurnde heaved on eiðer half of his heh hokede nease. Of his speatewile muð sperclede fur ut, ant of his nease þurles þreste smorðrinde smoke, smecche forcuðest; ant lahte ut his tunge, se long þet he swong hire abuten his swire; ant semde as þah a scharp sweord of his muð scheate, þe glistnede ase gleam deð ant leitede al o leie; ant al warð þet stude ful of strong ant of stearc stench, ant of þes schucke schadewe schimmede ant schan al. He strahte him ant sturede toward tis meoke meiden, ant geapede wið his genow up-on hire ungeinliche, ant bigon to crahien ant crenge wið swire, as þe þe hire walde forswolhe mid alle. (Pp. 20,22)

[There came out of a corner hastening toward her a devil of hell in the likeness of a dragon so grisly that she was terrified of the sight: that evil creature glistened as though he were covered with gold. His locks and his terrible teeth seemed made of black iron. His two eyes stared brighter than the stars and ten gemstones and were as broad as washbasins, in his horned head on either side of his high hooked nose. Fire sparkled out of his horrible mouth and out of his nostrils issued smothering smoke most hateful; and his tongue darted out so long that he swung it about his neck; and it seemed as if a sharp sword shot out of his mouth, glistening as a gleam and setting everything aflame; and the place became filled with a strong stench and from the devil's shadow everything glittered and shone. He made his way toward her, and moved toward the meek maiden. He gaped with his mouth wide open toward her threateningly and began to stretch his neck and draw it in against the neck (gulping) as if he would swallow her whole.]

The dragon of the Latin version is colorful and resplendent with jewels and gold. The English dragon, though still wondrous, is much more threatening, described with many more concrete adjectives such as

"grislich" and "swart," which, set against the jewels and gold, make the portrait more immediate. The dragon is more directly threatening to the maiden: in the Latin version, the dragon simply raises himself, whereas in the English version, the dragon is clearly interested in Margaret as a victim. The accumulation of adjectives combined with the addition of sexually menacing hyperbolic comparisons, such as the comparison of his tongue to a sword, not only make the passage more vivid but also place the dragon firmly within the physical world. The additions to the English version intensify the physical horror of the dragon, and thus the description emphasizes the main theme of the saint's life, the female saint's necessary battle with the physical world.

Although a figure of wonder, this English dragon also evokes the everyday world of the female contemplatives for whom this work was written. His eyes, which are compared to the quotidian "basins," remind the reader that such a creature may be found even in the most domestic of settings. Typical of a number of female saints' lives of the period, this work exploits both the literal and metaphorical meaning of the devil: the devil may appear as a peculiarly thirteenth-century dragon, or it may appear in disguise hidden in the basins, the site of routine tasks most probably often resented by a female contemplative. This image further implies a woman's inability to subordinate her moment-to-moment reactions as she engages in the physical tasks of her day to larger, abstract spiritual goals.

In the face of a visible physical threat, God may seem remote, but Margaret wisely recognizes God's presence in the physical world. Even her understanding of God is cast in physical terms. She reminds the reader that God controls all animals, "þe fisches" and "þe flihinde fuheles" ("the fish" and "the flying fowl") as well as all natural processes, "þe sunne . . . "þe mone ant te steorren . . . "þe sea strem, . . . þe windes, þe wederes, þe wudes ant te weattres" ("the sun, . . . the moon and the stars, . . . the seas, the winds, the weather, the woods and the waters") (p. 22). While the celebration of God's presence in the physical world was, by the thirteenth century, almost a commonplace due to the influence of the Chartrians and Victorines, Margaret's emphasis on God's physical immanence, here added to the Latin original, emphasizes the author's concern to elucidate the female saint's relationship to the physical world.

The fact that the dragon swallows Margaret is also central to the author's concept of female sanctity. This event literalizes the saint's

conquest of the flesh. Margaret's success against the dragon is a triumph against the physical world achieved through a complete experience of the physical. The rood saves Margaret and she bursts from the belly of the dragon unharmed. Thus the rood, or Christ, can save the female contemplative from the most intimate contact with the corporeal world. In addition, this image feminizes Christ's temptations in the desert by transforming the central confrontation into an image of birth; a woman could be said here to give birth to her own spirituality in this male appropriation and transformation of an image of childbirth.

Furthermore, a woman's dependence on Christ affords her specifically physical powers. Through physical strength combined with the power of prayer, which weakens her opponent, Margaret overcomes a second devil: "þet milde meiden Margaret grap þet grisliche þing þet hire ne agras nawiht, ant hetevest toc him bi þet eateliche top ant hef him up ant duste him dunriht to þer eorðe, ant sette hir riht-fot on his ruhe swire [the mild maiden Margaret seized the grisly being which did not terrify her at all and securely took him by the horrible hair of his head and raised him up and dashed him down to the earth and set her right foot on his rough neck]" (p. 28). The physical power she finds through dependence on Christ has sufficient strength to blind the devil. The devil says: "Me þuncheð þet tu schinest schenre þen þe sunne, ah over alle þine limen, þe leitið of leome. Þe fingers se freoliche me þuncheð, ant se freoliche feire ant se briht blikinde, þet tu þe wið blescedest ant makedest te merke of þe mihti rode þe reavede me mi broðer, ant me wið bale bondes bitterliche bindest; þet ich lokin ne mei, swa þet liht leomeð ant leiteð, me þuncheð [it seems to me that you shine brighter than the sun over all your limbs which alight your fingers with light so excellently it seems to me, so excellently fair and so brightly shining with which you made the sign of the mighty cross which took my brother away from me and which binds me with sorrowful and bitter bonds that I may not look at that light which shines and gleams]" (p. 30). Even a woman's salvation is cast in physical terms.

Yet despite the physical power women can exhibit, they remain nonetheless fundamentally weak. The devil says that he is particularly anguished that he has been overcome by a maiden. He laments, "alre wundre meast, þet tu þe ane havest overgan . . . wake beo we nu ant noht wurð mid alle, hwen a meiden ure muchele overgart þus avealleð [the greatest wonder of all is that you alone have overcome us . . . weak are we now and not worth anything when a maiden can cast down

our great arrogance]" (p. 36). Some might suggest that Margaret's display of strength, as well as the devil's recognition of that power, here reverses the accepted gender roles. The devil's comment does not dispel the view that women are by nature weak, however, for it is not that he has misperceived women's strength, but only that his own strength is that much the weaker if he can be overcome by a woman. Further, he adds that devils choose to war against maidens above all because "Iesu Crist, godes bern, wes of meiden iboren; ant þurh þe mihte of meiðhad wes moncun iborhen; binumen ant bireavet us of al þet we ahten [Jesus Christ, God's son, was born of a maiden and through the might of maidenhood was mankind redeemed and was taken away from us and bereft of all that we were owed]" (p. 38), a passage that again reinforces women's essential corporeality, for even Mary is praised primarily for her physical power in bearing Christ.

Margaret triumphs over the flesh not only through this dramatic physical encounter but also by enduring extreme physical torture. She herself views physical suffering as the corrective to the temptations of Olibrius. She says, "Hwen mi sawle bið bivoren godes sihðe in heovene, lutel me is hwet me do mid mi bodi on eorðe. . . . for ȝef ich wrahte þe wil of þe flesc þet tu fearest as þu wilt wið, mi sawle schulde sinken. . . . to sorhen in helle [When my soul is before God's sight in heaven little will I care what was done to my body on earth; . . . if I wrought the will of the flesh, with which you do what you wish, my soul would sink to the torments of hell]" (p. 18). The Middle English author emphasizes the redemption found through physical torture by expanding the details of her torture found in the Latin original. Her tormentors "beteð hire bere bodi wið bittere besmen . . . leiden se luðerliche on hire leofliche lich, þet hit brec overal ant liðerede o blode [beat her bare body with cruel rods, labored so fiercely that her lovely body broke all over and lathered with blood]" (p. 12). Those witnessing the event pity her willingness to lose her beauty: "Wa is us þet we seoð þi softe leofliche lich to-luken se ladliche! . . . hwuch wlite þu leosest ant forletest for þi misbileave [Woe are we that we see your soft lovely body torn apart so cruelly. . . . What beauty you lose and give up because of your misbelief]" (p. 14). The additions of adjectives such as "softe" and "leofliche" in these passages associate a woman's sexual attractiveness with male need to abuse that beauty. Margaret asks for help only to overcome her physical suffering: "Softe me mi sar swa, ant salve mine wunden, þet hit ne seme nowher, ne suteli o mi samblant, þet ich derf drehe [alleviate my pain and salve my wounds so that it

will nowhere appear in my appearance that I suffer grievously]" (p. 14), a passage that is odd for its assumption that a woman would be most concerned with her appearance. She asserts, however, that suffering will guarantee her salvation: "ȝef mi lich is toloken, mi sawle schal resten wið þe rihtwise: sorhe ant licomes sar is sawulene heale [if my body is torn apart, my soul shall rest with the righteous: pain and bodily wounds are the salvation of the soul]" (p. 14).

The work's obsessive interest in the physical torture of the female saint may reflect medieval notions of female physiology. Because women were perceived to be rooted in a body defined as containing excess fluid that had to be purged, the male author can be seen to have emphasized those aspects of female physiology in his account of female spirituality: the lathering blood can be seen as a woman's purging of her impure moisture.[17] The author's interest in blood may be linked further to his focus on female sexual temptation. His interest is not only gendered but also explicitly sexual, if not sexually perverse.

Another aspect of female sanctity emphasized in this work is the female saint's identification of her own suffering with Christ's own experience of physical torture. The above images often occur in descriptions of Christ's suffering, and in this work references to Christ emphasize the physical suffering he endured for humankind. For example, Olibrius is perplexed that Margaret could love one who suffered so much, who "reufulliche deide ant reuliche on rode [pitiably died and miserably on the rood]" (p. 8). She is willing to suffer extreme torments, even death, because of the suffering Christ endured for her: "Drihten deide for us, þe deorwurðe lauerd, ant ne drede ich na deð for to drehen for him [The Lord died for us, the dear lord, and I fear no death to suffer for him]" (p. 12). Notice how her attachment to her lover is associated with physical torment in the alliteration of "deorewurðe," "deð," and "drehen." Yet even her apprehension of Christ is realized physically; though she dwells on his past physical suffering, she also emphasizes his present physical appeal: "He is leoflukest to lokin upon ant swotest to smellen [he is loveliest to look upon and sweetest to smell]" (p. 10).

In these passages, the saint merges with Christ, whose physical suffering mirrors her own condition in society as an inherently incomplete

17. For accounts of medieval concepts of female physiology, see Maclean, *Renaissance Notion*, and Thomas Laqueur, "Orgasm, Generation, and the Politics of Reproductive Biology," *Representations* 14 (Spring 1986): 1–41.

or "wounded" man. Luce Irigaray has written about the appropriate-
ness of Christ as a meditative figure for women, for Christ shares
assumed feminine qualities of passivity and vulnerability.[18] Irigaray
argues further that Christ's wounds reflect the vagina, perceived by some
as a wound. By identifying with Christ, a woman can, like Christ,
overcome this wound. It may be argued that the association of Christ's
wounds with the vagina is a Freudian anachronism. There is little
evidence about how female genitalia were perceived in the Middle Ages.
Although we may not be able to say that women perceived themselves
as wounded because of their femininity, it can be said nonetheless that
there was a late medieval tradition that associated the wounds of Christ
with the female pudenda. As Wolfgang Riehle points out,

> Since the wound in Christ's side is given a new interpretation as an
> opening through which it is possible for the mystical lover to enter into
> his beloved and thus become completely one with him, this gives rise
> in Franciscan mysticism, especially in such an eroticized text as the
> *Stimulis Amoris,* to a typical and quite consciously intended analogy
> between this wound of Christ and the female pudenda: the *vulva,* as the
> place of sexual ecstasy, has, so to speak, been transformed into the *vulnus*
> of Christ as the place of mystical ecstatic union of the soul with its divine
> beloved. This is confirmed by the following statement of the Monk of
> Farne whose fourteenth century text represents the climax of Franciscan
> mysticism of the cross on English soil: "latus meum aperio ut osculatum
> introducam ad cor meum, et simus duo in carne una."[19]

The precise ways in which a female mystic might respond to such
an association have yet to be investigated in medieval works, yet in
this work we at least can say that women were assumed to identify
with Christ and that identification is reinforced by the prominence of
images of blood and suffering in the saint's life. If women perceived
the wound in Christ's side as analogous to their own vaginas in the
way that the Monk of Farne did, then meditation on that wound had
special resonance for the female observer. Whether or not such med-
itation and identification is redemptive for the female contemplative
remains problematic. While Irigaray suggests that hyperbolic images
of blood and suffering ultimately redeem women by celebrating aspects
of the female body—a view enhanced by Bynum's recent work on
female spirituality, *Holy Feast*—in the case of this saint's life, the focus

18. See Luce Irigaray, "La mystérique," in *Speculum de l'autre femme* (Paris, 1974),
pp. 238–52.
19. Wolfgang Riehle, *The Middle English Mystics* (London, 1981), pp. 46–47.

on female blood seems to reflect a male fascination with and horror of female blood. Christ's suffering can, as Bynum has argued, to some extent suggest a valorization of a woman's essential femininity. Bynum's most recent work on the resurrection of the body suggests further that medieval notions of the body whether male or female may be less disdainful of the body than we suppose, an argument that further supports the possibility that a woman's body might have been viewed positively.[20] Yet, the fact that the resurrected body does not bleed suggests to me that the emission of fluids, a quality particularly associated with women, is a negative quality even in heaven. Thus, the resurrected body seems to possess those attributes of completion, perfection, and freedom from excess fluid associated in medieval Aristotelian physiology with the male. The relationship of medieval notions of the body to gender issues remains to be investigated. At the very least, it is important to take note of the fact that this Middle English author (and for that matter, Irigaray as well) assumes a woman's identification with weakness, inferiority, and dependence. The feminine power celebrated in this work is therefore double edged; though it offers women an avenue of identification less fully available to men, that power is also limited only to that physical sphere of identification.

Part of a female saint's experience is a mirroring of Christ. Another equally significant aspect of female sanctity is that the female saint is presented as depending on Christ as a literal lover. Margaret is presented as the beloved of Christ who at her death says, echoing the Song of Songs, "Cum, leof, to þi lif, for ich copni þi cume [Come beloved, to your life, for I wait longingly for your arrival]" (p. 48). Critics have noted the addition to this work of lyrical phrases that alliterate such words as life, lord, and lover and that celebrate the virgin's betrothal to Christ. They have argued, however, that these additions are simple adoptions of passages from Saint Bernard and assume that they are gender neutral. As John Bugge has noted, however, these phrases reflect a significantly different view of female spirituality in which the *sponsa christi* motif is literalized for women.[21] The occurrence of the *sponsa christi* motif is important, not only because it defines a woman's relationship to Christ as emotional—a relationship

20. Caroline Walker Bynum, "The Theology of the Resurrection and Bodily Miracles in the Thirteenth Century" (Plenary address at the Twenty-third International Congress on Medieval Studies, Kalamazoo, Mich., May 7, 1988).
21. See John Bugge, *Virginitas: An Essay in the History of a Medieval Ideal*, Archives Internationales d'Histoire des Idées, Series Minor 17 (The Hague, 1975).

to some extent available to the male contemplative—but also because Christ is presented as the solution to sexual temptation, a level of interpretation not available to men. That is, a female saint can transcend sexual temptation by transferring her physical desires to a more suitable object, Christ. Simone de Beauvoir has discussed the particular suitability of Christian mysticism for women: "Love has been assigned to woman as her supreme vocation, and when she directs it toward a man, she is seeking God in him; but if human love is denied her by circumstances...she may choose to adore divinity in the person of God himself."[22] Although secular love, as de Beauvoir conceives of it, was not so clearly a central preoccupation of women in the Middle Ages, the centrality of a literalized *sponsa christ* motif in the saints' lives reveals that a woman's romantic relationship to Christ was fundamental to her experience of Christianity. The relationship between Christ and the virgin posited in Margaret's life allows a woman both to identify with Christ and to replace the men, on whom she has a perceived necessary attachment and dependence, with a more appropriate paternal figure.

The female saint is defined not only by her romantic dependence on Christ but also by her dependence on others in general. To use Carol Gilligan's terms, the male writer assumes that a woman's place in the religious life is fundamentally relational rather than hierarchical; that is, the female saint is defined first and foremost through her relationships to others rather than through her commitment to abstract ideals.[23] *The Life of Saint Margaret* therefore includes passages that illustrate the female saint's anxiety about her isolation from family and friends. In the Latin version, for example, the saint calls Christ "spes desperatorum, pater orfanorum, et iudex verus [hope of the desperate, father of orphans, and true judge]" (p. 133). The English version personalizes these abstract attributes, heightening the pathos of the virgin's sense of isolation and enhancing the especially emotional comfort Christ provides. Margaret laments, "Min ahne flesliche feader dude ant draf me awei, his anlepi dohter, ant mine freond aren me, for þi luve lauerd, famen ant feondes; ah þe ich halde, healent, ba for feader ant for

22. See Simone de Beauvoir, "La mystique," in *Le deuxième sexe* (Paris, 1949), p. 508. I have followed the translation of H. M. Parshley, *The Second Sex* (New York, 1952), p. 630.
23. See Carol Gilligan, *In a Different Voice: Psychological Theory and Woman's Development* (Cambridge, Mass., 1982).

freond;" and comments, "Þu art foster ant feader to helplese children. Þu art weddede weole, ant widewene warant, and meidenes mede. [my own fleshly father drove me away, his own daughter, and my friends are foes and fiends to me, but I have you Saviour, as both father and friend."] (p. 18) ["You are foster parent and father to helpless children. You are the joy of the wedded, protector of the widowed, and maiden's reward]" (p. 18). The saint's fundamentally feminine dependence on others is resolved through her relationship to Christ, who acts for her as father, mother, friend, and lover.

In keeping with the overall theme of the work—physical suffering— Margaret's life ends with her prayers for women in childbirth. In a long passage on childbirth added to the Latin version, Margaret comments on the physical suffering not only of women in childbirth, but also of the newborn: "i þet hus þer wummon pineð o childe, sone se ha munneð þi nome ant mi pine, lauerd; lauerd, hihendliche help hire ant her hire bene; ne i þe hus ne beo iboren na mislimet bearn, nowðer halt ne hoveret, nowðer dumbe ne deaf ne idervet of deofle [In that house where women suffer in childbirth as soon as they remember your name or my passion, Lord, Lord quickly help them and hear their prayers; let there be born in that house neither a deformed child, nor lame, nor hump-backed, nor dumb, nor deaf, nor injured by the devil]" (pp. 46, 48). It may seem odd that a chaste saint should be the patron saint of childbirth, but given this life's exploration of the particularly physical aspects of female spirituality, such a link is quite appropriate.

The Life of Saint Margaret provides the reader with a model of a woman successful in her battle against the temptation of the flesh, a model that has meaning for any contemplative, but one that has particular significance for a woman. Central to the conception of sanctity presented in this work is an assumption that a woman's essentially corporeal nature determines both the nature of her confrontation with temptation and her salvation. In some other female saints' lives, such as those of Katherine or Cecelia, it is the intellectual powers of female sanctity that seem to be praised, which may serve to complicate the picture of female sanctity here outlined. But even these women ultimately achieve sanctity through their bodies by transferring desire to Christ. In a recent review of Caroline Bynum's book *Holy Feast*, Maurice Keen argues that "she makes too much of the vocabulary of female mysticism and too little of a general as opposed to a specifically female concern with mystical union with Christ that is characteristic of late

medieval religion."[24] Such a comment underestimates the force of By-
num's overwhelming body of evidence that illustrates specifically fem-
inine developments in medieval spirituality. The exact relationship of
those feminine developments to the use of the feminine in male spir-
ituality still needs to be explored. Most studies of medieval mysticism
make the mistake of minimizing gender distinctions in spiritual de-
velopments in favor of celebrating the apparently gender-neutral emo-
tional fervor of the twelfth-century affective movement. Such studies
lead to an undervaluation of works like *The Life of Saint Margaret,* in
which the strengths and distinctiveness of the work lie in its focused
feminine concerns.

In addition, the preponderance of the concrete images we have dis-
cussed in this work suggests that the author assumes that they carry a
theoretical meaning. Underlying his use of concrete images seems to
be an assumption that because women are trapped in the senses, con-
crete images that evoke sensory response are the appropriate means to
convey religious ideals. The imagery, as we have seen, is of two different
kinds. On the one hand, we see excessive images of blood and torture,
such as the lathering blood of the tortured saint's body; and on the
other we see quotidian images such as the washbasin eyes of the dragon.
These images seem to pull in opposite directions. One set of images
pushes towards the surreal (that is, hyperbolic images of blood that
are outside of a context of time and place) and the other to what might
be called the hyperreal (the washbasin eyes: a very identifiable domestic
object rooted in time and place, yet startling because of its unusual
context—the washbasin eyes are a dragon's eyes). The work's emphasis
on the concrete and the quotidian might, of course, be attributed to
causes other than gender concerns. As an English work, the life falls
in line with a tradition of English works that utilize concrete imagery.
Yet although the focus on the concrete may be accounted for by a
number of different causes, the peculiar suitability of concrete imagery
for female readers suggests that the work's emphasis on them is at least
in part due to the perceived nature of its audience. Indeed, I would
argue that both sets of images are linked to the author's assumption
of the essential sensuality of women, a sensuality that underlies the
corporeality of the model of female sanctity provided by the work. All
aspects of the physical model of the work, including its imagery, are
therefore related to each other.

24. *New York Review of Books,* Sept. 1987.

The Life of Saint Margaret thus offers a distinctive paradigm of sanctity for women, which I suspect occurs elsewhere in works designed for women. In contrast to male models of sanctity, where the male saint follows a progressive ascent away from the flesh toward spiritual union with God, in this model, a female saint is inevitably rooted in the body. The desires of the body are both a danger to her and the way in which her relationship to God is defined. A woman's essential sensuality requires that she come to understand God through the physical world, an understanding conveyed in this work through its concrete details, all details that reinforce the association of her female spirituality with sensuality. The wondrous spiritual world must be realized for her through the physical world, through the objects of her daily life that surround her—including even that most domestic of all mundane objects—the washbasin.

Holiness and the Culture of Devotion: Remarks on Some Late Medieval Male Saints

In 1976 W. A. Pantin published a remarkable document from early fifteenth-century England under the title "Instructions for a Devout and Literate Layman."[1] A spiritual counselor, possibly a monk, wrote these instructions in Latin on a long, narrow parchment strip as a guide for the daily life of his disciple. The first sentence, "Always carry this about in your purse," sets the tone for what follows: "Remember to take holy water every day. You should get up out of bed with all swiftness. Make the sign of the cross at the head, at the feet, at the hands, and at the side. [Recall the story of] Saint Godric, who did not at once sign himself." As the devout follower of these instructions walks out his door en route to daily mass, he should say to himself with tears and groaning: "All the men of this city . . . from the greater to the less are pleasing to God, and only I am worthy of hell. Woe is me. Welawey." Along his way he should repeat the interjection, "Thou who hast made me, have mercy upon us and upon me." If he meets a dog or other animal he should express himself with chilling sincerity, saying: "Lord, let it bite me, let it kill me; this beast is much better than I; it has never sinned. I after so much grace have provoked you; I have turned my back to you and not my face, and I have done nothing good, but all ill. Woe is me. Welaway." Once at church he should say the matins of the Virgin, reverently. He should not talk during mass,

1. In J. J. G. Alexander and M. T. Gibson, eds., *Medieval Learning and Literature: Essays Presented to Richard William Hunt* (Oxford, 1976), pp. 398–400.

but should follow along in some devotional mass book. He should not go up to the altar but should cower in a side chapel. When others have left church he should stay and say the rosary. On his way home he should repeat the Angelic Salutation.

Further instructions guide this devout layman through his day. His meals should be accompanied by devout reading, to prevent vain or harmful speech. Like a Puritan, he may never amuse himself with dancing, buckler playing, dicing, or wrestling. Unlike a Puritan, however, he lives in a world rich with symbolic devotions. "You can make a cross on the table out of five bread-crumbs," the counselor tells his disciple, "but do not let anyone see this, except your wife; and the more silent and virtuous she is, the more heartily you should love her in Christ."[2] At set times he should withdraw to his private chamber or "cell" for pious conversation or prayer. During the summer he may take one or two drinks. The last words of this sober plan for a devout life lead from the present into eternity: "When you are in bed, go back to the beginning of the day, and look diligently into your heart: [see] if you have done any evil, and there be sorry; [see] if [you have done] any good, and there give thanks to God, always in fear and trembling, and do not think it certain that you will survive till the morrow."

We know little about the owner of this scroll. He may have belonged to the Throckmorton family, retainers to the earl of Warwick. He may have spent much of his time in London. We know nothing about how closely he followed all this counsel. One of the few things we know for sure is that he was not a canonized saint. But if the small corps of saints and *beati* formed the widely visible apex for a pyramid of sanctity, the broad base of that pyramid was composed of devout religious and laity such as this scroll envisages. The base itself may have been broader in the late Middle Ages than in earlier periods. Thanks to the spread of literacy, it is marginally more visible: if we cannot see the devout themselves, we can at least see the folios and the parchment strips that they fingered in their devotions. For the same reason, their piety was more complex: it brought them into contact with a long tradition of spiritual culture, which would have been less accessible to the unlettered. Recent studies have begun to uncover the richness of this piety, which was broadly shared between religious and layfolk, and which

2. Compare Henry Suso, *The Life of the Servant*, trans. James M. Clark (London, 1952), pp. 32–33.

was perhaps most elaborate—and at any rate most accessible to research, thanks to the abundance of surviving evidence—in courtly circles.[3]

The more we know about the piety of devout Christians in the late Middle Ages, however, the more difficult it becomes to distinguish them from their sainted contemporaries, or a fortiori from those *beati* whose cult lacked papal confirmation. All these groups shared in what we might call the culture of devotion: a socially defined set of attitudes, expressions, and behaviors that marked the pious individual as a particular kind of person, living in a particular way within the broader society. The psychological and social functions of this culture—like those of the chivalrous or any other culture—would have been various and varying, and the complex of behavior associated with it would also have admitted variations, but within boundaries. Not only the functions but the meanings of this culture could vary: its adherents were bound together in a kind of spiritual coalition, whose diversity was in some measure masked by their use of common language, common symbols, common patterns of conduct. The lowest common denominator was the commitment of self-consciously pious individuals to the habitual exercise of supererogatory exercises. From a social and psychological viewpoint, the supererogatory nature of these works was vital because it set these individuals apart as a subgroup within society while linking their distinctive behavior to a system of values widely shared within the broader society. The notion of supererogation (rooted in the monastic movement of early Christianity) provided religious inspiration and theological validation for a complex of behavior that might otherwise have been merely eccentric. It was this inspiration and validation, more than any particular social or psychological func-

3. See, e.g., Ellen Allard Macek, "Fifteenth-Century Lay Piety," *Fifteenth Century Studies* 1 (1978): 157–83; Hilary M. Carey, "Devout Literate Lay People and the Pursuit of the Mixed Life in Later Medieval England," *Journal of Religious History* 14 (1987): 361–81; Colin Richmond, "Religion and the Fifteenth-Century English Gentleman," in *The Church, Politics, and Patronage in the Fifteenth Century,* ed. Barrie Dobson (Gloucester, 1984), pp. 193–208. Two recent studies of courtly piety are M. A. Hicks, "The Piety of Margaret, Lady Hungerford (d. 1478)," *Journal of Ecclesiastical History* 38 (1987): 19–38; and Malcolm G. Underwood, "Politics and Piety in the Household of Lady Margaret Beaufort," *Journal of Ecclesiastical History* 38 (1987): 39–52. W. M. Ormrod, "The Personal Religion of Edward III," *Speculum* 64 (1989): 849–77, shows how a display of piety might consort with a program of royal propaganda. For a Continental example see Elisabeth Swain, "Faith in the Family: The Practice of Religion by the Gonzaga," *Journal of Family History* 8 (1983): 177–89.

tion, that defined the culture of devotion and made its devotees into a coalition.

The formation and life of this coalition is a broad theme, beyond the scope of the present essay, but it sets the context for the material here examined. The knight or the merchant distinguished for a life of fervent devotion could have been seen as sharing this culture of devotion along with the saintly monk or friar. The sainted and the unsainted alike participated in this culture, and the distinction between them emerged at least in part from circumstances of posthumous veneration rather than from differences in their conduct. If the owner of the parchment strip actually lived the life there outlined, would he not be indistinguishable from many of the figures who crowd the *Acta sanctorum?* Perhaps he lapsed, or grew cool. More probably, he and many like him did in fact closely resemble their more illustrious contemporaries.

One might hazard a generalization: the more we know about late medieval piety, the less distinctive the saints appear. But a vital qualification immediately asserts itself: this may be true of the male saints but not the women. For reasons we cannot and perhaps need not pursue at length, the women who were venerated as saints remain more easily distinguishable from the ordinary run of pious women, mainly by dint of their revelations and their extreme ascetic fervor. We shall return later to some features of women's piety, but for now let us focus on the men. Among the many services that Caroline Bynum and others have done is to make it possible now as never before to study men's religion as men's religion, not as religion *simpliciter*.[4] Let us, for the moment, take up this lead.

Immediately we confront a paradox. In one sense men's piety is easy to study: even in the late Middle Ages the great majority of saints were still male, and one would think the source material would be ample. When we consider the length and character of the sources, however,

4. Caroline Walker Bynum, *Holy Feast and Holy Fast: The Religious Significance of Food to Medieval Women* (Berkeley and Los Angeles, 1987). My own book, *Unquiet Souls: Fourteenth-Century Saints and Their Religious Milieu* (Chicago, 1984), does not focus on gender differences but rather tries to show how the private data of saints' lives (whether male or female, northern or southern European, etc.) were made into public data for a broader reading public; my purpose was not so much to penetrate the minds of the saints but to explore the minds of the hagiographers and their readers. Had I written after *Holy Feast* appeared, I might have made this distinction clearer. The present essay, unlike *Unquiet Souls*, shares the concerns of *Holy Feast*.

we find a different story, and we discover that male piety is not so easy to study as we might have hoped. This is particularly the case if we look at the vitae and set aside for the moment all other forms of hagiographic material such as canonization proceedings. Looking at the vitae from the thirteenth century, we find an interesting and curious phenomenon: brief lives of men vastly outnumber those of women, but the genders are more or less equally represented in the longer vitae: for every Francis of Assisi or Thomas Aquinas there is a Margaret of Cortona or a Juliana of Mount Cornillon. When we proceed to the fourteenth century, the picture becomes very different indeed, not at the bottom end of the scale, for shorter vitae are still preponderantly devoted to male saints. But when we look at the longer vitae of fourteenth-century saints we find almost exclusively a catalogue of holy women: Catherine of Siena, Christine of Stommeln, Dorothy of Montau, Angela of Foligno, and others. By my count there are ten lives of fourteenth-century women that extend to thirty-nine or more pages in the *Acta sanctorum,* or to comparable length in other editions.[5] For male saints we find far fewer vitae in this category. Specifying exactly how few is difficult because of questions as to what counts: should one include Suso's *Life of the Servant,* or the relatively late vita for John Colombini? If we exclude these, there are no male saints with biographies comparable in length to those of the above-mentioned women. In the fifteenth century the balance is in some measure restored, but the numbers are low in all categories, and women still claim a place in longer vitae disproportionate to their overall numbers.[6] The reasons for these shifts might be worth exploring, but for our purposes it is the effects that matter: if we tried to write a companion volume to *Holy Feast and Holy Fast* dealing with male sanctity, we would find that the source material itself, while not exactly a fast, is less of a feast than we might have hoped.

Furthermore, if it is spirituality that we are seeking, rather than surveys of ecclesiastical careers, the disparity becomes even greater. For women we have numerous probing accounts (written mostly though

5. Apart from those here named, see Clare of Montefalco ("of the Cross"), Joan of Orvieto, Birgitta of Sweden, Lukardis, Mary of Venice, and Oringa (or Christiana); for the vitae of these and other saints cited in this paragraph, see *Bibliotheca hagiographica latina antiquae et mediae aetatis* (Brussels, 1898–1901; repr. Brussels, 1949). For present purposes saints are assigned to centuries solely by the dates of their deaths, even when they lived mainly in the centuries preceding these dates.

6. Among the fifteenth-century women, see Frances of Rome and Lydwine of Schiedam; among the men, James of the March and John of Capistrano.

not exclusively by men) of the subjective elements in religious life. The souls of these women stand open to our eyes, if not to our understanding. For men of the fourteenth and fifteenth centuries, however, we have vitae that, in addition to being on the whole relatively short, are preponderantly written from an external and objective viewpoint. If we turn directly from the vitae of late medieval women to those of contemporary men, the latter documents generally seem at best understated, and their subjects tend to appear almost bloodless. We know that this one was caught up in rapture, or that one was blessed with visions. But we are tantalized with passing allusions; on the whole we hear painfully little about these bursts of inward fire. Were the male saints more reticent than the female ones? Was there less of an audience for the inner twistings of the male soul? Or were men too preoccupied with life outside the cloister to cultivate such experiences? Doubtless there is truth in each of these hypotheses. At any rate, if we want to write the story of male piety we must turn primarily to the pious acts, the devotional behavior of the saints: their veneration of statues and of relics, their daily regimens in the spiritual life, their pilgrimages and quest for indulgences. The vitae tell us more about these things than about the inner experiences of the male saints. In short, we must turn to those aspects of their lives in which they differ least from the anonymous holder of the parchment strip.

In the remainder of this essay, then, I will examine certain features of the devotional behavior portrayed in the vitae. I will focus mainly on the lives of male saints, not because they are more important or more interesting than the female saints, but because recent work on female sanctity requires complementary work on specifically male piety, in the interest of a full view of that culture in which both men and women participated. I wish to offer reflections first about the relationship between saintly and ordinary piety, and second about the relationship between male and female piety.

Most of the saints (and *beati*) to be highlighted here were members of religious orders. They include two Franciscans, two Dominicans, two Augustinian friars, and one Servite; of the members of these mendicant orders, two were lay brothers. Two were Augustinian canons. One was a diocesan priest, bishop, and eventually patriarch of Venice. Of the laymen, one was a member of the lay congregation of Gesuati, while another was a hermit; only one, a duke, lived outside any ecclesiastically recognized form of religious life. This is not to say, however, that the forms of devotion reflected in the vitae are always related to

Late medieval saints (including beati) distinguished for devotional exercises

Name	Year of death	Status
Amadeus of Savoy	1472	duke
Anthony of Stroncone	1461	Franciscan lay brother
Bernardino of Siena	1444	Franciscan Observant
Isaiah of Krakow	1471	Augustinian friar
Jacob Griesinger of Ulm	1491	Dominican lay brother
John of Bridlington	1371	Augustinian canon
John Tavelli of Tossignano	1446	Gesuati
Laurence Giustiniani	1455	priest, patriarch of Venice
Maurice of Hungary	1336	Dominican
Michael Gedroye	1485	Augustinian canon
Nicholas of Flüe	1487	hermit
Peregrinus Laziosi	1345	Servite
William of Toulouse	1369	Augustinian friar

the religious status of the saints, for in many cases the devotions recorded were part of the men's early habits before entering the religious life. Thus the material examined here is not wholly unrelated to the development that Pantin called "one of the most important phenomena of the religious history of the later Middle Ages, namely the rise of the devout layman."[7] The prominent role of the religious orders confirms what one might have suspected: that the support of these groups was a powerful aid in promotion of a posthumous cult. A plurality of these men (five) were from Italy, while three lived in eastern Europe, and one each in France, Savoy, Germany, Switzerland, and England. Chronologically, the saints are clustered in the late fifteenth century: two died in the first half of the fourteenth century (1336, 1345), two in the second half of the fourteenth (1369, 1371), two in the first half of the fifteenth (1444, 1446), and seven in the second half of the fifteenth (1455, 1461, 1471, 1472, 1485, 1487, 1491).[8]

If we want to find echoes of our parchment scroll in the vitae of these men they will not be hard to locate. The texts speak routinely of

7. W. A. Pantin, *The English Church in the Fourteenth Century* (Cambridge, 1955), p. 253 (within a broader discussion of the matter on pp. 253–61).

8. The figure most conspicuously absent from the list is Henry Suso, in whose life and writings devotions played a prominent role. Particularly important are book 1, chaps. 3–13, of *The Life of the Servant*. His style of piety was so distinctive, however, that to include it here would skew the description. I will be discussing his devotions in a book (currently in progress) on late medieval lives of Christ.

the prayer lives of the saints. Two examples may suffice to make the point. Jacob Griesinger spent the greater part of the night in prayer. Of the many prayers he had learned, none was sweeter and more suitable than the Pater Noster; when he said it, his mouth felt as if filled with the sweetest honey or sugar. He prayed daily for the pope, the other prelates, and especially for the superiors of his Dominican order. Having aroused himself to lively devotion, he would thank God for the blessings he had received. Then, each day, he would meditate with deep sighs and moaning upon the mysteries of the Passion: step by step he would ponder each moment of the narrative, straight through to the Resurrection. Then he would salute the Virgin and all the saints.[9] The vita for John of Bridlington presents similar details. When compline was ended, John would remain alone in the choir and persist in prayer and contemplation. He would ponder the state of his life, the care of souls, and the regimen of the monastery of Augustinian canons that was entrusted to him. When it came time for matins he would often arrive before the others and devote himself to prayer and meditation. After matins he would pretend to go back to his cell and fall asleep, but when the others were sleeping he would sneak back into church (or into the chapter house or some other place) and spend the rest of the night in contemplation, psalms, and other devout prayers. Along with one of his brethren he would recite the office of the Blessed Virgin, the office of the Passion, and other devotions.[10]

In these and similar cases one is reminded of the unsainted layman with the parchment strip, and of many other anonymous individuals committed to a life of devotion. Yet the biographers of the saints seem eager to distinguish the prayer lives of these men from that of the more ordinary pious Christians, and not simply quantitatively. Their subjects are not merely devout but saintly. The point is made in various ways: by stressing the heroic intensity of their attention in prayer, by recounting miracles occurring in prayer, by emphasizing their earnestness in prayer even in youth, and by telling of horrible temptations that beset them in their devotions.

Extraordinary attention to prayer is a common theme; a single ex-

9. *Vita*, 3.21, in *Acta sanctorum*, Oct. (Paris and Rome, 1866–84), 5:799; see also 1.2, p. 794.

10. *Acta*, 2.11, in *Acta sanctorum*, Oct. (Paris and Rome, 1866–84), 5:140. Cf. Bernardino of Siena, *Vita II antiquior* 4.27, in *Acta sanctorum*, May (Paris and Rome, 1866), 5:125*; Maurice Csaky of Hungary, *Vita*, 2.5, in *Acta sanctorum*, Mar. (Paris and Rome, 1865), 3:253–54.

ample may suffice to illustrate the point. God had given William of Toulouse the special gift of praying attentively, intelligibly, distinctly, and without wandering thoughts. Once he and a companion were on the road when time came for the office of prime, and he insisted on stopping on the spot and standing immobile until they had completed the office antiphonally, as if they were in church.[11] Other vitae similarly insist on this single-mindedness in prayer.

A more dramatic way of showing saintly (rather than merely devout) practice is to recall miracles associated with prayer. One night, for example, Maurice of Hungary was staying in a strange village. Knowing of his great devotion, his host arose during the night to see whether he was at prayer, but the saint was nowhere to be found. After searching through the house, the host finally went out to the village church, and there he found the saint hard at prayer. The doors to the house and the church had been locked, and the lights inside the church had been extinguished, but the saint had somehow made his way, and the church lights were miraculously ablaze.[12]

More often than we might expect, the biographers recount the saints' devotional habits in the early chapters of the vitae, even when these habits persisted through life. Before a saint entered the religious life, perhaps even in childhood, he was immersed in piety. In effect we have here a late medieval adaptation of the *puer senex* motif, announcing that the saint's later glory is prefigured even in the tenderest years. Here as in other cases, of course, the literary motif may have been lived out in the actual experience of the saints: they may well have been in fact religious prodigies. But what concerns us is the effect of this motif within the vitae, its highlighting as a way of showing the distinctiveness, the "otherness" of the saint. At times this thrust is quite explicit. Maurice of Hungary, for example, while still a boy, would gather his playmates about in his father's castle or palace and would fashion a makeshift chapel out of curtains, where he would play at celebrating Mass. To each of his friends he would assign a role: one would be deacon, another subdeacon, and so forth. Afterward he would give them food, and following his instruction they would sit and eat in silence, as he had seen being done in monasteries. Thus, says his biographer, God disposed the unformed matter of his youth, preparing it

11. *Vita*, 1.2, in *Acta sanctorum*, May (Paris and Rome, 1866), 4:197–98; cf. 3.17, p. 201.

12. *Vita*, 2.9, in *Acta sanctorum*, Mar. (Paris and Rome, 1865), 3:254.

to receive the form of substantial things in the regular life. When away from his studies he did not play games but prayed or sought out religious persons who might tell him stories from the lives of the saints. One aged Dominican responded by picking him up and telling him the story of Saint Alexius, whereupon Maurice wept uncontrollably.[13]

The biographers also underscored the saints' zeal in prayer by showing how the demons themselves tried in vain to distract them. When Michael Gedroye was at prayer, demons made loud clamor, hurled insults at him, and even struck him with blows, leaving him half dead on the floor behind the high altar.[14] William of Toulouse was also subject to diabolical molestations: harsh words, terrible apparitions, and loud thunder. At other times the devil would appear as a young woman beside the saint's bed, hoping to arouse him to lust. But he spurned these attacks as if they were nothing. Yet again the devil came to him at night disguised as the Madonna and besought his adoration—but the prudent saint instinctively knew better and chased the spirit away with the sign of the cross.[15]

Surely the most bizarre of these temptations was that which befell Maurice of Hungary. One night he kept vigil by lamplight in a Dominican church. He was alone, except for the body of a man who had been violently killed; this corpse lay exposed on its bier. Sometime before the cock crowed, the corpse suddenly began to raise itself as if to get off the bier. The saint, confident that this was a demonic ruse to interrupt his devotions, fortified himself with the sign of the cross, then demanded of the body, "Whoever you are, I order you in the name of the Lord Jesus Christ to lie back down and desist from molesting me"! The body at once obeyed; the saint covered it with a cloth and resumed his prayers.[16]

What we have here are essentially traditional hagiographic motifs, conventional devices, adapted to distinguish saintly from ordinary piety in an age when lay piety was increasingly visible and complex. This is not to say that the hagiographers invented such material, but their selection and use of it conforms closely to traditional patterns.

13. Ibid., 1.2–3, p. 253. For a Byzantine parallel to Maurice's liturgical play, from the same era, see Joseph A. Munitiz, "Self-Canonization: The 'Partial Account' of Nikephoros Blemmydes," in *The Byzantine Saint: University of Birmingham Fourteenth Spring Symposium of Byzantine Studies,* ed. Sergei Hackel (London: Fellowship of St Alban and St Sergius, 1981), p. 166.
14. *Vita,* 1.7, in *Acta sanctorum,* May (Paris and Rome, 1866), 1:580.
15. *Vita,* 1.6, in *Acta sanctorum,* May (Paris and Rome, 1866), 4:198.
16. *Vita,* 2.10, in *Acta sanctorum,* Mar. (Paris and Rome, 1865), 3:254.

Let us turn now to the question of gender: certain elements played a markedly greater role in men's piety than in women's, and the differences are worth exploring. Like the women saints, the men had profound reverence for the Eucharist. The context of this devotion, however, differed. Not only was the emphasis on seeing rather than on tasting and eating, though this was one important feature that the men's vitae, unlike the women's, shared with the broader religious culture. Beyond this, the eucharistic piety of the men was subordinated to a broader liturgical piety, rather than the reverse. The Mass itself and the divine office became centers of devotional fervor for those men who celebrated it, assisted at it, or even helped in preparation for it. Thus, Maurice of Hungary would prepare the altar for feast days, fitting it with hangings and other adornments. Out of reverence for the Eucharist he took care that a lamp always burned before it.[17] Michael Gedroye, too, was eager to help in decorating altars or in any other way assist the celebrant.[18] Anthony of Stroncone took pleasure in nothing so much as in assisting at mass or the divine office, "for hardly any other ministry is more pleasing to God." At the time of hours he would set all else aside to sing along with the friars. Once Christ appeared to him and told him that it pleased the divine majesty to have many candles blazing during mass. From then on, whenever he could, he arranged to have a full array of candles lighted on the altar at mass time, especially for feasts of Christ and the Virgin. We are told that throughout life he had great devotion to the Eucharist, but this was secondary to his liturgical fervor. He once remarked, "If you knew how much benefit the soul gains from hearing mass, you would be more than a bit astonished."[19]

If women had visions and miracles related to communion, men had them more readily in association with the consecration. The distinction here should not be drawn too strictly, but if not absolute it was nonetheless real. While Laurence Giustiniani was celebrating mass one year on the vigil of the Nativity, he entered into rapture just after the consecration. The deacon came up several times to urge him on. Finally, as if awaking from sleep, he said, "I will go on now, Brother. But what shall we do with this lovely little baby? How can we leave him alone and naked in such cold?"[20] Men, like women, could be sentimental.

17. Ibid., 2.5, pp. 253–54.
18. *Vita*, 1.5, in *Acta sanctorum*, May (Paris and Rome, 1866), 1:560.
19. *Vita*, 2.10–12, in *Acta sanctorum*, Feb. (Paris, 1863–65), 1:146–47.
20. *Vita*, 3.16, in *Acta sanctorum*, Jan. (Paris and Brussels, 1863), 1:554.

The sentiment here, however, has less to do with the intimacy of union between the hungering soul and its eucharistic food, and more with devotion to the Eucharist in its liturgical context.

Another area where the male saints' piety differed from the women's was in their use of religious art. Devotional recourse to art was by no means a strictly male phenomenon, yet it occurs in the men's vitae more often than in the women's, and its function is different. If women sought full empathetic identification with Christ or the Virgin—one thinks here, perhaps, of Margery Kempe weeping before a crucifix or pieta, or of the fluid boundary between meditations and visions that Craig Harbison has found in his study of Flemish art[21]—men seem to have inclined more toward an objective relationship: they stood before a picture or statue, and they related to it as a source of power or a surrogate for a real person more than as a means for entering into the experience of another individual. Michael Gedroye would pray in church day and night, particularly before the crucifix that stood in the nave, and he heard Christ speaking to him from the crucifix, but his vita says nothing about his being overwhelmed with compassion or empathetic identification.[22]

As a source of power, the crucifix might work miracles. When a surgeon had decreed that his festering leg must be amputated, Peregrinus Laziosi betook himself to the chapter house of his convent and prostrated himself before the crucifix; he then fell asleep, and as he slept Christ came down from the cross to cure his leg.[23] A crucifix that bestowed such favors might become the center of cultic worship. Thus, John of Sahagun often went to pray before a miraculous crucifix in an Augustinian church. On one occasion, while he was praying for reception into the order, a pauper came along to continue a novena he was making for cure of his paralysis. Inspired by the man's faith and fervor, the saint began adding his own petitions to this supplicant's, whereupon the paralytic at once was cured and cast down his crutches.[24] What this story illustrates graphically is the interaction between the male saint's piety and that of the late medieval populace at large, both

21. *The Book of Margery Kempe,* 1.28, 1.46, 1.60, ed. Sanford Brown Meech (London, 1940), 68, III, 148; trans. B. A. Windeatt (Harmondsworth, 1985), 104, 148, 186–87. Craig Harbison, "Visions and Meditations in Early Flemish Painting," *Simiolus: Netherlands Quarterly for the History of Art* 15 (1985): 87–118.

22. *Vita,* 1.7, in *Acta sanctorum,* May (Paris and Rome, 1866), 1:560.

23. *Vita,* c. 7–8, in *Acta sanctorum,* Apr. (Paris and Rome, 1865–66), 3:848.

24. *II Acta,* 1.2, in *Acta sanctorum,* June (Paris and Rome, 1867), 2:630.

seeking the objective favors available from a miracle-working image rather than using the image as a means for inward transformation.

Providing works of art could also be a service to the community, broadly or narrowly conceived. If his prayer and domestic labors left him with time to spare, Anthony of Stroncone spent it carving crosses out of wood, "so that he might bear in his hands and eyes that cross which was impressed in his heart."[25] He placed such crosses in the garden of the friary and in other fitting places to kindle piety in those who saw them.

Apart from crucifixes, the vitae speak of statues and other images of the Virgin as centers for devotion. In his youth, John Tavelli of Tossignano would stop on his way to and from school to pray before a statue of the Virgin.[26] Nowhere did Isaiah Boner of Krakow pray more often than before an image of the Virgin that he himself had made.[27] One incident does suggest empathetic identification: as a young boy Bernardino often stood weeping before a statue of the Virgin.[28] More typical of male piety was a habit of Bernardino's adolescent years: at a time when most young men would have been dallying with young women, he devoted all his amorous attention to a particular image of the Virgin. Unable to behold her beauty directly, he attached himself to the image above one of the Siena town gates, a portrayal of the triumphant Virgin of the Assumption, surrounded by a multitude of angels singing and playing musical instruments in her honor. Twice daily, morning and evening, Bernardino went out to pray on bended knees before this image and contemplate it with loving gaze. If he could not visit this image before going to bed, he would not sleep well that night. His companions would ask where he was going, and he would reply, "I am going to see my love, who is to my heart the most beautiful of all women." His devout cousin Tobia, herself a Franciscan tertiary, feared the worst: when he teased her about going out to see his beloved, she took this all too literally and feared for his virtue. She could not rest until she had spied on him several times and even had a friend spy on him. Only then was she bold enough to raise the question with him directly: just who was this beloved of his? Her literalism need not surprise us, since Bernardino himself appears to

25. *Vita,* 2.15, in *Acta sanctorum,* Feb. (Paris, 1863–65), 1:147.

26. *Vita,* 1.8, in *Acta sanctorum,* July (Paris and Rome, 1867–68), 5:789.

27. *Vita,* 1.4, in *Acta sanctorum,* Feb. (Paris, 1863–65), 2:215.

28. *Vita post corporis translationem composita,* 1.3, in *Acta sanctorum,* May (Paris and Rome, 1866), 5:93*.

have conceived his surrogate relationship in similar fashion.[29] Like the Florentines who (as Richard Trexler has shown us) viewed their Madonna paladin as a living presence with powers of consciousness and perception, so too Bernardino seems to have recognized the image over the gate as bearing a living personality.[30] But it was a personality over against his—a "thou" to his "I"—not one that he entered into or sought to participate in.

Devotional art might be abstract yet powerful, if it captured in a striking image some theme central to popular piety. We need not elaborate on the power that devout Christians of the late Middle Ages found in the *spoken* name of Jesus; Bernardino shared this devotion with his aunt in particular and with his society in general, and preached it with such fervor that contemporaries believed the holy name was engraved on his heart in gold letters.[31] The most famous manifestation of Bernardino's own devotion, however, was a form of popular devotional art that he cultivated: the tablet with the monogram of "Jesus" surrounded by the rays of the sun. Centuries earlier, the motif would have appealed to Constantine and his theologians. In the fifteenth century it appealed to the throngs. It did arouse protest in some quarters and got Bernardino into deep trouble even with the inquisitors on a trumped-up charge of idolatry, yet it remained a highly charged symbol for Bernardino's mission of preaching, conversion, and pacification.[32] The importance and the controversial nature of this plaque attest to the power of devotional art to galvanize public fervor.

One of the early biographers tells a story about the origin of Bernardino's devotional image. The saint had been preaching against vanity and had persuaded people to smash and burn their game boards and dice. The local woodworker who manufactured such things came to him, outraged at the assault on his craft and complaining that he was now reduced to poverty. Did he have no other craft to practice? No. Taking a board, Bernardino made a circle, and in it he depicted the sun, with the name of Jesus inscribed in it. Instead of earning his livelihood by producing vanities, the woodworker should from now

29. *Vita post corporis translationem composita,* 1.5, in ibid., p. 93*; *Vita I antiquior,* 2.11, in ibid., p. 110*; *Analecta,* 1.2–3, in ibid., p. 135*.

30. Richard C. Trexler, "Florentine Religious Experience: The Sacred Image," *Renaissance Studies* 19 (1972): 7–41.

31. *Vita I antiquior,* 1.9, in *Acta sanctorum,* May (Paris and Rome, 1866), 5:109*; *Vita II antiquior,* 1.7, in ibid., p. 119*.

32. *Analecta,* 2.10, in ibid., pp. 137–38*.

on make and sell these devotional plaques. The man took up the suggestion and made such a profit that he soon grew wealthy.[33] The story thus has two morals, one Franciscan and one perhaps more nearly Calvinist.

Another devotional image produced by a fifteenth-century holy man was more complex and theologically sophisticated than Bernardino's. Nicholas of Flüe, the Swiss hermit with a humanist following, produced a meditative tablet for his chapel that showed the intricate relationship between the Godhead and the mysteries of salvation. If in some respects it was unlike Bernardino's tablet, however, it shared certain common functions: it was intended as a means of instruction as well as meditation. According to his humanist biographer, Nicholas composed this image as a kind of "book," with which he taught the truths of the faith. While Nicholas did not travel about promoting the use of this image, his followers did secure its publication in more than one early printed book.[34]

It may seem odd at first that the biographers of male saints say little if anything about their reading habits. On this question I tread cautiously and tentatively. We know that certain women saints were enthusiastic readers, and we know that devotional reading figured prominently in the urban religious culture of the era. Paul Saenger has shown, however, that in the late Middle Ages reading was increasingly associated with inward piety, of a sort that we see most often in women's vitae.[35] This is not to suggest that pious women read more than men did, or that the content of books was less important for men than for women. Rather, it may be that the *activity* of reading was in closer accord with the central themes of women's piety than with those of men's, and perhaps for that reason the men's biographers pass over the matter in silence. Most of the saints dealt with here belonged to religious communities and would have sung the office in choir, and some lay saints in the late Middle Ages are said to have joined in this exercise, but recitation of the office or the "hours of the Blessed Virgin" or other private devotions figures specifically in women's vitae.[36]

33. *Analecta,* 2.9, in ibid., pp. 137–38*.

34. Robert Durrer, ed., *Bruder Klaus: Die ältesten Quellen über den seligen Nikolaus von Flüe, sein Leben und seinen Einfluss* (Sarnen, 1917–21), esp. pp. 433–35, 1068–77.

35. Paul Saenger, "Books of Hours and the Reading Habits of the Later Middle Ages," *Scrittura e civiltà* 9 (1985): 239–69.

36. On participation in public hours, see Elzear of Sabran, *Vita,* 1.8, in *Acta sanctorum,* Sept. (Paris and Rome, 1866–68), 7:576–93; Richard Rolle, in Stephen Willoughby Lawley, ed., *Breviarium ad usum insignis ecclesie Eboracensis,* 2 (Durham, 1883),

If the men's vitae emphasize outward conduct more than inward disposition, it is not surprising to find that for men, more than for women, piety played a role in pedagogy, or public religious instruction. Amadeus of Savoy took pains to teach love of God to others by word and by example.[37] When Bernardino began preaching, in his zeal for the salvation of souls he pondered how he might arouse people to penitence. The solution was characteristically Franciscan: he had a large and heavy cross made, and he himself carried it on his shoulders through the streets of the town.[38] The simple fact that men's piety expressed itself in preaching and in written counsel made it possible for men more than women to engage in piety as pedagogy, a fact so obvious that we need not belabor it.

This instructional role of devotions calls to mind a factor in devotional life that we have not yet considered: while devotions could be private exercises, calling an individual out of society or giving him a religious motive for seclusion, they also had a public side that does not come often to the fore in these vitae but would have been vital in the parishes of late medieval Europe. Devotions mediated between the privacy of the home and the public space of the church. They were exercises that a pious layperson could take into the withdrawal of a private chamber or cell, but the same devotedness (to a patron saint, perhaps, or to the Passion of Christ) could display itself in the activities of a parish or a confraternity. The devotions seen in the vitae may have been more often than not personal, but they could also serve for edification and instruction of others; it would be misleading to portray

785–820, lect. 2; Mary of Maillé, *Vita*, 2.10 and 5.28, in *Acta sanctorum*, Mar. (1865–68), 3:747–65, and *Processus canonisationis*, 5.51, in ibid., pp. 737–47; and Francis of Fabriano, *Vita*, 1.2 (regarding the saint's father), in *Acta sanctorum*, Apr. (Paris and Rome, 1865–66), 3:992–96. For examples of private use of hours, see Flora of Beaulieu, *Vita*, 1.2, in *Acta sanctorum*, June (Paris and Rome, 1867), 2:43–54 of appendix; Catherine of Sweden, *Vita*, 4.31, in *Acta sanctorum*, Mar. (Paris and Rome, 1865), 3:505–15; and especially Elizabeth of Portugal, *Vita*, 3.16, 6.48–49, 8.67, 10.85–86, 10.90–91, in *Acta sanctorum*, July (Paris and Rome, 1867–68), 2:173–213. One exceptional case of a male who used private hours was a prisoner who came under the influence of Jane Mary of Maillé and who kept a copy of the hours for daily recitation in his prison cell (6.41), but even in this case the story is told more to illustrate her piety than to underscore his.

37. *Virtutes et miracula*, 1.1, in *Acta sanctorum*, Mar. (Paris and Rome, 1865), 3:878. On the theme here reflected (*docere ... verbo ... atque exemplo*), see Caroline Walker Bynum, *Docere verbo et exemplo: An Aspect of Twelfth-Century Spirituality* (Missoula, Mont., 1979).

38. *Vita post corporis translationem composita*, 1.13, in *Acta sanctorum*, May (Paris and Rome, 1866), 5:96*.

them as essentially or necessarily introvertive.[39] Late medieval devotions are often seen as solitary and individualist exercises.[40] Yet the individualization of the collective was simultaneously a collectivization of the individual: if personal devotion diverted attention from the public liturgical sphere, it also brought themes and customs from that sphere into one's personal life.

We might explore further areas of men's and women's piety: their pilgrimages, for example, and their quest for indulgences. For these and other devotions, the vitae provide ample material. The themes we have already discussed, however, may suffice to establish a few modest points. If this brief exploration has proposed no single thesis, no governing concept that underlies male piety and distinguishes it from female devotions, we have nonetheless isolated certain characteristic traits of the men's vitae that I think deserve attention. First, the very absence of a central governing preoccupation makes men's piety, as presented in the vitae, more varied than women's. Caroline Bynum can conclude that for women food is not just *an* important theme but *the* central motif. There is, I think, no analogous principle in the devotional lives of the male saints. Preoccupied with the varying circumstances of their active lives, they were dedicated to the pursuit of multiple goals, both public and private. For women, one thing alone seemed necessary, and that one thing was more likely to be expressed in metaphor. Second, at a time when the very literary form of women's vitae was being modified to accommodate their emphasis on inward experience, the piety in the men's lives was presented within the traditional structures of hagiography. It was by use of traditional hagiographic conventions that men's piety was distinguished from ordinary lay devotion. The conventionality of the vitae may or may not be rooted in a traditional bent within the saints' actual conduct; in any case, if we examine what the biographers selected for telling, and how they told it, we find that the biographers for men resemble earlier hagiographers more than do the biographers for women. Third, the emphasis in men's vitae tends to be more on outward, objective, public behavior than in women's vitae, and more often their piety is seen as serving

39. For the notion that devotions form a middle category, between the privacy of contemplation and the public formality of liturgy, see Richard Kieckhefer, "Major Currents in Late Medieval Devotion," in *Christian Spirituality: High Middle Ages and Reformation,* ed. Jill Raitt (New York, 1987), pp. 75–108.

40. E.g., Georges Duby, ed., *A History of Private Life,* vol. 2, trans. Arthur Goldhammer (Cambridge, Mass., 1988), pp. 528–33.

the goals of pedagogy. And fourth, it is harder to distinguish men's than women's piety (as presented in the vitae) from the ordinary lay piety of the surrounding culture.

Let me close with two proposals for further research. First, we need to pursue the question whether these differences lie in the hagiographic conventions alone or in the lived experience: in the lives of these saints or in their vitae. We need systematic comparison of hagiographic with nonhagiographic texts, and specifically with writings by the saints themselves. This is a comparison I cannot claim to have done, but it is necessary for further progress in this area. Second, the goal of such gender studies must not be to isolate the genders from each other. Caroline Bynum makes clear that women's food-related piety was important for men as well as for women. The representation of male saints, likewise, cannot be seen as a concern of men alone. Women saints (even cloistered ones) did not simply live in a society of women; they lived in society as women. Male saints did not live in a society of men; they lived in society as men. The importance of gender will never be clear unless it is seen in its natural context—or its natural complex— of roles and meanings within society as a whole.

Notes on Contributors and Editors

Renate Blumenfeld-Kosinski, Associate Professor of French at Columbia University, is the author of *Not of Woman Born: Representations of Caesarean Birth in Medieval and Renaissance Culture* (1990) and of *The Writings of Margaret of Oingt, Medieval Prioress and Mystic (+ 1310)* (1990).

Kevin Brownlee is Professor of Romance Languages at the University of Pennsylvania. He is the author of *Poetic Identity in Guillaume de Machaut* (1984) and is currently completing a book on the courtly lyric and historiography in the writings of Christine de Pizan.

Magdalena Carrasco, Associate Professor of the History of Art at the New College of the University of South Florida, has published several articles and has lectured extensively on hagiographic iconography.

Brigitte Cazelles, Professor of French at Stanford University, is the author of *La faiblesse chez Gautier de Coinci* (1978), *Le vain siècle guerpir: A Literary Approach to Sainthood through Old French Hagiography of the Twelfth Century* (1979) (with Phyllis Johnson), and *Le corps de sainteté* (1982).

John Coakley teaches at the New Brunswick Theological Seminary. He wrote his dissertation at Harvard University on the representations of sanctity in Dominican hagiography.

David Damrosch, Associate Professor of English and Comparative Literature at Columbia University, published *The Narrative Covenant: Transformations of Genre in the Growth of Biblical Literature* (1987). He is currently writing a book on the future of literary history.

Cynthia Hahn is Associate Professor of Art History at Florida State University, Tallahassee. She published *Passio Kiliani . . . Passio Marga-retae: Faksimile-Ausgabe des Codex MS. I 189 aus dem Besitz der Nie-dersächsische Landesbibliothek Hannover* in 1988. Her current research is on monastic illustrated saints' lives.

Klaus P. Jankofsky, Professor of English, Medieval, and Comparative Literature at the University of Minnesota, Duluth, was educated in Germany and France. His research and publications focus on Middle English representations of death and dying in literature and historical reality, medieval legendaries, and medieval and modern Arthurian literature.

Richard Kieckhefer, Professor of the History of Religion at North-western University, is the author of *European Witch Trials: Their Foun-dations in Popular and Learned Culture, 1300–1500* (1976); *Unquiet Souls: Fourteenth Century Saints and Their Religious Milieu* (1984); and *Magic in the Middle Ages* (1989).

Lester K. Little, Dwight W. Morrow Professor of History at Smith College, is the author of *Religious Poverty and the Profit Economy in Medieval Europe* (1979), also translated into Spanish. His research con-cerns the social history of religious movements.

Jo Ann McNamara, Professor of History at Hunter College, has published *Daily Life in the World of Charlemagne* (1978) and *A New Song: Celibate Women in the First Three Christian Centuries* (1983). She is presently working on a history of Catholic nuns and, with John E. Halborg and Gordon Whatley, on a book about sainted women in the Dark Ages.

Elizabeth Robertson is Associate Professor of English at the University of Colorado in Boulder. Her book *Early English Devotional Prose and the Female Audience* and a book of essays, coedited with David Benson, *Chaucer's Religious Tales,* are to be published in 1990.

Gail Berkeley Sherman, Associate Professor of English and Human-ities at Reed College, is working on a book-length manuscript on Julian of Norwich and on a translation of Henry of Lancaster's *Livre de seintz medicines.*

Timea Szell is Assistant Professor of English at Barnard College. She writes fiction and is currently at work on a book about some of the cultural and literary implications of the rhetoric of medieval saints' lives.

Karl D. Uitti is John N. Woodhull Professor of Modern Languages

at Princeton University. His major publications include *Linguistics and Literary Theory* (1969) and *Story, Myth, and Celebration: Old French Narrative Poetry, 1050–1200* (1973).

André Vauchez, Professor of History at the University of Paris X, is the author of *La spiritualité du moyen âge occidental: VIIIe–XIIe siècles* (1975), *Religion et société dans l'occident médiéval* (1980), *La sainteté en occident aux derniers siècles du moyen âge d'après les procès de canonisation et les documents hagiographiques* (1981), and *Les laïcs au moyen âge: Pratiques et expériences religieuses* (1987).

Evelyn B. Vitz is Associate Professor of French at New York University. She is the author of *The Crossroad of Intentions: A Study of Symbolic Expression in the Poetry of François Villon* (1974) and *Medieval Narrative and Modern Narratology: Subjects and Objects of Desire* (1989).

Index

Library of Congress Cataloging-in-Publication Data

Images of sainthood in medieval Europe / edited by Renate Blumenfeld-
 Kosinski and Timea Szell.
 p. cm.
 Includes bibliographical references and index.
 ISBN 0-8014-2507-7 (alk. paper). — ISBN 0-8014-9745-0 (pbk.
alk. paper)
 1. Hagiography. 2. Christian saints—Cult—Europe. 3. Europe-
-Church history—Middle Ages, 600–1500. I. Blumenfeld-Kosinski,
Renate, 1952- II. Szell, Timea Klara.
 BX4662.I52 1991
 235'.2'0940902—dc20 90-55889